MAHMOUD ZIBAWI

EASTERN CHRISTIAN WORLDS

Preface by Olivier Clément

Translated from French
by
Madeleine Beaumont

English translation
edited by
Nancy McDarby

A Liturgical Press Book

THE LITURGICAL PRESS
Collegeville, Minnesota

1 2 3 4 5 6 7 8 9

Library of Congress Cataloging-in-Publication Data

Zibawi, Mahmoud.
 [Orients chrétiens. English]
 Eastern Christian worlds : Mahmoud Zibawi ; preface by Oliver Clément ; translated from the French by Madeleine Beaumont; English translation edited by Nancy McDarby.
 p. cm.
 Includes bibliographical references.
 ISBN 0-8146-2375-1
 1. Eastern churches. 2. Oriental Orthodox churches. I. Title.
BX106.2.Z5313 1995
281′.5—dc20 95-18409
 CIP

By wind from some great leaf the world is stirred
which God and you and I have character'd,
now being turned by unknown hands on high.

Rainer Maria Rilke
The Book of Hours
First Book: The Book of the Monastic Life
Number 8
Selected Works, vol. 2, trans. J. B. Leishman
(New York, New Directions, 1967) 30

Contents

Acknowledgments

We wish to thank the following for the invaluable help and support they have given us in the preparation of this book.

His Holiness Shenouda III, Patriarch of Alexandria
His Beatitude Ignatius IV, Greek Orthodox Patriarch of Antioch and all the East
His Beatitude Ignatius-Zakka I Iwas, Syrian Orthodox Patriarch of Antioch and all the East
His Holiness Karekin II, Supreme Patriarch and Catholicos of all the Armenians in Holy Etshmiadzin
His Excellency Bishop Samuel
His Excellency Bishop Serabion
His Excellency Bishop Sebouh Sarkissian
Rev. Father Paolo Del'Oglio, S.J., Monastery of St. Moses the Ethiopian
Rev. Father Martyrios, Monastery of the Syrians

Mr. Michele Cordaro, Central Institute of Restoration
Mr. Marc Dury, Sam Fogg Gallery
Mr. Tarek Mitri, Ecumenical Council of Churches
Mme. Souad Slim, Antiochene Center for Study and Research
Mr. Philip Michel Thirriet, Sers Library
Mme. F. Wasmer, Armenian Museum of France
Mr. Elias Zayat, University of Damascus

Abbreviations

JB Jerusalem Bible
PG Jacques-Paul Migne, ed., Patrologia Graeca
PL Jacques-Paul Migne, ed., Patrologia Latina
S Sūrah
SC Sources Chrétiennes (Paris: Cerf)

Preface

Led by Mahmoud Zibawi's stunning book, we journey to spiritual galaxies which have been too neglected, although they are Christian universes and fiercely faithful to what was given us at the beginning. For example, is not Ethiopia regarded as the new Israel in the strictest sense since the Ark of the Covenant is now resting in Aksum in the Cathedral of Zion and since the baptismal water always contains a few drops drawn from the Jordan river? If we set aside Ethiopia and, at rare intervals, Armenia, these Churches have lived in a condition of humility, of destitution, of recourse to the sole strength of the Spirit at the very time the first, the second, and the third Rome were immersed in the luxuries and aberrations of power. Those which were the weakest from the viewpoint of material goods, and primarily the Eastern Church called "Nestorian," have achieved, with an immense respect for the cultures they encountered, an altogether unbelievable mission in the deepest recesses of Asia: India, Tibet, Mongolia, China. This adventure would have changed the face of the world if the message of the divinity and humanity of Christ had not been, as it were, sundered between Buddhism, where everything is contained within an unnamed divine, and Islam, which—except in esotericism—radically separates the human from the transcendent.

To this Asiatic missionary adventure, corresponds an African adventure with the establishment of a vast Monophysite rectangle going from Egypt to Ethiopia through Nubia. This is a Nilotic axis at whose two extremities Christianity exists to this day.

Are these "Nestorians," these "Monophysites" heretics? The accusation has been hurled from various quarters when words have been at loggerheads because their context was ignored. And yet, the works of a "Nestorian" mystic, Isaac of Nineveh, have never ceased to nurture the most "orthodox" prayer, from the monks of Mount Athos to Dostoyevsky. And the cries, the flashes of lightning of a "Monophysite" poet of the tenth century, Gregory of Narek, still move us to the core by their modernity, nothing in them seeming foreign to us. For the "Nestorians," Jesus' human individuality is from Mary's womb, the temple of the divinity. For the "Monophysites," the one nature of the Incarnate Word designates the unity not only of the person but of the entire life of Christ.

The blazing fires of the Christological controversies have left behind hardened black slag cemented by a blind hatred and a theology of systems and obstinate repetitions. Today, we do not need enemies to define ourselves, and the somber walls are falling of themselves.

Here is precisely the reason for this book's timeliness and liberating importance: it shows that, at the time of the most grievous divisions, beauty was never divided. The book sets in full light what we could call the *ecumenism of beauty*.

It is in Syro-Palestine and Egypt that Hellenism became orientalized and the art of the icon was really born, as Mahmoud Zibawi showed in his previous book, *The Icon: Its Meaning and History*. It is here, in these transfigurative figures, that the body is absorbed into the face, and the face into the gaze, this fissure (in the opaque "garments of skin") through which, at times, we are given a presentiment of the luminous corporality of paradise.

Byzantine influence powerfully radiated throughout this East which was not Greek but properly Eastern, and even Oriental. However, the Persian border and then the protection of Islam allowed for the development of admirable original styles which also received other influences from Persia, India, and China. The story of Barlaam and Joasaph is a Christianized adaptation of Buddha's life; in Armenian gospel books, lion-dogs and serpent-dragons come from China; the Virgin of Adwa, in Ethiopia, resembles an Indian deity. We do not even have to mention a whole archaic bestiary, a prehistoric stock already used in Mesopotamia during the second millennium B.C.E. and also present in Romanesque art.

This book describes an even more remarkable symbiosis occurring at a later date, that of Christianity and Islam, *without relativism or syncretism, but in understanding and beauty.* Islam hardens only when it feels threatened: thus, in the thirteenth century, when it was caught between crusaders on the west and Mongols on the east. But before that, under the Umayyads and 'Abbāsids, a multi-religious culture and a poly-ethnic Arab society flourished. While Christians became gradually arabized— but how many Westerners today are aware that there are still Christian Arabs?—Nestorians, Monophysites, Melchites worked in perfect accord with the Muslims in the fields of scientific research and philosophical speculation. The Christians of the Middle East, especially the Nestorians, are the people who translated into Syriac, then into Arabic, the body of Greek science and thought. But what is striking above everything else, Mahmoud Zibawi tells us, is the profound communion in beauty existing between so many different milieux. In medieval Egypt, for instance, stucco decorations are almost the same in churches and mosques. Nearly everywhere, the Gospels are lettered with the same zeal as the Qur'ān. Among both Christians and Muslims, the visible is deciphered through the invisible; for, to cite Roman Jakobson, the visible is only "the tangible side of the sign." The result is that this trans-historical art is untouched by the convulsions of secular history: it pursues its course, Milky Way-like, to the edge of the black hole of Western modernity. For Christians, apophatic theology is fulfilled and transcended in the Incarnation: in Christ, the world is secretly the burning bush—in the words of Maximus the Confessor—and it is this incandescence which art strives to unveil. For the Muslims, mediation is effected through the semantic flesh of the Qur'ān, untiringly lettered over and over again. And calligraphy becomes arabesque: at the moment when Christian art closes all circularity in order to celebrate the Center at last present, Islamic art opens it in order to point to, and lose, an ungraspable Center. For all that, Islamic art is not totally aniconic: the miniatures of the Middle East teem with gardens and faces. These paradisiac gardens, these scenes of loves as impossible as that of the Song of Songs, experience neither third dimension nor shadow, exactly like icons. In this transfigured Neo-Platonism, whether Christian or Muslim, the world of ideas becomes that of angels. *Mundus imaginalis,* "world of images," says Henri Corbin, speaking of the Persian mystic vision of reality, a space at once interior and intermediary where flies the Senmurv, a figure of the Holy Spirit. But for Christians of these Eastern worlds, the paradisiac arabesque is bisected by the Cross which transforms the *mundus imaginalis* into an interior space mysteriously enveloping beings and things, therefore their very reality. Mahmoud Zibawi stresses that the great bare Cross, without any representation of the Crucified, the Cross already described in the second century by St. Irenaeus of Lyons, is everywhere—in churches, miniatures, cemeteries (particularly in Armenia). Paschal Cross, Cross of victory and light, Axis of the world, new Tree of Life whose fruit will be the Reign.

Today, these Churches, which are whole cultures, which are whole worlds, are diminished and threatened. Their art, including the present-day attempts at renewal, has been debased by the invasion of the second-rate products of Western pietism. At the very time the spiritual desert spreads, Mahmoud Zibawi reminds us—and this reminder is as good as a promise—that throughout the Christian and Muslim worlds of the East, and even farther, over deep Asia, a unique and diverse river of beauty once flowed, bringing peace and light, and that, therefore, it can do so again, provided we learn, in the very movement of the great Western "quest," to rediscover its source.

Olivier Clément

CHAPTER ONE

Eastern Christian Communities

The Hebrew prophets announce the Messiah. "His name is Orient."[1] "To him was given dominion / and glory and kingship, / that all peoples, nations, and languages / should serve him. / His dominion is an everlasting dominion / that shall not pass away, / and his kingship is one / that shall never be destroyed" (Dan 7:14). The Gospels announce his coming. Christ is the fulfillment of prophecies. Bethlehem is his cradle. From the East, the Magi arrive in Jerusalem in order to pay him homage. From Nazareth to the Galilee of the nations, "Land of Zebulun, land of Nephtali, / on the road by the sea, across the Jordan" (Matt 4:15; LXX Isa 8:23), Christ announces the reign of heaven. The last meeting is in Galilee where, on the mountain, the risen Christ charges his disciples to go "into all the world and proclaim the good news to the whole creation" (Mark 16:15).

Pentecost marks the birth of the Church. Microcosm of the world of that time *(oikoumenē)* the Jerusalem community listens to the Spirit-filled disciples: "Parthians, Medes, Elamites, and residents of Mesopotamia, Judea and Cappadocia, Pontus and Asia, Phrygia and Pamphylia, Egypt and the parts of Libya belonging to Cyrene, and visitors from Rome, both Jews and proselytes, Cretans and Arabs—in our own languages we hear them speaking about God's deeds of power" (Acts 2:9-11). Conversions multiply. Christianity grows in the Jewish milieux, penetrates into the pagan "Greek" world of the West and the pagan "Aramaic" world of the East. The apostolic expansion in the East reaches to the regions dominated by Persia. The disciples ardently participate in this expansion: in Antioch, they are called "Christians" for the first time (Acts 11:26). Peter accomplishes a Mediterranean crossing: miraculously delivered from prison, he leaves Jerusalem for "another place" (Acts 12:17). From Rome, he writes his letters to the Christians of Asia before being put to death on a cross. Paul crisscrosses the Roman world, directs his steps toward the West, reaches the shores of the Adriatic Sea and of Illyria, goes back to the East, and dies a martyr's death in the capital of the empire. John enlightens Asia Minor and leads his seven Churches. Matthew goes into Persia, reaches Ethiopia, and returns to Babylonia. Bartholomew brings Matthew's Gospel as far as India. Matthias, Jude, and Simon carry the word of God beyond the Taurus. Mark converts Egypt; Andrew, the Scythians; Philip, the Phrygians; Thomas, the Parthians. "Athletes of justice," the "divine earthlings" sow, "like a seed," "the Name of the one God," gather "the divided peoples from every realm," and manifest before them the unique Power, "in order that all tongues may tend toward the meeting with God's Name."[2] According to tradition, more than one hundred Churches have been established in the world by the end of the first century, three quarters of them in Eastern countries.

New torch-bearers arise. According to Eusebius of Caesarea, "They were content with establishing the foundations of faith in some foreign land; afterwards, they appointed other leaders and entrusted them with the charge of seeing to the needs of those they had just converted. This done,

they departed again for other nations with God's grace and help."[3] About 206, Abgar VIII converts to Christianity: the first Christian ruler is king of Osroene, a little realm in upper Mesopotamia, between the Parthian and Roman empires. About 280, moved by the grace of St. Gregory the Illuminator, King Trdat (Tiridates) receives holy baptism. In contrast to Abgar, he converts his people. The royal family as well as state and army dignitaries follow the Way. The pagan cult is forbidden, and Armenia becomes the first Christian kingdom.

The Christian Empire

Neo-Platonism dominates the spiritual culture of late antiquity. Gnostics, philosophers, and mystagogues rub elbows and sometimes clash. Faced with the primitive Church, the politics of the Roman empire oscillate between hostility, contemptuous tolerance, and persecution. Constantine is converted in 313. Constantinople becomes the residence of the emperor and the seat of administration. The Edict of Milan gives "to Christians and to everybody the freedom to follow their religion of choice." The empire remains multiconfessional: Christians enjoy "the most complete, the most absolute freedom" and may practice their faith "freely and sincerely without being in any way challenged or harassed." Likewise, the practitioners of other religions have "the full and absolute right to follow their custom and their faith and freely venerate the gods of their choice."[4] Gnoses blend with one another. Judean-pagan-Christian sects multiply. Initiates as well as ordinary people engage in passionate theological debates. Public disputes sometimes end in general riots. "If you inquire of someone about the price of milk," St. Gregory of Nyssa observes, "you are treated to a lecture on the Begotten One and Unbegotten One. If you ask for the price of bread, the answer is, 'The Father is greater than the Son and the Son is subordinated to the Father.' If you query, 'Is the bath ready?' you are told that the Son has been brought out of nothingness."[5] The Church defines its faith. In 325, the first council of Nicaea condemns Arius and defines the Son as "consubstantial" with the Father. In 381, the council of Constantinople affirms the divinity of the Spirit. God is Uni-Trinitarian. God's absolute unity is inseparable from the diversity of the three Persons: the Creed of Nicaea-Constantinople defines and confesses this faith.

In 392, Theodosius consecrates Christianity as the state religion. The Olympic games and the Eleusinian mysteries are suppressed. Paganism and Judaism are declared "superstitions." Christianity is everyone's religion. Kosmocrator, that is, Master of the World, the emperor is God's lieutenant. Without Rome's primacy being contested, the patriarch of Constantinople is the palace chaplain. State and Church are the pillars of the empire. The decisions of the councils acquire the force of law, and "heresy" is made a crime. While stressing the superiority of the priesthood over the civil power, St. John Chrysostom hails the empire, which supports the faith and makes its extension possible: "Nowadays, those vast expanses over which the sun shines, from the Tigris to the British Isles, the whole of Africa, Egypt, and Palestine and all that is subject to the Roman empire lives in peace. You know that the entire world is free of trouble and that, of war, we hear only rumors."[6] At the same time this historical metamorphosis takes place, monachism is growing rapidly in Egypt and Syria. Far from the *pax Romana* the Desert Fathers make their way "fearlessly into the vast retreats of solitude"[7] in order to guard the walls of the Church for Christ, to find again the lost paradise, and beyond history, to anticipate the reign of God. Theodoret of Cyrrhus writes about "the lives of human beings who have shone like stars in the East and whose rays have reached the limits of the Universe."[8] Palladius chronicles "the admirable life that our Holy Fathers, the monks and hermits of the desert, have led in virtue and asceticism."[9] These were found in Egypt, Libya, the Thebaid, Syene, Mesopotamia, Palestine, Syria, and "the West: Rome, Campania and its surroundings."[10]

In the fifth century, under the pressure of invasions of Visigoths, Ostrogoths, Huns, and Vandals, the empire collapses in the West but survives in the East. The Christological quarrels foretell the divisions between the Churches of the East. Antioch and Alexandria confront one another. The different terminological definitions center on Christ, his person, his humanity, and his divinity. Words like "physis," "hypostasis," and "ousia" tear Christendom apart. Nestorius tends to overemphasize the Savior's human nature: it is the temple of his divinity. Conversely, Eutyches absorbs his humanity into his divinity. In 431, the council of Ephesus condemns Nestorius' teaching and affirms the hypostatic union in Christ, the Incarnate Word. As a consequence, Mary, the mother of Jesus, is Theotokos, Mother of God. Those who do not accept the declarations of Ephesus take refuge in Persia. According to the author of the *Exposition of the Offices of the Church,* they "alone remained in the orthodox confession and preserved the truth of the Holy Apostles."[11] Under Persian domination, the school of Edessa emigrates to Nisibis. St. Nerses, one of its great masters, accuses "the doctors clad in pride" of abandoning "love, hope, and faith" in order to "babble empty and silly dreams."[12] Satan has torn the Church apart, he says. "Satan caused schisms to sprout among those outside [our communion] and quarrels among those inside."[13] "The one and pure body of the Church which is composed of several [members], it is he who has torn it to pieces by the diversity of his teachings."[14]

The mystery of the kenosis divides those who accept the definitions of Ephesus. Who underwent the Passion of the Cross? the Word or the flesh of the human Christ? The people who later on will be called "Monophysites" favor St. Cyril's formulas: "The nature of the Incarnate Word is One"; "God the Word suffered in the flesh." Against a Monophysite interpretation of Cyril's formulas, the council of Chalcedon declares in 451 that Christ is "true God and true human being," the two natures being united "without confusion or modification or division or separation." Those who do not accept Chalcedon see in this council a return to Nestorianism. The emperor supports Chalcedon and places its enemies among heretics. Dioscorus, bishop of Alexandria, is deposed and exiled. Archbishop Proterius, who accepts Chalcedon, replaces him with the help of the secular power. The waters become muddier and muddier. While claiming the title of Orthodox, the ecclesiastical hierarchies split into factions, excommunicate one another, and hurl anathemas back and forth. Egypt joins the non-Chalcedonians en masse. In 457, Proterius is assassinated on Holy Thursday during the celebration of the Divine Liturgy. There follows a bloody repression. Unshakable, the Egyptian opposition is crushed by imperial troops at the cost of thousands of victims. Syria is split: a non-Chalcedonian Antioch allies itself with Alexandria; its thrust reaches to Mesopotamia and shakes the Persian "Nestorian" citadel. The Churches keep their missionary zeal. Under the great metropolitan of Seleucia-Ctesiphon, the Nestorian community pursues its missionary expansion and reaches to southern India, where the faithful of Malabar celebrate in the Syriac tongue. In their flight from the persecutions of the central power, nine Syrian Monophysite Saints arrive in Ethiopia after having stayed in a monastery of upper Egypt. Scattered throughout the country, they convert the people and strengthen the young Ethiopian Church, which is placed under the jurisdiction of the patriarch of Alexandria.

Internal strife continues through the sixth century. Like Anastasius I, the Empress Theodora protects the non-Chalcedonians in order to maintain Byzantine domination over Egypt and Syria. Justinian reconquers North Africa, Italy, and southern Spain. Again, the Mediterranean is a Roman lake, but the frontiers remain in flux. Theological debates continue. St. Severus of Antioch and Julian of Halicarnassus keep up a controversy on the condition of Christ's body during his earthly life. Severus proclaims the natural passibility of Christ's body up to the resurrection. Julian, on the contrary, affirms the impassibility of the divine body and its incorruptibility during Christ's earthly life, crucifixion, and burial. Monophysitism begets monophysitisms. In 506, at the council of Dwin, the Armenian Church

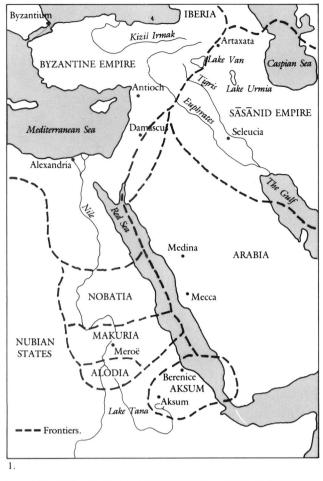

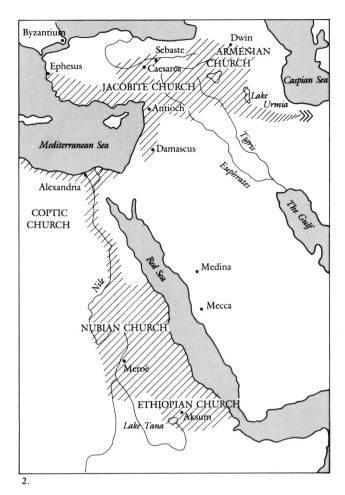

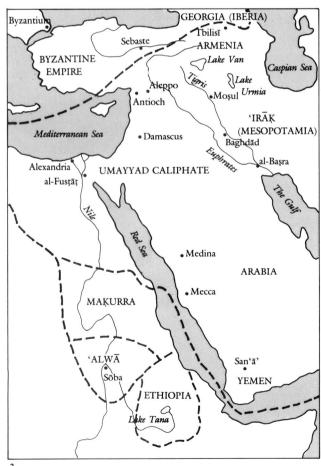

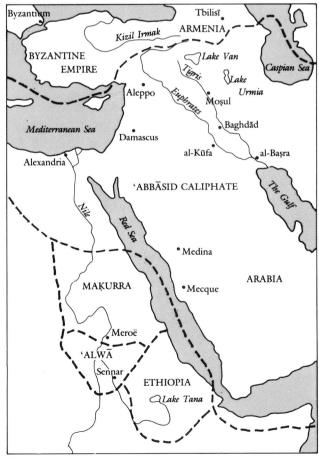

12

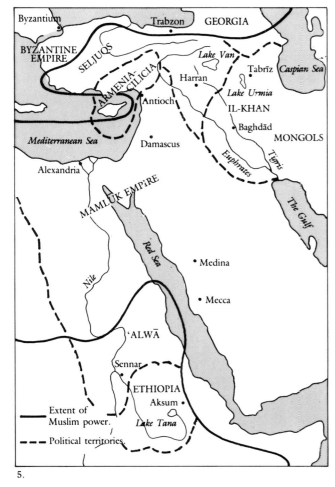

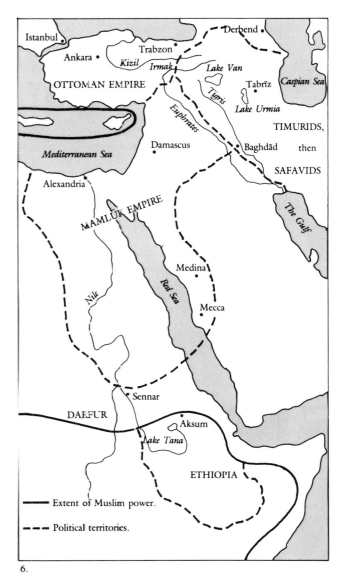

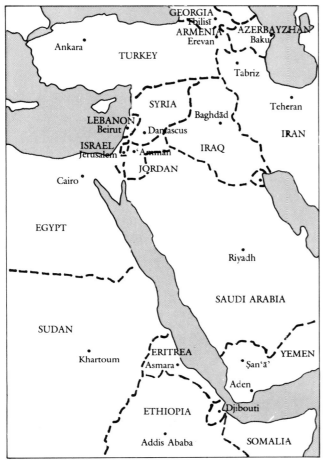

1. Byzantines, Sāsānids, Nubia, Aksum. Beginning of 7th c.

2. Monophysite Christianity (after H. Littell).

3. Byzantine Empire, Umayyad Caliphate, Nubia, Ethiopia. Beginning of 8th c.

4. 'Abbāsid Caliphate, Byzantine Empire, Armenia, Nubia, Ethiopia. 10th c.

5. Byzantine Empire, Georgia, Armenia-Cilicia, Seljug Turks, Mamlūk Turks, Il-Khan Mongols. About 1250–1300.

6. Ottoman Empire, Mamlūks, Timurids, Ethiopia. About 1500.

7. Present-day political divisions.

rejects "both the Nestorianism of the Persians and the Chalcedonian orthodoxy of the Greeks, all the while professing Julian's Aphtartodocetism, which allowed it to break away also from the Syrian Church."[15] St. Severus is expelled from his seat in 518. His "flight into Egypt" consecrates the alliance between Alexandria and Antioch. "The love between the Coptic community and the Syrian community increased,"[16] says a chronicle of the eleventh century. Bloody repressions redouble, Chalcedonians against non-Chalcedonians, as well as followers of Severus against adversaries of Severus. The bishop of Edessa, named Jacob Būrd'ānā (Baradai), succeeds in setting up a "parallel" hierarchy, whence the appellation of "Jacobite" which Chalcedonians give to the non-Chalcedonian Church of Syria. Indefatigable and elusive, the "ecumenical metropolitan," Jacob Būrd'ānā, clandestinely crisscrosses the Eastern countries of the empire, consecrating bishops and ordaining priests "by the thousand."

Justinian, "the emperor who never sleeps," seeks to impose the council of Chalcedon by force. Thousands of non-Chalcedonians perish in a dreadful massacre in the region of Alexandria. In 553, the council of Constantinople tries to renew contact with the Jacobites. Suspected of Nestorian tendencies, certain writings of Theodore of Mopsuestia, Ibas of Edessa, and Theodoret of Cyrrhus are condemned; the dogma of Chalcedon is interpreted according to Alexandrian theology, which insists on the deification of Christ's humanity. Speculations, debates, wars, and repressions continue. The bonds between the non-Chalcedonian Churches grow stronger: "The land of Egypt and the land of Syria became one single faith," says the Ethiopian *Synaxarion;* "the city of Alexandria and the city of Antioch, one single church, one single virgin for a single pure man, the Lord Christ."[17]

In Persia, Nestorians and Monophysites coexist as rival factions and vie for predominance in the official Persian Church. Khosrow appeals to the emperor of Byzantium to evict his rival so that he might gain access to the throne. The Chalcedonian emperor seeks to rally the Armenian Church under his authority. History has preserved Bishop Moses' answer, "I shall not cross the River Azat, eat oven-baked bread, or drink hot water."[18] The Azat is the boundary between Byzantine Armenia and Persian Armenia; the baked bread and the hot water represent the Byzantine Eucharist. The peace signed between the two empires is interrupted because of the deposition of Emperor Mauricius and the ascent to the throne of the usurper Phocas. In 614, the Sāsānid armies occupy Egypt, Syria, and Palestine. The Jacobite patriarch of Antioch, Athanasius the Camel Driver, writes to his colleague in Alexandria, "The world rejoices in peace and love because the Chalcedonian night has vanished."[19] In Arabia, on the other hand, the Qur'ān prophesies the defeat of the victorious but unfaithful Sāsānids and the future victory of the vanquished Christian Byzantines: "The Romans have been defeated in a neighboring land. But in a few years they shall themselves gain victory: such being the will of Allah before and after. / On that day, the believers will rejoice in Allah's help" (S 30:1-5). Heraclius takes up the fight and crushes the Persian power in 628. "In Edessa, Harran, and in the whole West as far as Jerusalem,"[20] his troops recapture the churches taken by the Monophysites after the Sāsānid advance. The true Cross, stolen by the invaders, is brought back from Ctesiphon and "glorified" in Jerusalem on September 14, 629.

The Islamic Tide

New doctrines make their appearance with a view to reconciliation. In order to rally the Monophysites, the emperors favor in vain new Christological teachings, Monoenergetism and Monothelitism: Christ has two natures, but one single divine-human energy and one single divine-human will. But nothing can stop the Islamic tide which invades the East. Syria, Egypt, and Palestine in turn sign their submission: the peace treaties offer the religious communities the threefold guarantee of freedom of cult, enjoyment of private property, and physical safety, in exchange for a poll tax called

the *djizya*. Manṣūr ibn Sardjūn, a Chalcedonian—negotiates with Khālid ibn al-Walīd and one gate of Damascus is opened to him. Ḥomṣ and central Syria undergo the same fate. In 636, the battle of Yarmuk signals the victory of the Arabs and the total defeat of the Byzantine army. The Armenian bishop Sebeos comments: "A terror inspired by the Lord seized the Greek army. They turned around to flee before them. But they were unable to do so on account of the thickness of the sand into which they sank to their knees."[21] Under the reign of Sophronius, the Chalcedonian patriarch, Jerusalem submits in its turn. The caliph 'Umar is "met by singers and the tambourine players of the inhabitants of Adhri'āt, carrying swords and myrtle."[22] The heavy taxes imposed by Heraclius had exhausted the Syrians, whether Chalcedonians or non-Chalcedonians. The brutality of the religious persecutions had resulted in a complete break between Byzantines and Jacobites. Chronicles, Islamic and Christian alike, emphasize the weakness of the resistance, the defeatism and indifference of magistrates and generals: "Great Syria," Khālid ibn al-Walīd says, "resembles a camel that quietly lay down."[23] The Arab army heads for Egypt through the Sinai.

Heraclius is implacably set against "heretical" Egypt. His main agent is the Caucasian Cyrus al-Moqawqas, who is named patriarch without having been elected and puts on one of "his feet the red shoe of the emperors and on the other a monk's sandal in order to show that he has both imperial and ecclesiastical authority."[24] The army comes on the scene to bring the Copts back to the sheepfold of the empire and its Church, imposing the doctrine of Monothelitism, refuted by Chalcedonians and non-Chalcedonians alike. The atrocities and the magnitude of the persecution are dreadful. Islam overruns this ravaged Egypt. A first treaty of capitulation is signed in 640, offering to the Egyptians "the safety of their persons, their communities, their goods, their churches, their crosses, their land, and their sea."[25] Heraclius dies at the time the Arabs are in the vicinity of Cairo. The capitulation of the Byzantines takes place on Easter Monday in April 641. The bishop of Nikiou sees in this a heavenly chastisement, "God thus punishes the Greeks who did not respect the life-giving passion of Our Lord and Savior Jesus Christ."[26] Lower Egypt is split between pro-Byzantine and pro-Arab. The Arab conquest continues in the direction of Alexandria. The great metropolis signs a complete capitulation. The "Greeks" take to the sea toward Constantinople and the islands of the Aegean. Severus of Ashmunain (Hermopolis) writes, "The Lord abandoned the army of the Romans as a punishment for their corrupted faith and because of the anathemas pronounced against them by the ancient Fathers on account of the council of Chalcedon."[27] After an exile of thirteen years, the Jacobite patriarch Benjamin regains his see. Running to meet him, "the people were joyful, like calves which, freed of their fetters, rush to their mothers' udders."[28]

Persia falls like a ripe fruit on the day of the battle of Nahavand. Persian Armenia promises to mobilize its "forces against any raid and to engage in any operation which the governor might judge useful to undertake. In return, the *djizya* will not be demanded from those who will respect these conditions."[29] In its turn, Byzantine Armenia yields. Theodore of Restuni betrays Byzantium and joins the Arabs. "Emboldened by the success of the Ishmaelites," his son Vard shows the conquerors how to gain access to the city of Dwin by cutting "the ropes which fasten the bridge of boats,"[30] and lets the attacked Greek army perish in the waters. According to Sebeos' chronicle, Theodore concludes a military alliance with the caliph 'Uthmān and also acquires protectorate status for the city. The caliph specifies: "I shall send neither emirs into the Armenian fortresses nor Arab officers nor one single horseman. No enemy must come to Armenia; and should the Greeks march against you, I shall send troops to help you, as many as you would want."[31]

In 680, the third council of Constantinople defines Byzantine Christology and condemns Monothelitism, considered a consequence of Monophysitism. The council affirms the free will of the human nature which Christ assumes and freely submits to the divine will. Having two natures, Christ has, as a consequence, two wills: the divine and the human. The Monophysites continue to confess the "unique nature" of the incarnate Word; the Nestorians persist in rejecting the "fusion"

of two natures, condemning the "shameless ones" who "mix the Word and the flesh."[32] Dogmatic cleavages are taking shape. Three Churches claim the exclusive title of Orthodox and obstinately anathematize one another. Eastern in the eyes of the West, Byzantium is Western in the eyes of the East. For them the Greeks are "Romans." The "Eastern" believers in Chalcedon are called "Melchites," partisans of the Roman emperor. The Eastern Christian empire is reduced to Asia Minor and the Balkans. The newborn Muslim empire stretches beyond the ancient empire of Alexander the Great, constituting a new common culture, of which the local Christian Churches are an important element. The guardians of dogma continue to combat heresies in order to keep pure their "true faith." In the name of the "saved" who "have walked dry-shod and crossed the salty sea of impiety,"[33] the Chalcedonian St. John of Damascus battles against the "folly of the Acephali" and "the anger of the Nestorians,"[34] "three times wretched."[35] The Copt Severus of Ashmunain condemns "the blind heart"[36] of the Melchites. The patriarchates and rival Churches coexist and survive in Islamic lands. Michael the Syrian writes, "When the Arabs came to power, they completely eliminated the pagan Persians; likewise, they destroyed the Greeks who persecuted the Christians, and their empire shone as long as just kings who did not persecute the faithful were reigning."[37]

Latins and Mongols

Farther afield, Rome and Constantinople embark on a fresh theological quarrel. The Creed of Nicaea-Constantinople confesses that the Holy Spirit "proceeds from the Father." The West adds " . . . and from the Son." The patriarch of Constantinople, Photius, refutes this Latin formula and declares that the Holy Spirit proceeds only from the Father. The "Schism of Photius" announces the break with the papacy, but is overcome in 880. The religious conflict interferes with political ambitions. The Greek empire is the first power in the world; Constantinople is its biggest market. The West is economically collapsing: "Rural, it appears poor and destitute in comparison with Byzantium, with Córdoba. A wild world. A world besieged by hunger."[38] The boundaries of empires remain fluid. The central power of the 'Abbāsids is disintegrating. Turkish Islam enters the scene. In the ninth and tenth centuries, Byzantium in its turn counterattacks. Incursions succeed one another, equally cruel on both sides. Reconquest often arouses among Muslims hatred for native Christians accused, or at least suspected, of collaboration with the Greek enemy. Christian communities remain separated. Matthew of Edessa bitterly evokes the Byzantines' violent acts which "caused more bereavement among Christians than the Muslims had done."[39] "Turks and their brothers the Romans" are placed on a par. The Jacobite patriarch leaves Antioch and settles in Amid, the present Diyarbakir. Impelled by an "implacable hatred," the Byzantines burn the Monophysite Syrians' books and force their dignitaries to be baptized anew.[40] The Nestorians and Jacobites of Nisibis are treated like enemies and their churches are desecrated and looted. Divisions among powers augment. Kings, princes, atabegs, viziers, and suzerains tear one another apart. History presents a most complex picture of composite elements. While a fragmented Turkish empire is forming in central Asia, the crusaders and Mongols sweep over the East.

Jerusalem is pillaged. The Latins walk "in blood up to their ankles," slaughtering "the Saracens even in Solomon's Temple . . . stealing gold and silver, horses and mules, and looting the houses overflowing with riches."[41] Latin states are established in the East. Offensives and counteroffensives succeed one another. Immersed in internal dissensions, viziers and petty emirs do not hesitate to appeal to the Franks to get rid of their Muslim rivals, and they keep their positions by shifting alliances. Byzantium and the Christian West are gradually separating. Their conflicts are political, cultural, and religious. The divorce of Rome and Constantinople is complete in 1054: the patriarch and the papal legate excommunicate one another. Venetians are expelled from Constantinople in 1171;

Latin merchants are massacred there in 1182. Latins persecute the Orthodox in Cyprus. Bohemond I preaches a crusade against the rebel and schismatic Greeks, responsible in his eyes for the failures suffered by Latins settled in the East. The territorial ambitions of the Latins accelerate the rupture. Byzantium offers its help to the Ayyūbids at the time of the Third Crusade. In 1204, the Fourth Crusade hurls itself against Constantinople. The Queen City is sacked and its churches are desecrated. The chronicle of Nicetas Chroniates draws a parallel between the crusaders and the Muslims: "At least, the latter did not rape our women, . . . did not reduce the inhabitants to destitution, did not strip them naked to parade them in the streets, did not kill them by hunger or fire. . . . However, this is how these Christian people treated us, these people who take the cross in the Lord's name and share our religion."[42] Pope Innocent III confirms the nomination of a Venetian patriarch in Constantinople. Frankish baronies appear in Greece. In the midst of this chaos, Christian communities discover the "Franks," "heretics" from afar. In northern Syria, the Armenians guide, inform, and supply the first crusaders with provisions. While Armenia is fragmented into little rival principalities, a Franco-Armenian barony establishes itself in the plain of Cilicia, between Syria and Anatolia. However, this alliance does not in the least seal a return to the great "mother-Church." The king of Armenia expels Latin archbishops from Cilicia; Innocent III excommunicates him. One Armenian Catholic sets down a list of the "one hundred and seventeen errors" of the Armenian Church for Pope Benedict XII. The frequent calls for union abort. The Syrian Church withdraws. The crusaders persecute the Copts after the conquest of Damietta. Muslim and Christian, the Egyptians fight against the knights of the Fifth Crusade. In his *Historia Orientalis,* the bishop Jacques de Vitry calls the Copts heretics "blinded for a long time by an unfortunate and lamentable error."[43] In his *Book of the Sunset,* Bishop Peter of Malīj makes an inventory of the "innovations" of the Franks: "With them, the priest is a horseman, goes to war, and sheds blood. . . . They put to death anyone who contradicts them or disapproves of them. . . . They have altered and denatured the text of the Scriptures."[44]

The two great empires of the tenth century are in the throes of agony in the thirteenth. Michael Palaeologus delivers Constantinople; but, reduced to Nicaea, Thrace, and a part of Macedonia, the empire of the Palaeologi is only a shadow of that of the Comneni. Turks, Serbs, and Bulgars divide among themselves the great Byzantium of former days. Saladin (Ṣalāḥ ad-Dīn) delivers Jerusalem, but Ayyūbids and Mamlūks continue their feud; wars between bellicose Muslims keep going on; and the unity of the caliphate is far from being even begun. The Mongol empire is established in 1227. Pope Honorius III sees in these "forces come from the East" a possible ally against Islam: forces "without religion," made of vassal populations, among which are Asian Christians who have been assimilated. This turn of events is of capital importance. Hūlegū, an agnostic friend of the Christians, rallies the Armenians and the Syrians to his power. The Dominican missionary Ricolte de Monte Croce writes, "He was a great friend of Christians and a very just man, without faith or law."[45] By his side stands the believing queen, Dokuz Khatun, venerated by the Christians of Syria-Mesopotamia. The Armenian Vartan says that she "was in effect Christian, belonging to the community of the Nestorian Syrians, without suspecting that she was a heretic. She had a sincere affection and a particular consideration for all Christians, from whatever nation, and asked for their prayers."[46] "The good Christian queen, who belonged to the lineage of the three kings who came to adore the birth of Our Lord," razes mosques and builds a multitude of churches, reducing the Muslims to "so great a servitude that they did not dare to show themselves."[47] In 1258, the troops of Hūlegū set fire to Baghdād. The caliph is put to death, the population massacred. On Dokuz Khatun's orders, Christians are systematically spared. Stephen Oberlian calls the royal couple a "new Constantine and Helena," "instruments of vengeance against Christ's enemies."[48] The Mongols are in power and the pope opens negotiations with the khan. Wars, quarrels, and battles continue. In 1280, a Turkish-Chinese monk is elected patriarch of the Nestorian Church under the name of Yaballaha III; his glorious reign ends in the ruin of his community. The success of the Mamlūks grows. The crusaders draw back.

The Mongols weaken, and revenge falls heavily upon their "servants," utterly abandoned. Bar Hebraeus writes, "Then, persecution and wrath were stirred against the hated Christians; and, although I should not say this, they were abandoned by God."[49] Missionaries fail in their mission, and "those who do not know whether God exists and could not care less about prayer and fasting"[50] end up choosing Muḥammad's faith. The conquerors turn away from their former allies. Bar Hebraeus adds, "Of course, in the beginning of their reign, for a very short time, the Mongols greatly loved the Christians . . . but their love was changed into a hatred so intense that they can no longer see them in an approving manner, because all became Muslims, myriads of persons and peoples."[51]

Modern Times

In the fourteenth century, Osman founds the Ottoman dynasty. John Cantacuzenus gives his daughter in marriage to the sultan Orhan and cedes to the Turks a fortified town in Thrace. The Ottomans meddle directly in the affairs of the empire. In less than fifty years, they take possession of the Balkans; the sultan Murad I subjugates Bulgaria and imposes his suzerainty upon John V in 1370. The Serbs are crushed at Kosovo in 1389. Bulgaria is conquered in 1392. Constantinople is besieged in 1397, but Timur's victory at Ankara saves the tiny principality of Byzantium. At the time the Great Schism of the West breaks out, the papacy seeks the submission of the Greek East. Obedient to the emperor, the patriarch of Constantinople, John VIII, goes to the council of Florence in 1439 and submits to the Pope's conditions. The efforts for union at Florence are disavowed by all the Orthodox Churches. The antagonism between East and West reaches its climax. According to Petrarch, "The Turks are enemies, but the schismatic Greeks are worse than enemies." According to Luke Notaras, "Better the reign of the Turkish turban than the Latin miter in our city." Left to its fate, Byzantium dies. The sultan Muḥammad II takes Constantinople. The head of those who sought union with the West, Gennadius II Scholarios, is elected ecumenical patriarch in 1453. A new empire inherits "great" Byzantium. The Chalcedonian Christians are regarded as one single *millet,* one nation, without consideration for national or liturgical differences. Likewise, the Monophysite Churches are a single *millet* under the jurisdiction of the Armenian patriarchate of Constantinople. The religious power is joined to the civil power; the patriarch of Constantinople becomes *millet-bachi,* ethnarch: head of the Christian nation, he enjoys great power and all acts of civil law are within his competence.

The West, which is progressively withdrawing from the Middle East, discovers the East of a limitless Ethiopia situated somewhere between Africa and China, beyond the Islamic countries, a Christian land governed by a legendary king called Prester John. Catholic missionaries are the first to enter Abyssinia. A Portuguese "embassy" settles there in 1490. In the sixteenth century, the high Christian citadel suffers the assaults of Aḥmad ibn Ibrāhīm al-Ghāzī. The emperor calls the Portuguese to his aid. Ruins are added to ruins. Finally, the battles end in the rout of the Muslim troops. Now saved, Ethiopia refuses to recognize Roman primacy and union with the Catholic Church. Bent on "converting" the imperial power, the Jesuits lead the people into a civil war. The faith of Alexandria triumphs; the Jesuits are expelled. Ethiopia continues to venerate St. Walatta Petros, zealous for the faith and known for her assiduous battle against the "agents" of Rome.

In the seventeenth century, while a modus vivendi is established among the Eastern Churches, a flowering of Catholic orders takes place in the East. Capuchins, Jesuits, Dominicans, Augustinians, Carmelites insure the propagation of the faith. Their "converts" are the "Eastern Catholics" who, while keeping to their original rites, recognize the primacy of Rome and its faith "pure of all deviation." The sultan recognizes a Catholic *millet:* at its head, one single patriarch, the sole intermediary between the supreme power of the state and the Catholics of the empire, without distinction of races. With the awakening of nations and the decline of central power, the great Church of Constantinople

weakens and the daughter-Churches become sister-Churches. Eastern Catholics become more assertive and hierarchies are duplicated, once more dividing Churches already divided. Cradle of Christianity, the Christian East now offers many Christian worlds; however, the histories of its Churches are only one face of its history. Beyond the walls of separation, life succeeds in reuniting enemy-brothers and sisters. Crucible of schisms, the Christian East is also the world in the middle, the place of exchanges, and the heart of communions. Peoples, religions, and cultures leave their mark on it. Science and philosophy unite minds separated by dogmas. Spirituality and beauty offer them a communion. A uni-pluralistic art develops there: Syrian, Egyptian, Armenian, or Ethiopian, its images take in all horizons. Being the work of prayer, these images celebrate the "Name that burns all lips," "East that nothing darkens," "Home open to all who come."[52]

Notes

[1] LXX Zech 6:12.
[2] Nerses, "Homily on the Parable of the Wicked Tenants." In Narsaï, *Cinq homélies sur les paraboles évangéliques* (Paris: Cariscript) 68–72.
[3] Eusebius, *Ecclesiastical History,* bk. 3, 37:2–3.
[4] Edict of Milan. Quoted by Ferdinand Lot, *La fin du monde antique et le début du Moyen-Age* (Paris, 1938) 31.
[5] Gregory of Nyssa. PG 46, col. 557. Quoted by Ernest Stein, *Histoire du Bas-Empire,* 1:146.
[6] John Chrysostom, SC 304, pp. 123–125.
[7] John Cassian, *Conférences,* 18:6. SC 64, p. 17.
[8] Theodoret of Cyrrhus, *Philothea,* Prologue 9. *Histoire Philotée,* SC.
[9] Palladius, *Historia Lausiaca,* Preamble. *Histoire lausiaque* (Paris: Desclée de Brouwer, 1981) 29.
[10] Ibid., 35.
[11] *Exposition of the Offices of the Church.* Quoted by J.-M. Fiey, *Jalons pour une histoire de l'église en Irak,* CSCO 310 (Louvain).
[12] Nerses, "Homily on the Parable of the Good Seed and the Weeds." Narsaï, *Cinq homélies,* 99.
[13] Ibid. (p. 100).
[14] Ibid.
[15] Dom Poulet, *Histoire du christianisme,* 1:595.
[16] Quoted by J.-M. Fiey, *Coptes et Syriaques: Contacts et échanges,* Studia Orientalia Christiana Syriaca 15 (1972) 312.
[17] Ethiopian *Synaxarion.* Quoted ibid., 319.
[18] Bishop Moses. Quoted by J. Mécérian, *Histoire et institutions de l'église arménienne* (Beirut: Imprimerie Catholique, 1963) 73.
[19] Severus of Ashmunain, *History of the Patriarchs,* ed. and trans. B.T.A. Evetts (Paris, 1907) 481. Quoted by J. Meyendorff, *Unité de l'empire et divisions des chrétiens* (Paris: Cerf, 1993) 361.
[20] Quoted by Fiey, *Jalons,* 139.
[21] Sebeos, *History of Heraclius.* Sébéos, *Histoire d'Héraclius,* trans. F. Macler (Paris: Imprimerie Nationale, 1904) 97–98.
[22] Baladuri, *The Origins of the Islamic State* (Beirut, 1963). Quoted by A. Ducellier, *Le miroir de l'Islam* (René Julliard, 1971) 54.
[23] Khālid ibn al-Walīd. Quoted by E. Rabbath, *La conquête arabe sous les quatre premiers califes* (Beirut, 1985) 1:253.
[24] Michael the Syrian, *Chronicle,* vol. 2. Michel le Syrien, *Chronique,* vol. 2, trans. J. B. Chabot (Paris, 1899) 432.
[25] Quoted by Rabbath, *Conquête arabe,* 1:381.
[26] John of Nikiou, *Chronicle. La chronique de Jean, évêque de Nikiou,* ed. and trans. M. H. Zotenberg, Notices et Extraits des Manuscrits de la Bibliothèque Nationale (Paris) 242. Quoted by Rabbath, *Conquête arabe,* 1:402.
[27] Severus of Ashmunain, *History of the Patriarchs,* 492–493. Quoted by Meyendorff, *Unité de l'empire,* 381.
[28] Severus of Ashmunain (Louvain: L. Dubecq, 1954) 111. Quoted by Rabbath, *Conquête arabe,* 1:442.
[29] Quoted by Rabbath, ibid., 1:350.
[30] Ghévond, *Histoire des invasions arabes en Arménie,* trans. Chahnazarian (Paris, 1956) 12–13.
[31] Sebeos, *History of Heraclius,* 133.
[32] Nerses, "Homily on the Wicked Tenants." Narsaï, *Cinq homélies,* 73.
[33] John of Damascus, "Homily on the Dormition," 3:3. SC 80, p. 185.
[34] John of Damascus, "Homily on the Nativity," 3. SC 80, p. 50.
[35] John of Damascus, "Homily on the Dormition." SC 80, p. 185.
[36] Severus of Ashmunain, *Book of Exposition.* Sévère d'Ashmouneïn, *Livre de l'exposition,* trans. G. Troupeau, OLA 18 (1985) 375.
[37] Michael the Syrian, *Chronicle.* Michel le Syrien, *Chronique,* 424.

38 G. Duby, *Le temps des cathédrales* (Paris: Gallimard, 1976) 12.

39 Matthew of Edessa, trans. Dulaurier (Paris, 1858) 52.

40 Ibid., 95–96.

41 *Histoire anonyme de la première croisade (Anonymous History of the First Crusade)*. Quoted by C. Morrisson, *Les croisades*. Que sais-je (1984) 32.

42 Nicetas Chroniates, *History* (Leipzig, 1888) 761–762.

43 Jacques de Vitry, *Historia Orientalis*. Quoted by Christian Cannuyer, *Les Coptes* (Belgium: Brepols, 1990) 42.

44 Peter of Malīj, *Book of the Sunset*. Pierre de Malîg, *Livre du coucher du soleil*, trans. M. Jugié, DTC 10 (1929) 2268–2269. Quoted by Cannuyer, *Les Coptes*, 117–118.

45 Ricolte de Monte Croce, *Itinerary*. Ricolte de Monte Croce, *Itinéraire*, trans. L. De Backer. Quoted by J.-M. Fiey, *Chrétiens syriaques sous les Mongols*, CSCO (Louvain, 1975) 19.

46 Vartan the Armenian. Quoted by Fiey, ibid.

47 Ibid., 20.

48 Stephen Oberlian. Quoted by Fiey, ibid., 23.

49 Bar Hebraeus, *Chronography*, quoted by Fiey, ibid., 51.

50 Ibid., 4.

51 Ibid., 106.

52 Gregory of Narek, *Prayers*. Grégoire de Narek, *Prières* (Paris: Orphée-La Différence, 1990) 29–30.

CHAPTER TWO

Exchanges and Communion

The Prophet, Muḥammad, founds the Islamic community and spreads its hegemony over the Arabian peninsula. His "successors" continue the conquest. In fifteen years, the Fertile Crescent, Egypt, and Persia come under Islamic domination. The fifth caliph, Muʿāwiyah, founds the Umayyad dynasty. A new empire arises with Damascus as its capital. Arabization and Islamization are far from systematic. With its peoples and its multiple communities, the "House of Islam" contains many mansions. The Christians subject to it have their place in it. Regarded as "people of the Book," they are "protected" by the Muslims without being their "equals." Freedom of cult is granted to them; however, they must renounce to proselytize, submit to a fiscal obligation, and swear loyalty to the caliphate.

In the early days of Islam, "Christian" Arabia looks like an arch-heretical hotbed where sundry sects find shelter: Nazarines, Ebionites, Arians, Sabaeans, Docetae . . . In its extraordinarily rapid expansion, Islamic monotheism confronts a Christianity torn apart. Refuting the dogmas of the Trinity and Incarnation, the Qurʾān sees in the division of Christians the sign of their "aberration." The revealed word of the Gospel has been altered, and its adherents "have forgotten much of what they were enjoined." Because of this aberration, Allāh has "stirred among them enmity and hatred, which shall endure till the Day of Resurrection" (S 5:14). For its part, Christianity sees in Islam a new Christian heresy and concedes to it only a semblance of truth. The more "generous" interpretations compare Muslims to an "evening midway between day and night, and neither clear nor obscure."[1] "They have left darkness behind because they have rejected the worship of idols in order to adore only God, the one God; but their light remains insufficient because they are very far from the light which belongs to our Christian faith and because they have not embraced the religion of truth."[2]

The dogmatic cleavages are intellectual constructs. In contradistinction to the doctrinal objections and violent aversions attested by history, Islam often appears tolerant, transparent, and prone to sympathy. The veneration of Christ, a prophet strengthened by the Holy Spirit (see S 5:110), and of his Mother Mary, purified and chosen by God and "exalted . . . above all women" (S 3:42), and the benevolent admiration toward those priests and monks who "are free from pride" (S 5:82) are attested by the Qurʾān. Caliphs, princes, and dignitaries are frequent visitors to Christian monasteries and love to have bishops in their retinue. In Jerusalem, Muʿāwiyah goes up Golgotha, meditates in Gethsemane, and prays at the Virgin's tomb. Al-Maʾmūn celebrates Palm Sunday and is miraculously cured by drinking water mixed with dust from the Holy Sepulcher. The ruler of Egypt, Aḥmad ibn Ṭūlūn, goes to pray in the monastery of al-Ḳaṣīr, where he makes friends with a monk named Anthony; being sick, he implores the Copts' prayers and weeps when listening to their faraway voices.

Muḥammad ibn Tughdj, governor of Egypt, shares in the celebration of Epiphany. The Fāṭimid caliphs al-Ḥāfiẓ and al-Ẓāfir recollect themselves in monasteries and attend Coptic liturgical offices. Kilij Arslan, the Seljuq sultan of Cappadocia, Syria, and Armenia, reveres the Syrian patriarch Michael and believes he has the power to turn away evil.

Despite all their reservations, the Christian chronicles do not fail to attest the Muslims' respect for the Christian religion. 'Amr ibn al-'Aṣ, John of Nikiou narrates, "did not touch church possessions, kept them from all plundering, and protected them throughout his entire reign."[3] According to the *History of the Patriarch Isaac,* the emir 'Abd al-'Azīz "built churches and monasteries around his town because he loved Christians."[4] The *Edessa Chronicle* stresses the kindness and mercy of the caliph al-Ma'mūn, who "commanded that the Christians be dispensed of the duty of lodging soldiers in their homes and that no Persian or Arab harass them."[5] While describing the horrors committed by Turks, "these ferocious beasts, drinkers of blood," Matthew of Edessa eulogizes Malik-Shāh, "the good and clement sovereign of the Persians and of all the faithful of Christ," "who exempted churches, convents, and priests of any tax" and who heaped honors on the patriarch Basil. Likewise, one of his successors, "Esmā'īl, who had Armenia under his domination," is called "merciful, kind, benevolent, charitable, peaceable," great protector of the faithful and monks.[6]

Christians in Islamic Lands

From the Umayyads to the Ottomans, the Eastern Christian communities make their presence felt in Islamic lands. Of course, conversions, always one-way conversions, shrink their communities as years go by; however, Christians keep their position and importance. As early as the seventh century, conversion to Islam seems conditioned by the desire to escape taxation. "Because of oppressive charges, many, whether rich or poor, denied their faith in Christ,"[7] notes the Copt Severus ibn al-Muqaffa'. The Nestorian bishop Ya'qōb III plaintively draws a parallel between the tolerance and benevolence of the Muslims, who "honor our priests and the Lord's Saints and are generous to our churches and monasteries," and the apostasy of the Christians of Merw who deliberately abandon "the religion which gives them eternal salvation in order to keep part of the ephemeral goods of this transient earth."[8] Under the 'Abbāsids, the poet Abū al-'Alā' al-Ma'arrī cynically depicts the Christians who become Muslims "for the gain / and not for love of Islam."[9]

In spite of successive conversions, the Churches keep their power. Attached to their lands and resigned to accepting "the limits of their condition," Christians remain present, active, and alive; and their participation extends to administration, commerce, and agriculture. Their collaboration proves useful for the smooth functioning of public services, and Muslim rulers do not hesitate to entrust them with key posts. Thus, Christians are promoted to the ranks of high officials; scribes and physicians are part of the caliph's court. The cleavages separating Jacobites, Nestorians, and Melchites still persist. Rival and enemy Churches vie with one another for the Muslims' favor, and "Orthodox" faithful have no qualms about appealing to them in order to weaken and overcome other faithful deemed "heretics."

Times are often difficult. Political upheavals and successive wars have their internal repercussions. Native Christians are rarely persecuted; but they are subjected to vexatious and discriminatory measures, often because they are conquered by enemy Christians, Greek first, then Latin. Temporary measures, often very humiliating, ranging from social pressures to differences in dress or the prohibition of riding horses—all these provoke and accelerate conversions to Islam. The freedom of cult granted to "people of the Book" remains inviolable, as the patriarch Michael the Syrian reminds his hearers in the camp of the emir al-Mawṣilī Saif al-Dīn: "Since God granted dominion to the Muslims, none of the just kings who have reigned have trampled underfoot God's law, but have observed it. Ac-

cording to God's permission, they have imposed all manner of tribute upon Christians and all manner of bodily servitude, but they have not claimed any authority over the faith."[10]

Two Empires, Two Luminaries

In the Middle Ages, Constantinople and Baghdād, in spite of the wars between them, also enjoy peaceful relations. The ancient Roman-Sāsānid commerce continues, and the artistic and cultural exchanges are not negligible. Muslims reverently praise "the sciences of the Greeks." Byzantium oscillates between contempt and fascination, refusal and desire to hear. Chronicles and religious polemics vehemently denigrate Arabs, Agarenes (descendants of Hagar), and Saracens, "people of inferior race," "barbarians," "foreigners." The Qur'ān is but a "lamentable little book";[11] its faith is a faith of darkness; its believers, pagan worshipers of "Khabar," an idol "carved in Aphrodite's image."[12] On the other hand, other testimonies acknowledge in this enemy the qualities of a human and civilized people. Nicephorus Gregoras hails the good administration and religious liberty of Syria under the Mamlūks. Monastic writers recognize the tolerance of certain Muslims and the protection they give to Christians. Nicholas the Mystic corresponds with the emir of Crete, evoking the example of Photius, "very great and illustrious among God's archbishops." "Being a man of God and deeply conversant with divine and human things, he knew that, even when the divergence of faith separates us like a wall, the firmness of reflection, of intelligence, of behavior; a strong humanity—in a word, all the qualities that adorn and enhance human nature—kindle in those who love goodness the love of people endowed with those same qualities. And this is why, although they were separated by different faiths, this great man loved your father, who was gifted with all the qualities I spoke of."[13] Although "separated by manner of life, customs, and religion," the empires of the Saracens and Romans, "which dominate and flood with their light all earthly sovereigns, as do the two great luminaries in the sky," are called "to live in community and fraternity."[14]

In the fourteenth century, Byzantium shrinks and crumbles. In the Islamic world, now shaken, Arabian power yields its place to the Turks and Persians. Relations are not always tense. Manuel II praises a Muslim teacher, and in Ankara their conversations become more and more frequent. While held prisoner by the Turks, Gregory Palamas cordially converses with their imāms, lauds their respect and tolerance, and "discovers" their religion: "For him, Islam is within God's design because it brings to innumerable pagans the revelation of a unique and personal God; in this, he says, it is far superior to the philosophy of ancient Greece."[15]

After three restless centuries dominated by wars and tumult, a new map is taking shape. Byzantium expires: the second Rome loses its Christian crown. The Muscovite state expands and its power grows. Ivan III ends the occupation of the Tatars and extends his domination as far as Novgorod. The monk Philotheos writes to him, "O blessed Tsar, look at, listen to this thing: all Christian realms are melting into your one kingdom; two Romes have fallen; a third one exists; and there will not be a fourth one."[16] Comprising more than twenty peoples, the Ottoman power spreads over three continents and extends from the Danube to the Indian Ocean, from the Caucasus to the Maghreb. No effort is made to create uniformity. Religious diversity and multiplicity are respected, even institutionalized. Dominated by Greeks and Armenians, Christians form a second-class community, which however shares in the life of the empire, contributing to its development and outward influence. Maurice Aymard reminds us that "at the time of Süleyman the Magnificent, Istanbul succeeds in becoming—paradoxically—the preeminent Turkish city, but also the preeminent Greek, Armenian, and Jewish city."[17] Ottoman-Ṣafavid wars succeed Roman-Sāsānid wars. Once more, Armenia is the apple of discord. Shāh 'Abbās seizes eastern Armenia and proceeds to deport a large community from among its inhabitants in the vicinity of Esfahān. He has an Armenian city, the "New

Julfa," built on the south bank of the Rūd-é Zarineh, thus establishing a new extension of the ancient Armenian presence in the heart of the Persian empire. On the Red Sea, Ethiopia keeps its Christian faith and king, loyal to the patriarch of Alexandria, thus giving Monophysitism its unique and ultimate crown. Although isolated and separated, it remains open to exchanges and communicates with Arabs, Turks, Indians, and Persians as well as with Portuguese, Spaniards, Italians, and the English governors of the companies settled in the East Indies.

The Mixing of Cultures

The most fruitful exchanges occur in science, culture, and art. In the ninth century, the "Greek" and "Arab" empires are the two pillars of the civilized world. At the junction of East and West, with their nations and ethnic groups, Byzantines and 'Abbāsids develop two cosmopolitan civilizations, two imperial cultures which incessantly communicate with and borrow from each other. The 'Abbāsid caliphate offers a zone of free exchange, extending from Khorāsān to Spain, open to all contributions of the great ancient civilizations, whether Greek, Persian, or Indian. Philosophy, metaphysics, medicine, astronomy, astrology, chemistry, and alchemy flourish. An urban culture adopts Arabic, a tool used by Muslims and Christians alike: Arabs, Persians, and Turks, Aramaic and Syrian Semites. Like Byzantine "Greek-ness," this "Arab-ness" is not ruled by ethnic, national, or political concepts. Antique Greek culture passes from Syriac to Arabic in an exchange in which Christians play a preeminent role. The learned Ibn Khaldūn observes: "As soon as the Arabs adopted a sedentary culture, they wanted to study the philosophical disciplines they had heard of through the bishops and priests of their Christian subjects. This is why al-Manṣūr asked the emperor that translations of books of mathematics be sent to him. The emperor had Euclid's treatise and a few books of physics brought to him. The Muslims read and studied all this, which gave them a taste for more learning."[18]

At court, speculations in physical and metaphysical disciplines go on. Caliphs and dignitaries become passionately fond of ancient sciences and give moral and financial support to researchers and translators. According to the patriarch Timotheos I, the caliph al-Mahdī had a love "which burns in him" for wisdom; he adds that "he is indeed pleasant and loves to learn the wisdom he encounters in others."[19] Founded by al-Ma'mūn in the ninth century, the "House of Wisdom" leaves its stamp on the history of this great creativity. Eminent Christian intellectuals find there a place of honor, Nestorians in the majority, but also Jacobites and Melchites. The extensive intellectual exchanges result in an original synthesis of the cultural heritages of antiquity. Freedom of thought and expression are astonishingly modern. A disciple of the great Muslim thinker al-Fārābī, the Jacobite Yaḥyā ibn 'Adi keeps up a philosophical correspondence with the Jewish philosopher Ibn Abī Sa'īd from Moṣul. Abū Sulaymān Muḥammad al-Sidjistānī, a pupil of Yaḥyā ibn 'Adi, organizes philosophical circles in Baghdād: Abū Ḥayyān al-Tawḥīdī describes in *The Book of Conversations* these sessions where Muslim, Christian, and Jewish initiates gather to converse, comment, and share sciences and cultures.[20] Tradition endures. In Damascus, in the middle of the thirteenth century, 'Izz al-Dīn ibn al-Nadjaf assembles around himself learned people of all confessions, passionately eager to delve into the inexhaustible "science of the Greeks." Arabic culture becomes hellenized. In the fourteenth century, Nicephorus Gregoras acclaims the intellectual milieux of Damascus by asserting that its culture "and that of the Greeks have everything in common."[21]

Faith too becomes imbued with Hellenism. Philosophy turns into theosophy. In their search for the hidden meaning of the "Book of God," theosophists go beyond the exoteric in order to discover the esoteric. Philosophy is the "tomb" from which theology rises as divine wisdom. People of prayer and revelation form "the family of knowledge, gnosis, and wisdom." Islam develops a spiritual hermeneutics in which sages and prophets are united in the Spirit. "All agreed in the affirmation of

the One," as-Suhrawardī declares. Guardians of the Word of God, the "Greek prophets" announce the Eternal Leaven, drawing their knowledge from the same "Recesses of Lights." Divine theosophists, they are witnesses of the Revelation.

In contrast to this hermeneutics, a dogmatic passion inflames minds and provokes in Islam a series of "Byzantine quarrels." The nature of evil, freedom, and predestination give rise to tumultuous controversies. The Incarnate Word's nature divided Christians in the past. Now, the nature of the Word of the Book of Allāh divides the Muslims. Is the revealed Qur'ān uncreated and formulated in its letter from all eternity, or is it inspired and created? The Mu'tazilites preach the created Qur'ān and affirm that their doctrine "can be considered to be in opposition to the Christian dogma of the Incarnation." According to them, in effect, "to say that the Qur'ān is the divine uncreated Word manifesting itself in time under the form of a discourse in Arabic, is equivalent to saying what Christians say concerning the Incarnation: that Christ is the divine uncreated Word, manifested in time under the form of a human being. This is so because the difference between the dogma of the Qur'ān and the dogma of the Incarnation consists not so much in the nature of the divine Word itself as in the modality of its manifestation: whereas for Christianity, the Word was made flesh in Christ, here this same Word was made enunciation in the Qur'ān."[22]

In Egypt as in Syria-Mesopotamia, Christian communities are progressively influenced by Arab thought. Syriac and Coptic lose ground before Arabic and become liturgical languages. In the common culture of Islam, Arabic acquires an ecumenical role no one could have predicted. As the Dominican J. M. Fiey remarks, "The contacts begun through the instrumentality of Greek, the language of another philosophy," are maintained and extended "thanks to Arabic, the language of another religion."[23] There are unceasing inter-Christian influences at work in hagiographical literature, liturgy, and art as well as in canon law, exegesis, and apologetics. Ethiopia translates into Arabic and adapts "Egyptian" works, whether in original versions or in versions derived from the Syriac, Coptic, Greek, or Latin languages. Such is the case of the homilies of St. John Chrysostom which Shenute and Jacob of Sarug collected in the *Lectionary of Holy Week;* of the *Paradise of Monks,* which is an arabized version of Palladius' *Lausiac History;* and of the apocalyptic Syriac *Book of the Covenant.* Viscerally attached to its own tongue, Armenia allows itself to be seduced by Arabic, without however adopting it. As early as the ninth century, Armenian Christians—like Syrian Christians—begin to bear Arabic-Muslim names: the most famous is Badr al-Jamālī, chief of the armies, director of missionaries, and Fāṭimid vizier. Scholars detect the influence of Arab poetry on Gregory of Narek because "he uses rhythmic prose punctuated by interior rhymes."[24] Taking up the challenge of an Arab prince met in Constantinople, Gregory Magistros intends "to do in four days what Muḥammad had not been able to accomplish in forty years."[25] Thus, in imitation of Arab tradition, his poetry includes rhymed and monorhymed prosody. His grandson, the great St. Nerses the Gracious, adopts this formula and has followers. His "innovation will gradually cause in Armenian prosody the substitution of the number of syllables for meter based on rhythmic value."[26]

Arabian-Greek exchanges increase. Borrowings are mutual and constant. Scientific and artistic theories interact and sometimes form a common culture. Emperor Theophilos has the palace of Bryas built "in the manner of Saracen architecture."[27] Fashioned by a Hellenic-Islamic education, the Assyrian-Antiochene Peter Libellesios finds himself promoted to court status. In the fourteenth century, through the crossroads of Trebizond, the Eastern Roman Empire is initiated into the art of Arab and Persian medicine and transmits it to the Latin West.

Whereas the Islamic-Christian East knows its golden age, Europe goes through dark times. East is synonymous with abundant riches. Offa, king of the Mercians, has an Arab inscription engraved on his gold coins in order to confirm their value. Bohemond calls Christians to conquer the East, "Take the cross; save the kingdom of Edessa, and you will acquire castles, splendid cities, rich lands."[28] Swarming with "infidels," "schismatics," and "heretics," the East nourishes the medieval West with

its civilization and cultures. Christian Europe discovers Islam through the channels of Spain and Sicily. At the very moment Pope Innocent III attempts to prohibit any commerce with the Saracens, translators follow the crusaders in order to conquer the enlivening sciences of antiquity. Thanks to Arab translations, "the new Aristotle," Ptolemy's astronomy, Euclid's mathematics, and Galen's medicine are transmitted to Latin culture. Two great "Arab" mediators are glorified in this culture: Avicenna (Ibn Sīnā), a Persian of the Khorāsān, and Averroës (Ibn Rushd), a "Spaniard" of Córdoba. Syriac Christian writings are translated into Latin. The Roman Church discovers St. Ephraem and the masters of the "Persian" school. St. Thomas Aquinas is interested in Theodore of Mopsuestia's exegesis. Sacred and profane intermingle. Crusaders are sometimes fascinated by their enemies. Saladin (Ṣalāḥ ad-Dīn) becomes the ideal knight who, in his admirable charity, divides his riches among disinherited Muslims, Christians, and Jews. The Norman court of Sicily adopts the spirit and mores of the Muslims. Emperor Frederick II arabizes his court and supports Arab and Jewish scholars; it does not matter to him that Rome excommunicates "the Sultan of Sicily" and calls him an atheist and a Saracen.

The Arts in Communion

The deepest communion happens in art. Nourished by all Mediterranean heritages, "Greeks" and "Arabs" create two permanent traditions, refined and majestic, religious in their foundation and nature, vowed and dedicated to the glorification of the One. The two traditions have a common origin. Through the multiplicity of its expressions, a resolutely monotheistic art takes root in the Middle East of the first centuries of the common era, during which, from Egypt to the cities of the Syrian and Mesopotamian deserts, Hellenism becomes orientalized and sacralized. Faithful to its vocation, this art borrows and remodels cosmopolitan contributions, innovates and renews itself, all the while jealously keeping its profound unity. What is religious is sacralized. What is civil and lay is spiritualized.

Byzantium banishes naturalism, rejects sculpture in the round, held in honor by the Romans, privileges the icon, and makes of it the sign of divine vision. Transfigurative, the icon uses the figurative as well as the non-figurative, which shows itself in the enduring use of the ornamental and geometrical. Turning away from both imperial and ecclesiastical history, the icon is illuminated by the Incarnate Word, "Sun without sunset," and speaks of the holiness which anticipates the ultimate transfiguration. Going beyond its dogmatic conceptions, it extends past its own ecclesial boundaries and sheds its radiance over the separated Churches, both in the East and the West. Islamic art undergoes a prodigious flowering. Very early on, it tends to be aniconic and develops a "vision of the invisible," which is untiringly at work in all the countries it spreads to. This predominance of the abstract does not exclude the figurative. Ornamentation gives a large place to the figurative element which, stylized and simplified, is incorporated into the arabesque and permeates the cultic milieu. The iconic element is visible in multiple settings and becomes crystallized in the miniature. Christians living in Islamic lands take part in the elaboration of these expressions and do not hesitate to use them in their own works, civil or cultic. Whether Christian or Muslim, artists, for the most part anonymous, place themselves at the service of the Eternal: "The fear of the LORD is instruction and wisdom, / and humility goes before honor" (Prov 15:33). In this inner pilgrimage, the petty "earthly I" becomes the "heavenly I," "I in the second person" which, in "the Spirit of the Eternal," lives and transcribes the "little resurrection," sign of the supreme resurrection to come, "the resurrection of resurrections."

Throughout a thousand-year history, two traditions of universality demonstrate their strength and creativity. Anachronistic, they ignore social and political mutations and reach some of their most

awesome peaks in the midst of the wars and tumults of "the world that passes away." In Palermo, the two traditions meet: Byzantine iconography on the walls, Islamic iconography on the vault. The fortunate union is effected in the heart of Eastern Christian worlds, where osmosis between styles sometimes gives birth to an Islamic-Christian art having integrity and homogeneity. Underlying these two styles are the traces of other traditions, adding complexity and dynamism. In their own way, these composite and pluralistic arts erect a limitless temple, at once iconic and aniconic: "The Lord of the Creation" (S 1:2) illuminates it; "all the earth" flocks "to his gates with thanksgiving, and his courts with praise." "For the LORD is good; / his steadfast love endures forever, / and his faithfulness to all generations" (Ps 100:1, 4, 5).

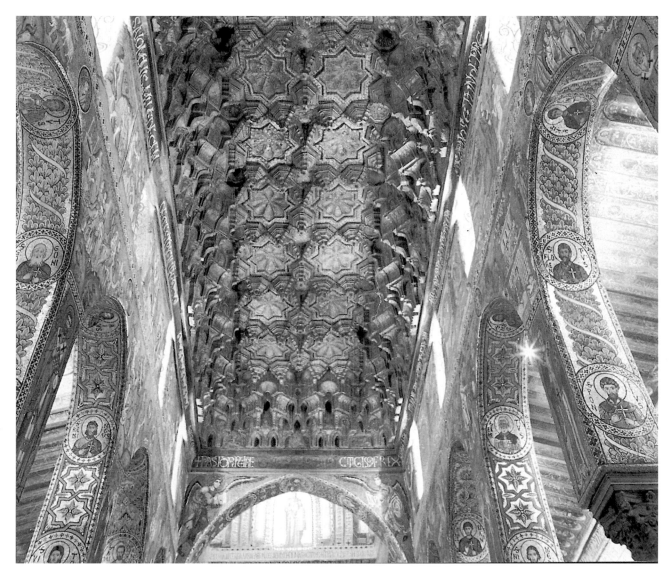

1. Interior decoration, 12th c. Palatine Chapel, Palermo.

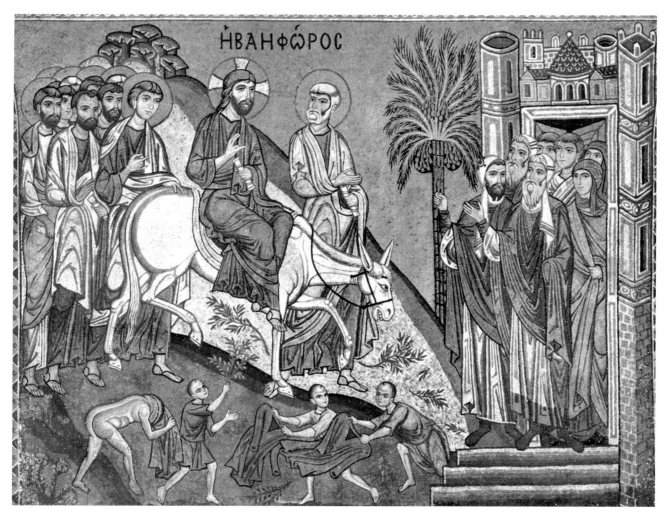

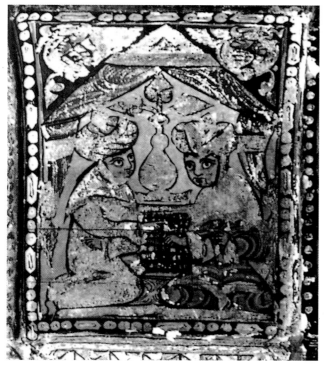

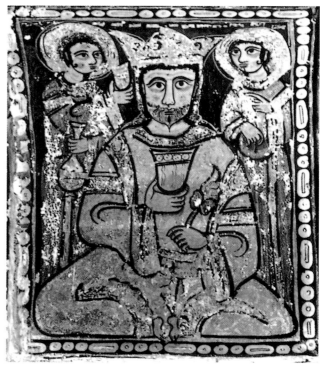

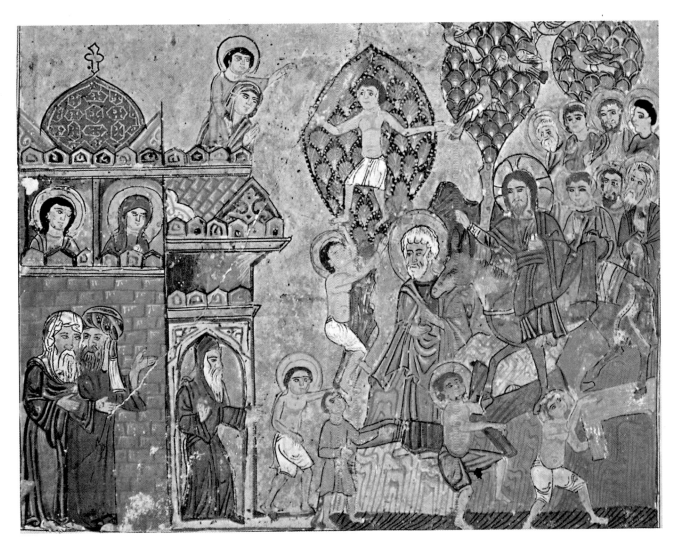

2. *Entry into Jerusalem,* 12th c. Palatine Chapel, Palermo.

3. Court scene, 12th c. Palatine Chapel, Palermo.

4. *The Feasting King,* 12th c. Palatine Chapel, Palermo.

5. *Entry into Jerusalem,* Jacobite Syriac gospel book, 1219–1220. Vatican Library.

6. *Entry into Jerusalem,* gospel book of Haghpat, 1211. Matenadaran Manuscript Library, Erevan.

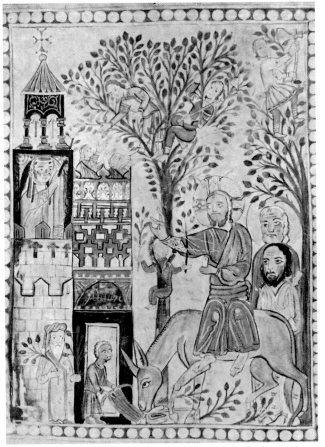

Notes

1 *Chronicle of Seert. Chronique de Séert,* P. O. 13 (1919) 626. Quoted by A. Ducellier, *Le miroir de l'Islam* (René Julliard, 1971) 36.

2 Bar Hebraeus. Quoted by E. Rabbath, *La conquête arabe sous les quatre premiers califes* (Beirut, 1985) 2:978.

3 John of Nikiou, *Chronicle.* Quoted by ibid., 988.

4 *Histoire du patriarche Isaac,* trans. E. Amelineau, *Bulletin de l'institut égyptien,* 2e série, 18 (1885) 62. Quoted by Ducellier, *Miroir de l'Islam,* 77.

5 *Chronicle of Edessa 1234.* Quoted by J.-M. Fiey, *Chrétiens syriaques sous les Abbasides,* CSCO (Louvain, 1980) 68.

6 Matthew of Edessa, *Chronicle.* Matthieu d'Edesse, *Chronique,* trans. Dulaurier (Paris, 1858) 203, 207.

7 Severus of Ashmunain, *History of the Patriarchs of the Coptic Church of Alexandria.* Quoted by Fiey, *Chrétiens syriaques,* 13.

8 Ya'qōb III. Quoted by J. Hajjar, *Les chrétiens uniates du Proche-Orient* (Paris: Seuil, 1962) 75.

9 Abū al-'Alā' al-Ma'arrī, *Luzūmīyāt* (Beirut: dar Sader, 1961) 2:457. Quoted by Fiey, *Chrétiens syriaques,* 203.

10 Michael the Syrian, *Chronicle,* vol. 3. Michel le Syrien, *Chronique,* vol. 3, trans. J.-B. Chabot (Paris, 1899) 351–352.

11 PG 105, col. 808. Quoted by A. Ducellier, *Miroir de l'Islam,* 198.

12 Ibid., cols. 776–777. Quoted by ibid., 210.

13 Nicholas the Mystic, *Second Letter to the Emir of Crete.* Nicolas le Mystique, *Lettre II à l'émir de Crète,* PG 111, col. 36–37. Quoted by Ducellier, *Miroir de l'Islam,* 249.

14 Nicholas the Mystic, *First Letter to the Emir of Crete.* Nicolas le Mystique, *Lettre I à l'émir de Crète,* PG 111, col. 28. Quoted by Ducellier, ibid.

15 O. Clément, *Un respect têtu* (Paris: Nouvelle Cité, 1989) 263.

16 Philotheos. Quoted by N. Berdyayev, *Les sources du communisme russe* (Paris: Gallimard, 1951) 12.

17 Maurice Aymard, *La Méditerranée: Les hommes et l'héritage,* 167 (Paris: Flammarion-Champs, 1986) 142.

18 Ibn Khaldūn, *Discourse on History.* Ibn Khaldoun, *Le discours sur l'histoire universelle,* trans. V. Monteil (Beirut, 1967) 1046.

19 *Les versions arabes des dialogues entre le catholicos Timothée I et le calife al-Mahdi, Islamochristiana* 3 (1977) 115.

20 H. Corbin, *Histoire de la philosophie islamique* (Paris: Gallimard-Folio, 1986) 235.

21 Nicephorus Gregoras. Quoted in *Le Proche-Orient médiéval* (Paris: Hachette-Université, 1978) 257.

22 Corbin, *Philosophie islamique,* 160.

23 J.-M. Fiey, *Coptes et Syriaques: Contacts et échanges,* Studia Orientalia Christiana Syriaca 15 (1972) 365.

24 V. Godel, Postface to Grégoire de Narek, *Prières* (Paris: Orphée-La Différence, 1990) 117.

25 H. Thorossian, *Grigor Magistros et ses rapports avec deux émirs musulmans* (originally in *Revue des études islamiques*) (Paris: Paul Geuthner, 1946).

26 J. Mécérian, Preface, Grégoire de Narek, *Livre de prières,* SC 78, p. 15.

27 Kedrenos-Şkylitzes, PG 121, col. 992. Quoted by Ducellier, *Miroir de l'Islam,* 257.

28 Quoted by Hugh Trevor-Roper, *L'essor du monde chrétien* (Paris: Flammarion, 1968) 129.

CHAPTER THREE

Iconic and Aniconic

God's Dwelling

King David has the Ark installed in Jerusalem. In order to give it a dwelling worthy of Yahweh, he resolves to erect a temple, but this building is to be his heir's work. Availing himself of the collaboration of architects and artisans from Tyre, Solomon builds the renowned Temple. Vestibule, Holy, and Holy of Holies are its three parts. The interior of the Holy and the Holy of Holies is panelled in cedar carved with floral decorations and palms; the walls are entirely overlaid with gold. The Ark is placed in the Holy of Holies: it is God's dwelling. Two Cherubim of olive wood covered with gold are also placed there. Here, we find again the two Angels which God commanded Moses to put over the mercy seat: "There I will meet with you, and from above the mercy seat, from between the two cherubim that are on the ark of the covenant, I will deliver to you all my commands for the Israelites" (Exod 25:22). Facing one another, the two Cherubim enclose an empty space: apophatic sign of an invisible presence, that of the ineffable Face of God.

In the Christian East, we find again the two Angels on the side doors to the Sanctuary which the image of Christ dominates: "And the Word became flesh and lived among us, and we have seen his glory, the glory as of a father's only son" (John 1:14). Solomon's Temple consecrated Yahweh's victory. Hagia Sophia, the Great Church, is the sign of the Trinitarian God's victory. On December 25, 537, on the day of its solemn consecration, Emperor Justinian exclaims, "Solomon, I have vanquished you!" Centuries later, mystical Islam sees the basilica as an Edenic place:

> If you seek Paradise, O Sufi,
> It is Aya Sofya which approximates it best.[1]

Taking up the challenge offered by Byzantium, Islam in its conquest wants to make Allāh's glory visible. Thus, the Caliph al-Walīd ibn 'Abd al-Malik resolved to give the mosque in Damascus a magnificence never seen before. He announces, "My will is to build a Dwelling of God, the like of which no one has built before me and no one will build after me." The mosque of Damascus, jewel of the Umayyads, celebrates the Eternal, for "there is no victor except God."

In the service of the Eternal, art becomes communion. The cultic buildings want to be Dwellings of God, signs of God's victory and reign. A sacred alliance is sealed between art and religion. Sumptuous and imperial, or poor and simple, art is always deeply spiritual. Its world foreshadows the other world, the one which endures forever. Purified from "the elemental spirits of the world," "weak

and beggarly'' (Gal 4:3, 9), art celebrates ''the Supreme Excepted One,'' ''God from afar,'' ''God from near,'' God whose face remains forever hidden. ''Thrones or dominations or rulers or powers'' (Col 1:16) pass away with ''the present form of this world'' (1 Cor 7:31). Architects, painters, artisans, and scribes participate in the same creation, celebrating and praying to the one Creator.

Sign and Image

It is well known that in the monotheistic East, the image occupies a singular place. In the Old Testament, the prohibition of any representation of human or animal figures is categorical: ''the likeness of male or female, the likeness of any animal that is on the earth, the likeness of any winged bird that flies in the air, the likeness of anything that creeps on the ground, the likeness of any fish that is in the water under the earth'' (Deut 4:16-18). To the fear of idolatry will be later added the desire to found a celestial art free from anything vain or corruptible. While recognizing the pedagogical role of the image, the Church Fathers stress the necessity of a worthy mode of expression faithful to its theme and message. Humans, created in the image and likeness of God, reign over paradise. Their fall caused a cosmic fall: ''The whole world lies under the power of the evil one'' (1 John 5:19). Believers are called to a redeemed world, a ''new heaven'' and a ''new earth'' where the Creator dwells among God's creatures. Beyond any kind of Manicheism, both the earth and humankind are destined to be deified because ''everything created by God is good, and nothing is to be rejected, provided it is received with thanksgiving'' (1 Tim 4:4).

Greek thought only reinforces this biblical command. Platonic spirituality places its stamp on the monotheistic East. While rejecting ''profane'' culture, the Church Fathers appreciate its values and lights. As St. Gregory of Nyssa teaches, this ''sterile'' culture, which ''constantly conceives without ever giving birth,''[2] possesses in itself ''something to which we must not disdain to unite ourselves in view of begetting virtue.''[3] Thus, Christians feed on the milk of the Church by frequenting profane culture. Stoicism, Aristotelianism, Platonism, and Neo-Platonism penetrate Christianity and are Christianized. The Creator is One, Source of the Beautiful and the Good, and everything that is worthy of these attributes belongs with God. We inhabit time, process, and corruptibility. Our life is lack, emptiness, generation, and corruption. The sensible world is only a provisional background, separated and faraway from the divine perfection, a semblance and a mirage, the reflection of a loftier region more real than this reality crumbling into dust. We are, as it were, at the bottom of the sea: we think its floor is the earth and its waters the sky. We are prisoners in a cave, chained down, our backs to the entrance open to the light: we watch shadows on the wall at the rear of the cave and we deem them to be reality. The bodily eyes are powerless. Once converted to the Spirit, they can look up to the absolute principle and renew contact with being, the intelligible, and the immutable.

''The Good is the One,'' Plato says. ''Divinity must be the measure of everything, to the supreme degree—much more, I think, than people claim humanity is.''[4] To imitate nature is to betray the intelligible world: ''To paint an object of the sensible world is to attempt to pass off not only a sham but the copy of a sham as authentic.''[5] Painters are nothing but counterfeiters. Their fabrications are imitations to the square power, fraudulent visions of an ephemeral and mortal reality produced by an ephemeral and mortal world. The eye of the soul opens onto the Eternal. Gorgias calls upon painters, architects, and artisans to become workers of the divine: ''When the workers, having their eyes fixed upon immutable Being, work after such and such a model and reproduce its form and good quality, everything they execute is necessarily beautiful. On the contrary, if they fix their eyes on what is the product of generation and take a model of this sort, nothing they make is beautiful.''[6] There is a dialectic at work between invisible and visible, indescribable and describable, being and appearance, presentation and representation. From being a sediment discarded by the ether, the sen-

sible, rocky, opaque, and obscure world is regenerated, remodeled, permeated by the emanations of the Incorruptible. Within the "pure light," the pure geometric forms carry the Eternal and witness to it, "perfect, simple, immutable, blissful appearances."[7] According to the *Timaeus,* whatever moves follows this ordinance: "God, wanting everything to be good and nothing bad, inasmuch as possible, took the whole restless mass of visible things, moving without rule or order, and led it from disorder to order, deeming order to be preferable to disorder on all counts."[8] Sages dwell in rest. Reining in their restive horses, bearers of passions, chaos, and disorder, they mount the "good white horse," that of equilibrium, measure, and truth, and ride with an indomitable strength toward the Good, adorned as they are with a profound inner peace and silently contemplating an ineffable, indescribable vision.

Judeo-Christians (hellenized or not) or Christianized Greeks, the Eastern Fathers construct a vision in which the Beautiful is inseparable from the Good. The world of Ideas loses ground before "life in Christ." Monastic life deepens this transfigurative vision and gives it its own characteristic stamp. Theodoret narrates, "Zeno lived alone and purified and cleansed the eye of his soul, giving himself over to the contemplation of the Divinity, causing God to ascend within his heart, and wishing he could take wing like the doves and fly into God's rest."[9] Godly humans live "the fast of the eyes" in order to see and to see themselves. St. Gregory of Nyssa comments, "Since it is natural for the eye to see all that surrounds it and all the while remain invisible to itself, likewise it happens that the soul is busy with everything else, is concerned about what is outside itself and knows it thoroughly, and yet is unable to see itself."[10] In its quest for God, the soul turns toward "its own image" and "contemplates, as if it belonged to itself, what it sees in the model after which it has been patterned."[11] "Embellished by incorruptibility, inalterability, and immunity from all evil,"[12] it lives an ecstasy, but an interior ecstasy, in reality an "instasy" at the deepest level of its interiority.

God is the supreme Artist. In Christ, God becomes the perfect Human One and rehabilitates the divine image and likeness. St. Nerses says, "By his proximity, humans learn to seek what is beyond, and by his manifestation, they see the beauty of invisible things."[13] From the invisible, the eye leads toward the transfigured visible. "The master of painters,"[14] "God, who, by God's glory, is like those glorifying God," opens the way. "For God can resemble them, but they could not be like God" before the Incarnation.

> Terrestrial beings cannot be compared to the reign on high; but the reign is compared to them by the very fact that it invites them to share its happiness.
> By that sign, the reign was compared to us, terrestrial beings, in order that by its comparison we might possess the likeness of its glories.
> The image that the Master of truth drew is a very good likeness, but no artist can paint the reign's image with precision.
> The image that its Sign drew and expounded in its Good News is precise: we must look carefully at the splendor of its beauty.[15]

Terrestrial humans lead dead lives; their "limbs exist without existing," and their souls "move them by a lifeless life."[16] Separated from its Creator, our world is the world of the fall, and "all that is in the world . . . comes not from the Father but from the world" (1 John 2:16). Clothed with Christ and living in Christ, the Saints form in their communion one single human being and one single spirit. A new creation takes shape: "Everything old has passed away; see, everything has become new! All this is from God, who reconciled us to himself through Christ, and has given us the ministry of reconciliation" (2 Cor 5:17-18). Holiness is "the wealth that does not become poor"; it grows like a vine and yields, "untiringly, immortal fruit."[17] The supreme action is a wordless contemplation, the contemplation which will reign in the world to come. As St. Gregory of Nyssa

7. *Christ in Majesty,* detail, 5th c. Church of St. Pudentiana, Rome.
8. *Christ Pantocrator,* 6–7th c. Monastery of St. Catherine, Sinai.
9. *Christ in Majesty,* detail, Bawīṭ, 7th c. Museum of Coptic Art, Old Cairo.

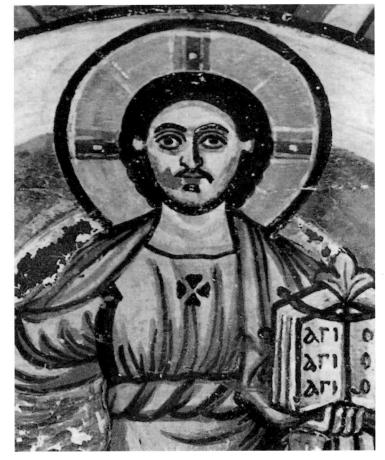

reminds us: "Agriculture, commerce, military life, and all other occupations of the same kind will no longer be practiced; we shall live in complete rest from all these activities, harvesting the fruits of the seeds which we shall have sown during our present lives. These fruits will be incorruptible if the seeds of our lives are good, perishable and corruptible, if such are the fruits of the works of our present lives."[18]

In the sixth century, Constantinople, Rome, Alexandria, Antioch, and Jerusalem share one art. The particularities do not amount to particularisms. Despite the ethnic, political, and dogmatic cleavages, one single Christian, international esthetics takes shape and is being refined, thus trans-figuring the late antiquity still present in common Roman culture. Painting, which was still Greco-Roman at the time of the catacombs, becomes orientalized, spiritualized, and Christianized. Monumen-tal sculpture is eclipsed by two-dimensional reliefs. "The provinces march against Rome," Roden-walt will say. The pronounced stylization of the Roman portrait leads it to the threshold of the icon: the fine closed mouth, the thin nose, the large and fully open eyes form an idealized face. The partic-ular tends toward the ideal; the temporal, toward the intemporal. The landscape grows lighter and becomes an ornamental accent, an ontological, paradisiac place and reflection of the world to come. Heeding St. Ephraem's call, artists lift the veil from their eyes[19] in order to see and show to others the garden of Life. Everything turns toward God, "For the soul is precious, / Even more than the body, / And precious is the spirit, / Even more than the soul; / And Divinity, / More hidden than the spirit."[20] Rather than lingering in this world, "this port of failures,"[21] the eye sets sail for "the port of the Saints." The worker's perishable hand implores God's hand, the hand which goes "from the universe to the first Adam / And from the Second to the universe."[22] Trees, flowers, birds, and animals are fitted into ornamental undulations: "Thus the crown of paradise is splendidly braided / all around the created world."[23] "Its rampart, its bastion, / Is the very concord that reconciles every-thing." Everything there is "pure and holy," "subtle and spiritual."[24] Enclosed garden whose door remains open, the Church is "prepared as a bride adorned for her husband" (Rev 21:2).

> Well ordered, splendid,
> Entirely desirable,
> In height, in beauty,
> Perfumes and variety:
> The port of all treasures,
> The Church portrayed.[25]

There, everything lives by the Spirit; there, everything is "good and acceptable and perfect" (Rom 12:2). Inaccessible Light, God dwells there, "All-hidden," "All-secret."[26] "Orient of the Father of glory,"[27] Christ is the column, the vine, the wine, and the living water. The lush decorations represent the crown of graces, the wine of the last days, the festive banquet, and the Dwelling Place of the Father. Friezes, tracery, and ornamental designs announce the Islamic arabesques to come. "Existence that can be grasped, Essence that cannot be grasped."[28] "Fruitful Rest, unerasable Sign," "omnipresent Will, Presence making everything fecund."[29]

Legacies and Heritages

Far from withdrawing into itself, expanding Islam makes the Near East its center and heart, as-suming its heritages, its traditions, and its cultural legacies. Verses of the Qur'ān consecrate this pas-sage; Allāh bequeaths as their heritage good things to Allāh's people: "How many gardens, how many fountains, they left behind! Cornfields, and noble palaces, and good things in which they took

delight. All this they left; and that which once belonged to them We gave to other men" (S 44:25-28). The mosque of the Dome of the Rock is built in Jerusalem. Byzantine artists participate in the decoration of the Umayyad mosque in Damascus. Flowers, trees, crowns, diadems, vases, and cornucopias; olive, almond, and palm trees; hippodrome, palace pavilion, gate, and house: the walls of its court offer a green oasis on a gold background, stylized, a Roman-Byzantine river landscape showing a knowledge of the laws of perspective and foreshortening. The human image is absent. The believer is the actor in this pictorial space. As is well known, Islam does not have clerical hierarchies or sacraments. The whole of religion is prayer which binds the faithful to their Creator. Without altar, God is all in all. In the thirteenth century, Ibn al-'Arabī writes: "Every person who prays is an imām, because the angels pray behind the worshipers when they pray alone. Then, during prayer, their persons are promoted to the rank of divine messengers."[30]

When not in a mosque, Muslims pray in front of a rug placed according to the *kibla*, the direction of the Ka'bah, a small cubic building erected by Abraham, towards which worshipers must direct themselves for prayer. A niche in one of its exterior corners holds the black stone given by the angel Gabriel. "Ka'bah" means "cube"; geometrically, the cube is the form equal to itself—unchanged, whatever the angle from which it is looked at: "To Allah belong the east and the west. Whichever way you turn there is the face of Allah" (S 2:115). Woven in the prayer rug is an empty niche. The emptiness symbolizes the unknowableness of God. A lantern at the top of the niche is the iconic image of the verses of the "Light": "Allah is the light of the heavens and the earth. His light may be compared to a niche that enshrines a lamp, the lamp within a crystal of star-like brilliance. It is lit from a blessed olive tree neither eastern nor western. Its very oil would almost shine forth, though no fire touched it. Light upon light" (S 24:35). Reduced to their one-dimensional signs, tree and plant motifs surround this apophatic void symbolized by the niche. No anthropomorphic figure can

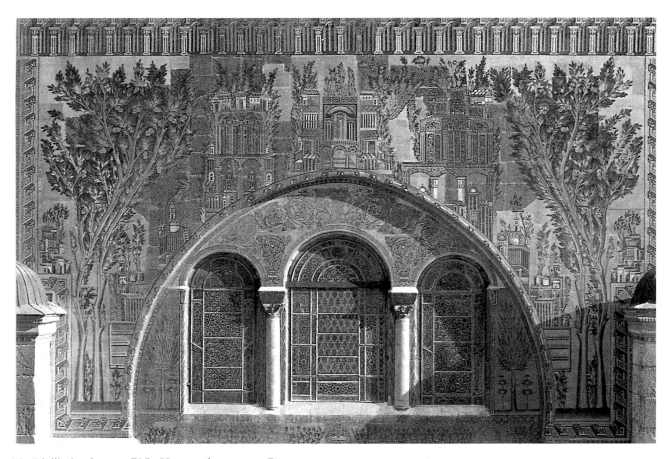

10. Idyllic landscape, 715. Umayyad mosque, Damascus.

be found there. The praying persons are alone before the Lord, and their "voyage takes place no longer toward God but within God."

Human figures can be found outside places of worship. Umayyad pictorial art continues Eastern Hellenism: scenes of hunts, baths, and athletics; mythological iconography where Greek inscriptions designate Thought, History, Poetry; stylized reliefs in which the Roman-Sāsānid art of Palmyra endures. The image precedes empirical perception, stylizes and purifies the different figurative elements.

The Iconoclastic Crisis

Iconoclasm, which bursts forth in 726, tears Byzantium apart for more than a century. The icon receives its baptism in fire and blood. Only the Transfigured Image is accepted. The visible is inseparable from the Invisible; the human is unthinkable without the Divine. The iconodules stand against both the iconoclasts and the iconolaters. "Rid of the fear of idols," writes St. John of Damascus, "we have received the gift of being with God in the purity and knowledge of truth. . . . Having been given discernment, we know what can be or cannot be made into an icon. . . . If anyone pretends to represent the immaterial and incorporeal divinity, we reject this person as a liar."[31] The icon of icons is that of Christ. Holiness is life in Christ; therefore, the icon of a Saint is akin to that of Christ. Christlike and Christocentric, the figuration limits itself to the world of transfiguration. Deliberately non-naturalistic, the image obeys a symbolism proper to the Eastern Church. Images are many, but their theme is one, rigorous, conditioned and modulated by Church canons. Hieratism does not exclude human movements and gestures. The modeling sets off the flesh tones of the immobile faces. Dissymmetry is found within symmetry, thus creating a flexible and living geometry. In the beginning, the icon is "the Bible of the illiterate." Later on, transcending its pedagogic role, it becomes "vision of God." "Vision of the invisible," it says what words cannot say: "The hand has painted the mother of the [divine] Economy," one can read on the wall of a Cappadocian church, "but the tongue has not been able to discover how she gave birth."[32] "Channel of grace," the image wants to open "heaven on earth." It is the beauty of the world in Christ which extends beyond historical changes and geographical cleavages. "The new and non-composite world" replaces the fallen world. Theological and liturgical, the image magnifies "God beyond everything, through everything, and in everything."

The Byzantine iconodules regard the "non-Orthodox," condemned by council after council, as the creators of iconoclasm. St. John of Damascus implicitly emphasizes the Gnostic Monophysite influences upon iconoclasm. St. Tarasius, patriarch of Constantinople, using a rhetoric of curses, accuses the enemies of images of taking their inspiration from the Jews, Saracens, Samaritans, Manicheans, Phantasiasts, and Theopaschites. The Byzantine chronicler Theophanes points out the Monophysite influences playing on the iconoclastic emperors, natives of the Eastern regions of the empire. The second council of Nicaea mentions the names of Sts. Philoxenus of Mabbug, Severus of Antioch, and Peter the Fuller as masters of Monophysitism and iconoclasm. A disciple of St. John of Damascus and contemporary of St. Theodore Studites, the Arab theologian Theodore Abū Qurra, writes a *Treatise on the Worship of Icons* devoted to the refutation of the iconoclasm of some Christians influenced by the Jews and Muslims, who prohibit the cult of images. Nicephorus of Byzantium enlarges the list of insults: iconoclasts are deicides, idolaters, murderers, fornicators—filthy and sterile, homosexual and obscene—destroyers of both nature and culture, bloodthirsty hunters. They are "wild beasts, pigs, boars which ravage the crops"; "limited in their bodies and intelligence, dimwitted, these 'indescribable' people know no other freedom than that of transgression and excess."[33] A chronicle of John of Jerusalem calls iconoclasm a Judaic-Arab invention. Thus, according to him, a Jew from Laodicea urges the caliph Yazīd to eliminate all icons from his empire and prophesies that he will

11. Stucco relief, Qasr al-Ḥayr al-Gharbī, 8th c. Museum of Damascus.

12. Stucco relief, Qasr al-Ḥayr al-Gharbī, 8th c. Museum of Damascus.

13. Head of a man, fragment of a mural, 8th c. Museum of Damascus.

be rewarded by a reign of forty years. Likewise, a Jew from Tiberiadis, "a magician, an instrument of the demons who deceive souls," invites the caliph to take away from the churches "every representation by way of image." Contaminated by this heresy, Constantine, bishop of Nakoleia in Asia Minor, adopts this policy and spreads iconoclasm.[34]

In contrast with this Byzantine upheaval, the Muslims seem to show very little concern for this quarrel about images. Beyond the Byzantine frontiers, at the very heart of the Muslim empire, St. John of Damascus defends icons. While a prisoner in Baghdād, the iconodule St. Romanus suffers the attacks of some iconoclasts, his fellow inmates: the Muslims come to his defense and save him. The hagiographer of this martyr writes, "The Saracens, although strangers owing to their different faith, proved to be better than those who considered themselves Christians; they were more respectful of the monastic habit than those who regarded themselves as faithful."[35] As the studies of Peter Brown and Stephen Gero prove, iconoclasm is an endogenous phenomenon, specifically Byzantine: its theater is Constantinople; its protagonists are indigenous people belonging to the imperial and ecclesiastical elites. The Muslim origin of iconoclasm has never been proved, and history acquaints us with Muslims very appreciative of the beauty of Christian images. In Mecca, Muḥammad, who destroys idols, protects with his two hands the image of the Mother and Child and urges his followers to preserve it. Ibn Jubayr stops in front of the cathedral of the Mother of God in Damascus, praising its paintings which "confound the mind and fascinate the eyes."[36] The caliph al-Mutawakkil admires the "marvelous paintings"[37] in Syrian convents. The Fāṭimid emir Khumārawayh has a belvedere built on the terrace of the monastery of al-Ḳaṣīr in order to admire a mosaic representing the Mother and Child surrounded by Angels and Apostles. The chronicler Abū Ṣāliḥ recounts that "he used to go often, on the spur of the moment, to this monastery in order to contemplate this mosaic, which he judged magnificent and on which he never ceased to gaze."[38] The Supreme Sheikh (ash-Shaykh al-Akbar), Ibn al-'Arabī, writes in his *Revelations of Mecca*, "The Byzantines have developed the art of painting to perfection because, for them, the singular nature of 'Our Lord Jesus Christ,' as expressed in its image, is the support par excellence of their concentration on the divine Unity."[39] In Hagia Sophia, Muḥammad the Conqueror contemplates "the strange and wondrous images" of the building's inside walls and goes up to the cupola "like Christ, God's spirit, who ascended to the fourth sphere of heaven."[40] The basilica is turned into a mosque and the Muslims pray in the midst of its mosaics, not hidden by paint until several centuries after the conquest.

Because it is dedicated to the celebration of the Transcendent, Islam leads to an aniconic art. Very early, calligraphy becomes preeminent. For the Muslims, the Qur'ān is what Christ is for the Christians, an Arabic corpus, watched over by Angels in the highest heaven. The first scribes of the Qur'ān were called "scribes of the Revelation": "It is set down on honoured pages, purified and exalted, by the hands of devout and gracious scribes" (S 80:13-15). In the service of God, calligraphers participate in the supreme jihād, this great holy war which asceticism is. The ink that flows from their reeds is like martyrs' blood. In the eighth century, an angular hand, specifically linked to the Qur'ān, is developed. By about the year 1000, six handwriting styles have evolved and are accepted as authoritative. From the mystical viewpoint, calligraphy transcends its pedagogical role. In contrast to the prose of the Qur'ān in which the verses flow "without interruption, like an impetuous torrent, in staccato, breathless words,"[41] the calligraphy becomes more harmoniously "complicated," to the point of illegibility, and is subtly transformed into arabesques. Stripped of any figurative root, the stylization of the letters is quasi-abstract. Beyond words and speech, calligraphy praises the One—the Inaccessible, the Ineffable. "Allāh is the One, the Eternal; Allāh is a third of the Qur'ān,"[42] says the Ḥadīth. If the divine word of the Book becomes illegible in a first stage of contemplation, the "Mother of the Book," source and essence of the Qur'ān, becomes legible in the alternation of straight lines and curves woven into an infinite calm, celebrating the One, the Wide, the Omniscient. The straight line is the sign of the Spirit; the curve, that of the soul. Titus Burckhardt comments: "To the incisive

repetition of the vertical lines, formed especially by the extremely elongated upstrokes of the alif and the lām, corresponds, in the horizontal direction, the melody of ample and varied curves. When transposed to the monumental order and used in the epigraphy inspired by the Qur'ān, this hand-writing is the tireless attestation of the divine Unity accompanied by the joyful and serene expansion of the soul."[43]

Whether animal, vegetal, or geometric, ornamentation recalls calligraphy. Animated by the one Spirit, everything is a vehicle of the Divine. Arabesque reproduces itself ad infinitum. Baudelaire in the *Fusées* notes that "among all styles of drawing, the arabesque is the most spiritual, the most ideal of all."[44] Valéry admires the logic and the lucidity of "the art of the Arabs," an abstract vision of forms where being and knowledge are united, where the world one sees, and which blinds us, withdraws in order to let us glimpse an absolute movement.[45] Rilke sings of the flowery arabesques, gardens "poured as into a glass," "transparent, untrampled," of "breezes, almost visibly bearing fragrance of blossoming branches."[46]

Mundus Imaginalis

Some specialists of Islam think they find in a certain number of Ḥadīth, a prohibition that would justify the absence of images in Islamic art. For instance, "God will punish those who fabricate images, until they can breathe souls into them, something they will never be able to do."[47] Every return to idolatry, every Promethean temptation is banished. We must remind ourselves that Islam never knew any phenomenon such as Christian iconoclasm. The Qur'ān anathematizes only the pagan use of images. "Idols and divining arrows . . . are abominations devised by Satan" (S 5:90). Hellenized Islam is passionately seeking the knowledge of unveiling and of contemplation. Far from

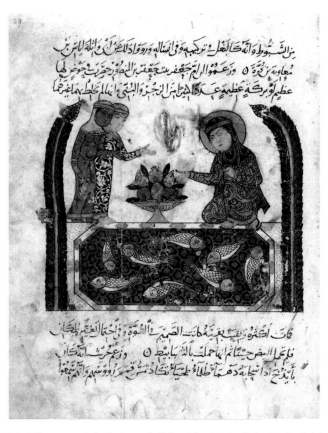 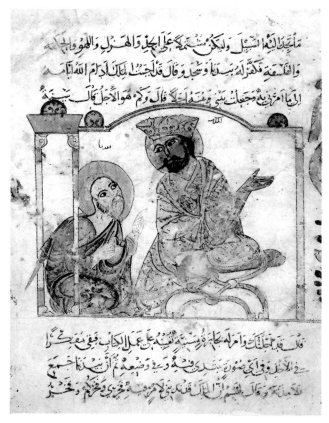

14. Women with fruit and fish, *The Book of Animals,* 14th c. Ambrosian Library, Milan.
15. *Bidpay and the King, The Book of Kalila wa-Dimna,* 13th c. National Library, Paris.

being insensitive to the image, it assumes it in order to create its very own figurative art. This art is found again and again in the different media of artistic expression, such as metal, tapestry, ceramic, and stone. Bookmaking gives this art its stable domain, and the miniature becomes its primary expression. In both Christian and Islamic art, sculpture in the round and naturalistic painting are rejected. The image precedes empirical perception. Transfigurative, it draws its inspiration from the world of pure ideas as well as from the perception of sensible objects. Here we find the *mundus imaginalis,* the world of images, admirably described by Henri Corbin: "It is the intermediary world between the intelligible world of the beings of pure Light and the sensible world; the organ that perceives it is the active imagination. It is not the world of Plato's Ideas, but the world of Forms and Images 'in suspense'; the expression signifies that they are not immanent to a material substratum (as the color red, for instance, is immanent to a red body), but they are 'places of epiphany' where they manifest themselves as the image 'in suspense' in a mirror. It is a world in which the wealth and variety of the sensible world is found, but in a subtle state, a world of Forms and Images, subsistent, autonomous, a world which is the threshold of the World of the Soul."[48]

Nurtured by Mesopotamia, Byzantium, and Persia, Islam affirms and imposes its style and schools. To the divine transcendence of the One, corresponds the science of unification; to the multiplicity of the one, corresponds the identity of the multiple. All beings are relative to God and exist only through God: when purified, they manifest the divine attributes and become epiphanies. Thus, created worlds are signs of God. The icon reveals the light of Tabor, the eighth day, the heavenly Jerusalem. The miniature celebrates the "eighth climate," outside the seven geographic climates, the convex side of the sphere of spheres, the Na-Kajo-Abat, this "land of the non-where" evoked by as-Suhrawardī. What is apparent is only a veil. Whether religious, mythological, or historical scenes; fables, tales, or narratives, the action is located in a garden, image of paradise. "In paradise, there is a market where images are sold,"[49] the Prophet predicts. The garden found in miniatures is an inner garden. The Asiatic influence is evident; however, we are far from those Chinese gardens where, as Pierre-Jean Jouve writes, "everything is blurred, and behind on muted steps—listen—thunder," where "everything is loss, phantom, absence after death."[50] Here, the sky is gold, the water silver. There are no shadows. Everything is bathed in light, "Light upon Light." The drawing is clear, the color pure. Gestures are measured. Angels, men, and women are of the same nature. The universal predominates over the particular. Human beings, horses, and flowers, each the only one in its species. It is the world of immutable essences, archetypes of the beings and things which the eye of the mind perceives through the contemplative imagination. In this two-dimensional space, the action, immobilized, moves vertically. The Ḥadīth recounts, "In paradise, there is a tree under whose branches a horseman mounted on an excellent steed, well trained and swift, can ride for one hundred years without ever leaving its shade."[51]

The Radiance of the East

Byzantium sacralizes the image and elevates it to the same plane as the Gospel and life-giving Cross. The second council of Nicaea commemorates the first: the cult of images is the sign of the "Triumph of Orthodoxy." The West is unconvinced by such dogmatics. The *Caroline Books* reject the acts of the seventh council: "Humans can be saved without seeing images; they cannot be saved without the knowledge of God." However, beyond these disaccords, from the paleo-Christian era to the fourteenth century, Western Europe advances and develops in the wake of the East. Ostrogothic and Merovingian arts are at the antipodes of Roman classicism. The reliefs on sarcophagi show flatly carved images where a symbolic bestiary is mixed with fascia and intricate interlacing. Visigothic, Asturian, and Mozarabic arts perpetuate an original Christian art which is Eastern in its origins, forms, and

expressions. Islam is not absent from these styles. Pre-Romanesque English and Irish arts radically diverge from realism and develop an ornamental style in which the figurative element, reduced to its one-dimensional nucleus, flourishes in a superabundance of interlacing. Although the Carolingian empire distances itself from the Greek empire, the communion of the arts is maintained and even increased. The "way from the land of the Vikings to the land of the Greeks" opens onto Byzantium: Western frescoes and mosaics show Byzantine elements outside their tradition. And the way from Asia to the West passes through Transcaucasia: Cadalfach sees in the first Romanesque art "a Mesopotamian invasion of the West." Profoundly Christian, Romanesque art propagates its vision and style. Whether French, Italian, Spanish, German, or English, art reflects one single spirit and one single humanity. Plants are reduced to their essential forms. Everything, stripped of the non-essential, is clothed in humility and spareness. Everything is arranged and harmonized according to a well-controlled, imaginary realm where everything is ordered and finds its rest in God. The liturgy calls Christ the Orient, and people pray looking to the east, towards which the apse faces. The Bible places the garden of Eden in the east (Gen 2:8). The advent of the Messiah "comes from the east and flashes as far as the west" (Matt 24:27). The crusaders pursue a mirage of the East. The Latins loot the churches of Constantinople and break their icons. The Latin emperor Baldwin of Flanders makes a list of the heresies of the Greeks and denounces the cult of images. Paradoxically, the Latins convert very early to iconic art and paint in the pure Byzantine tradition, scrupulously observing its canons and beauty. Roman apses are covered with "Byzantine" mosaics. Palms, vines, and acanthus are seen in the "Eden of Saints." Fantastic architectural structures are represented on the vaults: the figures of two cities, Bethlehem, the cradle of Christ, and Jerusalem, the place of his Death and Return. Following historical vicissitudes, art is fed with all ecumenical traditions and proves to be itself resolutely ecumenical. The parting of the ways happens at the time of the Renaissance: humanism gives new life to Italy; art becomes rooted in the ancient Roman glory and obeys an exclusive Euro-centrism from then on.

Islamic-Christian Encounters

Separated from the Christian empire of the East and made subjects of Islam, Syrians, Copts, and Armenians give varied facets to medieval art. Ways converge and styles intermingle. While calling the Greeks "deceitful" and "vicious," neo-Byzantine Christians freely borrow their methods and techniques. As citizens of the common Islamic culture, they share in the development of its art and find in it their own cultural identity. Christian Ethiopia does not part company with them. Artistic conviviality is total and uninterrupted. Whether under Umayyads or Ottomans, Christian stonemasons, painters, and sculptors collaborate with their Muslim colleagues in the building and decoration of mosques. The ornamental motifs travel and are also found in churches and monasteries. The iconic style, inseparable from the aniconic, persists in paintings, reliefs, miniatures. Ornamentation and stylization become more dominant. Christian iconography adopts the fashions of Baghdād, Moṣul, Cairo, and Esfahān. Some gospel books are written and decorated in a quasi-Qur'ānic manner. Syrians and Copts erect aniconic iconostases in which the empty space is covered with a forest of arabesques. Stuccowork, oblique intaglio reliefs, woodwork, polished ceramics, carpets, and miniatures: the osmosis is total. There germinates and flourishes an Islamic-Christian art. In a geometric symphony of pure forms, the cross reproduces itself without end, embracing the exuberance of the paradisiac arabesque.

In the second century, St. Irenaeus of Lyon ponders the cosmic dimension of the Cross. The "invisible presence" of the Word "extends to the whole creation and sustains its length, width, height, and depth. . . . The Son of God was crucified in these four dimensions, the four dimensions of

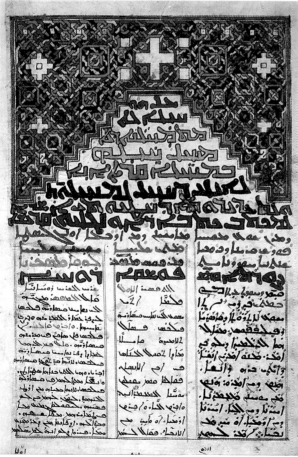

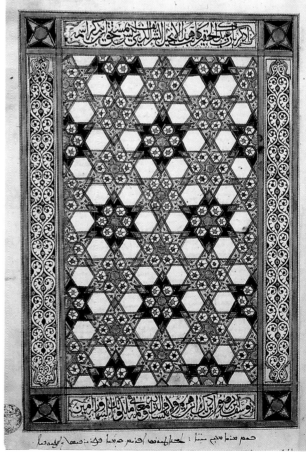

16. Coptic gospel book, 1340. Museum of Coptic Art, Old Cairo.

17, 18. Jacobite Syriac manuscript, 18th c. Church of Sts. Sergius and Bacchus, Qarāh (Ṣadad), Syria.

the universe already bearing the cross-shaped imprint. Having become visible, he had, of necessity, to manifest in a sensible manner, on the Cross, his invisible action. For it is he who illumines the heights, that is, the skies; who plumbs the depths of the earth: he covers the distance between east and west; he reaches to the immense space between north and south, and calls human beings scattered everywhere to the knowledge of his Father."[52] Sign of kenosis, the Cross is glorified as a cosmic sign which gathers creation anew, the Tree of Life which covers the universe with its flowering branches. Christian art of the first centuries multiplies aniconic crosses. They are seen in monumental art, on funerary stelae, silver platters, ampullae from the Holy Land, chalices, and jewels. In Justinian's time, no apse shows Christ on the Cross: art celebrates the redeemed and transfigured world. Eastern Christians have kept this tradition to the present. Whether made of stone, wood, or metal; whether Armenian, Coptic, or Ethiopian. "Hail to the Cross," the Coptic liturgy sings, "which has sweetened the bitter waters; and the believing peoples have drunk of them."[53] In this inexhaustible hymn, crosses continue to beget new crosses—trees of life, signs unfurled on all the horizons of the East.

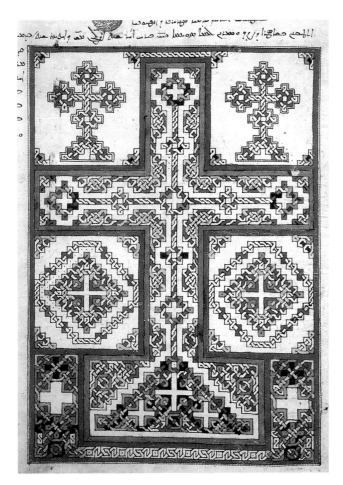 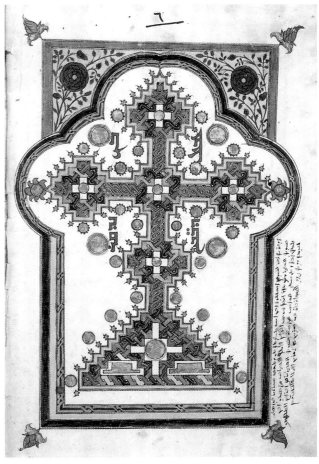

19. *Triumphal Cross,* Jacobite Syriac manuscript, 17th c. Church of St. George, Ṣadad, Syria.
20. *Triumphal Cross,* Jacobite Syriac manuscript, 18th c. Church of Sts. Sergius and Bacchus Qarāh (Ṣadad) Syria.

Notes

1 Quoted by B. Lewis, *Istambul et la civilisation ottomane* (Paris: J. C. Lattès, 1990) 17.
2 Gregory of Nyssa, *Life of Moses*. Grégoire de Nysse, *Vie de Moïse*, Spiritualités chrétiennes 112 (Albin Michel, 1993) 66.
3 Ibid., 73.
4 Plato, *Laws*, 4:716c.
5 J. F. Revel, *Histoire de la philosophie occidentale: Penseurs grecs et penseurs latins* (Paris: Le livre de poche-Stock, 1968) 192.
6 Plato, *Timaeus*.
7 Plato, *Phaedrus*.
8 Plato, *Timaeus*.
9 Theodoret of Cyrrhus, *History of the Monks of Syria*, 12:2. SC 234.
10 Gregory of Nyssa. PG 46, col. 510b. Quoted by A. Botterman, *L'homme face à Dieu selon Grégoire de Nysse*, Contacts 199 (1982) 210–211.
11 Ibid. Ibid., col. 509c. Ibid., 211.
12 Gregory of Nyssa, *Life of Moses*. *Vie de Moïse*, 165.
13 Nerses, *Homily on the Ten Virgins*. In Narsaî, *Cinq homélies sur les paraboles évangéliques* (Paris: Cariscript, 1984) 10.
14 Nerses, *Homily on the Parable of the Rich Man and Lazarus. Cinq homélies*, 49.
15 Nerses, *The Ten Virgins*. Ibid., 10.
16 Nerses, *The Rich Man and Lazarus*. Ibid., 44.
17 Ibid. Ibid., 60.
18 Gregory of Nyssa, *Life of Moses*. *Vie de Moïse*, 106.
19 Ephraem Syrus, *Hymns on Paradise*, 14:10. Ephrem de Nisibe, *Hymnes sur le paradis* (14,10), SC 137, p. 181.
20 Ibid., 9:20 (p. 129).
21 Ibid., 14:10 (p. 181).
22 Ibid., 6:21 (p. 90).
23 Ibid., 1:9 (p. 39).
24 Ibid., 11:3 (p. 146).
25 Ibid., 2:13 (p. 50).
26 Ibid., 4:11 (p. 68).
27 Nerses the Gracious, *Jesus Only Son of the Father* (420). Nersès Snorhali, *Jésus Fils unique du Père*, SC 203 (1973) 122.
28 Ephraem Syrus, *Hymns on Paradise*, 15:11 (p. 187).
29 Gregory of Narek, *Prayers* (1). Grégoire de Narek, *Prières* (Paris: Orphée-La Différence, 1990) 29, 31.
30 Ibn al-'Arabī. Quoted by H. Corbin, *L'imagination créatrice dans le soufisme d'Ibn Arabi* (Paris: Flammarion) 191.
31 John of Damascus, *The Orthodox Faith* and *The Defense of Icons*. Jean Damascène, *La foi orthodoxe suivie de Défense des icônes* (Paris: Cahiers Saint-Irénée, 1966) 222.
32 N. Thierry, *Nouvelles églises rupestres de Cappadoce* (Paris. 1963) 70.
33 M. J. Mondzain-Baudinet, Preface to Nicéphore, *Discours contre les iconoclastes* (Paris: Klincksieck, 1989) 20.
34 John of Jerusalem. PG 109, cols. 517–520. Quoted by A. Ducellier, *Le Miroir de l'Islam* (René Julliard, 1971) 230–231.
35 Quoted by A. Ducellier, *Le Drame de Byzance* (Hachette, 1976) 198.
36 J. Nasrallah, *La peinture monumentale des patriarcat melkites*, catalogue of the exhibition *Icones melkites*, Musée Sursock (Beirut, 1969) 70.
37 MS, British Museum add. 14908. Quoted by Nasrallah, ibid., 73
38 Abū Ṣaliḥ, *Chronicle*. Quoted by L. Leroy, *La peinture des couvents de Ouadi Natroun* (Paris: IFAO, 1982) 11.
39 Ibn al-'Arabī, *Revelations of Makkah*. Quoted by T. Burckhardt, *L'art de l'Islam* (Paris: Sindbad, 1985) 69.
40 Quoted by Lewis, *Istambul*, 17.
41 E. Rabbath, *Mahomet prophète arabe et fondateur d'état* (Beirut, 1980) 59.
42 El-Bokhari, *L'authentique tradition musulmane*, 66.13:2 (Paris: Sindbad, 1986) 225.
43 Burckhardt, *L'art de l'Islam*, 96.
44 C. Baudelaire, "Mon cœur mis à nu," *Fusées* 4–5.
45 P. Valéry, "Regard sur le monde actuel," Œuvres, vol. 2, *La Pléiade* (Paris: Gallimard, 1960) 1044.
46 R. M. Rilke, *Sonnets to Orpheus*, Second Part, No. 21, Selected Works, vol. 2, trans. J. B. Leishman (New York, New Directions, 1967) 279.
47 El-Bokhari, *L'authentique tradition musulmane*, 77.92:1, p. 134.
48 H. Corbin, *Histoire de la philosophie islamique* (Paris: Gallimard-Folio, 1986) 297.
49 As-Suhrawardī. Quoted by S. Stétié, *Lumière sur lumière*, les Cahiers de l'Egaré (1992) 45.
50 P. J. Jouve, "Paysage Chinois," *L'Arc*, special issue "Painting," pp. 73–74.
51 El-Bokhari, *L'authentique tradition musulmane*, 81.51:6, p. 105.
52 Irenaeus, *The Preaching of the Apostles*. Irénée de Lyon, *La prédication des Apôtres* (Paris: Desclée de Brouwer, 1977) 43–44.
53 M. de Fenoyl, *Le sanctoral copte* (Beirut: Imprimerie Catholique, 1960) 68.

SYRIA-MESOPOTAMIA

CHAPTER FOUR

The Syrians

Christ spoke Aramaic; the Gospels used Greek. Christianity develops in the Roman Middle East where native languages and cultures remain alive. The great theological edifice of the Eastern Church bears the indelible mark of its Hellenistic heritage. Jerusalem illumines Athens with its light; Athens transmits to Jerusalem its wisdom and intellect. Fertilization is reciprocal and tradition is enriched by all the contributions of both cultures. Besides Greek and Latin, Syriac, that is, Christian Aramaic, leaves its imprint on the heritage of the Great Church. Language of the people, language of the illustrious monastic Saints' prayer, this branch of the Semitic tongues is also the language and "expression" of spiritual lights, such as Aphraates, the Persian sage, and St. Ephraem Syrus. Missionary language, it leaves its mark on the nascent communities of Armenia, Arabia, and Ethiopia.

Being the language of a Church at once one and multilingual, Syriac is linked in the sixth century to the names of two Churches which secede from the Great Church by excommunicating one another. Two enemy Churches, but born of the same land, of the same "people," even of the same school, Edessa. In the fifth century, the masters of that school are divided between two extreme Christological doctrines: "Nestorianism" and "Monophysitism." Rejecting these labels, the two Churches call themselves the Eastern Syriac Church and Western Syriac Church. In this case, East and West do not refer to Greek and Latin, but to the two banks of the Euphrates, both Churches radiating centers of a "common" presence rooted in Syria-Mesopotamia and extending to the continent of Asia. Even after Greek ceases to be the koine of the Middle East, it remains the tool of cultures and sciences. Minds are bilingual. Both Semitic and hellenized, Syria-Mesopotamia is the land of perpetual osmosis and exchange. Rome and Persia inhabit this land and take advantage of all it has to offer. It is difficult to define the boundaries. The Syriac sphere is neither that of ancient Syria nor that of present Syria. Far from being a closed world, it extends from the Mediterranean to Persia, enclosing part of Asia Minor and opening onto the deep regions of Asia, touching China, India, and Tibet.

House of Eternity

The most important Christian historians attribute a major role to the Middle East in the formation of Christian esthetics. Its earliest beginnings are found in the creations of the "port cities" of the desert. In the Syrian desert, between the Mediterranean and Mesopotamia, Palmyra's influence grows and reaches to Egypt and central Anatolia. In the Mesopotamian desert, beyond the limits

of the Roman East, Hatra, whose masters call themselves "kings of the Arabs," is adorned with Hellenistic splendor. But besides the colonnades, capitals, and contours of the moldings, there is a plethora of deified faces. Hieratism reigns supreme. The body, foundation of classicism, stiffens and disappears under stylized folds and costumes decorated with embroidery in relief. Veils and tightly twisted hair frame faces dominated by the immense eyes of the soul. The circle of the iris surrounds the circular point of the pupil, thus being the prototype of the iconic eye: "Pupil, Christ of the eye,"[1] Guillaume Apollinaire will say. Whether representations of gods, kings, or the dead, the portraits point to the face humankind had at its origin, the dwelling of eternal life. The funerary mosaics of Edessa give Syrian iconography its expressive form. Portraits, busts, or full figures, the subjects are turned toward the observer. A conventional style gives all the faces a family resemblance and departs from naturalism. Semitic inscriptions identify the names of the subjects. "I, Belaï Bar Gūsaï, have had this house of eternity built for me, my sons, and my heirs."[2] The Hellenistic banquet becomes a still and is transformed into a group portrait where the people are side by side in their solitudes. No narration, no description of "this house of eternity." The contemplative gaze alone can silently evoke the otherworldly life.

The monuments of Dura-Europos on the Euphrates complete this vision. Painted before the second half of the third century, an ensemble of frescoes in a temple of a Palmyrene god, a synagogue, and a house church, offer a laboratory of images which announce the international Christian art of Byzantium. Scenes from both the Old and New Testaments are recognizable. What remains of the church fresco shows a beardless Christ as the Good Shepherd, Adam and Eve after the fall, the cure of a paralytic, Peter walking on the water, and the Myrrh-bearing Women at the sepulcher on Easter morning. Awkward and rustic, the painting belongs to the Greek-Eastern style of the time; it is found again, but mature and accomplished, in the vast pictorial program of the synagogue. Here, Prophets take their places: Abraham getting ready to sacrifice Isaac; David, Orpheus-like, charming the animals; Jacob blessing his sons and Joseph's; Moses in front of the burning bush, then ascending the mountain to receive the tablets of the Law. Biblical scenes abound within separate frames, evoking the cycles of Elijah, Ezekiel, Moses, and Solomon. The heads are painted full-face. The actions are tem-

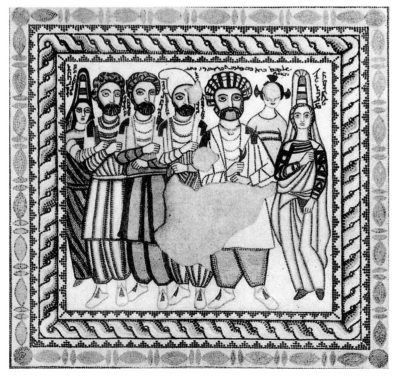

21. Funerary mosaic of Moqimu, 3rd c. Edessa.
22. *Winged Victory,* 3rd c., Dura-Europos. Museum of Damascus.

pered by solemnity. Biblical episodes are not simply historical events, but the signs of a meta-history continually alive. The visual field is a counter-field: the action is open toward the viewers and invites them into its space.

Antiquities and Stylizations

Byzantine Syria-Mesopotamia has left little evidence of its art. A small number of works have survived from among the great heritage attested by writings of the time. The mosaics of northern Syria continue Greco-Roman art with its geometric and animal decorations. Stone and marble works offer few specifically Christian representations. The Nativity of Christ is found on a bas-relief in Yabrud, which a Christian mason hammered on in the mistaken belief it was a pagan scene. The faces are disfigured, but the composition retains its characteristics and modeling. A Greek inscription is engraved on the horizontal band placed above it: "The ox knows its owner, / and the donkey its master's crib" (Isa 1:3). The two animals stare at the swaddled Infant lying in an oblong cradle. Apart, to the right, a woman is seated, her head in her hand. An inscription names her: Holy Mary. The three rows of cubes on the oblong crib, the way the clothes are draped on the sitting Virgin, and the expressions on the two animals' faces link the work to ancient Hellenistic tradition, honored throughout the Roman world. A flagstone showing the adoration of the Magi belongs to an entirely different esthetics. True, the style is naive and awkward, but the Eastern origin seems evident. A stippled border in parallel lines forms a large frame around the personages. With their Phrygian headgear, their Persian clothing—floating cloaks, tunics coming down to the knees, and tight pants—the Magi are a trio on the move. The Virgin, holding the Child, is shown facing forward. "Sitting" on her lap, her Son is flat and in effect "standing" in the middle of his Mother, thus emphasizing the schematic hieratism of the representation. The eight-rayed star of the adoration is between the Mother and the Magi. A similar flagstone coming from the same sanctuary supplies us with a scene from the Old Testament which is dear to Christian iconography worldwide. Despite the poor quality of its execution, the scene is impressive in its originality and stylization. Triangles, little gadroons, and vertical lines form the large frame which surrounds the scene. Daniel, standing with his arms lifted in prayer, forms the central axis of the bas-relief. An Assyrian beard, a huge braid, a tight bandeau, and dangling earrings frame the Prophet's face. His dress is quasi Oriental: a long tunic, a belt with two fringes, and a pearl necklace in the opening at the neck. The marked stylization of the lions transforms them into fantastic felines standing on either side of the hero. On the thick panaches of their tails, two

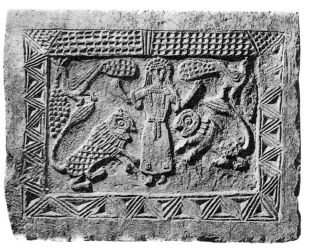

23. *Adoration of the Magi*, 6th c., Rasm al-Qanafez. Museum of Damascus.
24. *Daniel in the Lions' Den*, 6th c., Rasm al-Qanafez. Museum of Damascus.

peacocks carrying in their beaks enormous clusters of grapes transform the den of torture into a found-again paradise.

Gold work presents another facet of the art of the period. Sacred vessels and liturgical objects are adorned with Christian images. Chalices, named after the places where they were discovered, constitute the greatest part of these objects. In the Louvre, the vase of Ḥomṣ, the ancient Emesa, is adorned with a series of busts chased in medallions adorned with cordons and fleurons. Christ and the Virgin are the two axes around which two groups of Saints are placed. Shown full-face, the Son appears in his historical reality, bearded and long haired in the manner of Nazirites consecrated to God. Four Saints surround him on both sides: to the right, Sts. Paul and John the Evangelist; to the left, Sts. Peter and John the Baptist. The second group shows the Virgin full-face, draped in the antique maphorion and flanked by two winged Angels. The spare decor, the treatment of faces and of the folds of the clothing link this representation to the monumental art of Greco-Roman antiquity. The famed chalice of Antioch at the Metropolitan Museum in New York differs from this tradition because of its more elaborate decoration, but its style belongs to the same classicism. Twelve medallions are incorporated in an abundance of ornamentation using the motif of the grape vine, trunk and branches. Christ is shown twice in two medallions. He is seen in his earliest Hellenistic form, young and beardless, presiding over two groups of Apostles. The vine forms a solid background, covering the whole space with its branches and heavy clusters. The animal kingdom is amply represented: we recognize the dove, the eagle, the lamb, the rabbit, the snail, the grasshopper, and the butterfly. In its general aspect and style, the work appears to be Greco-Roman; and the decoration, laden with detail, is not without heaviness. The plant motifs are executed realistically, without any stylization or lightening. The Master and his Disciples, although seated in the air, still have their physical weight as is attested by their faces and by the folds of their garments, which—according to the traditional principles of classicism—harmoniously follow the contours of their bodies.

Local Saints are not absent. The figure of St. Simeon Stylites is found very early on the eulogias of the fifth century. In the Louvre, it is found on a gilded silver plaque engraved with a Greek inscription. Its head crowned with a shell, according to the usage of antiquity, a frontal bust emerges

25, 26. Chalice of Antioch, 5th c. Metropolitan Museum of Art, New York.

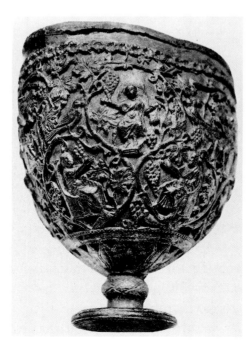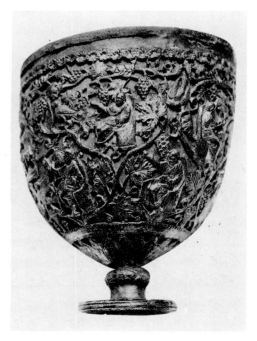

from a basin, forming the great capital of a column around which a long scaly serpent is coiled. A ladder leaning against the column evokes hagiographical history—certain pilgrims climbed a ladder in order to communicate with St. Simeon—and biblical memory—it is a reminiscence of the celestial ladder which Jacob saw joining earth to heaven.

Paleo-Christian Syriac Illuminations

From Sts. Ephraem Syrus to John of Ephesus, through Zacharias Scholasticus and Jacob of Sarug, the Syriac "Fathers" rapturously describe the paintings adorning their sanctuaries. The miniatures which have survived give an idea of this vanished monumental art. Like work in gold, reliefs, mosaics, and mural paintings, the earliest Christian manuscripts reflect multiple, eclectic, and composite styles. Experts disagree about their origin, and any precise assignment of date or place often remains hypothetical.

A precious manuscript in the Syriac language witnesses to specifically Syro-Mesopotamian artistic work: the famous gospel book of Rabbula[3] offers a vast ensemble of illuminations which specialists of Christian art have untiringly studied, reviewed, analyzed, and dissected. Rabbula was the scribe and his work dates from 586. The manuscript gives neither the date of the illuminations nor the names of the artists; however, its iconographic characteristics link it to the same period. A lengthy note designates the monastery of St. John at Beth Zagba as its place of composition. The monastery does not exist any longer and the location of Beth Zagba remains uncertain. Scholars generally place it in upper Mesopotamia. Jules Leroy disputes this assertion and places the monastery "in northern Syria, more open to the influences of the Byzantine world to which it belongs."[4]

The gospel book of Rabbula shows a great ensemble of decorated columns framing the Canons of Eusebius, which are comparative tables of the parallel or divergent passages of the four Gospels. A profusion of ornaments decorate these columns: geometric shapes and an abundance of birds, animals, plants, and flowers. There are marginal miniatures that reduce scenes to a condensed sketch of the elements of the action; there are also full-page miniatures recalling large monumental compositions. Animals and plants, portraits, and gospel scenes crowd the margins of the text, evoking sacred history, from the first covenant to the foundation of the Church. The Hebrew Prophets, the announcers of Christ's story, appear full-length. Besides the sixteen Prophets of the prophetic books, there are three heroes of the Heptateuch, Moses, Aaron, and Joshua, and three heroes of the historical books, Samuel, David, and Solomon. Set off by a neutral background, scenes from the New Testament follow a course of eclectic abbreviation, going from the Announcement to Zechariah to the Judgment of Christ. Signs and symbols emphasize the spiritual import of the historical event. A large oblong shape transforms the crib into a sanctuary; a yellow flame emanates from the waters of the Jordan, announcing the baptism "with the Holy Spirit and fire" (Luke 3:16); a rooster, placed alone above Judas' Betrayal, symbolizes Peter's denial.

Among the marginal images, Christ is shown young, with a small beard and short hair. He appears in the same way on the full-page miniatures, enthroned under a flattened arch, among four unnamed personages clothed in dark-colored tunics. The Crucifixion, Resurrection, and Ascension give him his Nazirite's face, that of a mature man with long hair and a thick beard coming to several points. The pictorial interpretation of the three principal events of the Gospels is remarkably profound. The painter closely follows the gospel accounts. Christ is crucified between two thieves, and with his spear Longinus strikes Christ's right side from which blood flows. On the other side, a standing soldier lifts the sponge full of vinegar, hanging from a stick. At the foot of the Cross, three figures are dividing Christ's garments. Their eyes fixed on the Son, his Mother and St. John stand on the left, while a group of three Holy Women is their counterpart on the right. The Savior is the axis

and the cornerstone of the composition. L. Bréhier sees there, "the first true representation of the crucifixion." The thieves are naked, girded with white cloths, their chests tied with two crossed ropes. In contrast to this historical representation of Roman crucifixions, Jesus is clad in a collobium, which covers his entire body to the feet. Blood is running from the pierced side, but the face is, as it were, impassive. His eyes are wide open. One of St. Ephraem's prayers says, "Lord Jesus Christ, King of kings, who has power over life and death."[5] The Resurrection, which is located on the lower part of the same page, continues the scene. In accordance with the practice of grouping several episodes together, three events occur simultaneously under the same sky. The sepulcher forms the center of the composition. In front of its partially open door from which three red rays issue, three guards are thrown down to the ground. On the left, a seated Angel converses with the Myrrh-bearing Women, who are found again on the right prostrated before the Risen One.

The iconographic interpretation is equally symmetrical, ordered, and rich in the scene of the Ascension. Although absent from the gospel accounts, the praying Virgin occupies the center of the composition. Flanked by two Angels, she appears surrounded by the Apostles, who lift their eyes to contemplate the glorious Ascension of the Son. Iconography transcends the historical event and places St. Paul among the Apostles, thus giving the scene its full theological scope. Above the Virgin, Christ, in white vestments, stands in the middle of a blue mandorla and lifts his right hand while holding in his left an unrolled scroll, empty. Four Angels, resting on four wings strewn with eyes, surround the mandorla; the two wheels of fire and the four gospel animals, all symbols borrowed from Ezekiel's vision, arise from the wings. At the two extremities of the higher tier, two human figures appear, one in a blue moon on the left and the other in a pink sun on the right directing their rays on the ultimate Theophany.

Like the famous ampullae of Jerusalem, the gospel book of Rabbula shows the crystallization of iconographic prototypes destined for an immense expansion in Eastern and Western Christian art.

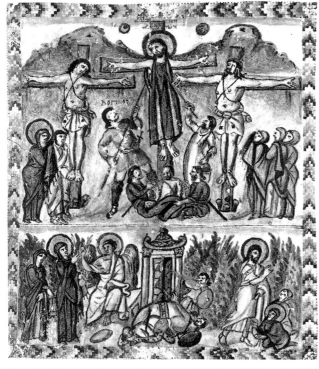
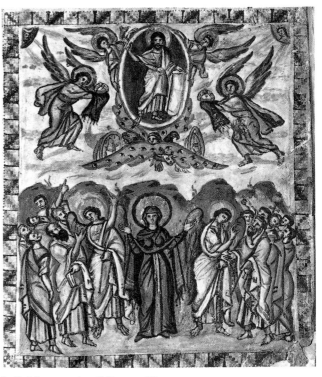

27. *Crucifixion, Resurrection,* gospel book of Rabbula, 586. Medici-Laurentian Library, Florence.
28. *Ascension,* gospel book of Rabbula, 586. Medici-Laurentian Library, Florence.

Charles Diehl sees there "all that Byzantine iconography owes to Syria and Palestine."[6] However, it is good to stress that the plastic treatment of the subject is in no way revolutionary. P. Lavedan believes he recognizes there the victory of "Asian-Oriental trends" over "Hellenistic traditions."[7] This is not the case. Landscapes present an airy space, treated according to the laws of perspective. The Evangelists are painted on the model of the sages of antiquity. In the Ascension, the Virgin's bosom has a pronounced roundness which is counter to the Christian canons of feminine beauty. Gestures are quick and natural. The fluidity of the colors adheres closely to the modeling of clothing and the suggestion of space. Underscoring the curious contradiction that is the earmark of the ornamental architecture of dramatic scenes, Tibor Köves makes a judicious remark: "The clearly modeled individuals are crowded on the narrow field; their bodies overlap; their gestures interfere with one another. Immediately behind them, the slope of a mountain is visible. But the subjects take advantage of the whole depth of the terrain: the Virgin's, Angels', and Apostles' feet are set down more and more to the rear. This method proves how conscientiously, how forcefully, the artist seeks and realizes the illusion of a complete space. It is an empirical art, legitimate offspring of Hellenistic art, which was never able to do without the three dimensions of space."[8]

The same esthetic characteristics are found also in two Syriac manuscripts of the sixth and seventh centuries preserved in Paris.[9] The first one comes from Mardīn, in northern Mesopotamia. Its paintings are reduced to the frames and arcades of Eusebius' Canons, decorated with geometric motifs, and to marginal images. The pronounced taste for decoration obvious in the gospel book of Rabbula is here sparer and lighter. Leaping fountains, together with animals and plants—baskets of fruits and flowers, sheep, roosters, birds, and snakes—form the decoration. The Annunciation, the Healing of the Woman Bent Double, the Cure of the Woman with an Issue of Blood, the Wedding at Cana, and the Myrrh-bearing Women at the Tomb are the selected gospel scenes. The second manuscript is an incomplete Bible probably originating in upper Mesopotamia. There are four paintings drawn

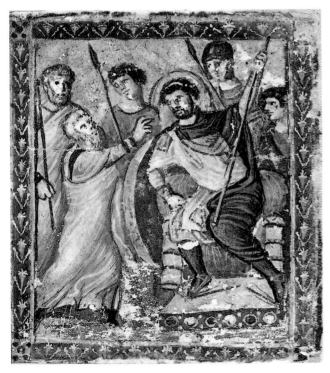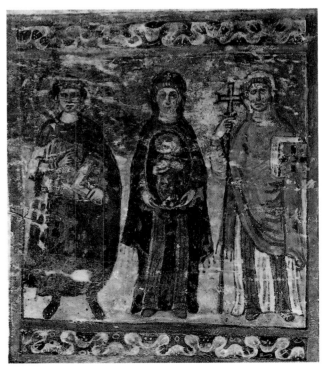

29. *Moses before Pharaoh*, Syriac Bible, 7th c. National Library, Paris.
30. *The Virgin, Source of Wisdom*, Syriac Bible, 7th c. National Library, Paris.

from the Old Testament: Moses in front of Pharaoh, Aaron's staff, the brazen serpent, and Job with his friends. A work of originality shows the Virgin and Child flanked by Solomon, the figure of wisdom, and a woman carrying a book, the symbol of the Church. Full-length individual figures are placed in a number of corners: here, one recognizes Jeremiah, Ezekiel, Hosea, Obadiah, Jonah, Micah, Nahum, Habakkuk, Zephaniah, Haggai, Zechariah, Daniel, Ezra, Sirach, and the Apostle James— Biblical themes and Hellenistic style. More Greco-Roman than Greco-Oriental, these Syriac paintings remain faithful to late antiquity, still alive in both East and West.

From Byzantines to Arabs

Christological definitions divide the Syro-Mesopotamian Christian community into three rival churches. The coming of Islam separates it from Byzantium. The language of the Qur'ān, Arabic, becomes the language of a new culture, without however excluding or suppressing other tongues. Native Christians participate in the activity and life of this nascent empire. For the first fifty years of its existence, Muslim power keeps the system of the Byzantine financial administration in place in the large cities of the Middle East. A polyglot and multiconfessional world is developing with Damascus as its capital. The Syrian horn of the Fertile Crescent becomes the heart of Umayyad lands. Because of their geographical position and their cultural importance, the Jacobite and Melchite Christian communities outstrip the Nestorian Christian community of Mesopotamia, which has been called Church of the Persians for a long time. Two Christian names are linked with this history. The first one, the Melchite son of Manṣūr ibn Sardjūn and a high official of the caliphate, becomes a monk in Jerusalem under the name John of Damascus; illustrious theologian, he is often raised to the rank of "last" Father of the Great Church. The second, al-Akhtal, a loyal Jacobite from the tribe of Taghlib, glorifies the Umayyads and is a luminary of Arab-Islamic poetry.

Whether cultic or lay, Umayyad art is imbued with the Greek-Oriental heritage. At Quṣayr 'Amrah, a fresco from the first half of the eighth century illustrates the triumph of the new power: en-

 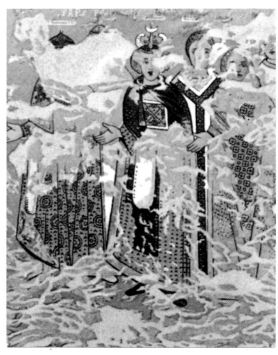

31. *The Master of the World,* fresco, 8th c. Quṣayr 'Amrah, Jordan. Copy by A. Mielich
32. *The Kings of the Earth,* fresco, 8th c. Quṣayr 'Amrah, Jordan. Copy by A. Mielich.

throned in the manner of a *basileus,* an emperor of the Eastern empire, the caliph sits between two persons. Full-face, six hieratic kings stand in two rows. Greek-Arabic inscriptions identify four of them: the emperor of Byzantium, shāh of Persia, king of Spain, and negus of Abyssinia. The motif is akin to Persian iconography of the "king of kings," but the interpretation is resolutely Byzantine. A Sāsānid bas-relief commemorates the victories of King Shāpūr I by showing him on horseback, dragging his prisoner, the emperor Valerian, by the wrist, crushing the corpse of Gordianus III, and triumphally advancing toward the emperor Philip the Arabian, seen kneeling and lifting his hands in an ultimate gesture of supplication. The glorification of the caliph is of another nature. The king does not need to vanquish, crush, or humiliate. Proud and majestic, the kings of the world respectfully welcome their king by pointing to him with their lifted hands. The ornaments and modeling are Byzantine in character. The errors in the Greek inscriptions prove that the artist's tongue was not Greek. The embellishments of the inscriptions reveal a Christian participation in the execution of the work.

The 'Abbāsids overturn the Umayyads about the middle of the eighth century. The foundation of Baghdād, the "City of Peace," marks the establishment of the new reign. The capital of the caliphate moves to the east. In the Syriac chronicles, the Umayyads are called Arabs; and the 'Abbāsids, Persians. The internal quarrels of the native Churches go on. "The Greeks hate us more than the Jews," a Nestorian physician of al-Mahdī declares. A patrician prisoner confirms this view and tells the caliph, "Nestorians are hardly Christians! They are closer to the Arabs than to us."[10] The opposition between the Syriac Jacobite Church and the Syriac Nestorian Church is no less vigorous. The *Chronicle* of the Jacobite patriarch Michael records the disillusioned exclamation of the caliph al-Ma'mūn: "You worry and trouble me greatly, o Christians! and especially the Jacobites, although we ignore the mutual grievances you set forth."[11] Far from forming a separate, marginal ghetto, Christian communities take part in the life and culture of the empire. This participation is often desired and encouraged by those in power. "If you find a Christian fit for the job," the caliph al-Mu'taḍid explains to his secretary, "hire him, because Christians are safer than Jews, for the Jews hope that power will come back to them; safer than any Muslim, for a Muslim, being of the same religion as you, will keep a covetous eye on your position; and safer than the Magi, for the kingdom was theirs."[12] This surprising logic allows Christians to occupy key posts and to enjoy happy periods which Bar Hebraeus calls "wedding-feast days." A Nestorian chronicle of the ninth century says: "At that time, the city of Moṣul was built opposite Eden and Nineveh. Muslims became numerous: they lived in Persian cities; they destroyed the fire shrines [of the Zoroastrians]; they honored the Christians more than the followers of all other religions."[13]

Traditions and Practices

The 'Abbāsid caliphate makes the Mesopotamian horn of the Fertile Crescent the center of its power and creativity. This geographic fact raises the Nestorian Church to the first place among the three Churches of the Muslim empire. As J.-M. Fiey stresses: "The Church—Eastern Syriac for the most part—represented in high places by secretaries and physicians, is in a position to play a role in the flowering of this civilization each time it has a patriarch or a bishop somewhat distinguished by either his holiness or his learning, for Muslims appreciate both. Then, the Church regains the place of second religion (unofficial of course) it used to enjoy under the Sāsānids. This it does by the same means: its patriarchs and bishops on the one hand, its secretaries and physicians on the other. By the way, the patriarchs are often former secretaries or physicians, or at least belong to families of secretaries or physicians."[14]

As was the case for the preceding periods, literary references attest to a large diffusion of pictorial arts of which few traces have come down to us. According to the hagiography of St. Anthony the New Martyr, an icon of St. Theodore in Damascus converts "outsiders": Shooting at the holy image, the Arab Rawah, a relative of the caliph Hārūn ar-Rashīd, sees his arrow miraculously turn back toward him and wound his hand. "Because of this miracle he had witnessed through the icon," Rawah is converted, takes the name of Anthony, and finally embraces martyrdom in Raḳḳa.[15] A poem by al-Wāthiḳ evokes a painting in the palace al-Mukhtār in Sāmarrā', representing a church in a landscape, with its watchman and monks. Al-Mutanabbī describes a scene decorated with animals, in which the Byzantine king prostrates himself before the Ḥamdānid sovereign. The excavations at Sāmarrā' and Nīshapūr reveal the first witnesses to a new style which becomes widespread throughout the Middle Ages. A fragment of fresco from Sāmarrā' suggests the face of an ecclesiastic. A painting showing a Nestorian bishop is found again on a tall earthenware wine jug of Sāmarrā'. A stern-faced person is standing, fixing the observer with his eyes. His attire bespeaks his episcopal dignity: the prelate's staff, the hat with earflaps, the chasuble with black stripes. His face belongs to a new prototype. Nourished by fermenting ideas from everywhere, Islamic art asserts its originality and creates its own figurative style. Syriac arts follow this evolution very closely.

Byzantium remains close by, through both its culture and its arts. An Arab manuscript of *De Materia Medica*[16] has miniatures executed according to Byzantine canons. Only the costumes are Muslim. Dioscorides and his two students wear turbans, following the Islamic iconographic tradition which places "the crown of Islam" on the heads of Hebrew Prophets and Greek sages. Dioscorides is painted in accordance with the classical principle of the author-portrait, seated under an elegant arch on a gold background, enthroned in his armchair, his feet on a footstool. The folds of the clothes, the flesh tones and nuanced modeling are in the Byzantine manner. However, the majority of known

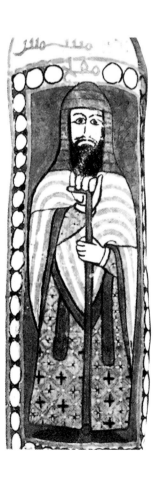

33. Fragment of a fresco, 9th c., Sāmarrā'. Museum of Islamic Art, Berlin.
34. *Standing Bishop,* painting on a wine jar, 9th c. Copy by E. Herzefeld.

illuminated manuscripts available in collections around the world offer another style of painting. Far from constituting a local national school, the "School of Baghdād" shares the multinational character of medieval Arab civilization. It spreads and grows into an empire-wide school. Its iconography and prototypes are common possessions and are discernible in the figurations of the multiple facets of Islamic art. Whether wood, stone, parchment, or paper (the materials differ) the language is one.

One visage influences the various visages: immense eyes, long aquiline nose, ample cheeks, and powerful chin. The heads are often systematically circled with haloes. Firm and precise lines trace the forms and contours. Rhythmic motifs replace the folds of the garments. Freed from gravity, reality is reduced to the necessary. Action is stilled. Animated movement loses animation. A fantastic symmetry unifies all the elements of composition. Secular life is transformed into ceremony. There is no desire to paint life from life. People, plants, and various objects are grouped in theatrical settings. Illuminated texts belong to very different genres. Their subjects are philosophic, scientific, historical, and medical. At the expense of the text illustrated, the painting preserves its own world. The boat of Abū Zayd vanishes in order to leave the whole space to an "island of the East" inhabited by a gold crested bird, a sphinx, and a Harpy, none of which the text mentions: "an image, unattached and unspoiled, arising from the mind,"[17] as R. Ettinghausen observes. Art dedicated to the celebration of power and the court is infused with the same "spirit." "The pleasures of days and nights without cease or change,"[18] says the Arabic inscription on the cloak of Roger II of Palermo. These pleasures culminate in an apotheosis: an immense eagle, stylized into an arabesque, carries the king on its back to the celestial regions.

Syriac art breathes the same air. Of course, painters are not ignorant of the important lessons of Byzantine painting, predominant throughout the whole medieval world. Dated to 1054, a Syriac manuscript from Melitene[19] shows a unified ensemble of five miniatures. The standing silhouettes

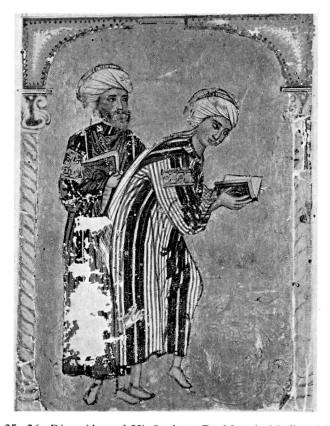 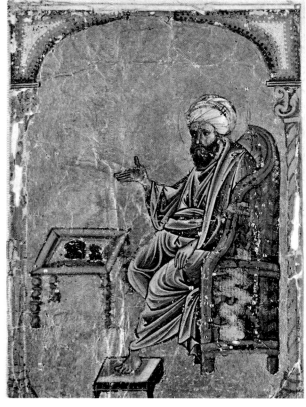

35, 36. *Dioscorides and His Students*, De Materia Medica, 1229. Topkapi Museum Library, Istanbul.

are set off by a dark blue background. Noble faces on stout bodies follow the custom common to all Eastern non-Byzantine communities. All else is Byzantine. Christ is represented between Sts. Peter and Paul shown three-quarter face. The Virgin and John the Baptist each carry a scroll in Syriac and Greek. The holy Monk Bar Ṣaumā lifts his arms in prayer, while a dragon and wolf curl at his feet. Finally, the holy Warrior George, in his gold armor, carries his spear in one hand and buckler in the other. Manuscripts of the twelfth and thirteenth centuries share the same esthetics. The inscriptions are in Syriac but the painting is Byzantine. One manuscript[20] is adorned with a double portrait of Sts. Ephraem Syrus and Jacob of Sarug. The two God-inspired poets stand under honorific arches whose columns are draped with red curtains. The setting is classical. But the mode of execution is new. The linear drawing, the forms emptied of their volumes, the pronounced stylization of the faces reflect the painting techniques proper to the Eastern non-Byzantine Christian communities.

PL. 1
PL. 2
PL. 3
PL. 4,5

Contemporary works immerse us in another world. An abundant iconographic plan is found in two rich gospel books, one in the Vatican,[21] the other in London.[22] There, we see the Evangelists Matthew and Mark, the Virgin and Child enthroned in majesty, the Forty Martyrs of Sebaste, Constantine and Helena, seven of the great Feasts—Nativity, Epiphany, Entrance into Jerusalem, Crucifixion, Ascension, Pentecost, and Transfiguration—and a profusion of scenes depicting Christ's life, from the announcement to Zechariah to the incredulity of Thomas, with the cycle of the Passion in between. Only the scenes themselves are traditional. The style, the use of colors, the physiognomies, and the settings are purely 'Abbāsid. The faces are more rounded and the eyes become slanted. Ovoid masses replace the folds of the clothing. Sts. Mark and Matthew, no longer represented in the classical manner of author-portraits, are now ensconced in those famous pulpits of the mosques. Caiaphas is sitting in the "Turkish" way, his legs crossed under the cloth of his costume. The Christ of The Communion of the Apostles adopts another Eastern posture. The painter has him seated, full-face, legs apart and dangling according to a convention found again and again in the works of Arab, Persian, Armenian, and Turkish artists. Vegetation becomes more stylized into quasi Islamic forms and is depicted in vigorous growth in both exterior and interior scenes, the symbols of these paradisiac places, "festooned with fruit, crowned with flowers."[23] Trees, mountains, and rocks are identical with those of Arab miniatures. The same is true of the architectural elements, where cupolas, domes, uniform courses of bricks, and foundations of masonry are transformed into geometric, one-dimensional compositions. Carpets are not lacking. Like their Muslim counterparts, the miniaturists paint in light relief, scrupulously rendering the multiplicity of their geometric motifs: squares with stars inside, diamonds with rosettes, or diamonds with crosses. Certain elements of the ornamentation follow this peculiar absence of perspective, for instance the bed of the Dream of Joseph, the table cloth of the Meal at Simon's House, or the pool of the Cure of the Paralytic. The water of the Jordan is heaped up in rhythmic waves, covering the Savior to the neck. Forty busts set in a composition of octagonal frames offer in the Martyrs of Sebaste a novel geometric iconography. Similarly, the uppermost level of the Ascension unites eight busts of Angels in a chain of eight disks set on a wide horizontal strip. Christ, his Mother, and his Disciples keep their traditional "Greek" clothing, whereas the secondary characters adopt the dress of the time: turbans, veils, and Arab "robes." Constantine and Helena exchange their Byzantine imperial attire for two sumptuous garments with 'Abbāsid ornamentation. Far from being the province of a Christian particularism, this pluralism of costume is found also in Islamic miniatures of the time: one meets Bidpay dressed and haloed in the manner of a holy Apostle and sees Abū Zayd before his audience, wearing a monk's hooded habit, according to a representation which K. Weitzmann compares to that of the Washing of the Feet.

PL. 6,7

Byzantine iconography and 'Abbāsid treatment: the same osmosis exists also in a Chalcedonian manuscript[24] of the thirteenth century. Translated from the Greek, the narrative tells the story of Barlaam and Joasaph. The Christian tale is inspired by the life of the Buddha. At Joasaph's birth, an astrologer predicts to his father, the Indian king Abenner, the future conversion of the prince

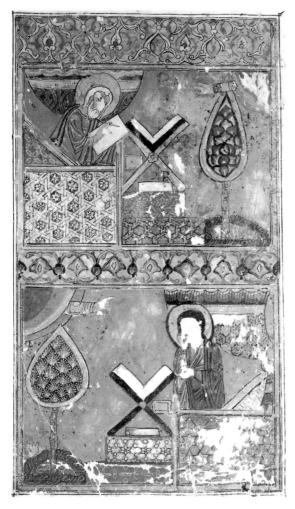

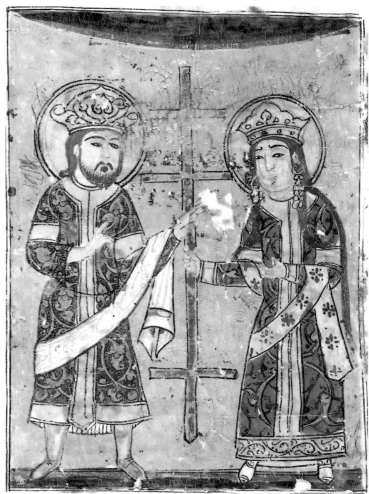

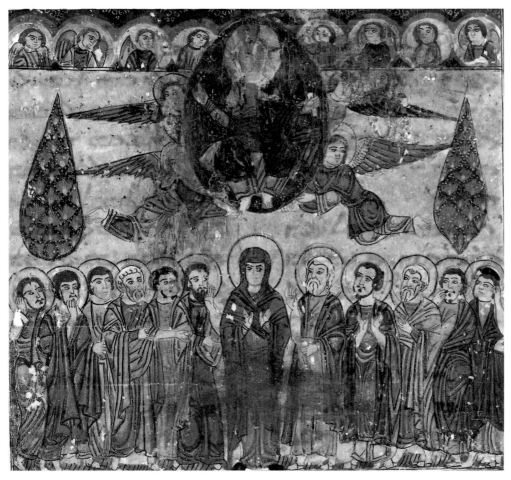

37. *Sts. Matthew and Mark*, Jacobite Syriac gospel book, 1219–1220. Vatican Library.
38. *Constantine and Helena*, Jacobite Syriac gospel book, 1219–1220. Vatican Library.
39. *Ascension*, Jacobite Syriac gospel book, 1219–1220. Vatican Library.

to Christianity. The father, who is very hostile to Christians, raises his son in a luxurious palace far from the world, sheltered from any preaching of the Gospel. Inspired by God, the hermit Barlaam disguises himself as a merchant and goes to Joasaph to announce the good news to him. Touched by grace, the prince, heir to the throne, embraces the Christian faith. After baptizing him, the hermit silently withdraws to resume his life in the desert. The king attempts by all possible means to turn his son away from Christianity. Unshakable, the neophyte succeeds in converting his father. After his father's death, he renounces the throne and sets out on a search for his spiritual father.

PL. 8-9, 10,11 The meeting takes place in the desert, where the two men spend their lives in prayer and contemplation until their deaths. According to Byzantine page design, the illustrations, disposed in horizontal strips, are harmoniously integrated within the text. Seven miniatures recount Joasaph's journey. Behind a fantastic architecture, the prince is seen with his teacher, his father, and his spiritual master. Prayer crowns the whole thing: having received the Eucharist from Barlaam's hands, Joasaph retires into his nook where he turns toward heaven, imploring God on his knees, barefoot and arms lifted in prayer. Decorated with baldachins, gables, and curtains, the buildings of the scenes are simplified and represented one-dimensionally according to Arab perspective. Joasaph's baptism takes place against a red background bounded by two flowering stems stylized into arabesques and placed at the extremities of the image, a common formula of 'Abbāsid painting. Besides the seven biographical images, there are two miniatures devoted to the parables recounted by the monk in the story. The *Allegory of the Fowler* also uses the setting of the miniatures just described. In the manner of Arab miniatures, the *Allegory of the Man Fleeing from the Unicorn* is set against a plain background with two small trees spread fanlike and bearing golden fruit. The man in flight, the blackbird, the rats, the serpents, and the dragon are faithfully patterned after types in 'Abbāsid manuscripts.

In the Time of the Mongols

At the turn of the eleventh century, the caliphate weakens and finally is dismembered. Secessions succeed one another, and the once subject peoples assert their independence. The first Turkish states are formed. Viziers now have power over the 'Abbāsids, relegated to the rank of nominal leaders. Christian communities experience the tumults of history. In 1075, the Jacobite patriarch writes to his colleague in Alexandria: "All you say about what befell your father's flock has likewise befallen our Christian flock. And like you, we have been expelled from our earthly dwellings. . . . Our afflictions are the same. . . . All this is the result of our faults."[25] One century later, during a visit in Melitene, the Seljuq emir convokes the Jacobite patriarch Michael by sending him an escort of honor: the cross, the book of the Gospels, candles, and the chanting of the office by the faithful accompany the patriarch's glorious entry. Christians continue to occupy high administrative positions. Sometimes, converts from "the outside" occupy key functions: their loyalty to their community leads them to protect Christians and give them the opportunity to be an active social presence.

The arrival of the Mongols creates a new state of affairs. In the beginning, the Christians side with their Muslim fellow-citizens and take part with them in the defense of Melitene. Baghdād is burned down in 1258, the population slaughtered, the caliph put to death. "Moved with pity, some Christians welcomed into their homes several Saracens who had been their neighbors, in order to save them. Upon hearing this, the Khan ordered that all be killed, whether Christians or Saracens, which was done."[26] Very early, the pro-Christian politics of Hülegü, inspired by his wife, the "most faithful" Dokuz Khatun, urges Syrians and Armenians to unconditionally rally to the conquerors. The weakness of the central power is evident at the death of the royal couple. "A great sadness overtook Christians in the whole world because of the departure of these two shining luminaries who

had insured the triumph of the Christian religion,"[27] says the chronography of Bar Hebraeus. A Turkish-Chinese monk accedes to the Nestorian patriarchal see. His biography is candid about the reasons for this choice: "The kings holding the reins of power were Mongols and there was no one besides Mar Yaballaha who knew their mores, their customs, the way they conduct their affairs, and their language."[28] According to the chronicler Silwa: "He enjoyed glory and power beyond everybody else before him, to such a point that the Il-Khans and their children uncovered their heads and knelt before him. His orders were executed in all Eastern kingdoms, and in his time, Christians were elevated to great honor and power."[29] What follows lacks glory. A few decades after their coming into Mesopotamia, the Mongols are Islamized. The two Syriac communities experience the worst debacle in their history. Toward the end of the century, massive conversions occur among rich and poor. "Whether nobles or common folk, all became Muslims."[30] Agents of the Mongols, Christians bitterly realize the consequences of this alliance. Bar Hebraeus confesses, "With the Mongols, there is neither slave nor free, neither believer nor pagan, neither Christian nor Jew. All they ask is service and submission beyond the limits of one's strength."[31] The conquerors are weakened and revenge is directed at their allies. The glorious biography of Yaballaha culminates in a fateful failure: "The Muslim peoples rose in order to revenge themselves on the Church and its children for the destruction which the father [Hülegü] of these kings inflicted upon them."[32]

Paradoxically, art ignores history and its events. It remains creative and dynamic. Hülegü's invasion has little effect on the artists' zeal. Beyond local quarrels, the Islamic world shares an artistic language which continues to flower luxuriantly. The Syrians are part of it, and the osmosis obvious in the art of bookmaking is also obvious in other artistic expressions. Christian iconography is found again in arabized form on beautiful copper artifacts engraved and inlaid with gold and silver. Objects cease to have a cultic function. Liturgical iconographic programs are in abeyance. Sacred themes are side by side with profane themes: scenes about Christ, secular life, and courtly pleasures are found together. But the ensembles retain their homogeneity. The iconic, aniconic, and epigraphic form a unified decor of graceful arabesques. Under the reign of the atabeg Badr al-Dīn Lu'lu', an Armenian slave elevated to the rank of sultan and officially recognized as such, Moṣul is the center of this art, found also in Damascus and Cairo. In 1954, D. S. Rice listed fourteen pieces with a Christian theme: boxes, ewers, candlesticks, and basins executed and destined for Muslim high dignitaries, among them Nadjm al-Dīn, the Ayyūbid sultan of Egypt and Damascus in 1240. Masters sometimes humbly signed their work. There is a candlestick, dating from 1248, in the Museum of Decorative Arts in Paris, showing four quadrilobate medallions with the Presentation in the Temple, the Baptism of Christ, the Bath of the Child, and a group scene which might be the Last Supper. This work is by Dāwūd ibn Salāmā, a Christian goldsmith of Moṣul. The beautiful ewer of Homburg, decorated with two groups of haloed Saints dressed in ecclesiastical garb, is the work of another inhabitant of Moṣul, the Muslim Aḥmad al-Dhakī, who made it in 1242. One single creative current unites Muslims and Christians, causing these artifacts covered with gold to share a moving similarity of signs and symbols.

The Signs of St. Behnam

The monumental witness of this period is the martyry of St. Behnam near Moṣul and a destination of pilgrimages. Dating from the middle of the thirteenth century, its ornamentation in stone reliefs is in the atabeg style. With its door trim, moldings, reliefs, arabesques, and decoration in the form of animals, the building is one of the finest sanctuaries of the time. The architectural ordonnance is quasi Islamic and the stylization of Christian figures is strongly reminiscent of Islamic styles.

The presence of figures does not amount to a transgression. Indeed, the decoration of Muslim buildings of this period does not shrink from using figurative elements which are found even in places of worship. Examples of this are the Great Mosque of Diyarbakir and the Mosque of Divriği, dating back to the twelfth and thirteenth centuries. There, one can see bee hives, alveoli in the shape of shells, friezes of palms and epigraphic friezes, stuccowork, and intricate arabesques. One can also see stylized birds, lions with square heads, serpents with darting tongues, the intertwined bodies of dragons. The ornaments of the sanctuary of St. Behnam are the same as those found in contemporary Muslim edifices, but crosses of many shapes and little figures of Saints and Angels confer upon the building its Christian character.

The exterior facade has two doors and three central niches. Represented as two small silhouettes with haloes and carrying the Cross and the scroll of the Book of Life, Sts. Peter and Paul are incorporated within the geometric decoration of the first door. Higher up, two Angels on the same scale as the Saints flank the Cross. An inscription reveals the sculptors' names: the monks "Abū Salem and Ibrāhīm, his brother." The animal ornamentation of the other door is reduced to zoomorphic figures common to all the arts of the time.

Inside the church, two small Warrior Saints make a timid appearance on the Royal Door. The wall on the south side offers "the most beautifully carved door in the whole ensemble, the only one where the inside of the door jambs are decorated."[33] The door trim is two parallel columns forming fourteen medallions, six of which frame individual figures of Saints. Only two names are inscribed, Sts. Daniel and Sohdo. Similarly, two among the seven medallions on the upper lintel contain human figures. The first one has two silhouettes in a baptism scene. The second shows a Warrior on his mount, holding aloft the Book of Life, sign of martyrdom confirmed by the presence of two little executioners flanking the horse. The engraved inscription links the two scenes: "The holy Martyr Behnam grew between two baptisms. He bathed in water, but he did more: he also bathed in his own blood." When one returns from the enclosure around the sanctuary, one sees two damaged stucco reliefs representing St. Behnam and his sister St. Sarah. On a small carved plaque placed in the choir, the Warrior Saint, who underwent martyrdom at the time of the Sāsānids, is shown for the last time; here, he wears the traditional Persian ribbon on his shoulder and stands in a space strewn with stars in the shape of octagons and crosses.

The numerous inscriptions are in either Syriac or Arabic. There is also an Armenian text on a stone embedded in the wall and decorated with Eucharistic symbols: doves, clusters of grapes, and loaves of bread framing the Cross. The information supplied by the inscriptions dates the ornamentation from 1248 to 1261. One line in Old Turkish is engraved at the beginning of the fourteenth century above the half cupola of the tomb: "May the peace of Khidr Elias, God's elect, rest on the Il-Khan, his dignitaries, and his ladies." To this day, the Arab name of the sanctuary is al-Khidr. A thirty-line inscription tells of a Mongol raid and a profanation of the sanctuary in 1295. Afterwards, in order to save the monastery, a monk from the community made St. Behnam into al-Khidr, "the Verdant," a mysterious prophet venerated by Muslims and often identified with the Prophet Elijah. As the line written in Old Turkish attests, this astute stratagem protected this place of pilgrimage and secured for it the protection of the Mongols, who had become Muslims in great numbers as early as the end of the thirteenth century.

St. Isaac of Nineveh calls the Saints "giants." Divinized humans become, as it were, microcosms recapitulating within themselves the regenerated cosmos. Before him, St. Ephraem saw the fruits of the tree of paradise vanquished by the "fruits of the just ones" and its ornaments, "by the ornaments of the victors": flowers are overcome by these "other flowers," the Saints "whose crown is joy / for [every] creature and for the Creator." Trees, fruits, and flowers are the ornaments of paradise and the Saints are the reigning crowns there.

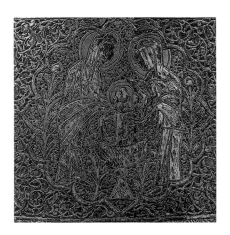
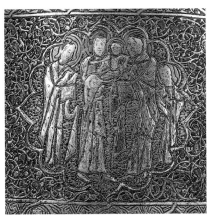
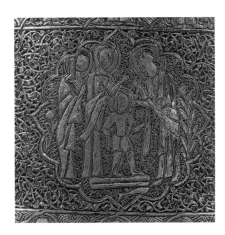

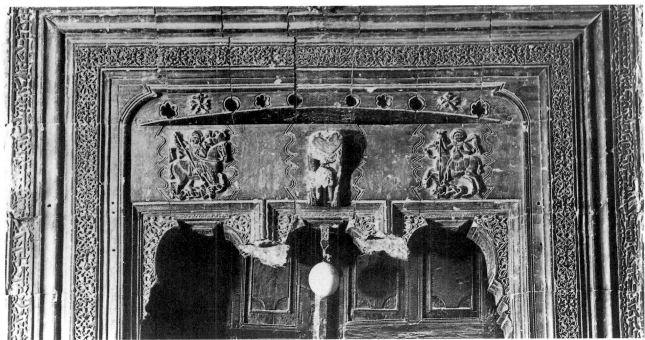

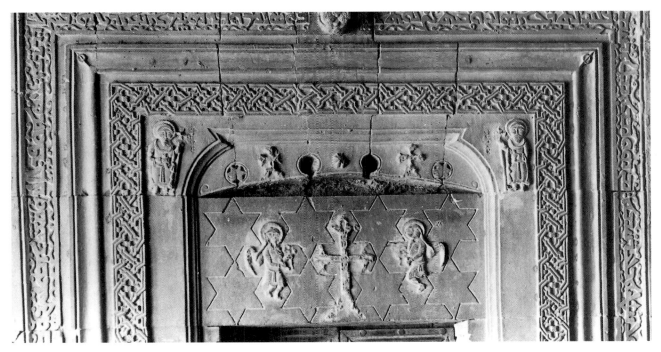

40, 41, 42. Candlestick, details: *Bath of the Child, Presentation, Baptism,* work of Dāwūd ibn Salāma, 1248, Moṣul. Museum of Decorative Arts, Paris.

43, 44. Carved decoration, 13th c. Martyry of St. Behnam, Moṣul.

SYRIA
Color Plates 1–24

1. *The Holy Virgin,* gospel book, 1054. Library of the Syrian Orthodox Patriarchate, Damascus.

2. *St. George,* gospel book, 1054. Library of the Syrian Orthodox Patriarchate, Damascus.
3. *St. Bar Saumā,* gospel book, 1054. Library of the Syrian Orthodox Patriarchate, Damascus.

4. *St. Jacob of Sarug,* 12th c. Library of the Syrian Orthodox Patriarchate, Damascus.
5. *St. Ephraem of Nisibis,* 12th c. Library of the Syrian Orthodox Patriarchate, Damascus.

6. a. *Cure of the Paralytic,* 1219–1220. Vatican Library.
b. *Christ and the Paralytic,* 1219–1220. Vatican Library.
7. *The Resurrection,* 1219–1220. Vatican Library.

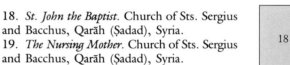

8–9. *Joasaph Speaking with His Teacher, Story of Barlaam and Joasaph,* 13th c. Monastery of Our Lady of Balamand, Lebanon.

10. a. *Joasaph Speaking with His Father the King, Story of Barlaam and Joasaph,* 13th c. Monastery of Our Lady of Balamand, Lebanon.
b. *Barlaam Revealing His Identity to Joasaph, Story of Barlaam and Joasaph,* 13th c. Monastery of Our Lady of Balamand, Lebanon.
11. a. *Joasaph Embracing Barlaam, Story of Barlaam and Joasaph,* 13th c. Monastery of Our Lady of Balamand, Lebanon.
b. *Barlaam Baptizing Joasaph, Story of Barlaam and Joasaph,* 13th c. Monastery of Our Lady of Balamand, Lebanon.

12. *Standing Saint.* Monastery of St. Moses the Ethiopian, Nebk, Syria.
13. *St. Elizabeth.* Monastery of St. Moses the Ethiopian, Nebk, Syria.

14. a. *The Last Judgment,* detail: the Virgin, Abraham, Isaac, and Jacob. Monastery of St. Moses the Ethiopian, Nebk, Syria. (Restored by the Central Institute of Restoration, Rome.)
b. *The Last Judgment,* detail: St. Peter Opening the Gates of Paradise. Monastery of St. Moses the Ethiopian, Nebk, Syria. (Restored by the Central Institute of Restoration, Rome.)
15. *Angel.* Monastery of St. Moses the Ethiopian, Nebk, Syria. (Restored by the Central Institute of Restoration, Rome.)

16. *St. Cyril of Alexandria.* Monastery of St. Moses the Ethiopian, Nebk, Syria. (Restored by the Central Institute of Restoration, Rome.)
17. *The Holy Bishops Basil the Great, Athanasius of Alexandria, and John Chrysostom.* Monastery of St. Moses the Ethiopian, Nebk. (Restored by the Central Institute of Restoration, Rome.)

18. *St. John the Baptist.* Church of Sts. Sergius and Bacchus, Qarāh (Ṣadad), Syria.
19. *The Nursing Mother.* Church of Sts. Sergius and Bacchus, Qarāh (Ṣadad), Syria.

20. Biface Icon: *Baptism of Christ,* detail, 13th c. Archbishopric of Mount Lebanon.
21. Biface Icon: *Mother of God as Guide,* detail, 13th c. Archbishopric of Mount Lebanon.

22. *Mother of God as Guide,* 1318, restored 18–19th c. Monastery of Our Lady of Balamand, Lebanon.
23. *Mother of God as Guide,* detail: *Angel Praising the Mother,* 1318, restored 18–19th c. Monastery of Our Lady of Balamand, Lebanon.

24. *The Trinity and Deesis,* 18th c., Syria. Private collection, Lebanon.

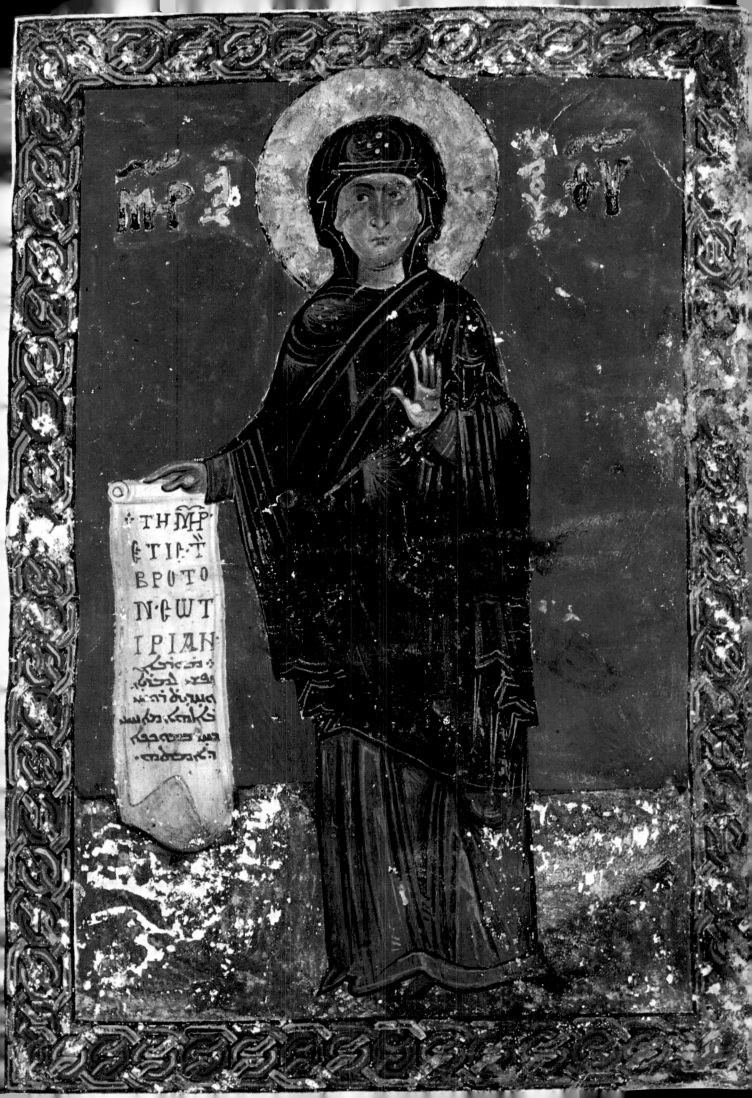

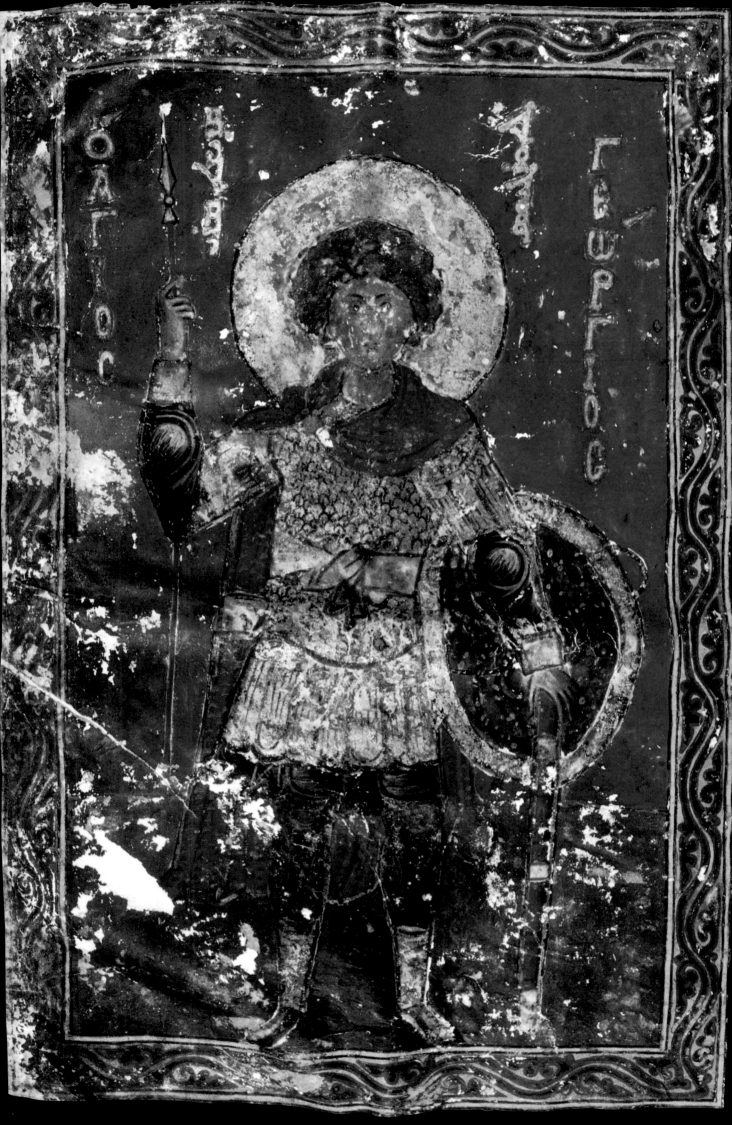

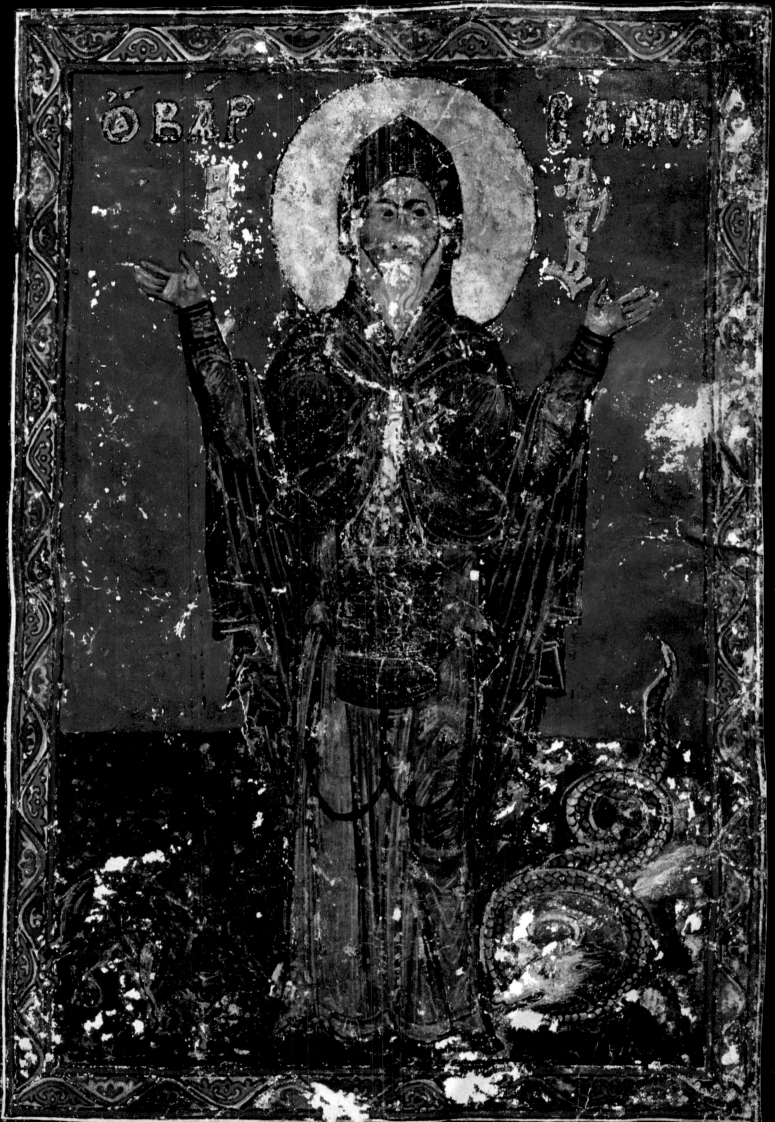

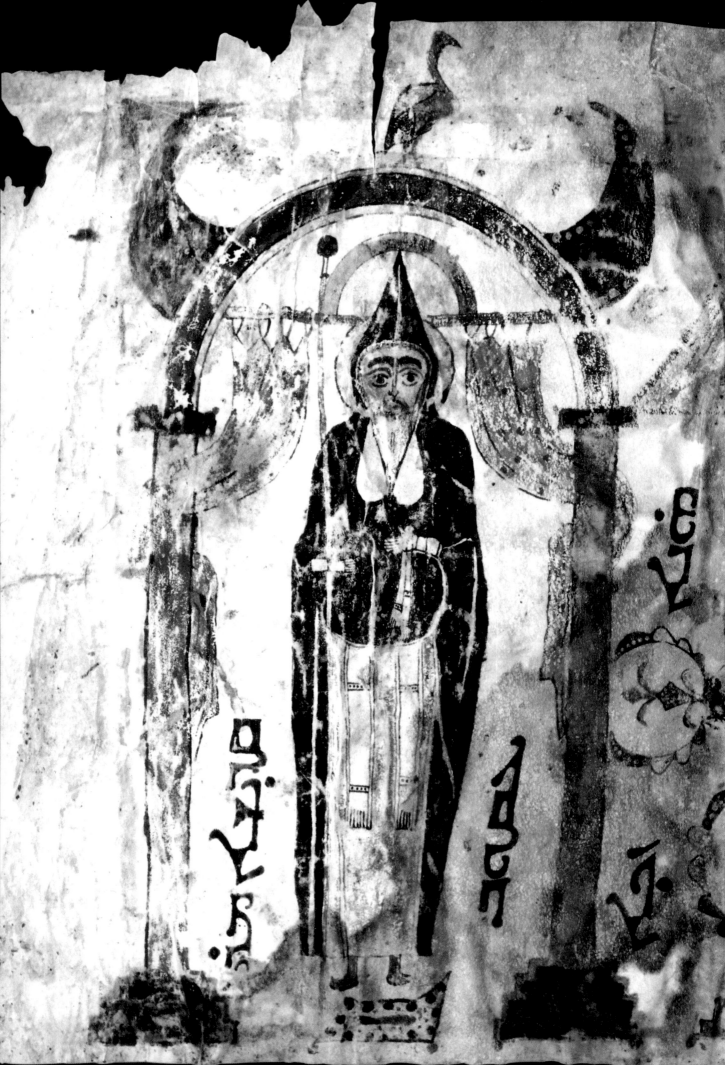

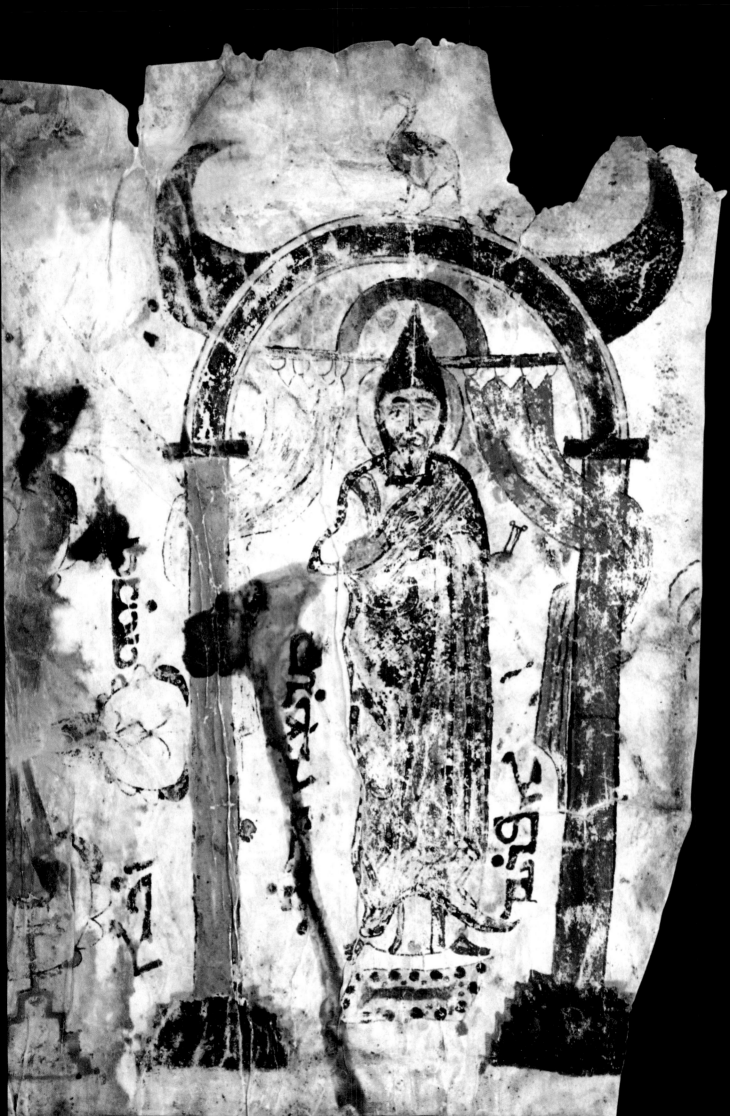

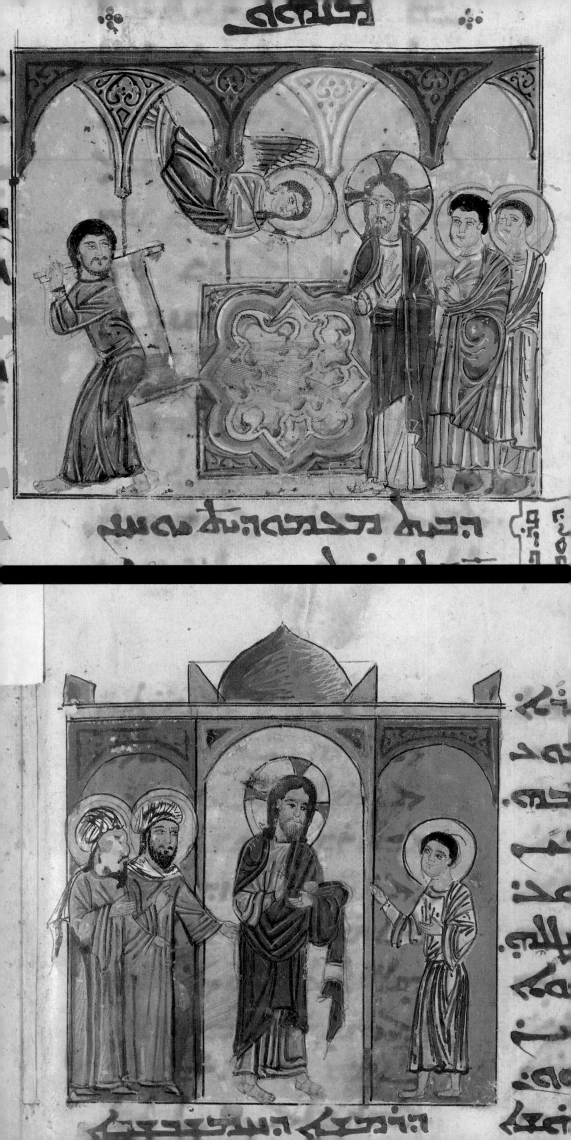

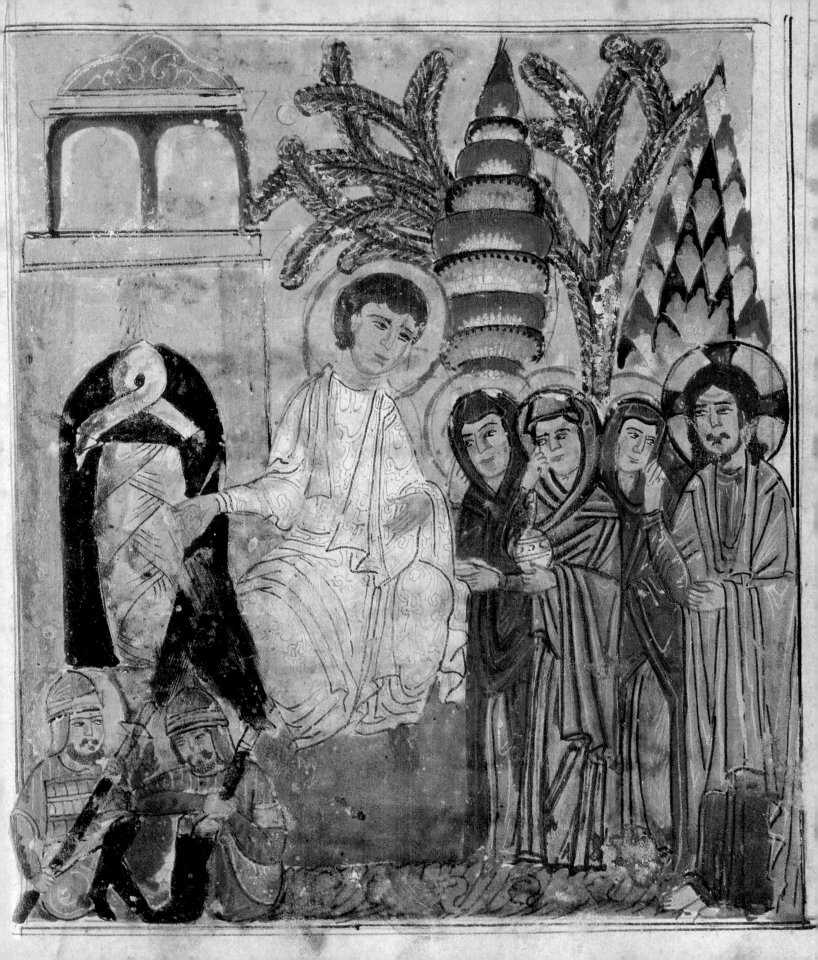

صورة ابن الملك ... هكذا

يخرج الصورة والأخرى الملك ...

انظر الى التي لا ان كان لحيه جبا منطا في بعض الاوقات قال لابيه
صورة الملك وابنه يواصف لحرث في خلاط

استنهيت ان اعلم منك ايها السيد الشب الذي مرا بابوه
وهو لا يسكن معه باكا قلبي وان اباه عندما استمع هذا الكلام
اخذاه فنا له قال ايها الد خل بشوا ما الخزر الذي

الباعند

فلما راى يواصف ذلك الذي العبد المرهل وذلك اللباس الحسن لابسه
وذلك الجسم المحروق المسود والعظام الملتصق بها الجلد فاحار ونجن

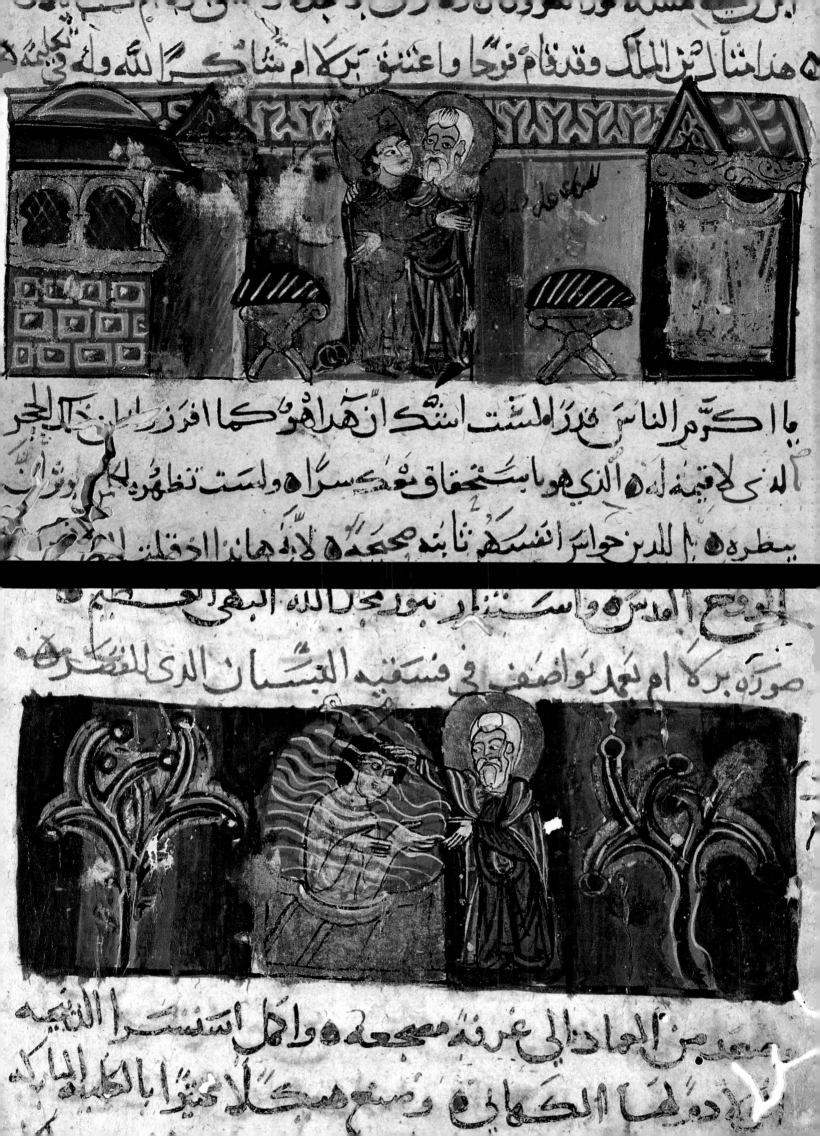

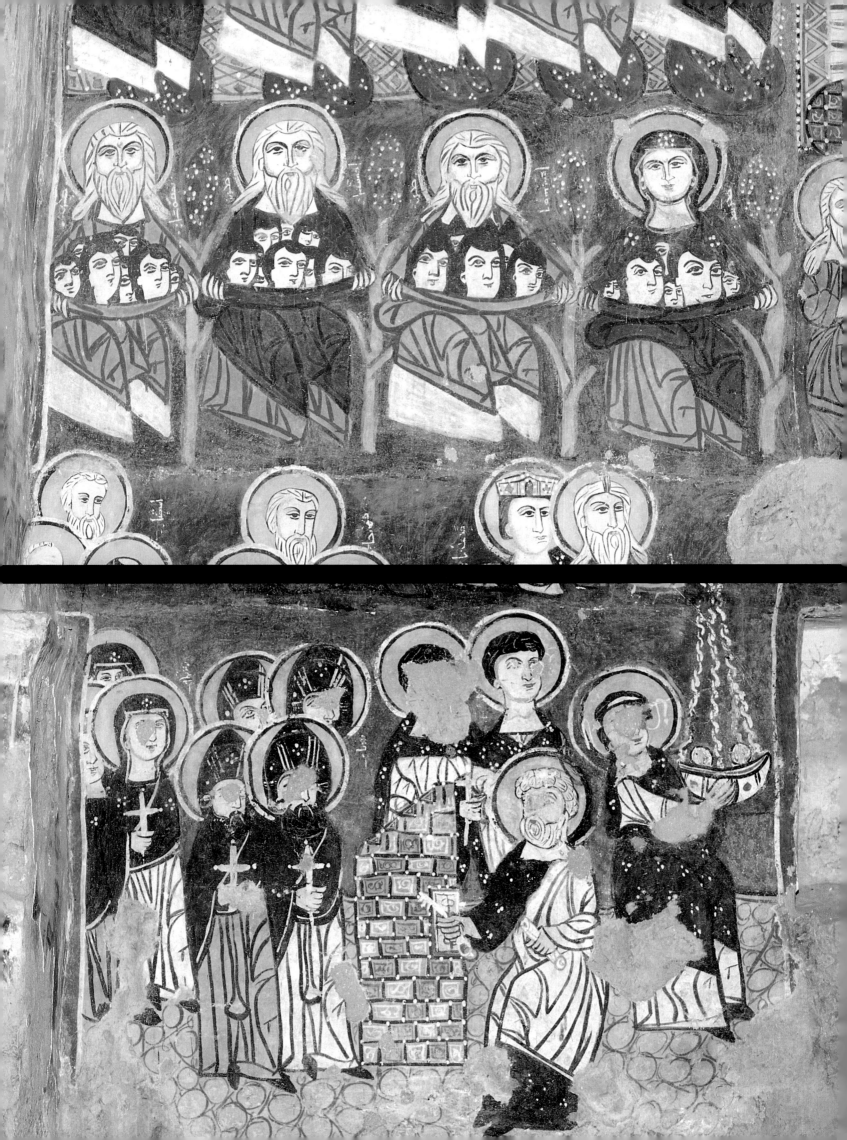

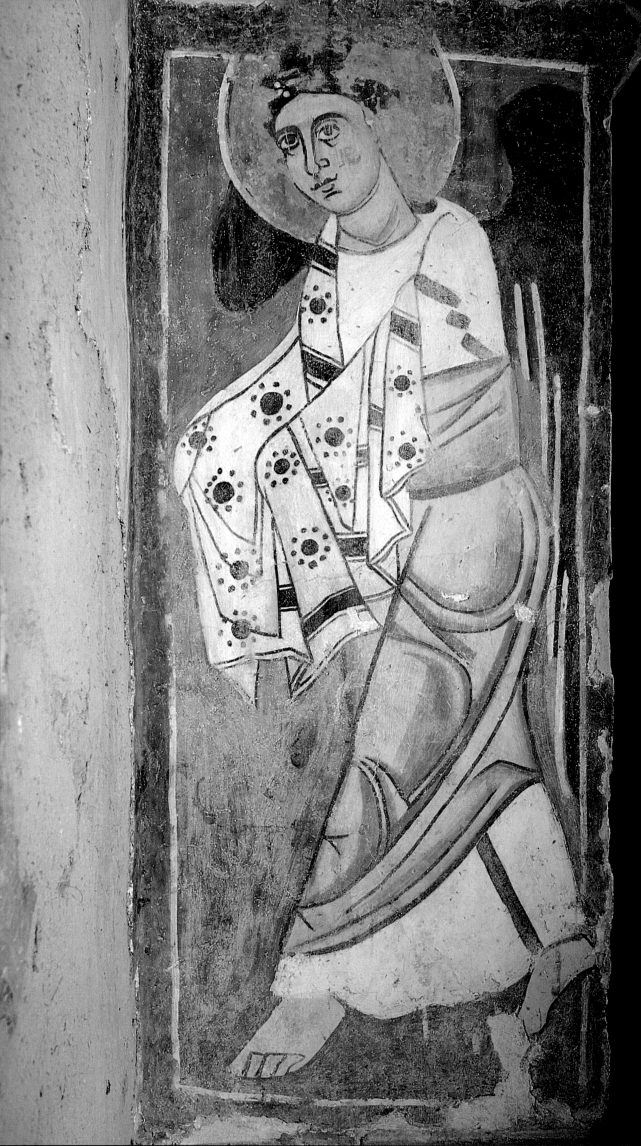

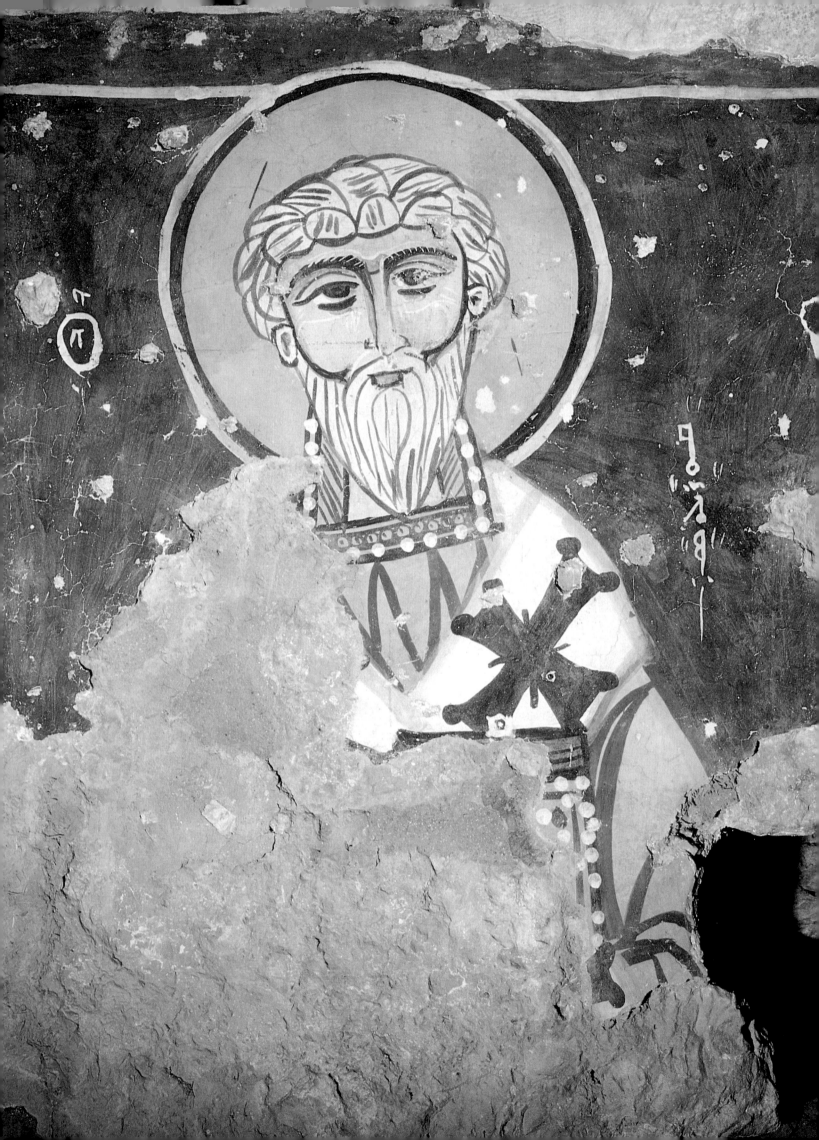

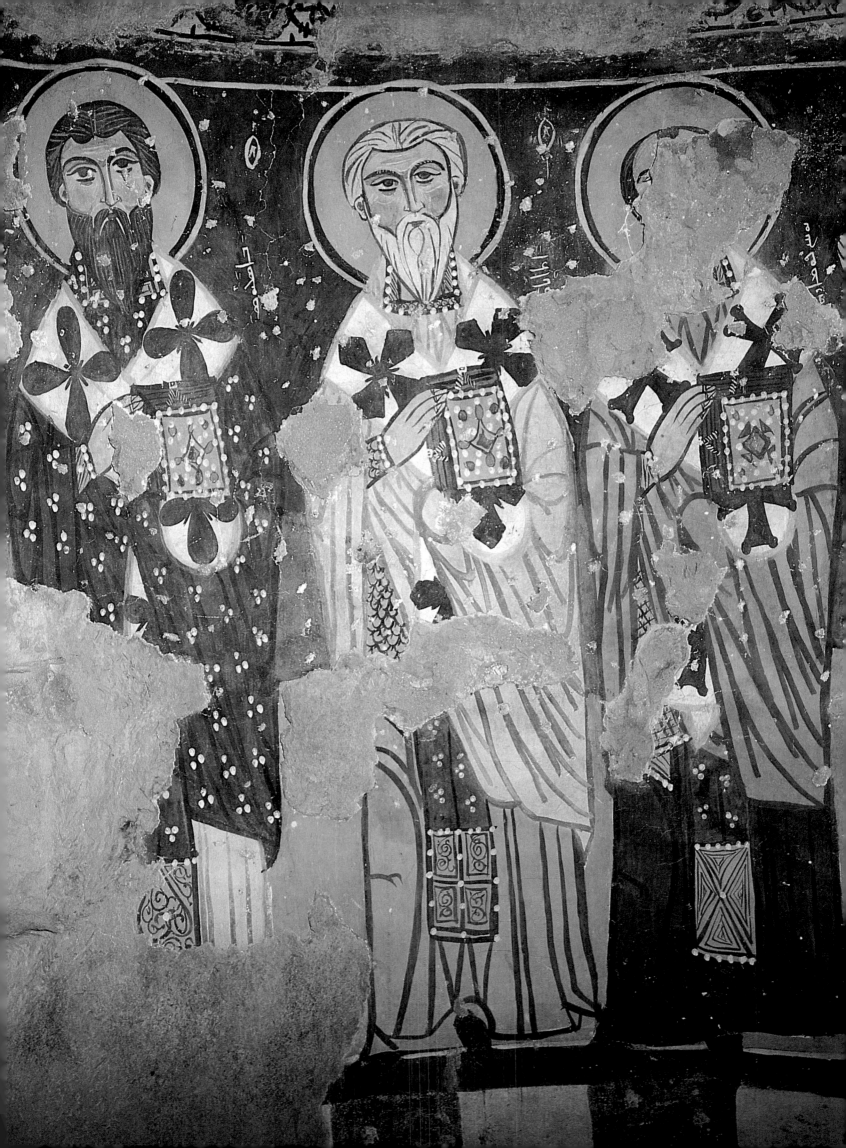

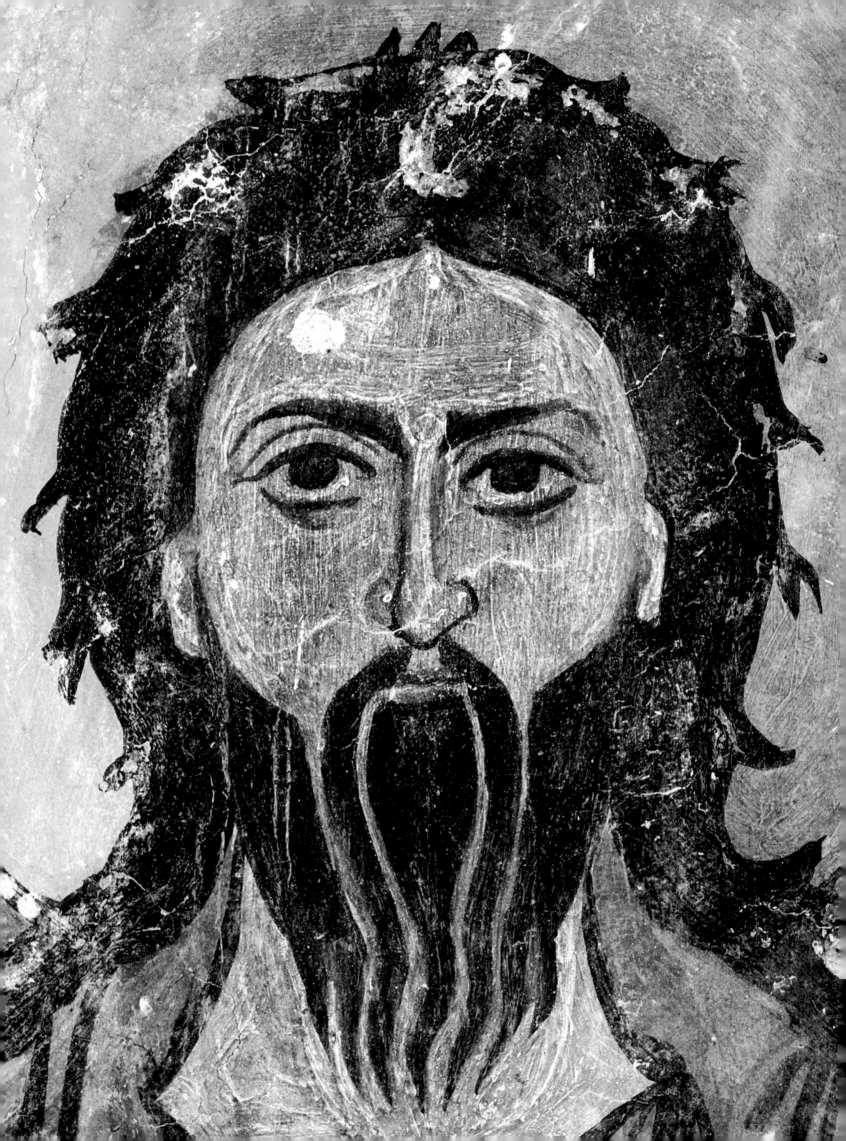

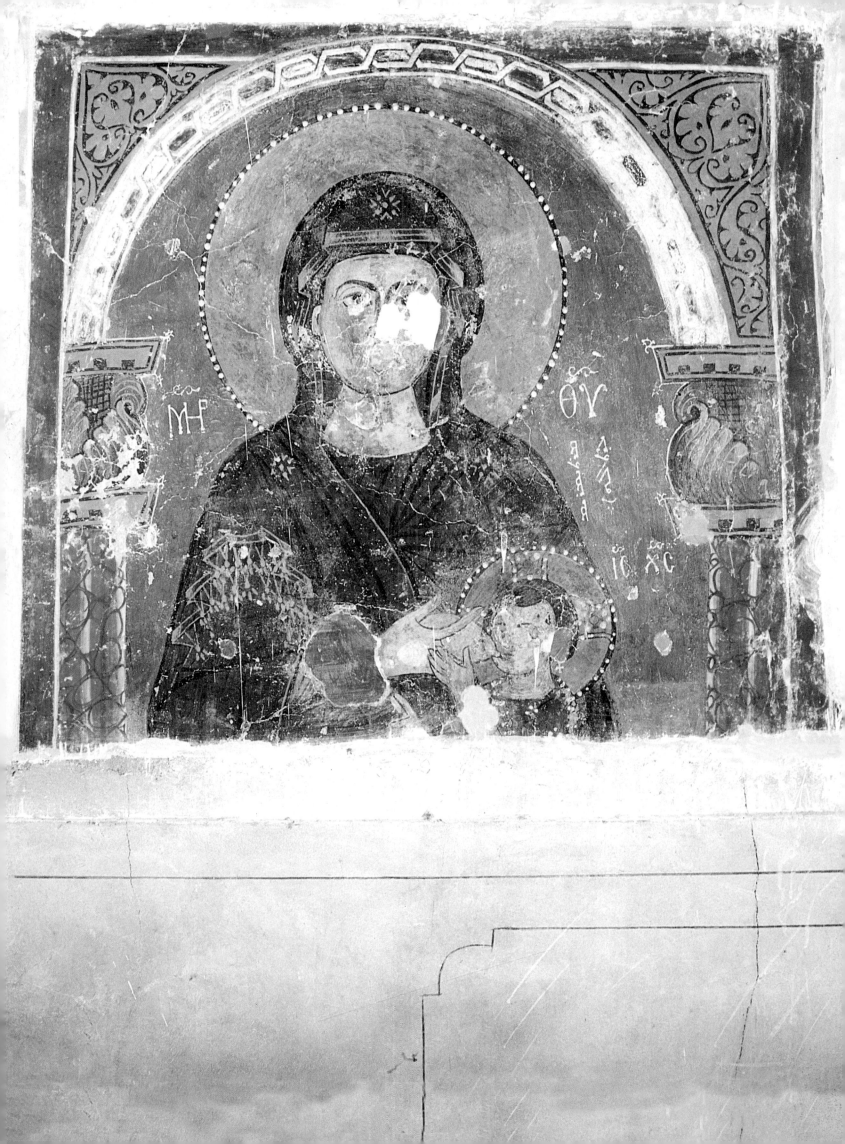

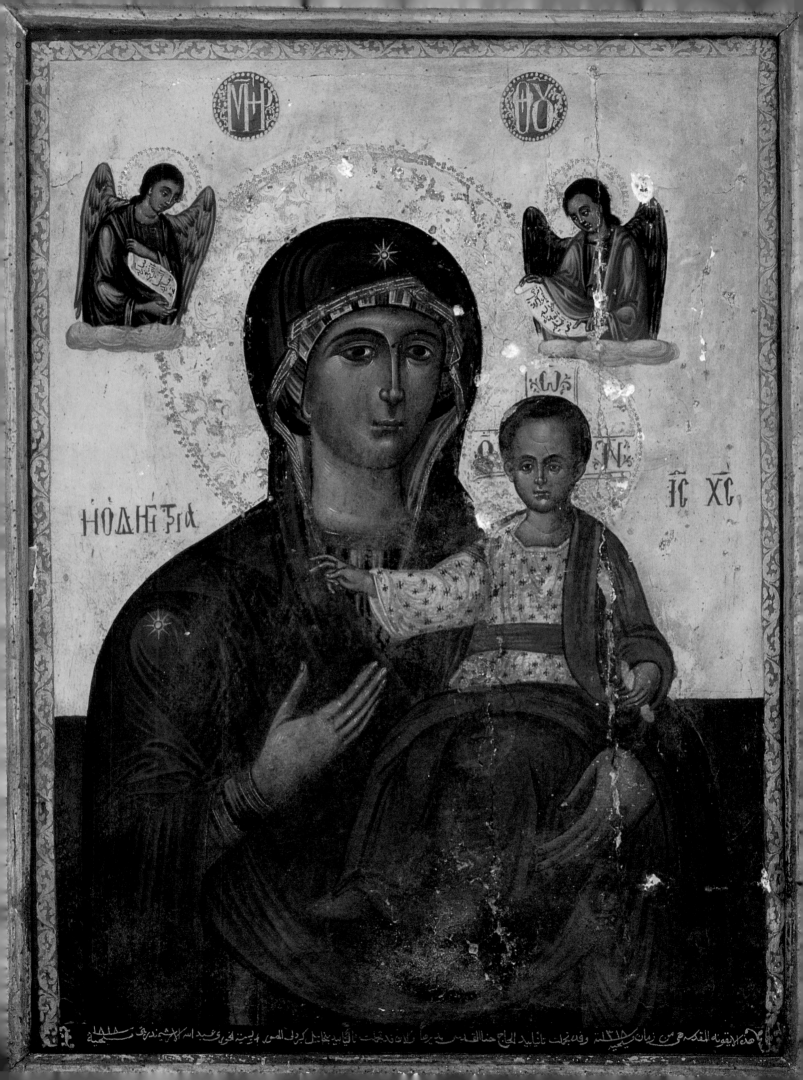

МР ΘΥ

ΙС ХС

ΗΟΔΗΓΗΤΡΙΑ

هذه الايقونه المقدسه من زمان قديم ... وقد جددت تانيد الحاج حنا القدسي ... صلاه ... اليا يد بخائيل كيرلوس الصور بدمينه الخرى وعبد اس ... عند ف مشطلبيه

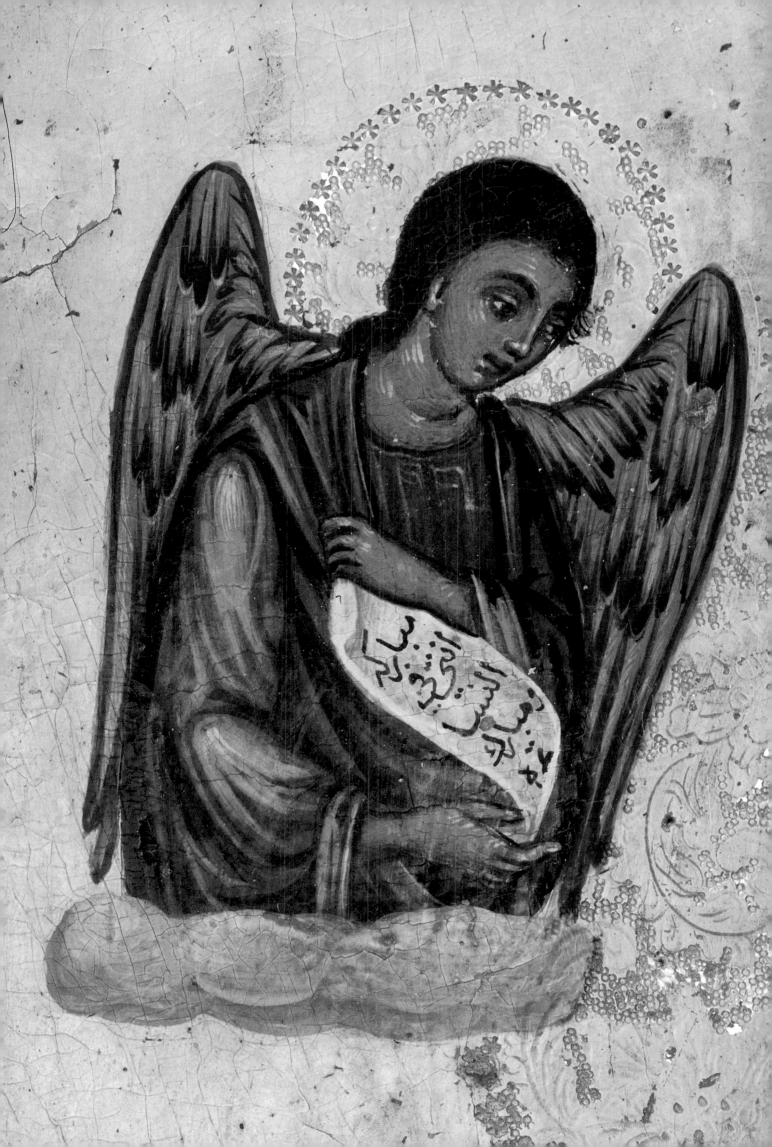

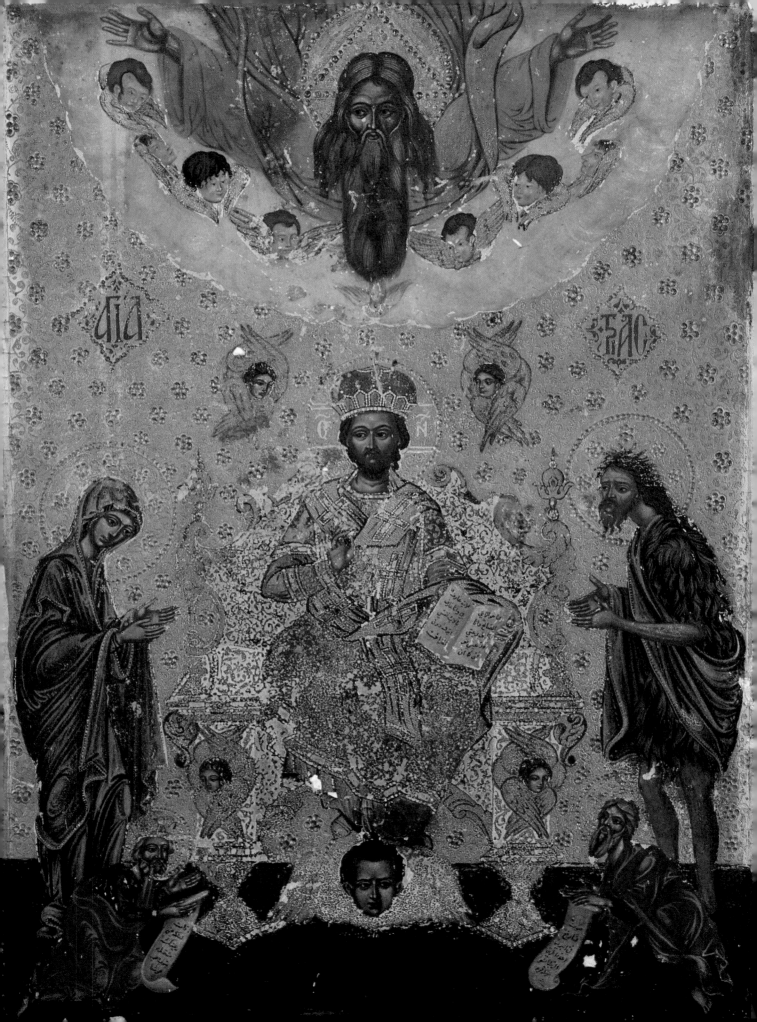

Still more than the blessed
Themes of paradise
It is fitting to recount
The deeds of the victors:
They have arrayed themselves
In the image of paradise,
The beauty of the garden
Is embodied in them.
Instead of lauding the trees
Let us speak of the victors,
Instead of the heritage,
Let us praise the heirs.[34]

The Byzantine iconic milieu canonizes this vision. Its space is dominated by the "giants," absolute masters of the transfigured earth. The atmosphere of the sanctuary of St. Behnam is completely other. The reign of Islamic style is undisputed, and the surface occupied by Christian figures is quite limited. Iconography finds itself submerged in a splendid garden of arabesques. More than the figures of Saints, it is the Cross which Christianizes the whole of the work. Aniconic, it is lifted as the Tree of Life, "standard of trust and emblem of victory," surrounding the Word "with a boundary of silence,"[35] stamping with its sign the divine "recess of lights."

The Permanence of Byzantium

The importance of Byzantine art is demonstrated by other contemporary testimonies. The second council of Nicaea sees the Monophysites as relentless enemies of images. For their part, Syriac chronographies coolly mention Byzantine iconoclasm, never endorsing the position or the action of the destroyers of images. In the Islamic-Christian world of the 'Abbāsids, not only is Byzantine culture not ignored; it enjoys a veritable veneration. To divide the Syriac artistic world into a Byzantium-oriented Syria and a Persia-oriented Mesopotamia is a simplistic categorization. Artistic exchanges and communications pay scant attention to the boundaries between states and Churches. In 1285, the daughter of Michael Palaeologus, having become queen of the Mongols, engages two Constantinople painters to decorate the church of the Greeks in Tabriz; the Jacobites take advantage of their presence to entrust them with the decoration of the church of St. John of Negar in Bartallah near Moṣul. Miniatures and remnants of frescoes show the permanently dominant influence of Byzantium on this world which distances itself from Byzantium without ever repudiating its prodigious creativity. A Syriac manuscript[36] dating from 1226 and adorned with thirty-two miniatures, embodies this duality in its own way. The colophon speaks of the "mendacious Greeks," but the pictorial style adheres rigorously to the "Greek manner." From the Announcement to Zechariah to the Dormition of the Virgin through the cycles of Feasts, healings, and the Passion, the traditional liturgical program is similar to that found in the precious manuscripts of the Vatican and London, whose contemporary it is. However, its mode of painting exhibits no trace of the Moṣul school. Although executed by Syrian hands, it belongs to Byzantine tradition, whose established canons it carefully follows.

Only rare traces of murals have survived to the present. According to John Lassus, the walls of the Syrian churches had been covered with a plaster base for frescoes; Tchalenko's research confirms this hypothesis. The most impressive ensemble is found in the Syriac Monastery of St. Moses the Ethiopian, on the rocky plain of the Nebk between Damascus and Ḥomṣ. A vast composition from

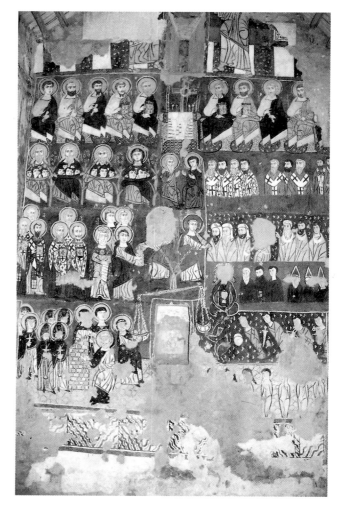

45. *Two Standing Saints.*
Monastery of St. Moses the
Ethiopian, Nebk, Syria.
46. *Elijah and Elisha.*
Monastery of St. Moses the
Ethiopian, Nebk, Syria.
47. *The Last Judgment.*
Monastery of St. Moses the
Ethiopian, Nebk, Syria.

the end of the twelfth century covers a previous work from the eleventh. Present-day restorations have uncovered Elijah leaving his mantle to Elisha, a group of Apostles, and a standing female Saint. PL. 12 Provided with Greek inscriptions, these precious fragments are closely dependent upon Byzantine academicism. The style changes with the later design. The arrangement of subjects is rigorous. The Saints are grouped in families. Erect on their horses, Warrior Saints parade across the walls. The four Evangelists with their writing implements settle themselves at the intersections of the arches. Paired Virgins and female Martyrs are superposed, standing head against head, on the intrados of the arches. Behind the altar, the Praying Virgin is beside the Fathers of the Church. A Deesis, now lost, once occupied the vault. Above, the busts of the Twelve are represented around Christ Pantocrator. A PL. 16,17 beautiful Annunciation placed on a higher level recently disappeared. At its apex, as both a child and the Ancient One (Dan 7:9-13), Christ Emmanuel, in a medallion, was flanked by the Virgin and Gabriel. The Christocentric composition superposes the typical representations of Christ, linking from top to bottom Emmanuel seated in the bosom of the Praying Virgin, Christ enthroned in majesty, the Pantocrator, and Emmanuel in a round shield. The Virgin, the Apostles, and the Fathers surround the Word in the Father's house, which remains invisible: "As you, Father," the Johannine Christ says, "are in me and I am in you, may they also be in us, so that the world may believe that you have sent me. The glory that you have given me I have given them, so that they may be one, as we are one, I in them and you in me, that they may become completely one, so that the world may know that you have sent me and have loved them even as you have loved me" (John 17:21-23). In parallel fashion, facing this assembly, a monumental Last Judgment unfolds on the back wall. The Twelve are seated "on twelve thrones, judging the twelve tribes of Israel" (Matt 19:28). In their midst the throne of the Hetoimasia: "But the LORD sits enthroned forever, / he has established his throne for judgment" (Psalm 9:7). The throne remains unoccupied, a sign of the unknowableness of God. The Cross stands there, "Judgment of the judgment." Beneath the throne, Adam and Eve face one another in a common prayer. At their side, the Virgin, Abraham, Isaac, PL. 14a and Jacob symbolically carry the children of the earth. The scales of Justice occupy the center of the composition. The sheep are on the right; the goats on the left. The Just and the Fathers are together in the heavenly dwelling. In an unprecedented scene, St. Peter opens the door of paradise with his PL. 14b

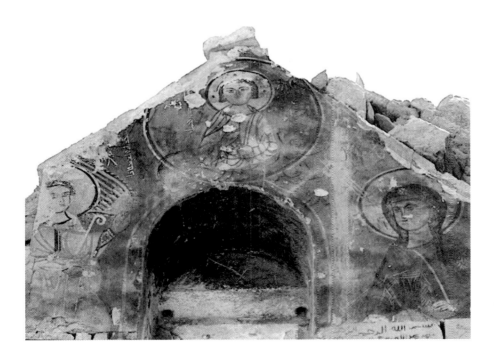

48. *Annunciation.* Monastery of St. Moses the Ethiopian, Nebk, Syria.

key in order to welcome a group of Syriac monks and nuns. Opposite those who have done good are the damned, plunged "into the eternal fire prepared for the devil and his angels" (Matt 25:41). Brood of vipers, adulterers are devoured from the inside by serpents. Prostrate under a rain of stones, assassins are delivered to torments. Pitiless Pharisees and greedy scribes are sent to the Gehenna of torture. Lovers of money find themselves with their purses hanging from their necks.

PL. 18,19 In Qarāh, in the vicinity of Ḥomṣ, the Orthodox church has four fragments of frescoes. The nursing Mother and St. John the Baptist are standing under honorific arches, along with two Warrior Saints, Sergius and Theodore, seated on their mounts. The same style of painting is found in the church of St. Theodore in Badhīdat, in the region of Byblos in Lebanon. A rich composition covers the walls of the building. Following the great Christian tradition, Hebrew protagonists announce the good news accomplished in Christ. One can recognize Abraham, Isaac, and the "lamb of substitution"; Moses and the tablets of the Law; and Daniel lifting his hands in prayer. The Deesis dominates the vault. Behind the altar, a succession of arches shelters the twelve Apostles, shown standing. The Archangel Gabriel and the Virgin are separated, facing one another on the rounded curve of the arch. Finally, the two Warrior Saints, Theodore and George, occupy the sides of the arch. The paintings in the two churches share the same style. The drawing, use of colors, and faces are strikingly similar. The frescoes of St. Moses the Ethiopian are in the same spirit. The diversity of inspiration and the unevenness of execution betray a collective work; however, the whole retains its unity. Whether in the Nebk, Qarāh, or Badhīdat, without forgetting the infinitesimal traces preserved in other churches, the different artists belong to one school of mural painting. The style is akin to that of the cave churches of Cappadocia and Cyprus. Faces with round cheeks and slightly slanted eyes give an Oriental touch to the work. The Latin component is easily detected in the representation of St. Sergius. In two places, the most popular of Syriac Saints brandishes, crusaderlike, the white banner with its red cross. The painters' personal religions are unknown. The monastery of the Nebk is Syriac; the Church of Qarāh is Chalcedonian Orthodox. Maronite today, the Church of Badhīdat could have been originally Jacobite or Chalcedonian. Bilingual inscriptions use Greek and Syriac. The relationships between arts and artists seem to pay scant attention to the doctrinal cleavages separating the hierarchies of

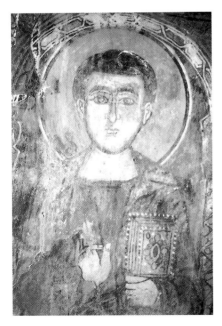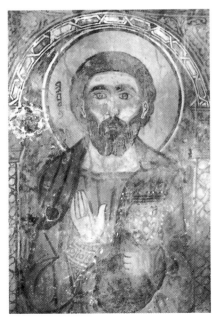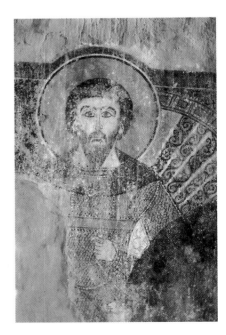

49. *St. Mark.* Church of St. Theodore, Badhīdat, Lebanon.
50. *St. Mark.* Church of St. Theodore, Badhīdat, Lebanon.
51. *St. Theodore.* Church of St. Theodore, Badhīdat, Lebanon.

Antioch. Arabic, Syriac, and Greek remain non-exclusive languages; they are shared in liturgy, life, and culture. They are even found together on an icon of Byzantine style representing the Baptism PL. 20 of Christ. Thought to go back to the thirteenth century, it is an exceptional witness to a medieval art whose near total disappearance we bitterly regret.

Survival and Assimilation

The 'Abbāsid caliphate ends forever. For over one hundred and fifty years, Mesopotamia is only a province of a Far Eastern empire. At the beginning of the fourteenth century, Timur burns Baghdād again and devastates Syria. The arrival of the Ottomans in the fifteenth century ushers in a new period. These important dates seal the fate of the Syriac Churches. As early as the end of the thirteenth century, Bar Hebraeus evokes the "prosperity of former days" compared to the destitution into which his people have now fallen. Greeks and Armenians dominate the Christian peoples of the new Eastern empire. Impoverished and provincialized, the Syriac world gradually becomes marginal.

Once again, art ignores the vicissitudes of history and exchanges continue. Civilizing currents build upon local accomplishments. The Islamic style is discernible in the new illuminated manuscripts. The paintings of a Mesopotamian gospel book kept in Qaraqōš demonstrate new cultural exchanges. According to the traditional iconography of the Deesis, Christ is flanked by his Mother and St. John the Baptist and the three stand on three brocade carpets. The draping of the costumes mixes Greek

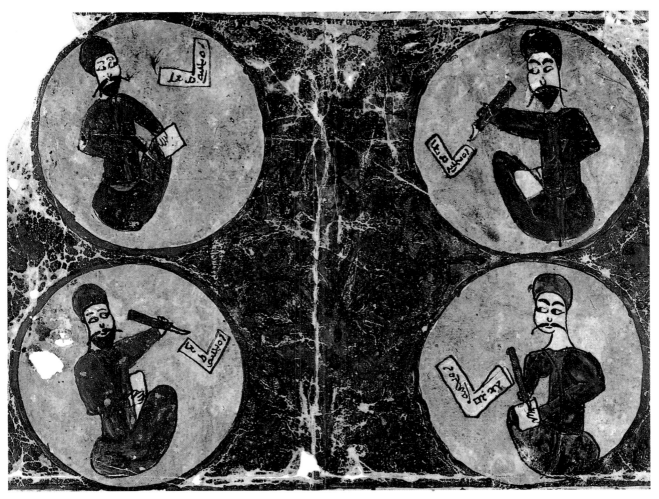

52. *The Four Evangelists,* Nestorian Syriac gospel book, 1499. British Museum, London.

93

folds with Arab ovoid masses. The "Turkish" character of the faces is obvious. The visages are rounded and the cheeks marked by red balls. The Virgin has left behind her customary maphorion and unveiled her hair, which is pulled back, like angels' in Islamic miniatures. Christ carries a gospel book adorned with a cross and eight Armenian letters. Eight scenes are on two pages, each grouping four Feasts. The Magi in the Nativity wear turbans, and the architectural elements abandon the Byzantine manner for Oriental cupolas and masonry work.

The Islamic aspect sometimes permeates the whole composition. An astonishing Mesopotamian manuscript[37] of 1499 attests this assimilation. The drawing and use of colors are awkward, but the composition of the scenes reveals novel prototypes. The iconography of the Feasts, unchanged for centuries, is completely left out, and not only secondary figures but the protagonists in gospel scenes are dressed in Turkish garments. Wearing turbans and long mustaches, the four Evangelists are presented according to the conventional Eastern presentation of authors. They are settled, sitting cross-legged on the ground, within four circles, in the middle of a flat space covered with foliage. In the center of the Nativity, Christ's head rests on a latticed square. His Mother, her face framed by an Oriental veil, is seated on the ground in Turkish fashion. On another level, there is a file of five figures wearing turbans against a background of plants hastily sketched. Painted horizontally, the Visit of the Shepherds is turned vertically in a frame in which it is placed side by side with the Nativity. In the Epiphany, John the Baptist exchanges his ascetic attire for a long Persian robe and an enormous turban. In the Entrance into Jerusalem, Christ has the features of a Persian prince, beardless and youthful. Welcoming him are ten figures in ranks on a flat space. Once more, all the people in the scene wear turbans. The Ascension shows a bold innovation: the Risen One is winged like an Angel and flies toward a green starry sky. The iconographic characteristics of this Nestorian manuscript are found also in a

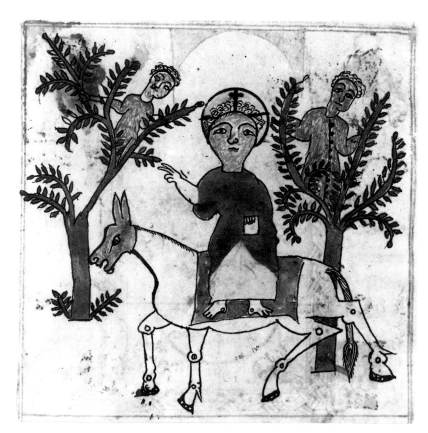

53. *Entry into Jerusalem,* Jacobite Persian manuscript, 1547. Medici-Laurentian Library, Florence.
54. *St. Luke,* Jacobite Persian manuscript, 1547. Medici-Laurentian Library, Florence.

Persian manuscript[38] written by a Jacobite priest in 1547. Holding their Gospels with identical gestures, the four Evangelists, wearing turbans, stand under arches and are separated by three columns ornamented with arabesques. Facing the viewer, his legs dangling, the young beardless Christ is seated on his mount between two trees with two children on top. The only difference between this representation and the others is that the Savior's turban is marked with a cross in the middle.

Icons of Aleppo

Spareness and schematization characterize an unpolished style which spreads throughout Nestorian Mesopotamia. The scene is reduced to its bare essentials. The precise drawing is without modeling. The ground is a simple flat horizontal strip, often with one or two other similar strips. Trees and flowers are simplified to their one-dimensional nucleus. Side by side with these Christian stylized figures, are vast surfaces covered with geometric forms, interlacing, and calligraphy.

In parallel fashion, Christian Greater Syria shares in the honored Byzantine tradition dominant in the whole Ottoman Christian world. An abundant production of icons at the local level continues what is in progress in Greece and the rest of the Balkan world. Its fruits are the work of Christians of the Byzantine rite, those whom Syrians have called "Melchites" since the fifth century. The first of these local icons dates to the seventeenth century. The painter humbly reveals his name in his Arabic signature: Yūsuf al-Muṣawwir, in other words, Joseph the Iconographer. This name is the symbol of this huge creativity that goes beyond the Chalcedonian Syro-Palestinian world and spreads to the Monophysite Churches of the Middle East. The master of this Arab icon is also the founder of an Aleppo family which is to produce four icon painters, from the father to the great-grandson: Yūsuf, Nemeh-Allāh, Ḥannania, and Girgis. The changes in this family's works, continuous from one period to another, perfectly mirror those undergone by the icon in modern times. Thus, Yūsuf's works are entirely faithful to Greek tradition. The icon follows its own canons and obeys the inherited norms which make it the image of Scripture. A Descent into Hell and an Acathistus Hymn, both signed by Yūsuf, represent the typical models of post-Byzantine iconography. On the Resurrection, only the dedication is written in Arabic; the figures' names are in Greek. The Acathistus Hymn transposes into images its twenty-four stanzas which are placed around King David in the center of the icon: the inscriptions repeat the liturgical text in Greek and Arabic. The iconographer is also a miniaturist. The Greek character of the work is incontestable. One of the illuminated manuscripts in Arabic is entirely devoted to the chronicles of Byzantine emperors; Yūsuf is the painter, calligrapher, and translator.

Having solid roots does not exclude enjoying creative freedom. Among all the Aleppo icons, St. Simeon Stylites and St. Simeon of the Wonderful Mountains is a work of great originality. The subject appears in two icons, one of which bears Nemeh's signature. The theme, which is found in Byzantine, post-Byzantine, and Russian iconography, bears here a novel Aleppo character. Two Stylites from two different periods are together under a golden sky. In a central half-circle, the bust of Christ, with open arms and brandishing two scrolls, crowns the scene. The two illustrious ascetics are seen full-face, seated on two long columns standing in the traditional rocky landscape. Like Christ, the two Stylites hold open scrolls bearing passages from the Gospels and liturgical texts in Arabic. The names of the two Simeons are in Greek. The treatment of the various elements of the scene is purely Byzantine. Many people are lodged in the landscape. The costumes are "Greek." Only two figures are distinguished by their clothing and turbans, but the treatment of the garb and the modeling byzantinize them to perfection. The work faithfully follows in all their purity the principles and canons

of Byzantine art, while at the same time creating a completely new scenic composition. The landscape shows us ten simultaneous scenes of the miracles worked by the two Saints, reminiscent of the iconography of the Dormition of St. Ephraem by Andreas Pavias painted in the second half of the fifteenth century and kept in the church of Sts. Constantine and Helena in Jerusalem: a horizontal scene in the foreground shows the gathering of Bishops and Monks around the dead Monk; above this central image, a Stylite appears on his column in the midst of a vast composite landscape where his life is recounted in a series of small vignettes. The Aleppo iconography draws from this source and integrates its scenes into a new arrangement. New events are added as well: an Arab dignitary and his servant, sent by the barren Ishmaelite queen, lift their hands toward the Saint; a disciple of the Stylite is miraculously raised; a prostrate person possessed of an evil spirit exhales three little black devils, a sign of cure.

The production of local icons is anything but limited. The Aleppo School leaves a considerable work. Other Syrian iconographers share in this movement. In the eighteenth century, there are two parallel hierarchies (the Orthodox and the Eastern Catholic). The Eastern Catholic Churches have difficult beginnings, and they are the occasion of successive inter-community wars. The expansion of the icon continues independently of religious dissensions: it asserts its inherent and unchanging "ecumenism." Although belonging to the Orthodox confession, Nemeh works both for his own Church and its new Catholic "branch." Similarly, he is in demand by the Monophysite Armenians and the "Catholic" Maronites, and he decorates their churches in Aleppo. Ḥannania, Nemeh's son, represents a new generation of painters. His work reflects a transition period in which the icon opens

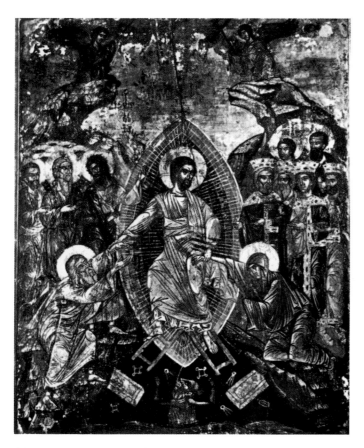
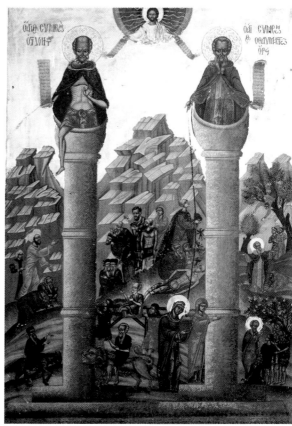

55. *Resurrection,* work of Yūsuf of Aleppo, 1645. Private collection.
56. *Sts. Simeon Stylites and Simeon of the Wonderful Mountains,* work of Nemeh-Allāh of Aleppo, 1699. Monastery of Our Lady, Balamand, Lebanon.

to new artistic ideas. Nemeh often chooses an ornamentation which blends with the background spaces, and his son shows his own predilection for this stylization. Arabesques, friezes of lines, concentric circles, and compact masses cover the emptiness of the spaces. However, solid shapes escape this stylization. Clothing is draped in such a way as to follow the shapes of bodies. Flesh tones are more natural, the modeling firmer. The silhouettes abandon their traditional stiffness and movement returns. While emphasizing the human element, the style retains its balance and homogeneity. Still alive, tradition bears new fruits.

The Catholic Breakthrough

The last descendant of the Aleppo family takes a new turn. There are now two sets of themes: the traditional ones and the Catholic ones. In the Middle Ages, the long passage of the crusaders had left little trace on the Arab-Christian arts. The settlement of the Latins was not of short duration, but "the contact between the two worlds never succeeded in creating a mixed civilization, like those of Spain and Sicily."[39] In the middle of the eighteenth century, the growing presence of Catholic missionaries and the establishment of Eastern Catholic Churches profoundly mark Eastern communities. The icon seeks a compromise between Byzantine tradition and Western painting. This alliance, as the European tradition until the fourteenth century attests, results in the East in a composite and heavy style. Girgis produces specifically Catholic paintings in the form of icons. In the Immaculate Conception, the baroque Madonna standing barefoot and crushing the serpent replaces the The-

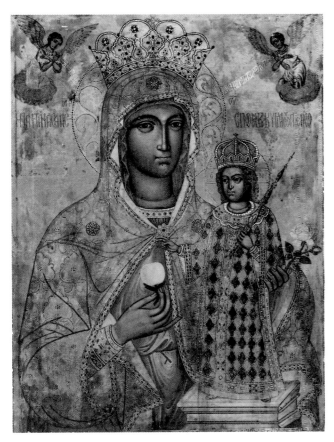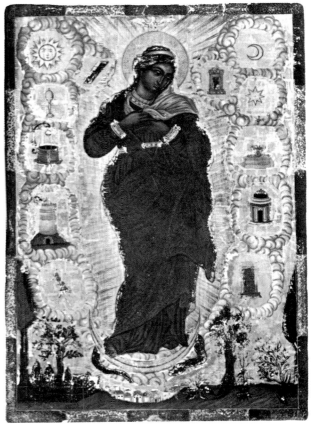

57. *Mother and Child,* work of Ḥannania of Aleppo, 1736. Church of the Virgin, Aleppo (Ḥalab).
58. *The Immaculate Conception,* work of Girgis of Aleppo, 1762. Monastery of St. George of Chir, Bmakkin, Lebanon.

otokos. The very theme is a Latin concept foreign to the Christian East and refuted by the non-Catholic Eastern Churches. The Virgin of the Rosary derives from another Latin model. The Virgin and Child are represented in the heavens amid clouds and Seraphim. The Son holds out a rosary to St. Dominic and the Mother another to a Dominican nun. God the Father blesses the scene with open arms. A red rosary frames the composition. Two Angels unfold a scroll bearing in Arabic the text of "You Fill All Creatures with Joy," a liturgical hymn attributed to St. John of Damascus.

From one generation to the next, the icon, having lost its identity, turns into a new style of painting. The basic models are still recognizable, but the execution is awkward and unskilled. Falsely naive, poorly Western, it is a heterogeneous mixture of local and foreign elements gathered into a hybrid interpretation. We have here a folkloric pictorial tradition in which painters borrow equally from Byzantine art and Western painting styles, while lacking a thorough knowledge of the basic principles of either one. The popular icon reaches its apogee. Abraham is turned out like an Eastern dignitary, the Prophet Elijah carries a scimitar, and little Mary is asleep in a cradle of Syrian make: the local elements find their way into many objects and ornaments, but the integration of these elements has to do with the theme, not with the plastic language properly so called. Despite the constantly increasing number of painters and the abundance of their production, destined for all Churches, this prolific output is part of the decadence of the icon which in the nineteenth century prevails throughout the Balkan peninsula.

Eternal Memory

The council of Ephesus relegates the Nestorians to Persia. That of Chalcedon divides the Syro-Mesopotamian Christian community into rival and enemy Churches. In the East as well as in the West, the Roman empire declares itself Christian, the guardian of the only true faith. While Byzantines celebrate for centuries their "pious emperors who have exchanged their earthly kingdoms for the kingdom of heaven," other Eastern Christians share another history, long and lively, ignoring both Greek Caesaro-papism and Roman Papo-caesarism. These Christians without Christian kings, living in Islamic countries, have a share in a long history and glorious civilization. Constantly separated on dogmatic matters, they intuitively seek unity along the path of art and beauty. Byzantium consecrated the icon and made its triumph the Triumph of Orthodoxy: "The Church of Christ is resplendent with the brilliance of the holy images and concord reigns among believers." Liturgical words sanctify the lips and holy images sanctify the eyes: "Words in writings and things in figures" celebrate the same "eternal memory." A Syriac prayer reserved for the consecration of holy images echoes the Byzantine office of the procession of holy icons: "We implore you, O Lord, merciful Father and God of all. Stretch out your hand and sanctify this image so that it may become the haven of troubled souls, the liberation of those who are tempted."[40] The image extols one single beauty: beauty of the Spirit, nourished by all sorts of saps and ferments. Far from constituting a separate style, Syro-Mesopotamian art joins the great creative currents, adopting in turns different traditions and practices. Eastern Greco-Roman in the first centuries, it follows Byzantium without accepting either its empire or priesthood. Then Arabic-Persian, it becomes Islamized while remaining faithful to itself. Its themes are exclusively drawn from the Gospels and the early Saints' lives: its memory is that of the early Church, "eternal memory," memory common to all Churches, untiringly celebrated, vivified by all sorts of colors and symbols. "The Lord is near. Do not worry about anything, but in everything by prayer and supplication with thanksgiving let your requests be made known to God" (Phil 4:5-6). Images, forms, colors—everything tells of the indescribable presence of God. Everything is adoration, prayer, and grace: contemplation of the new world, "with eyes like Cherubim, always trained on the knowledge of the heavenly vision."[41]

Notes

1 G. Apollinaire, "Zone," *Alcools* (Paris: Gallimard, 1920).

2 J. Leroy, "Mosaïques funéraires d'Edesse," *Syria* 34 (1957) 314.

3 Florence, Laurentian Syr. Plut. I 56.

4 J. Leroy, *Les manuscrits syriaques à peintures* (Paris: Paul Geuthner, 1964) 156.

5 Ephraem Syrus, *Prayer of the Old Man*. Quoted by A. J. Hamman, *Livre d'heures des premiers chrétiens* (Paris: Desclée de Brouwer, 1982) 79.

6 C. Diehl, *Manuel d'art chrétien* (Paris, 1925) 1:228.

7 P. Lavedan, *Histoire de l'art*, Coll. Clio 2 (Paris, 1944) 23.

8 T. Kövès, *La formation de l'ancien art chrétien* (Paris: J. Vrin, 1927) 169.

9 Paris, National Library, Syr.33 and Syr.341.

10 Quoted in J.-M. Fiey, *Chrétiens syriaques sous les Abbasides*, CSCO (Louvain, 1980) 37.

11 Michael the Syrian, *Chronicle*, vol 3. Michel le Syrien, *Chronique*, III, trans. J. B. Chabot (Paris, 1899) 65–67, 70, 73, 76.

12 Quoted by Fiey, *Chrétiens syriaques sous les Abbasides*, 118.

13 *Chronicle of Seert. Chronique de Séert*, P. O. 13 (1919) 628. Quoted by A. Ducellier, *Le miroir de l'Islam* (René Julliard, 1971) 94.

14 Fiey, *Chrétiens syriaques sous les Abbasides*, 29.

15 I. Dick, "La passion arabe de saint Antoine Ruwah néomartyr de Damas," *Le Muséon* 74 (1961) 109–133.

16 Istanbul, Topkapi Museum.

17 R. Ettinghausen, *La peinture arabe* (Genève: Skira, 1962) 123.

18 Ibid., 47.

19 Damascus, Library of the Syrian Orthodox Patriarchiate, Midyat.

20 Ibid.

21 Vatican, Apostolic Library Syr.559.

22 London, British Museum add. 7170.

23 Ephraem Syrus, *Hymns on Paradise* (5:6). Ephrem de Nisibe, *Hymnes sur le paradis*, SC 137 (1968) 73.

24 Monastery of Our Lady of Balamand, Koura, Lebanon.

25 Letter of John of Susa, *Bulletin de la société d'archéologie copte* 22 (1974–1975) 60.

26 Quoted by J.-M. Fiey, *Chrétiens syriaques sous les Mongols*, CSCO (Louvain, 1975) 23.

27 Bar Hebraeus. Quoted ibid., 32.

28 Quoted ibid., 39.

29 Silwa. Quoted ibid., 44.

30 Quoted ibid., 63.

31 Bar Hebraeus. Quoted ibid., 57.

32 *Histoire du Patriarche Jabalaha III et du moine Rabban Cauma, Revue de l'Orient latin* 1 and 2 (Paris, 1985) 105.

33 J.-M. Fiey, *Mar Behnam*, Série touristique et archéologique 2 (Baghdād: Direction des publications, 1969) 12.

34 Ephraem Syrus, *Hymns on Paradise* 6:11, 14, 15. SC 137, pp. 86–87.

35 Ephraem, ibid. Ibid., 68.

36 Damascus, Library of the Syrian Orthodox Patriarchiate, Midyat.

37 London, British Museum add. 7174.

38 Florence, Laurentian XVII (81).

39 Leroy, *Manuscrits syriaques*, 33.

40 Quoted by C. Chaillot, *Rôle des images et vénération des icônes dans les églises orthodoxes orientales* (Genève, 1993) 29.

41 Isaac of Nineveh, "Saying 29." Quoted by J. Popovitch, "Connaissance de Dieu chez saint Isaac le Syrien" (II), *Contacts* 70 (1970) 139.

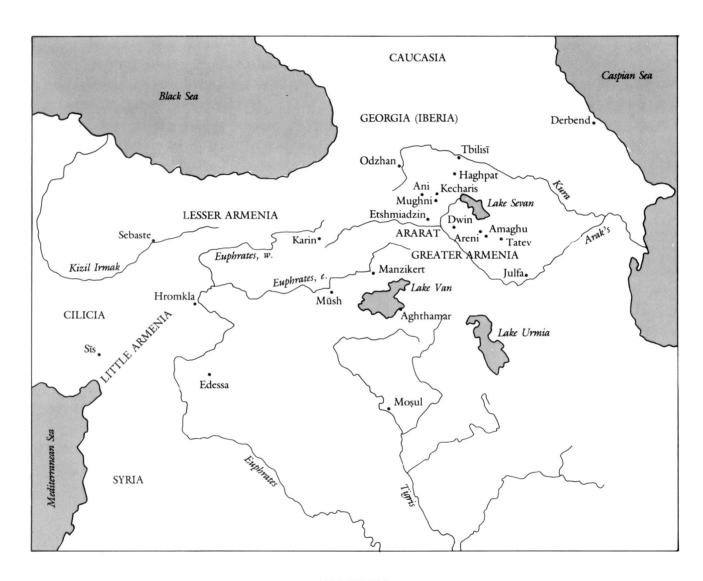

CAUCASIA

Caspian Sea

Black Sea

GEORGIA (IBERIA)

Derbend.

Odzhan. Tbilisī.

• Haghpat

Ani • Kecharis

Mughni • *Lake Sevan*

LESSER ARMENIA Etshmiadzin.

Dwin • Amaghu

Sebaste. Karin. ARARAT Areni • • Tatev

Euphrates, w. GREATER ARMENIA

Kizil Irmak *Euphrates, e.* Manzikert Julfa.

Hromkla. *Lake Van*

Mūsh •

CILICIA Aghthamar *Lake Urmia*

Sīs.

Edessa.

Moṣul
.

Mediterranean Sea SYRIA *Euphrates*

Tigris

ARMENIA

100

CHAPTER FIVE

The Armenians

Faustus Byzantinus calls the ecclesiastical see of Armenia "the throne of Thaddeus." It is believed that the Holy Apostle arrived there in 35 from Edessa and underwent martyrdom forty years later. One thousand Armenians followed him in order to gain "the crown that does not perish." After preaching in Arabia and Persia, Bartholomew came to the city of Arevpan. Condemned by King Sanatruk, he was flayed alive in 68. Thus, two Apostles brought the New Light into ancient Armenia. The third Illuminator is Gregory, who is said to have been a Parthian prince. Tortured and confined to a den full of snakes, he finally succeeds in converting his jailer, King Trdat, whom he cures of lycanthropy; and the repentant king receives holy baptism on the banks of the Euphrates. The Illuminator, who grew up in Cappadocia, leaves for Caesarea where he is ordained and consecrated bishop. Back in his own country, he receives a revelation from Christ who enjoins upon him the duty of erecting a church and with a golden hammer shows him the place where the building is to stand. Gregory orders the construction of the cathedral of Etshmiadzin: the hymn says, "Approach, and let us build together the holy Altar of Light, for it is here that the Light has appeared on Armenian soil."[1]

Christian Armenia, at its birth, is part of the Great Church, and the rites are celebrated in the Greek and Syriac languages. The creation of the Armenian alphabet is the work of two Saints, Sahak and Mesrob. Raised in Caesarea and Constantinople, the catholicos Sahak perfectly masters Greek, Persian, and Syriac. A scholar of note, linguist, artist, and musician, he ardently labors for the diffusion of the Holy Scriptures. The Armenian alphabet is worked out by his principal collaborator, the priest Mesrob. The latter goes to upper Mesopotamia and continues his studies in the Greek "cultural centers" of the adjacent regions. Exhausted and in despair, he withdraws to give himself to prayer. In 405, the alphabet is born miraculously in Edessa: a divine vision reveals to him, written on a tablet, the letters he has been looking for. St. Mesrob "prepares a textbook for teaching, then goes to Samosata where he has the characters drawn by Ruphinos the Greek. He tests the characters himself by translating the Book of Proverbs, attributed to Solomon."[2] His return to Armenia is compared to the descent of Moses from the mountain. St. Sahak "confirms" the alphabet by giving it the final touch. The translation of the Scriptures and the Fathers is undertaken. One hundred translators are gathered to devote themselves to this task: sixty are trained by St. Sahak and forty by St. Mesrob. The Armenian Church celebrates their memory during "Cultural Month," that is, October. The translation of the Bible is termed "Queen of translations." It is done from the Greek text of the Septuagint, "with many variants in conformity with the Syriac translation."[3]

Situated between East and West, Armenia is a land of unceasing invasions. After having been independent during the first and second centuries, it finds itself successively dominated by Persian,

Greek, Arab, Georgian, Turkish, and Russian powers. These dominations run the gamut from occupation to suzerainty to protectorate. Armenian history extends far beyond its geographic center. To Greater Armenia, situated between the mouth of the Euphrates and the Kura, one must add Lesser Armenia in the southern part of Pontus, Little Armenia in the region of Sebaste and Cappadocia, and Cilicia where an Armenian kingdom is established in the Middle Ages. Other little Armenias, formed by migrations and deportations, add to this perpetually unstable history. The "Armenian Citadel" is constantly torn between Rome and Persia. In 387, the Sāsānids and Byzantines divide Armenia between themselves. The greater part falls to the lot of Persia, which will maintain three Armenian Arshakuni dynasties. Christological quarrels divide the Christian East in the fifth century. In 551, the council of Dwin repudiates both the council of Chalcedon and the Monophysitism of Severus. The break is avoided thanks to continual dialogues and exchanges. (The Armenian Church and the Jacobite Syriac Church will confess their common faith at Manzikert in 726.) The relationship with Byzantium is extremely complex. Armenia dissociates itself from the empire without ever going far from it. The Chalcedonian "temptation" remains present, but the Church and the people oppose it without flinching. In 591, a new division of Armenia favors Byzantium. An anti-see is created in Avan, but the union aborts. Beyond these cleavages, Hellenistic culture remains the emblem of wisdom and knowledge. Hellenophile and Byzantinophobe, Armenia keeps its faith, its unique language and writing, while absorbing Greek culture and arts. In the sixth century, the Armenian Church dominates the Churches of Georgia and Albania. Its catholicos is the spiritual leader of all Transcaucasia. In 608, the Georgian Church breaks away at the synod of Dwin by confessing the Chalcedonian faith. In its turn, the Albanian Church rebels. Islam comes onto the scene of history and Armenia becomes one of its protectorates in 661. Byzantium multiplies its attempts to recover Armenia. Justinian II leads a final attack in 688, but the Muslims maintain their victory. A new map is in the making. The Arab empire rises opposite the Greek empire.

Paleo-Christian Armenia

Few artistic witnesses remain from ancient Armenia. Imported works are mingled with native works: rhytons, medallions, small statues, and mosaics. Native creations reflect the Greek-Eastern syncretism which is found in the countries of the hellenized East. The Armenian pantheon welcomes Persian, Greek, and Persian-Greek divinities. Greek inscriptions confirm the survival of Hellenism. Persian reminiscences are obvious. "The silver tetradrachmas of Tigranes the Great concretely manifest the two sources of Armenian culture: on the face of the coin, the king, wearing the high three-pointed tiara of the Persian potentates; on the other side, according to the principles of Greek coinage, the tutelary goddess Tyche (Fortune) of the city where the money was minted."[4]

Paleo-Christian Armenia partakes of the same cultural climate. Sculpture in the round is rejected. Relief is subordinate to architecture. Spare and restrained, carved decoration adopts the ornamental language of antiquity. Leafy branches, palmettes, and rosettes; interwoven circles and curves in the shape of horseshoes. Plant decorations on dentils show birds and deer. Crosses with flowered bases crown lintels and transoms. Paleo-Christian Armenia shares in this pre-Byzantine art practiced throughout the different Christian worlds. Human figures are not absent. Georgian contributions are constant. In Odjun, an enthroned Virgin points to the Child with her hand in the manner of the Mother of God as Guide. The two faces are the same size. The enlarged face of the Savior is that of the adolescent Christ. The pronounced stylization of the visages and the folds of the clothing accentuate the austere and spare hieratism of the work and take away its likeness to ancient Greek pictorial art. The Mother and Child are found also on a capital from Dwin—kept in the Museum of Armenian History: with an enlarged face, a small and stout body, Christ blesses with his right hand while holding

the scroll of Scriptures in his left. The founders' and donors' figures are sometimes incorporated into the carved ornamentation. They are shown in postures of prayer near Christ and the Saints, clothed in contemporary dress, their hands extended as a sign of devotion.

Funerary art also makes use of carved decoration. Stelae of the seventh century are covered with engraved images and signs, crosses, geometric and floral motifs, representations of Saints and donors. The compositions do not obey any fixed liturgical program. The standing figures are seen facing forward; they are separated and set in rectangles superimposed on one another. Their outline is reduced to the essential. The heads rest atop small bodies; the eyes are enormous, the nose minuscule; the mouth and the ears are shaded off; the folds are simply incised parallel lines. The figures reproduce the types of the Monk, the Bishop, the Warrior. Donors are recognized by their hands held in the gesture of prayer and by their contemporary attire. Group scenes follow iconographic prototypes for the gospel scenes or those from the Old Testament, such as Abraham's Sacrifice, the Three Youths in the Furnace, Daniel in the Lions' Den.

Mosaics are rare. The most famous is in Jerusalem, near the Gate of Damascus. With its vine stocks, fruits, birds, fowls, peacocks, the style is that seen in churches and synagogues of the time. The artisans' identities are unknown. Only the inscription that crowns the composition is specifically Armenian: "In memory and for the salvation, of all Armenians whose names are known to the Lord alone." Mural painting survives only in tenuous remnants, of which the best known are those of Lmbat, Harut, and Gosh. The art of the miniature is represented by four paintings on two sheets incorporated later into the gospel book of Etshmiadzin dating from 989. The four miniatures and the binding are contemporary, but their styles are clearly different. The two ivory plaques of the binding borrow a traditional subject. Two Angels holding a wreath encircling a cross occupy the higher level on both. On the first plaque, the enthroned Christ is the central figure and five gospel scenes featuring Christ surround it on three sides. On the second, the enthroned Virgin is surrounded by five scenes featuring the Virgin. This Byzantine work of the sixth century conforms to the canons of early Christian art from Roman antiquity. The four miniatures, which are in a good state of preservation, are in another style. They represent the Announcement to Zechariah, Annunciation, Adoration of the Magi,

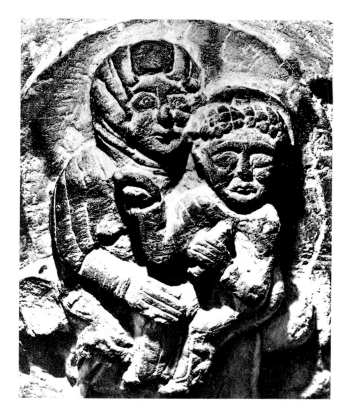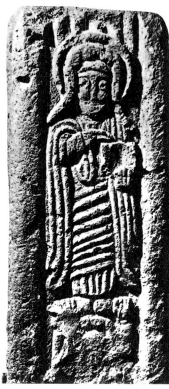

59. *Mother and Child,* Capital of Dwin, 6th c. Museum of Armenian History, Erevan.
60. *Christ Standing,* Stele of Harich. Museum of Armenian History, Erevan.

103

and Baptism of Christ. J. Strzygowski thinks they are the work of a Syro-Palestinian studio. In their execution, they belong to this Greek-Persian art common throughout the hellenized East. Globular eyes are prominent in the round faces. The Archangel has wings of peacock plumage strewn with eyes and spangled with green and gold. Knees apart and heels together, the Magi resemble Sāsānid kings on their thrones; and one of them has a Persian profile with a long pointed beard. The vessels they carry are in the Parthian style. The columns of the buildings are Corinthian. The enthroned Virgin's face is surrounded by a shell, in the traditional manner of antiquity. The representation of the Baptism follows the antique iconographic model in which the water of the Jordan covers Christ, still an adolescent, to the elbows. A wide decorated band frames the scene. On the four edges, four faces in circles seem to represent the Evangelists. A motif repeated on the frame symbolizes the Eucharist: the pelican feeding its young with its own blood emerges from a gold chalice placed on a paten.

PL. 25a

The Image and the Cross

The great currents of Armenian art take shape in the dawn of the Middle Ages. In Byzantium, under the Isaurian and Amorian dynasties, theological quarrels center on iconoclasm. The "Triumph of Orthodoxy" (Nicaea II) marks the victory of the iconodules. The Greek empire ranks Monophysite Armenia with the iconoclasts. Anti-Chalcedonian Armenia accuses the Greeks of iconolatry. The dogmatic debate is inseparable from the numerous conflicts that oppose the Armenians and Byzantine power. From the beginning, Armenia, like all the countries of the Christian East, rejects sculpture in the round and limits itself to holy images either painted or carved in relief. This position of principle is formulated by Hypatios of Ephesus: "We accept that veneration be shown to images traced on wood and stone, but not to sculptured images."[5] Chalcedon divides Byzantium from the East. Armenia often makes plain the matter-of-fact disaffection it has toward Byzantium; however, the ties are never severed. More than once, the imperial power succeeds in imposing an Armenian hierarchy faithful to the Great Church, but union with the "Greeks" is invariably rejected. This obstinate refusal is always allied to a strong fascination. Toward the end of the sixth century, the catholicos Moses II forbids his faithful to receive books, images, or relics from the Byzantines. At an Armenian-Byzantine synod held at Kars in 632, Theodore of Siounie loudly proclaims, "We and they are one; they are the true trunk and we are a branch, having derived from them and having received from them the Christian faith and all the Christian commandments."[6] In contrast with this discourse, the catholicos Eghia Ardjitshātsi fights relentlessly against Chalcedonian doctrine in the beginning of the eighth century. His library is thrown into the river by his successor, the catholicos Simeon, who declares it "Chalcedonian" anyway. During the same period, Vrtanes Kertogh writes a treatise in defense of images. According to him, the Armenians, being incapable of making images, borrowed those of the Greeks for their own use. At the time iconoclasm breaks out, Armenia is "crushed" between Greek and Arab pressure. About the end of the tenth century, in order to counteract the ever increasing threat from Byzantium, Armenia seems to adopt a hostile position toward images, which had become the emblem of the Chalcedonian faith of the Greeks. In 969, the synod of Ani deposes the catholicos Vahan I for having installed several Georgian icons on the altar: the Armenian usage was to place on the altar either a cross or one single icon. Vahan transgresses this "canon" and forbids the celebration of the liturgy without an icon. He also promotes the decoration of churches in the manner of the Greeks by putting a profusion of images in them.

The deposition of this iconodule bishop remains simply an episode linked to the anti-Byzantine politics of the time. Like the many non-Byzantine Eastern churches, the Armenian Church never formulated any explicit dogma concerning images. According to the Armenian patriarch of Constantinople, Malachia Ormanian: "The cult of images, discussed at the second council of Nicaea, aimed

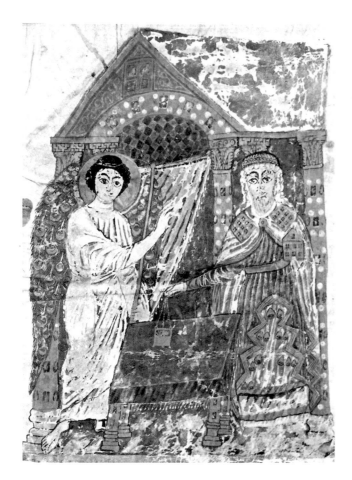

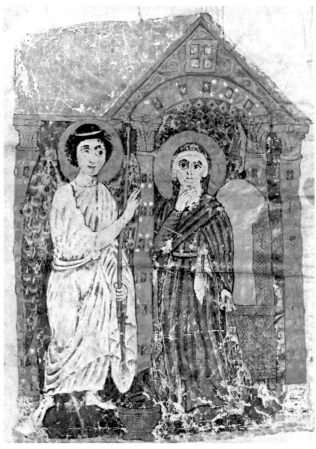

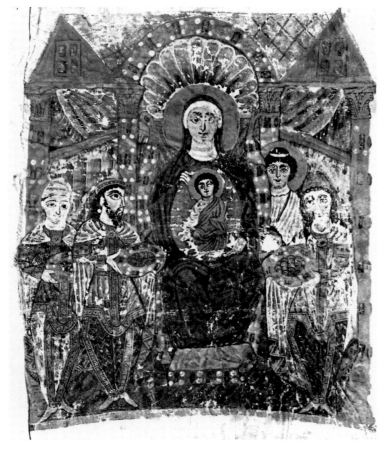

61. *Announcement to Zechariah*, gospel book of Etshmiadzin, 7th c. Matenadaran Manuscript Library, Erevan.

62. *Annunciation*, gospel book of Etshmiadzin, 7th c. Matenadaran Manuscript Library, Erevan.

63. *Adoration of the Magi*, gospel book of Etshmiadzin, 7th c. Matenadaran Manuscript Library, Erevan.

at only one point, more ceremonial than doctrinal in character. Without being absolutely banished from the Armenian Church, this cult was always narrowly limited. Statues are excluded for fear of the idolatry of antiquity. As to paintings and bas-reliefs, they are blessed and anointed with holy chrism in order to set them apart from ordinary objets d'art, and it is only after their consecration that they are placed on the altars. In contrast with the use in other communities which adorn the interior of their homes with icons, Armenians have no holy images in their private houses."[7] Neither iconoclast nor iconodule, Armenia in its worship is devoted more to the Cross than to images; however, it does not reject the latter or deny their role in religious life, a role rightly emphasized by diverse revered figures of the Armenian Church of yesterday and today. In its decoration of buildings, the Church gives images their place without favoring their profusion. Always transfigurative, images are worked in different materials. In times of "good ears" as well as in times of "empty ears" (Gen 41:25-27), uninterrupted artistic creativity witnesses to the vitality of painters and sculptors. The characteristics of this epoch can be detected through the alternation of its seasons. Images "traced on stone" take their place in the sculptural design of religious edifices. The human figure is always reduced to the essential. The most important Armenian buildings show a restricted choice of "iconized" portraits, integrated into aniconic ornamentation. Similarly, Armenia seems little attuned to mural painting; the rare large cycles of frescoes seen in certain of its churches are often the work of Georgian or Greek artists. Whereas it is the sign and paradigm of the Byzantine Church, here the icon appears nonexistent. It is the art of bookmaking that offers painting its main avenue of expression. Whether gospel books, lectionaries, hymnals, synaxaria, or collections of homilies, manuscripts are reverently and meticulously lettered and painted. They enjoy a veritable "veneration," and Armenian piety attributes to them a role of protection against evil. As C. Delevoye notes: "In Armenian piety, the book acquired a place comparable to that of icons in Greece. In their military campaigns, Armenians took along a manuscript of the Gospels."[8] In Armenia proper as well as in its close or distant colonies, the art of bookmaking experiences an impressive flowering. Iconography joins calligraphy. In the course of the ages, it creates different styles through osmosis with neighboring traditions, cultures, and arts.

'Abbāsid Armenia

In the second half of the seventh century, Christian Armenia enters the orbit of Islam. It finds itself absorbed into a vast "province" extending from the Caucasus to the Taurus. "This immense territory, of which historical Greater Armenia was the central part, was called 'the Arab province of Armenia' by the Arabs. At first, this province was one of the nine provinces; then later on, one of the five viceroyalties that constituted the empire of the first Ottoman caliph. Among all the people inhabiting this empire—Greeks, Jews, Syrians, Kurds, Persians, Georgians, Aghuans, Alans, Khazars, and mountain tribes—Armenians, it seems, formed the most numerous and active element, hence the name Armenia, which this vast region historically bore anyway, at least in the greater part of its central regions."[9] It will be a long time before Armenia enjoys Arab peace. Victorious Islam dreams of possessing the Byzantine empire and its "Queen City," Constantinople. Armenia is the battlefield open to the expeditions of the two warring camps. Byzantium attempts to recapture it. By strictly adhering to its refusal of Chalcedonian dogma, Armenia keeps its own faith and religious independence. The Church experiences difficult times. From 728 to 755, twelve catholicoi succeed one another in its see. In the ninth century, the caliphate suffers a drawback. A balance is established between the two Eastern empires. "The conquest of Constantinople passed from the domain of politics and propaganda to that of legend and eschatology; it was put off till the end of time and would be a

precursive sign of the last judgment.''[10] 'Abbāsid Armenia enjoys administrative autonomy. The caliphate grants it vassal principalities. In 862, Ashot the Bagratid is recognized ''prince of the princes of Armenia, Georgia, and Caucasus.'' His nephew, Ashot, is named king by the caliphate in 886. In his turn, the emperor Basil I sends him a royal crown. The implicit accord of these two forces makes Armenia a buffer state open to the innumerable exchanges between the two empires.

The most important building of this period is the illustrious church of the Holy Cross in Aghthamar, built by Gagik I in the beginning of the tenth century. The reliefs decorating the outside walls are exceptionally numerous. Inside, an ensemble of frescoes develops a vast iconographic cycle. The choice of themes on the reliefs is composite and cosmopolitan. Religious and royal scenes form a unified and homogeneous program. The figure of an Evangelist stands atop the central gable of each facade. On the west facade, King Gagik, wearing a halo and a royal mantle woven with bird designs, offers, according to the Byzantine convention, the church to Christ. On the east facade, flanked by members of his guard wearing caftans, a king, seated in the Eastern manner, carries in one hand ''the cup of the worlds'' and in the other a cluster of grapes plucked from the vine that surrounds him. Placing the work in its historical context, M. S. Ipşiroğlu identifies the king as the caliph who confirmed Gagik in his royal dignity. K. Otto-Dorn takes up this interpretation. This confirmation ''would have been the reason why—in some way an homage of the Armenian prince to the loyalty of the 'Abbāsid caliph—in Aghthamar the figure of al-Muktadir is enthroned in majesty.''[11] S. Der Nersessian refuses this identification: ''The feasting king of Aghthamar, just like the king painted on the ceiling of the Palatine Chapel in Palermo, is an iconographic type inspired by Islamic art, and not a portrait.''[12] Whether it is a symbolic figure or a historical portrait, the feasting king is placed in a quasi Islamic setting. The hunting scene gives the king a different aspect: wearing a military costume and on horseback, the regal hunter slays with a golden arrow the bear which threatens him. The elements revealing the contributions of 'Abbāsid art are many, for instance, the musicians, dancers, fighting wrestlers, animals, and human masks. Figures of walking women evoke the famed jar-bearing women in the paintings of Sāmarrā'. The man carrying a gazelle is derived from a Persian-Arab proto-

64. *The Feasting King,* Church of the Holy Cross, Aghthamar.
65. *Fantastic Animal,* Church of the Holy Cross, Aghthamar.

107

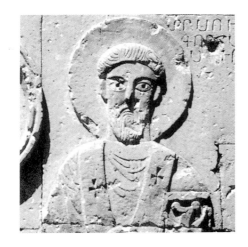

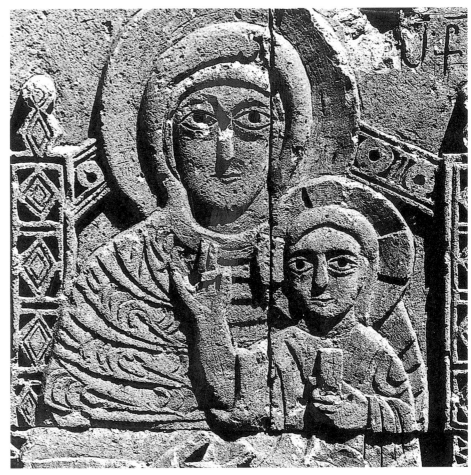

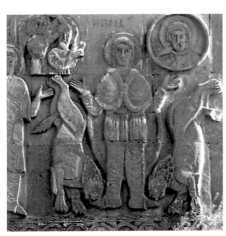

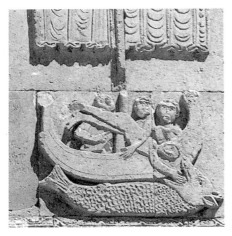

66. *St. Gregory the Illuminator*,
Church of the Holy Cross,
Aghthamar.
67. *Jonah Thrown to the Whale*,
Church of the Holy Cross,
Aghthamar.
68. *Mother and Child*,
Church of the Holy Cross,
Aghthamar.
69. *Daniel in the Lions' Den*,
Church of the Holy Cross,
Aghthamar.
70. *Adam*, Church of the Holy
Cross, Aghthamar.

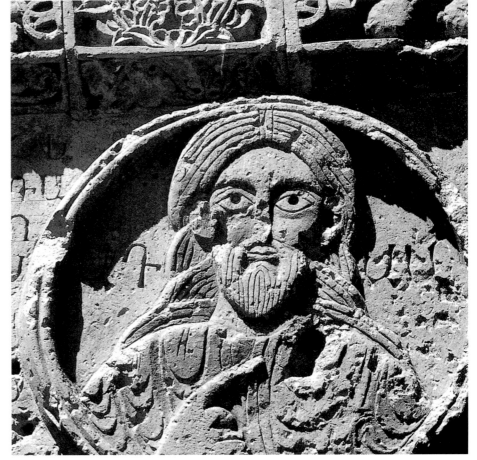

type. Animals abound, whether real, like dogs, hares, gazelles, bulls, foxes, lions, boars, roosters, and fowl of different kinds; or fantastic, like griffins, sphinxes, ram-birds, and winged fishes. Among the religious themes, one finds figures from the Old Testament, the Gospels, and the lives of the Saints. Heroes from the Old Testament occupy the greater part of the whole composition: one sees Adam and Eve in paradise, the sacrifice of Abraham, Daniel in the lions' den, the three youths in the furnace, the combat of David and Goliath, Samson killing a Philistine, and the cycles of Jonah, Moses, Saul, Elijah, Isaiah, and Ezekiel. For the Gospels, there are representations only of Christ and the Virgin, standing, in medallions, or enthroned. The figures of Saints deal with Armenian memory, and one sees the three great Illuminators, Thaddeus, Bartholomew, and Gregory the Parthian; the holy Warriors, George, Sergius, and Theodore; and the two Arshakuni princes, Sts. Sahak and Harmazasp, martyrs at the hands of the Arabs in 786. Angels, Seraphs, and crosses surround the different personages. And, there are more animals. Hieratism conditions and orders the numerous figures. In narrative scenes, movements are reduced to stereotypical gestures. In contrast to antique tradition, the folds of garments are lightened, schematized, and flattened to the extreme. The Arshakuni princes are clad in caftans with richly decorated belts. King Saul, wearing a turban, is similarly attired in an Oriental costume. The king of Nineveh sits in the Eastern manner. A fantastic, dragon-like *senmurv* replaces Jonah's whale. Varied and complex, free of any liturgical program, the composition nonetheless keeps its unity, and its diverse elements are harmoniously disposed on all the facades.

The inside murals, arranged on three levels, illustrate the great gospel cycle. The traditional principal Feasts are augmented by other important episodes of Christ's life. Twenty-five scenes are linked to narrate the childhood of the Son and his public life, Passion, Resurrection, and Second Coming. A cycle relative to Genesis is represented on the tympanum, and figures of Bishops appear on the supports partly engaged in the wall. The pictorial style is of one piece with that of the reliefs on the exterior. In the scenes depicting several people, the figures and the spatial elements are brought down to one single plane. The treatment of the folds of garments is similar inside and outside the church. The work is kindred to medieval Mesopotamian art: "The round shape of women's faces and the tightly coiled curls on their foreheads reflect contemporary 'Abbāsid taste, as do the well drawn beards under the thin noses on the men's faces. Finally, hanging lamps, low stools, ewers, goblets, and jars—as well as the architectural decoration, the airy galleries, and especially the brick and stucco mausoleum which represents Christ's tomb—all of these elements give a good rendition of the Muslim milieu of the time."[13]

Eclectic and cosmopolitan, the Armenian kingdoms make use of all styles. In Tatev, Western artists are hired to paint the inside walls of the church dedicated to Sts. Peter and Paul. According to Stephen Oberlian, Bishop John "sent far away for draftsmen and *zoracs,* that is, image painters, of the Frankish nation, whom he commissioned at enormous cost to paint the vaults of the edifice."[14] In the beginning, the apse was occupied by Christ enthroned, Prophets, and Apostles surrounding the Virgin and St. John the Baptist. A vast Nativity was on the north wall; the Last Judgment and the Resurrection from the Dead on the west wall. What is left of these frescoes shows a vigorous and lively style. The gestures of the subjects convey vivacious and expressive movements. The inscriptions on the scrolls are in Armenian. The work is akin to post-Carolingian tradition, strongly influenced by Byzantium, and shows "a composite art which is reminiscent of that of Rome and northern Italy from the eighth to the tenth centuries, that of the miniatures of the schools of Ada and Tours, and that of the school of Reichenau at the end of the tenth century."[15]

The manuscripts produced between the ninth and twelfth centuries reflect the same multiplicity of styles. The gospel book of Queen Mlke[16] is the oldest of the manuscripts. King Gagik's wife would have commissioned it in 862 in order to offer it to the Monastery of Varag. The style is antique; the miniatures represent the tables of concordance adorned with aquatic scenes; the four Evangelists

are painted according to the classical model of author-portraits; and the Ascension conforms to the pattern established in the fifth and sixth centuries: Christ in his mandorla on the higher level and the Virgin in the midst of the Apostles on the lower level. Going back to 989, the gospel book of Etshmiadzin[17] is decorated with miniatures in the initial letters, which are pre-Byzantine in style. The columns framing the canons are surrounded by songbirds, pomegranates, flowers, and fowl. Beardless and youthful, Christ is enthroned between Sts. Peter and Paul. Arms lifted in the gesture of prayer, the Mother and Child are seated in a space framed by two drawn curtains. The gospel book[18] of 1038 is in a far different style. The painters limit themselves to a minimum of techniques of which drawing is the most important. The people in the paintings which have a theme are presented on a plain background; there is no gold. The tempera is lightened by being treated like watercolor. The composition of the scenes is remarkable because of its simplicity and boldness. The prototypes of the Feasts are noticeably modified and the artists do not hesitate to "reinvent" the Epiphany, Last Supper, Crucifixion, and Resurrection. The traditional models of the Feasts are found again in the gospel book of Mughni,[19] whose paintings are reminiscent of Byzantine frescoes on the walls of rock-hewn churches. While faithfully adopting the traditional composition of the Nativity, the painter writes the name Eve above the head of the midwife holding the infant, thus evoking through this simple "name" the apocryphal Armenian account of Christ's childhood in which Joseph, looking for a "Hebrew midwife," meets a woman "who was coming from the mountain"; he asks her her name and the woman says, "Why do you ask me my name? I am Eve, the first mother of all humans, and I have come to see with my own eyes my redemption which has been accomplished."[20]

Antique, Byzantine, popular, naive, audacious, or inspired by the frescoes of cave churches, Armenian illumination—albeit restricted to a few religious themes—adopts many styles, sometimes even within a single manuscript. The gospel book[21] made in the eleventh century for King Gagik of Kars is a striking example of this. A miniature of impressive refinement offers a portrait of the royal family. The painter works in the Islamic manner with exceptional strength and mastery. The king, queen, and their little girl "are sitting in the Oriental way on a divan covered with a red rug adorned with long-trunked elephants, birds, and flowers, all enclosed within circles outlined with pearls. On Gagik's crimson mantle one sees ibexes inside medallions outlined with two rows of pearls and decorated with palm branches. Smaller circles with four palmettes in the shape of a cross are interspersed between the larger medallions. Kufic letters are woven on the *ṭirāz* of the mantle and on the white bands of the red veil in the background."[22] The miniatures devoted to the Gospels go back to Byzantine tradition in all its purity. Faces, garments, landscapes, and buildings faithfully follow the Greek-influenced style of the Macedonian period.

The International Melee

The eleventh century ushers in a tumultuous period. Fragmented into rival kingdoms, Armenia finds itself at the center of the international melee in the East. Its northern principalities are under Arab domination; the southern ones enjoy the favor of Byzantium. The Seljuqs come upon the scene. Byzantium increases its pressure, and its troops annex the Bagratid kingdom. Ten years later, the Seljuqs are the masters of Armenia. Borders continue to be unstable. Georgia advances and conquers northern Armenia. The country is under the power of great feudal families. Armenian princes, vassals of Georgia, govern it. In 1220, Mongol forces settle in. In 1237, the Armenian feudal lords recognize their suzerainty. Throughout these developments, a number of Armenians emigrate toward the north to find refuge in Georgia, Crimea, Poland, Moldavia, Wallachia, and Hungary. In parallel fashion, another movement of emigration takes the southern route toward Commagene, Syria, and Caramania. In Fāṭimid Egypt, a colony of thirty thousand Armenians finds a more and more important place

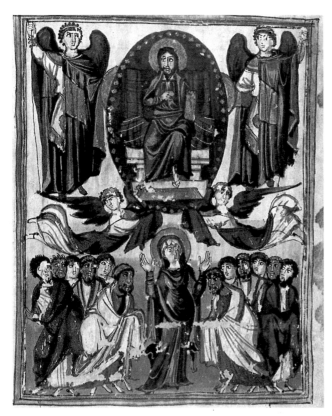
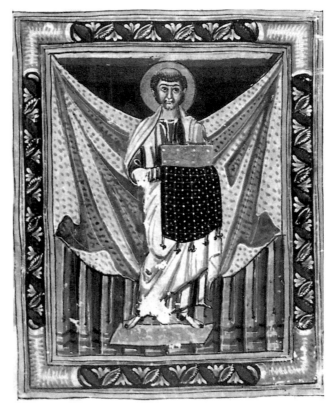
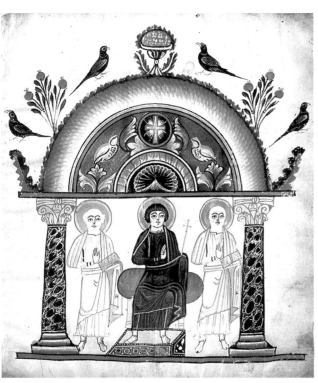

71. *Ascension,* gospel book of Queen Mlke, 862. Library of the Mechitarist Fathers, Venice.
72. *An Evangelist,* gospel book of Queen Mlke, 862. Library of the Mechitarist Fathers, Venice.
73. *Christ and Apostles,* gospel book of Etshmiadzin, 989. Matenadaran Manuscript Library, Erevan.
74. *Temple,* gospel book of Etshmiadzin, 989. Matenadaran Manuscript Library, Erevan.

under the reign of Bahrām, the Christian vizier called "Sword of Islam." In Cilicia, the Armenian community establishes its sovereignty: the Rubenian dynasty founds a kingdom destined to endure from 1087 to 1375.

On the internal scene, conflicting allegiances characterize the politics of rival feudal rulers. The Church experiences a series of ecclesiastical and jurisdictional disputes, punctuated by the splitting of dissident patriarchates and the creation of new sees in Cilicia and Jerusalem. As A. Brissaud underscores, "The Armenian people seems rock solid, but the rock is cracked by the differences, rivalries, and tensions that perdure at its core."[23] The inter-Armenian wars accompany the play of alliances and counter-alliances in these centuries. Two Armenias "separately" occupy center stage. Greater Armenia submits to the Mongol power. The see of its Church is in Hromkla on the Euphrates. Far from the ancestral land, an Armenian kingdom is established in Cilicia. Its founding is contemporary with that of the Latin states of the Levant in Edessa, Antioch, Tripoli, and Jerusalem. The rulers of the new kingdom multiply alliances in order to buttress their sovereignty. Toros II captures the Byzantine governor of Cilicia and allies himself with the Latins. The "renegade" Mleh offers his help to Nureddin and conducts a twofold war against the Franks and Greeks. Rupen III chooses a resolutely Latinophile politics. Under the aegis of the crusaders, Prince Leo II becomes King Leo I in 1198; the barony is transformed into a kingdom. Alexius III Angelus sends a crown to the Armenian king, calling upon him to turn away from the Latins: "Do not place on your head the diadem which the Romans gave you," he admonishes, "for you are much closer to us than to Rome."[24] In the thirteenth century, Hetum I casts his lot with the Mongols and becomes the khan's "ecclesiastical adviser." Later on, "throwing aside secular pomps," he joins the Franciscans and yields his throne to his son and heir Leo II. Rome advocates the return of the heretical Church to the Mother Church, but any union will always be rejected. Today, the catholicos Karekin II comments, "Relations with the Latin Church, the most powerful at the time, were pursued in connection with political relations: on the part of the Armenian people, it was a concern for security and protection; and on the part of the Latin Church, it was a desire for domination and expansion."[25] Greater Armenia violently opposes Latin ambitions. As years go by, the bonds become looser and looser. At the time of the kingdom's demise, a Dominican declares that the Armenians are "the worst heretics" among all the Eastern people, "so immersed in errors, clergy and laity alike," that they cannot change any more than "Ethiopians can change their skins."[26] In 1262, the Mamlūks crush the Armenian army. At the time the vanquished Franks prepare to leave the East, King Oshin convokes the council of Sīs in 1307, and under coercion signs an agreement of union. A bloody repression crushes the opposition of clergy and faithful. Theologians are imprisoned and monks deported to Cyprus. In Jerusalem, refusing to recognize the council of Sīs, which established the union, the Armenian bishop Sargis takes the title of patriarch with the "blessing" of the sultan of Egypt, Nāṣir Muḥammad. In 1439, the council of Florence ratifies the union proclaimed at Sīs: eastern Armenia calls upon the catholicos of Cilicia, Gregory IX, to disavow the decree of union and to transfer his person and see to Etshmiadzin. In 1441, the "Eastern ones" proceed to elect a counter-catholicos whom they install at Etshmiadzin. While "abandoning" the union, Cilicia persists in keeping its own catholicos. At the end of this eventful period, Armenia finds itself with three sees and three catholicoi. A few years later, with the ascent of the Ottomans and the formation of their empire, Armenia will have a fourth catholicos installed in the "Constantinople Armenian Orthodox" see.

In the midst of this chaotic melee, arts experience a remarkable expansion. The architectural decoration of buildings renews itself and becomes more refined. In Asia Minor, the fall of the Seljuq empire and its fragmentation do not seem to affect local arts. Similarly, the Mongol invasion does not slow the creativity of builders and artisans. Transcaucasian Armenia shares in the traditions of the time. Islamic art leaves its imprint on Armenia's ornamental style: stars, triangles, polygons, alveoli, leafy branches, and palmettes; lines and forms intertwining, crisscrossing, and reproducing themselves

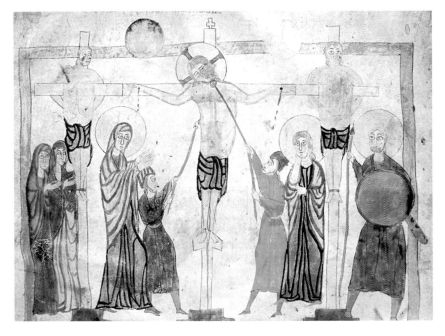

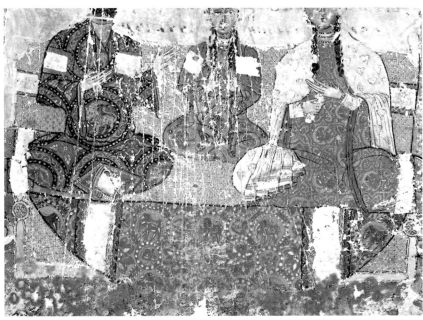

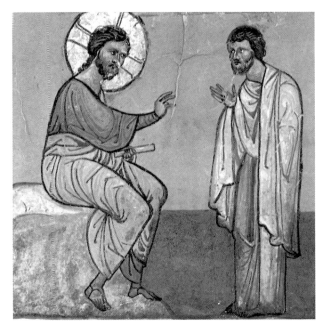

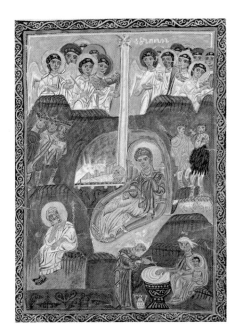

75. *Crucifixion,* gospel book of Van, 1038.
Matenadaran Manuscript Library, Erevan.
76. *Baptism,* gospel book of Van, 1038.
Matenadaran Manuscript Library, Erevan.
77. *Portrait of the Royal Family,* gospel book of
Gagik of Kars, 11th c. Armenian Patriarchate,
Jerusalem.
78. *Christ and the Rich Man,* gospel book of Gagik
of Kars, 11th c. Armenian Patriarchate, Jerusalem.
79. *Nativity,* gospel book of Mughni, 11th c.
Matenadaran Manuscript Library, Erevan.
80. *St. John,* gospel book of Horomos, 1181.

without end. The figurative is incorporated into the geometric: vegetation flowers and bears new fruits; coming from all the ancient heritages, animals populate this universe of signs. Although not originating in the Bible or the Qur'ān, they are found in both Christian and Muslim decoration. Traditional fantastic animals give birth to new composite bodies. A new chimera is invented, having a woman's head, goat's body, eagle's talons, and serpent's tail. A strange animal, the griffin, bears the wings and head of an eagle on its lion's body. A winged reptile has a dragon's body and lion's head. Playing the role of talismans, these heraldic creatures meld into the ornamentation without having a precise function. Christian themes—especially the Cross—give this decoration its religious identity. The figures of Christ, his Mother, and the "members of his body" are stylized and harmoniously blended with the decoration. The door of the Monastery of the Holy Apostles in Mush— kept in the Museum of Armenian History—is a typical example of this art. An inscription gives 1134 as the date. The two panels form a purely geometric composition: eight starry octagons weave a background made of strips crossing one another and forming lozenges and crosses. On the frame, people and animals are drawn inside a graceful Seljuq foliated arabesque. On the lintel, five human silhouettes are side by side with a fowl and a siren. Standing in the middle and flanked by two equestrian Saints, a person on foot sounds the trumpet. Only the name of St. Theodore is legible. Aniconic surface and iconic frame: this formula becomes common in the specifically Armenian compositions dominated by a great Cross in the center. And it is continually repeated in architectural ornamentation as well as on the famed funerary stelae called *khatchkars*.

Erected "in intercession to God" for the salvation of a dead person's soul, the Cross unfolds, surrounded by two large leaves which sprout from its foot. St. John Chrysostom sings: "O Cross that scintillates! The sun darkens, the stars fall like leaves, but the Cross shines, more radiant than

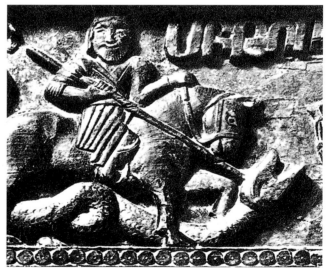

81. Door of the Monastery of the Holy Apostles at Mush, 1134. Museum of Armenian History, Erevan.
82. Lintel of the door of the Monastery of the Holy Apostles at Mush, detail: *St. Theodore,* 1134. Museum of Armenian History, Erevan.

right:
83. Khatchkar, Noraduz.
84. Khatchkar, Gerhard, 1213.
85. Khatchkar, Etshmiadzin.

all of them; it occupies the whole of the sky!"[27] Traditional ornamental motifs in relief cover the surface of the stone with a fine lace. Treated on a smaller scale, figurative scenes are once again found around the great Cross which dominates the whole composition. Figures of people in the Gospels, silhouettes of Saints, festive scenes, donors. Stars, flowers, and animals. Everything and everybody glorify the sign of the Cross: "Holy Sign always victorious,"[28] says St. Nerses the Gracious, "it shines from the East and reaches the four cardinal points."[29]

Christian iconography comes under the influence of the East. The facades of churches are adorned with figures of undeniable originality. The Greek component is attenuated to the point of disappearance. Reliefs emerge from a background of intertwined designs. The bodies are stout; faces, rounded and enlarged, are enormous; folds of clothing, in parallel curves, follow the contours of bodies. Leafy branches occupy the free space in the scenes. Sometimes the artists do not hesitate to create new gospel scenes. In Amaghu, the church of the Mother of God shows reliefs integrated into the decoration of its facades. Two scenes adorn the west: on the tympanum of the door, the Virgin is enthroned between the Archangels Gabriel and Michael. Christ, flanked by Sts. Peter and Paul, is represented on the tympanum of the window. The Apostles, standing, hands stretched toward the Master, are shown in three-quarter face. According to the model of the Pantocrator, the bust of Christ is shown facing forward, blessing with one hand and holding the Gospels with the other. The two scenes obey traditional iconography, but the shorter statures and the expressions on the faces are different from Byzantine models. The tympanum of the door of the porch is devoted to the Mother and Child. In the church of St. John the Baptist, the Mother is enthroned, holding the Child on her left knee. The throne is hidden by a beautiful carpet carefully drawn in a flat perspective, common in Islamic-Christian art of the time. Flowery arabesques cover the background. Two Prophets, seen in profile, harmoniously fit into this garden of interlacings. Above the door, the relief adorning the window

 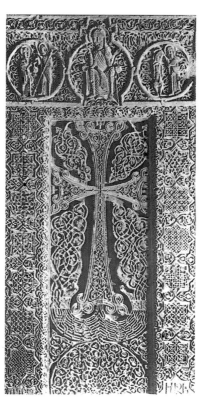 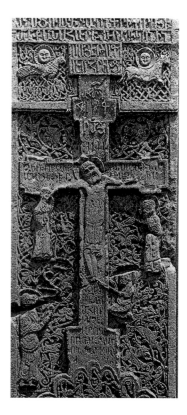

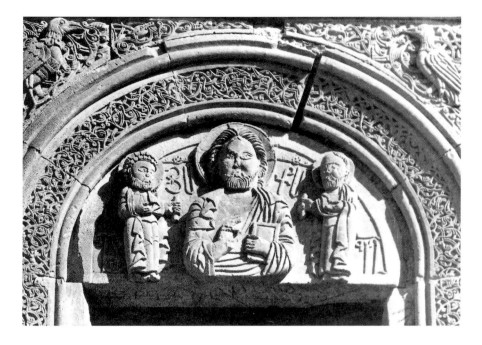

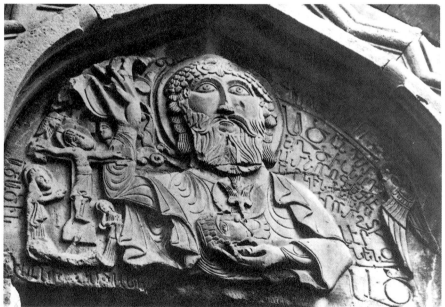

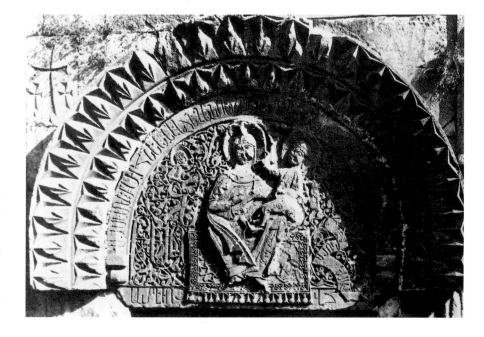

86. *Christ and Apostles,* 14th c.
Church of the Mother of God,
Amaghu.
87. *Creation of Adam, Crucifixion,*
14th c. Church of St. John the
Baptist, Amaghu.
88. *Mother and Child,* 14th c.
Church of St. John the Baptist,
Amaghu.

offers a novel rendition of the creation of Adam: the bust of the Ancient One faces forward, blessing with one hand and holding in the other Adam's head shown in profile. The dove of the Holy Spirit, placed in a medallion, is between the two faces. Carved in smaller scale, the Crucifixion is shown on the left: under the large blessing hand of the Creator, Christ on the Cross lifts high his haloed face. The Prophet Daniel contemplates the ''Son of Man,'' who advances toward the Ancient One (Dan 7:13).

These images carved in relief take us a long way from Byzantine forms of art. Under the reign of feudal rulers, Transcaucasian Armenia creates its works of art which are the most obviously Eastern in character. Faces exaggeratedly large, ample cheeks, heavy chins, and slanted eyes; stout bodies, standing as though frozen or seated with legs apart; backgrounds adorned with lacy patterns modeled in low relief; aniconic ornaments joined to a profusion of plants and animals: art basks in an Asiatic atmosphere. Donors' figures reflect the times: dressed in Mongol costumes, Prince Eatchi and his son Hasan are shown on two carved plaques in the church of the White Virgin in Areni. The first one shows the sovereign teaching the art of hunting to his heir: on horseback, his face averted, Hasan shoots an arrow at a fleeing doe.

The innumerable *khatchkars* are adorned in this sculptural style. On the stone Cross itself as well as the surface on which it is carved, the same aniconic and iconic elements are woven and intimately mingled. While continuing to show its predilection for the naked Cross, tradition fosters Crucifixions of great beauty. Drawing dominates: the Savior's body lifted on the Cross is reduced to its outline. Christian Armenia names him the ''Savior of All.'' His face serene, his chest expanded, his arms stretched out in an infinite calm, Christ rests on the Tree of Life. Claudel says, ''My God, I see the perfect human being on the cross, the perfect human being on the perfect tree.''[30]

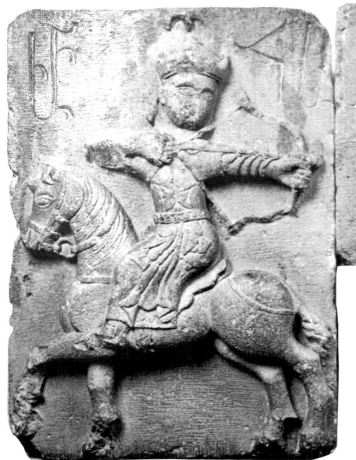

89. *Amir Hasan Hunting,* Church of the White Virgin, 1321. Museum of Armenian History, Erevan.

Mural paintings retain their familiar Byzantine color. The style, themes, and inscriptions reflect the artists' identity. Greeks and Georgians work with the help of Armenian assistants. In Ani, the church of St. Gregory the Illuminator has an impressive ensemble of frescoes, commissioned by the merchant Tigran Honens; painted in the Byzantine manner, they completely cover the walls. The gospel cycle going from the Annunciation to the Resurrection is "completed" by a cycle devoted to St. Gregory the Illuminator and a fresco dedicated to St. Nino, the Illuminatrix of Georgia. On the south arm, a chain of medallions with *senmurvs* reproduces in painting a motif found on Islamic cloth. In Kecharis, the church of St. Gregory contains a painting in the Eastern style that joins the Deesis and Pentecost in one scene. Christ, the Virgin, St. John the Baptist, Apostles, and Angels occupy the tympanum and arch. The style is resolutely "Asiatic." The faces are simply circles devoid of any modeling, and the features are sharply outlined.

Illumination, Its Currents and Trends

The art of bookmaking flourishes in an extraordinary way. In Greater Armenia as well as in the little Armenias outside its boundaries, schools multiply and their output is abundant. The greater part of this is gospel books. Bibles, lectionaries, hymnals, and collections of homilies are second. Miniatures dealing with historical subjects appear late—the earliest, dating from 1482, represents the battle of Avarayr. The decoration of gospel books follows a classical plan inherited from ancient Christianity. The book begins with ten paintings devoted to the letter of Eusebius explaining how to use the canons. Eight or ten illuminated tables indicate the parallelisms and divergences among the four Gospels. The manuscript contains full-page miniatures treating definite subjects; these miniatures either appear singly or are joined in groups of as many as sixteen. The Evangelists' portraits are frequently present. Series of small miniatures in the margins accompany the text, illustrating cures, other miracles, and parables. A richly decorated vignette is set at the top of the title page. The initial letter of each book is a large capital harmoniously united to the symbolic animal proper to each Evangelist. The canons and title pages are adorned with plants and animals from all the iconographies of the world. Zoomorphic and floral motifs are sometimes also inserted into the full-page scenes. The design of hymnals and lectionaries proves freer and shows two principal tendencies. The first, aristocratic and akin to Byzantine art, is distinguished by the richness of its materials and the high quality of its artisanship: Cilician painting is the main representative of this. The second, destined for customers of more modest means, is less richly adorned: gold is often absent, and the drawing and execution lack refinement; however, the style attests to an incontestable creativity with regard to both themes and artistry. The great diversity in the work of this school gives to the Armenian miniature its specificity and originality.

Painted in 1204, the frontispiece of the *Homiliary* of Mush[31] puts together in a full-page composition the Nativity, Baptism, and Christ enthroned. The way the elements of the painting are flattened, their stylization, and the partitioning of the background of the crib give the work an orientalized Cappadocian character. Illuminated by the painter Markare in 1211, the gospel book of Haghpat[32] shows an Entry into Jerusalem whose style is reminiscent of contemporary Arab-Syriac paintings. The composition is faithful to tradition, but its details and their execution are wondrously orientalized. The action takes place on a single plane. The painter represents four children welcoming Christ and reduces the presence of the Apostles to two figures standing behind the Master's mount. Two trees and a fantastic pavilion resemble Arab painting. The Armenian Cross surmounting the building transforms it into a religious edifice. Traditional iconography shows an assembly of Jews facing Christ. Markare eliminates this and emphasizes the picturesque character of the scene: dressed in Armenian

fashion, a woman and two young girls sit in the highest story of the pavilion. Standing in front of the building's door, an Armenian dignitary wearing a turban replaces the Jerusalem Jews. The sign of his power and rank is the presence of a black servant who unfolds a red carpet before the Messiah.

The Eastern style develops and is codified. The painter Ignatios of Ani leaves seven manuscripts in which the native style is mixed with Byzantine and Islamic traditions, adding a graceful local color to the miniatures. Scenes with human figures make use of Byzantine conventions while modifying the proportions of bodies and faces to suit Eastern taste. Gospel characters keep their ancient costumes, but donors are clad in the rich attire of the period. The painter puts into one two-level miniature St. Mark and the two donors of the gospel book.[33] The Evangelist is represented according to the classical author-portrait. Beneath him, the couple is shown kneeling, their hands raised toward a gospel book engraved with an Armenian Cross. Brnavor wears a large hat and a sumptuous mantle with dangling sleeves; his wife is veiled and clothed in an Eastern robe trimmed with gilded ornaments. The famous school of Van deepens its orientalizing intuitions. Polylobed arches grow more numerous; plant elements become foliated decorations; architectural details are covered with uniform bricks; roofs are conical; faces are moon-like and eyes clearly slanted; people's repetitious gestures are typically Armenian: the drawing creates non-symmetrical compositions of exceptional boldness. The works of Kirakos of Urunkar are masterly examples of this local school. The gospel book he decorates in 1330 devotes three pages to the donors: "Hovhannes, the donors' son, is a proud horseman, represented in the manner of horsemen in Muslim manuscripts, his mace against his shoulder, his quiver full of arrows and hanging from his belt. His red cap is edged with fur and sports an egret's plume, and inscriptions imitating Arab script adorn the *ṭirāz* of his red tunic. On the opposite page

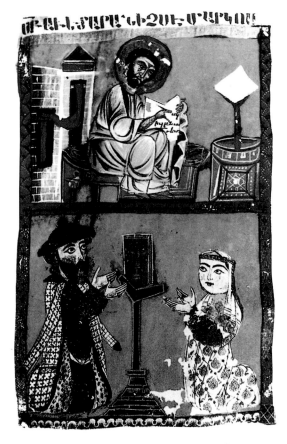

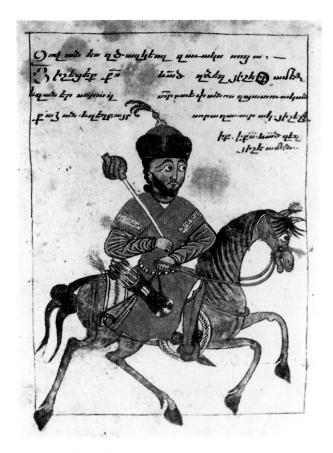

90. *St. Mark and Two Donors,* work of Ignatios of Ani, 1236. New Julfa (Esfahān).
91. *The Donor Hovhannes,* work of Kirakos of Urunkar, 1330. New Julfa (Esfahān).

ARMENIA
Color Plates 25–48

25. a. *Baptism of Christ,* gospel book of Etshmiadzin, 8th c. Manuscript Library of Matenadaran, Erevan.
b. *Baptism of Christ,* work of Toros Roslin, 1263. Manuscript Library of Matenadaran, Erevan.

26. *Letter of Eusebius,* gospel book, 1248. Armenian Catholicosate of Cilicia, Anṭilyās, Lebanon.
27. *Letter of Eusebius,* gospel book, 1248. Armenian Catholicosate of Cilicia, Anṭilyās, Lebanon.

28. *St. Matthew,* gospel book, 1248. Armenian Catholicosate of Cilicia, Anṭilyās, Lebanon.
29. *St. Mark,* gospel book, 1248. Armenian Catholicosate of Cilicia, Anṭilyās, Lebanon.

30. *St. Luke,* gospel book, 1248. Armenian Catholicosate of Cilicia, Anṭilyās, Lebanon.
31. *St. John,* gospel book, 1248. Armenian Catholicosate of Cilicia, Anṭilyās, Lebanon.

32. *Glorification of the Holy Cross,* gospel book of Vaspurakan, 1450. Sam Fogg Gallery, London.
33. *Deesis,* gospel book of Vaspurakan, 1450. Sam Fogg Gallery, London.

34. *Transfiguration,* gospel book of Vaspurakan, 1450. Sam Fogg Gallery, London.
35. *Washing of the Feet,* gospel book of Vaspurakan, 1450. Sam Fogg Gallery, London.

36. *St. Mark,* gospel book, 1454. Armenian Catholicosate of Cilicia, Anṭilyās, Lebanon.
37. *St. John,* gospel book, 1454. Armenian Catholicosate of Cilicia, Anṭilyās, Lebanon.

38. *Annunciation,* hymnal, 15th c. Armenian Catholicosate of Cilicia, Anṭilyās, Lebanon.
39. *Resurrection,* gospel book, 15th c. Armenian Catholicosate of Cilicia, Anṭilyās, Lebanon.

40. *Announcement to St. Ann,* hymnal, 1591. Armenian Museum of France, Paris.
41. *Pentecost,* hymnal, 1591. Armenian Museum of France, Paris.

42. a. *Cherub,* hymnal, 1591. Armenian Museum of France, Paris.
b. *The Forty Martyrs of Sebaste,* hymnal, 1591. Armenian Museum of France, Paris.
43. a. *St. John the Baptist,* hymnal, 1591. Armenian Museum of France, Paris.
b. *Christ,* hymnal, 1591. Armenian Museum of France, Paris.

44. a. *Ornamental Cross,* hymnal, 1591. Armenian Museum of France, Paris.
b. *Ornamental Cross,* hymnal, 1591. Armenian Museum of France, Paris.
c. *Ornamental Cross,* hymnal, 1591. Armenian Museum of France, Paris.
45. a. *Adam and Eve,* hymnal, 1591. Armenian Museum of France, Paris.
b. *Jonah,* hymnal, 1591. Armenian Museum of France, Paris.

46. *St. Gregory the Illuminator,* synaxarion, 1658. Armenian Catholicosate of Cilicia, Anṭilyās, Lebanon.
47. *Resurrection,* synaxarion, 1658. Armenian Catholicosate of Cilicia, Anṭilyās, Lebanon.

48. *St. Nerses the Gracious,* scroll, 19th c. Armenian Museum of France, Paris.

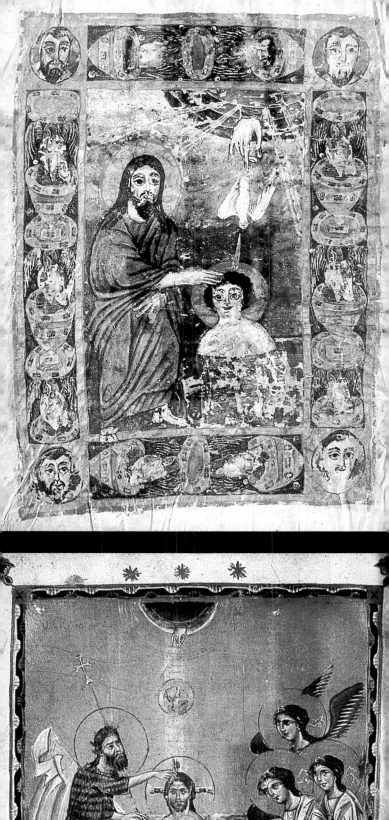

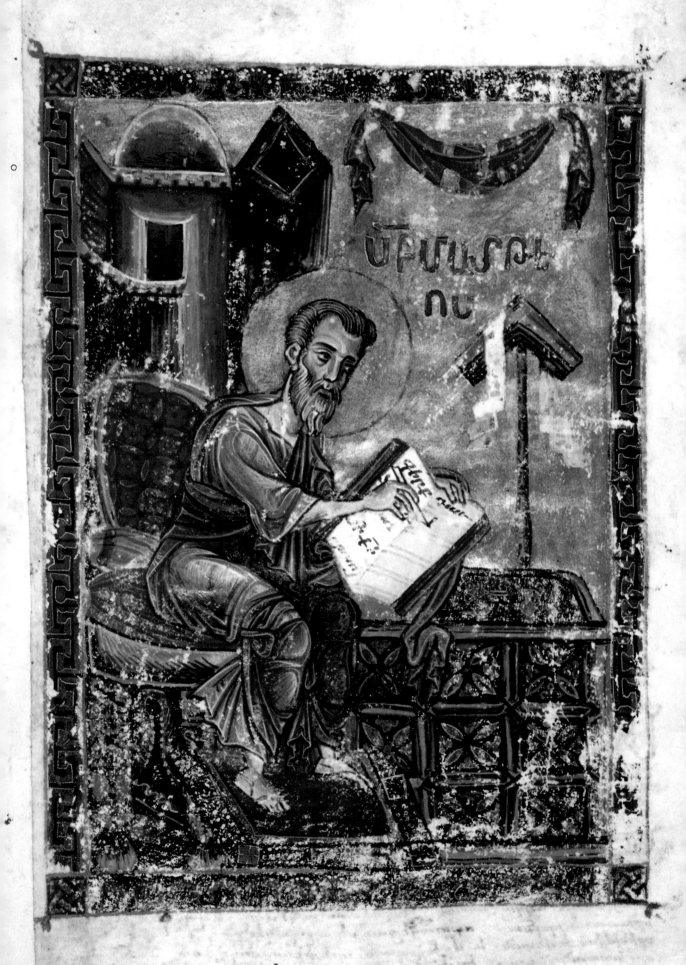

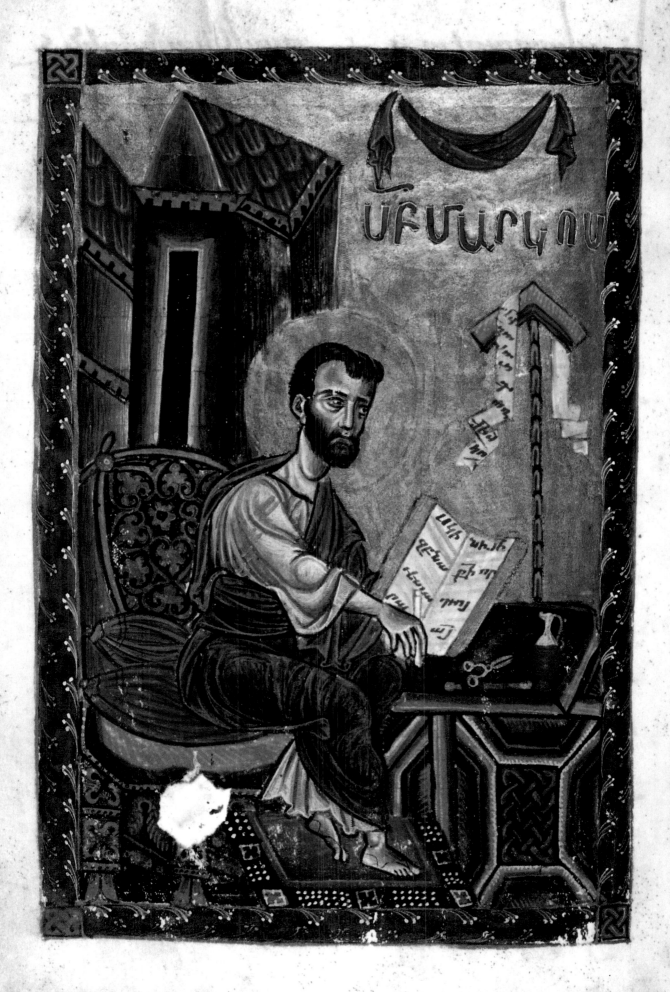

ՄՄԱՐԿՈՍ

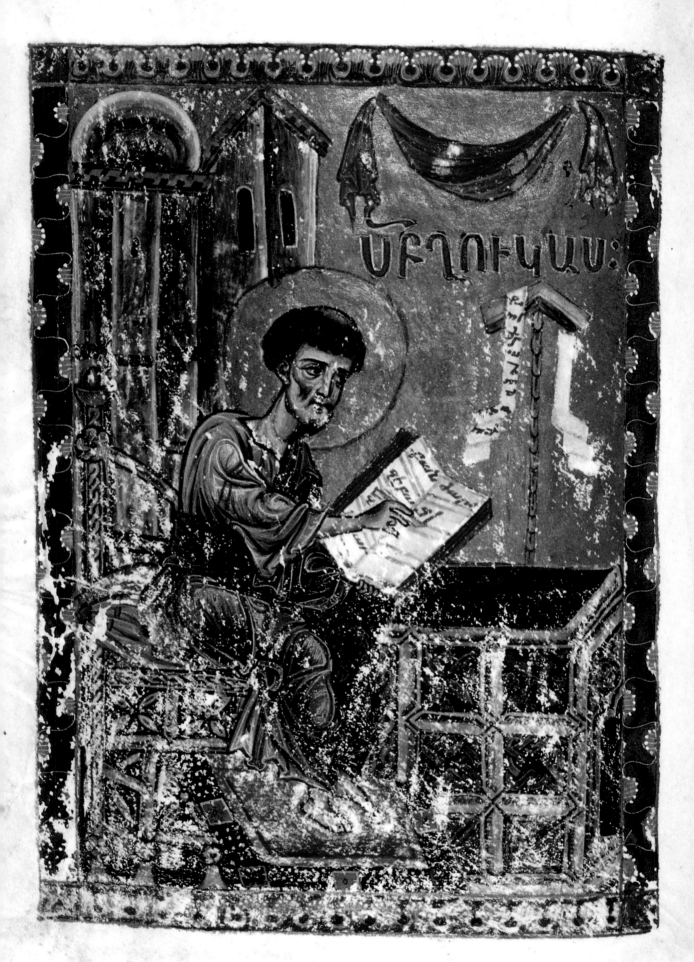

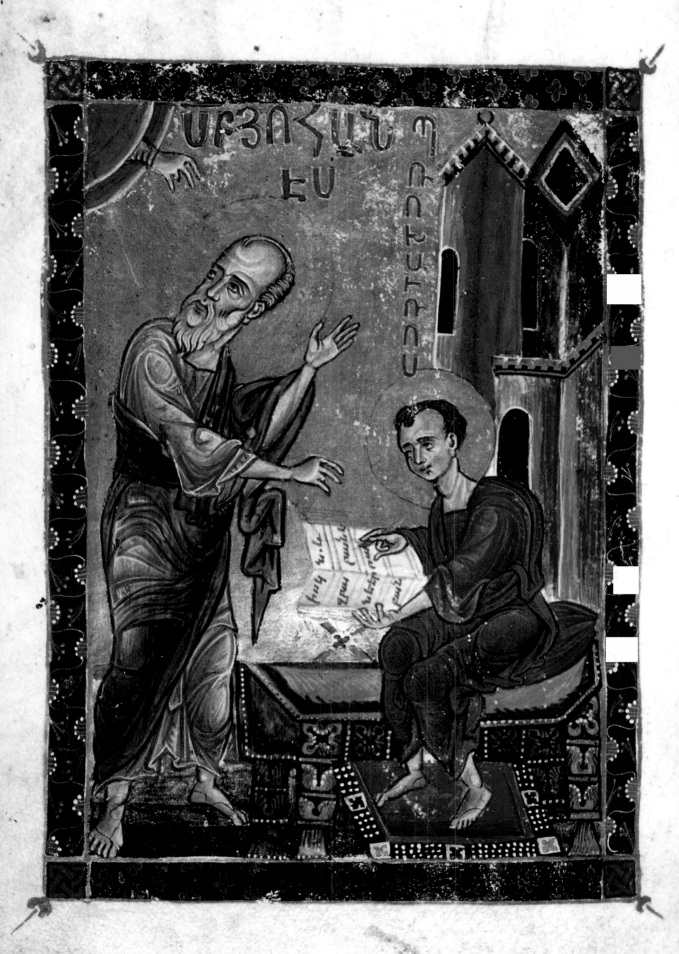

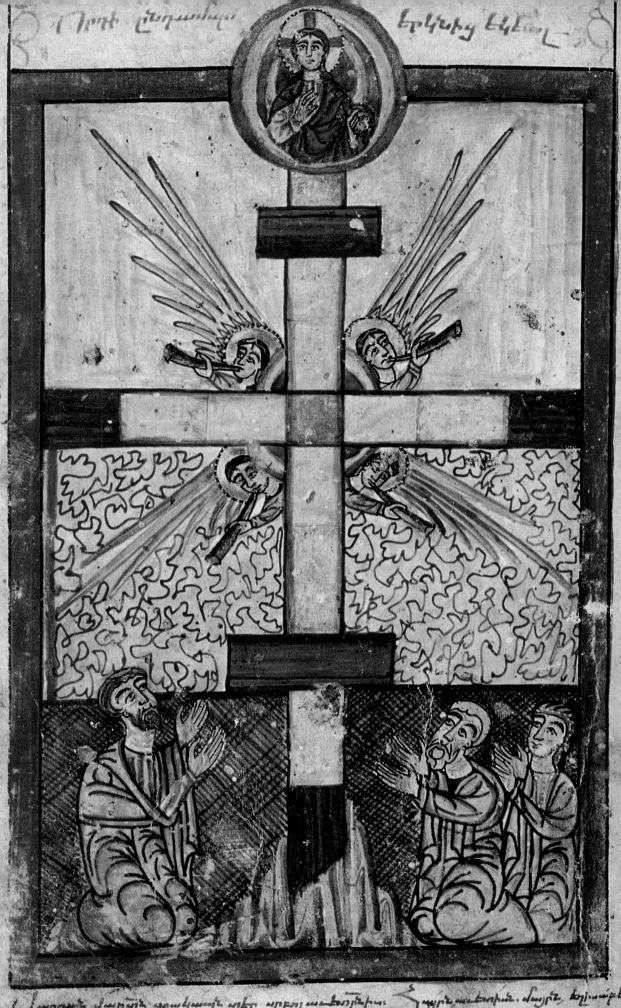

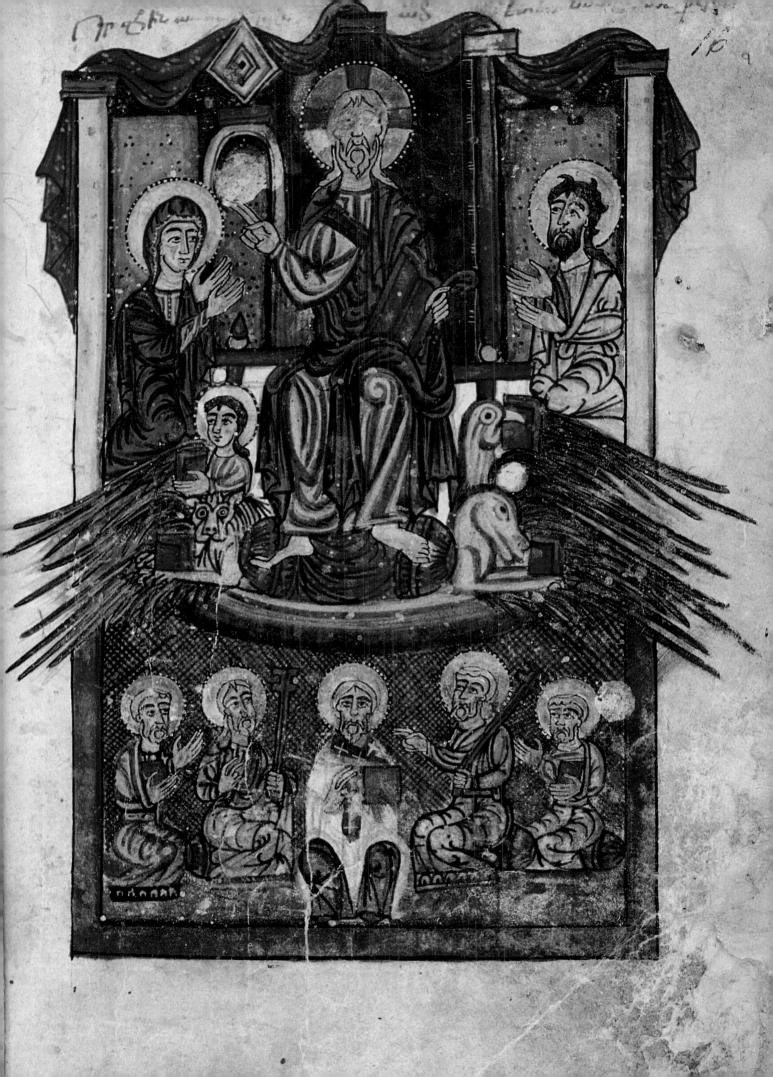

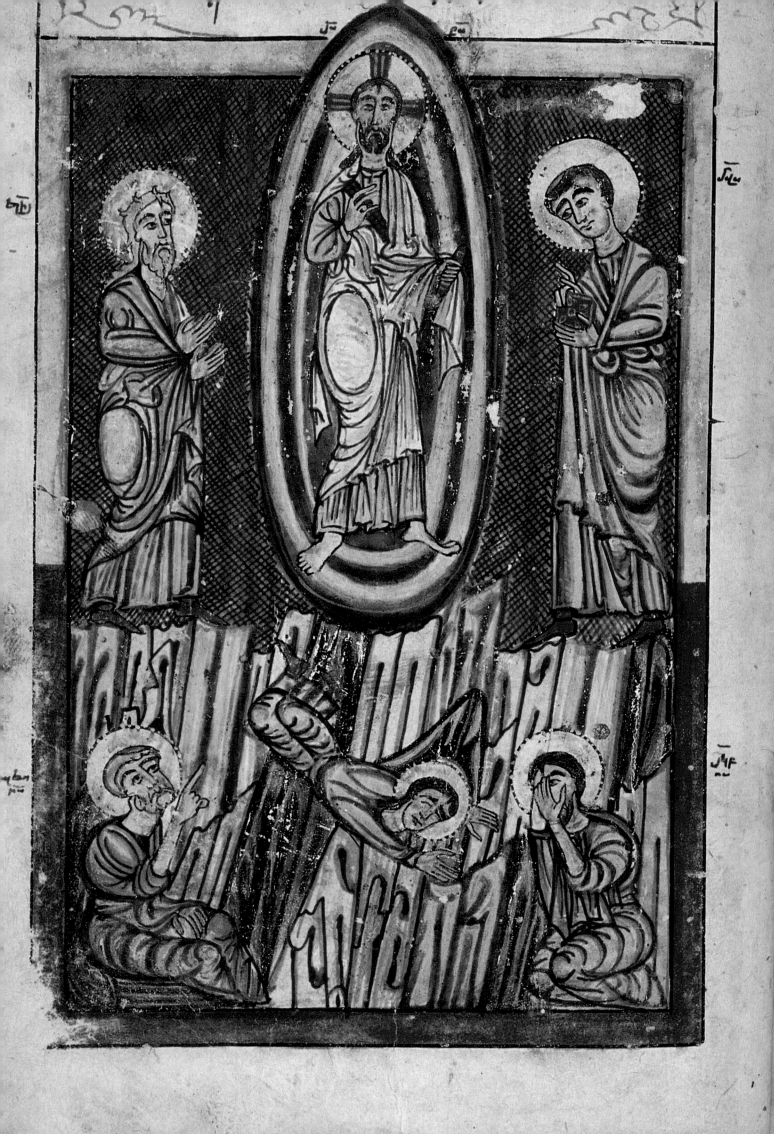

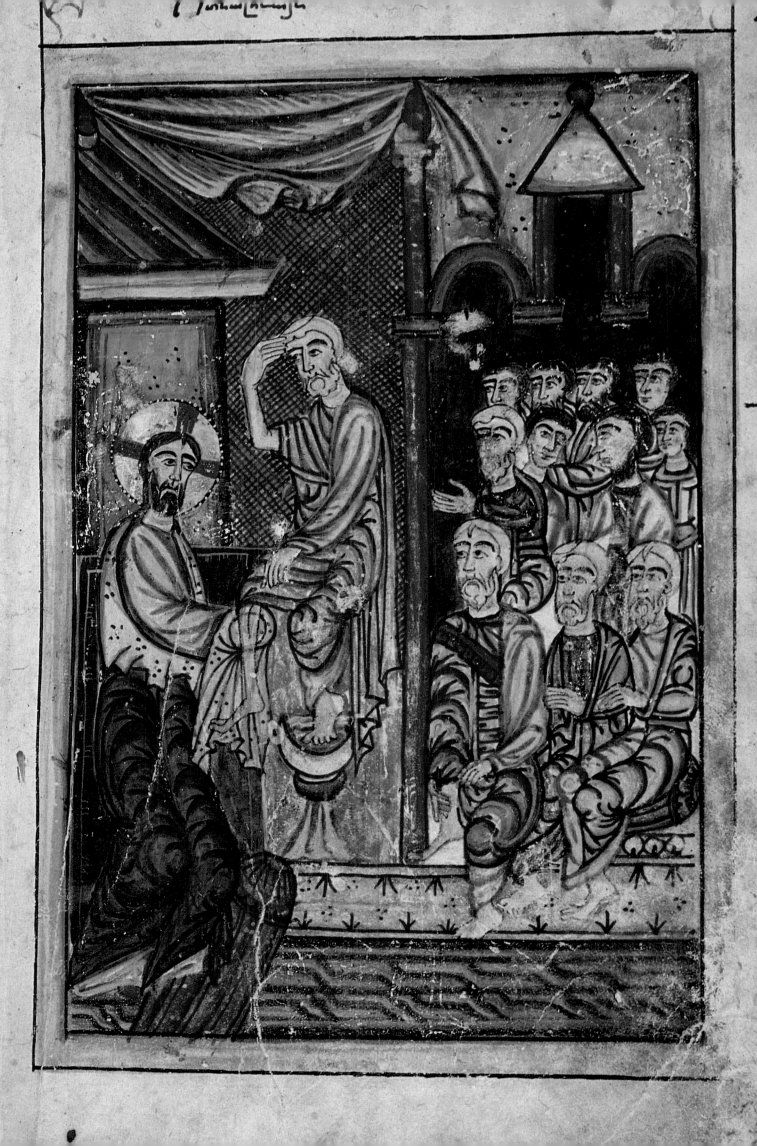

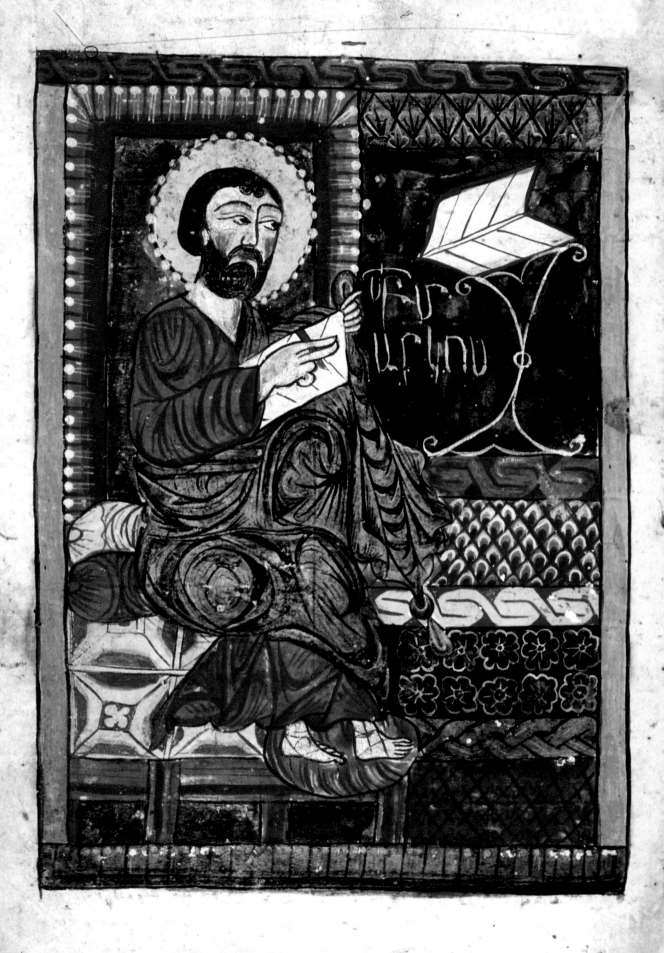

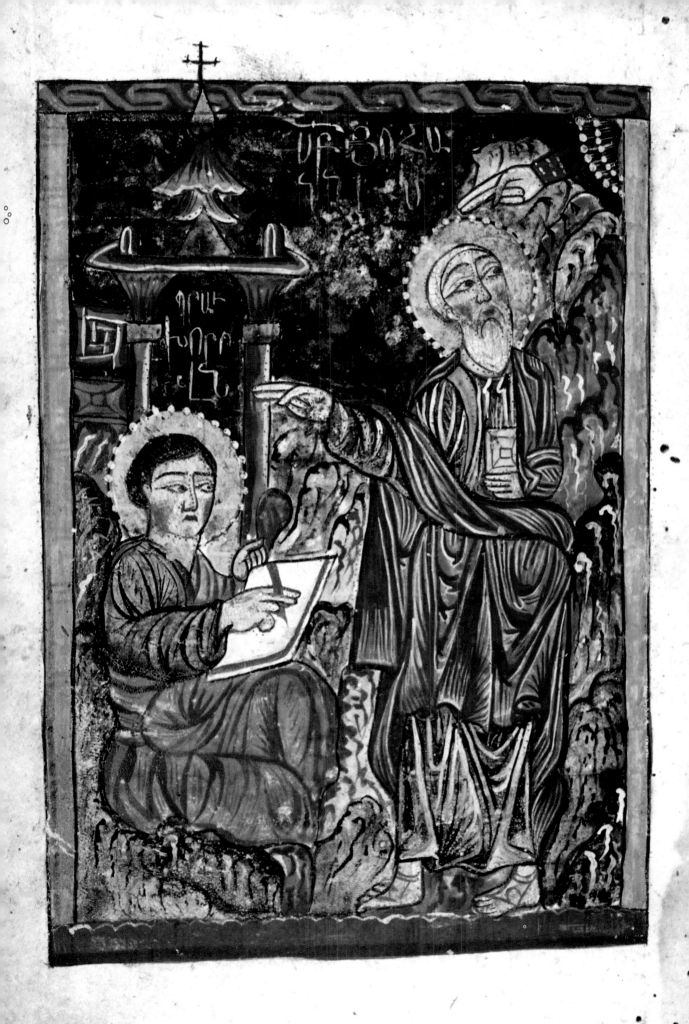

Ասաց հրեշտակն ... ած ...

այց
...
...
...
... ...
... ...

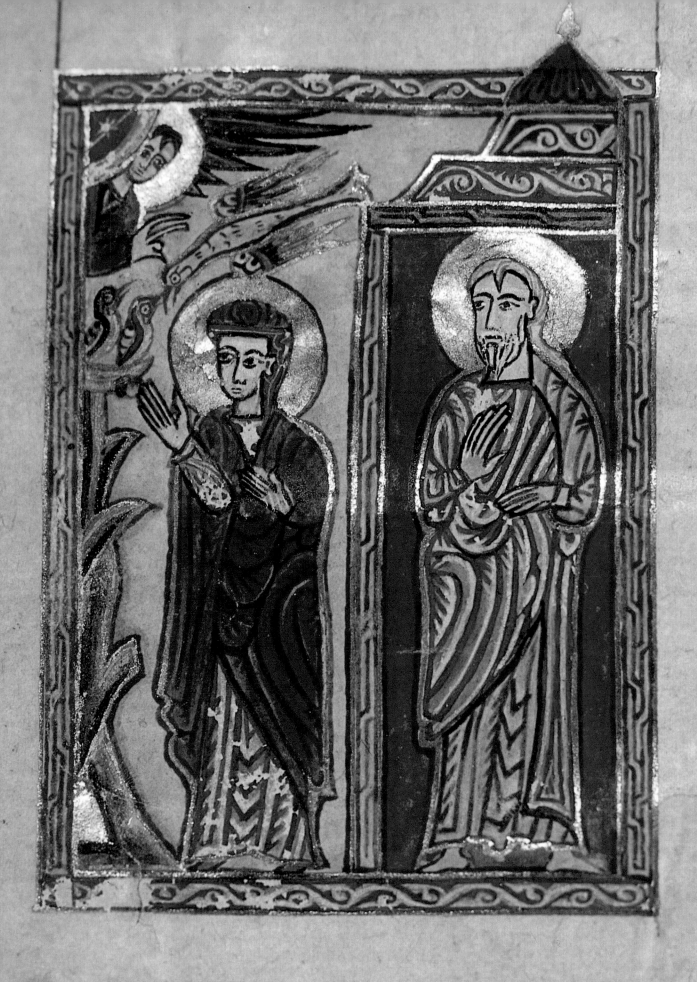

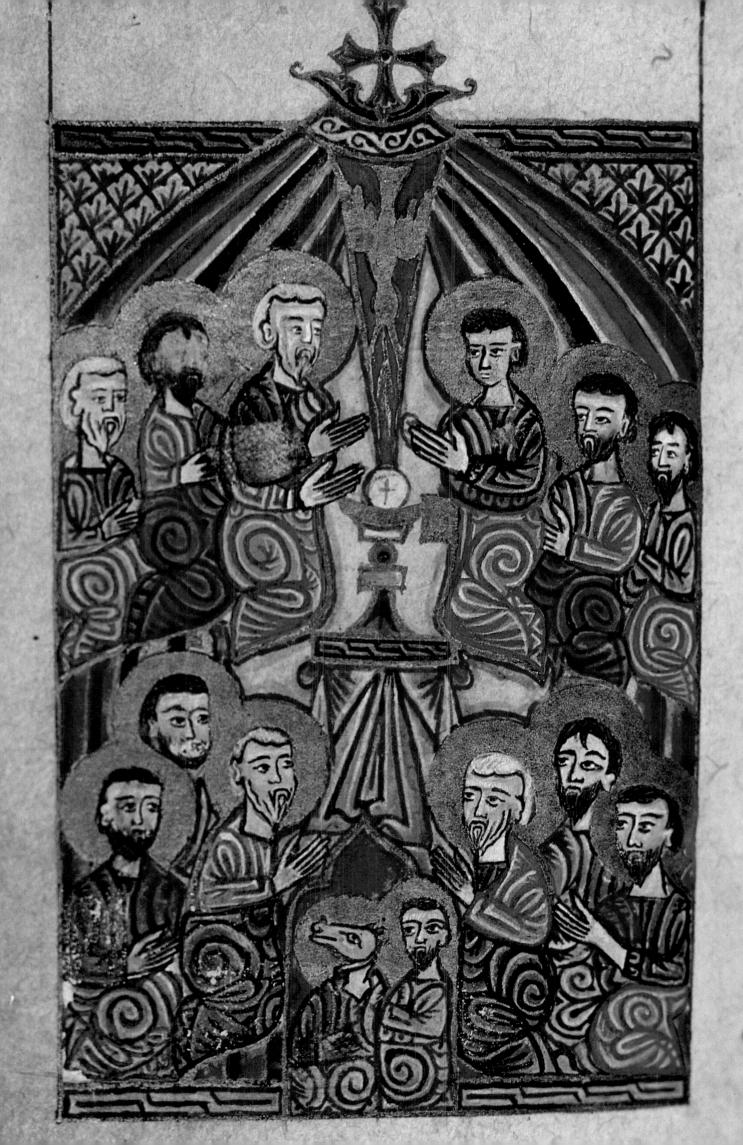

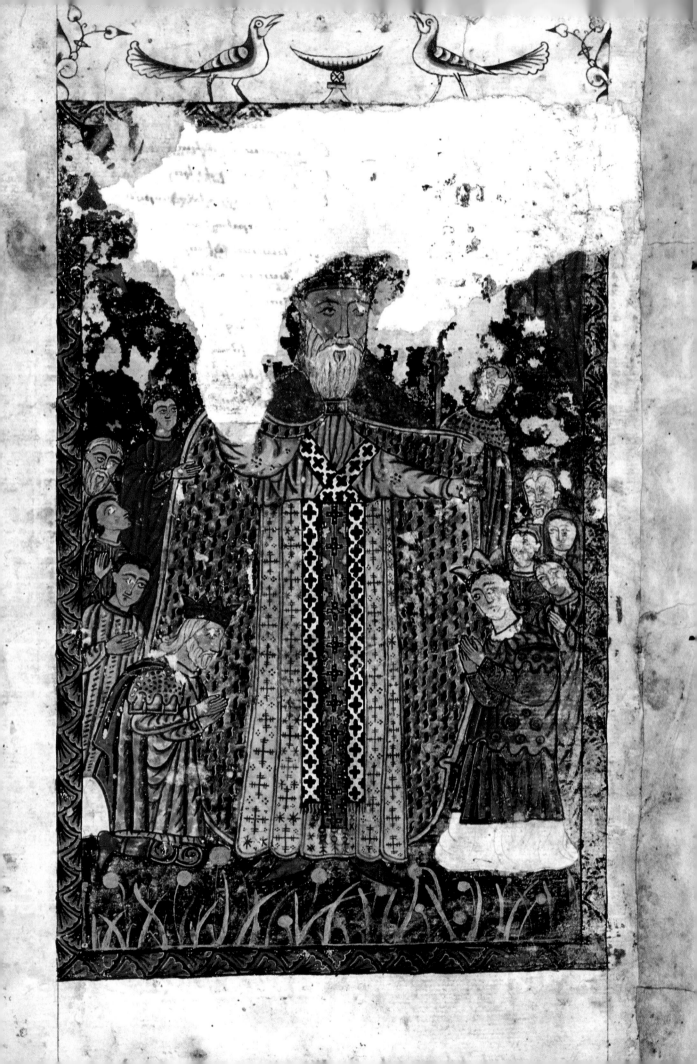

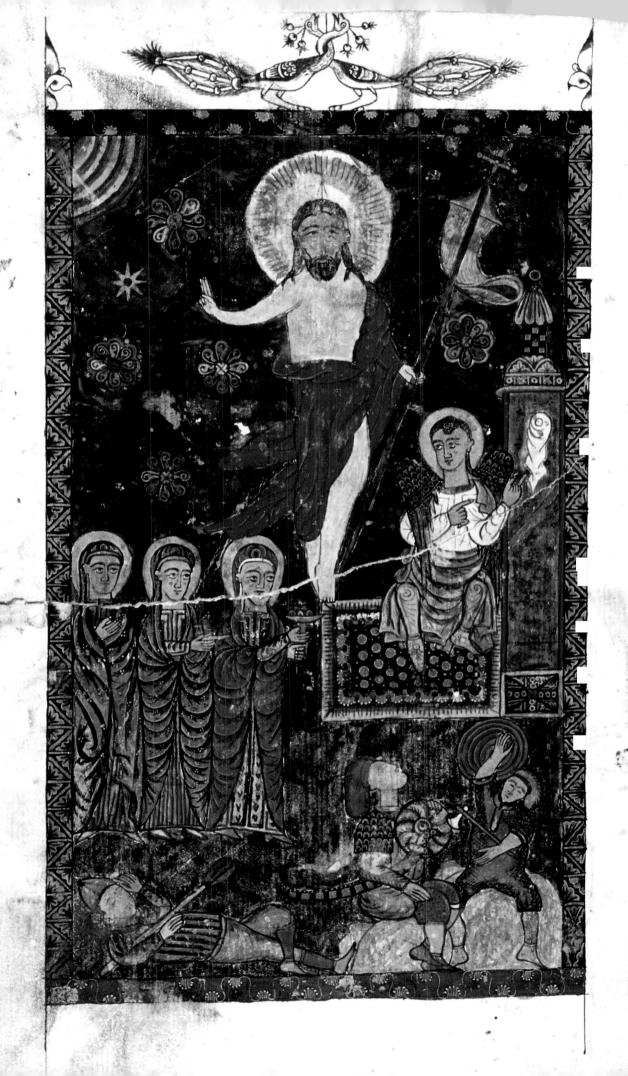

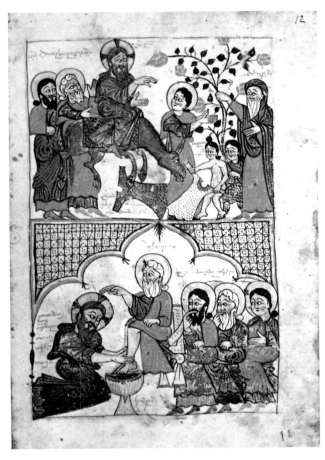
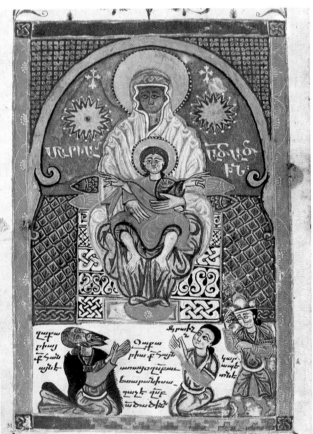
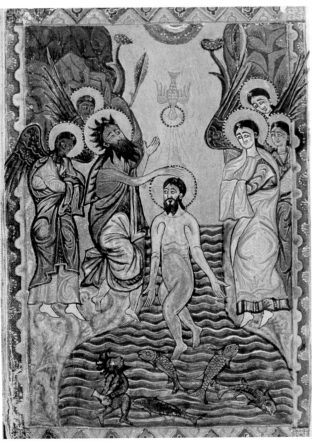

92. *Annunciation,* gospel book of Vaspurakan, 1330. Matenadaran Manuscript Library, Erevan.

93. *Entry into Jerusalem. Washing of the Feet,* gospel book of Vaspurakan, 1330. Matenadaran Manuscript Library, Erevan.

94. *Mother and Child and Donors,* gospel book of Xizan, 1368.

95. *Baptism,* gospel book of Xizan, 1368.

an intimate scene represents the wife and sister of Hohvannes; sitting on the ground, one is spinning and the other is holding her young child in her arms."[34] The garments are in the fashion of the period, but the painting remains closed to any naturalistic tendency. Humans, nature, things are in conformity with idyllic prototypes which persist from one generation to the next. Painters introduce secular elements into religious scenes and integrate them by "spiritualizing" them. The Magi are clothed in the Eastern fashion and their *ṭirāz* are woven with a pseudo-Arabic inscription. The groom of the wedding at Cana is a young Armenian proudly holding a sword in his hand. Bishop of bishops, Christ, wearing an Armenian chasuble, washes his disciples' feet. The watercolor added to the drawing reinforces the freshness of the scenes which follow one another from page to page and from manuscript to manuscript.

At the same time, a parallel tradition continues to draw from the great Byzantine art. Of course, Greater Armenia is not ignorant of this current, but its true center is in the Lesser Armenia of Cilicia. The miniature, learned, refined, and perfected can be ranked with the great paintings of the thirteenth and fourteenth centuries. One of the earliest works representing this school would seem to be a manuscript of the Elegies of St. Gregory of Narek. Dated 1173, it is adorned with four portraits of the great Armenian poet. He who regarded himself as "the last of the authors and the least of the masters" appears successively sitting at his writing, standing holding a book, standing with hands extended in a gesture of devotion, and finally prostrate before the enthroned Son. With his bent body, the Saint humbly lifts his eyes toward the Son of the Living God: "You look on me with your customary kindness and immediately I am able to contemplate you, to implore you."[35] These illuminations partake of the same inspiration as the decorations of churches. Their manner of execution belongs to the Byzantine-Oriental style: the painter enlarges the faces and diminishes the bodies while harmoniously maintaining the Greek way of rendering flesh tones, folds of garments, and ar-

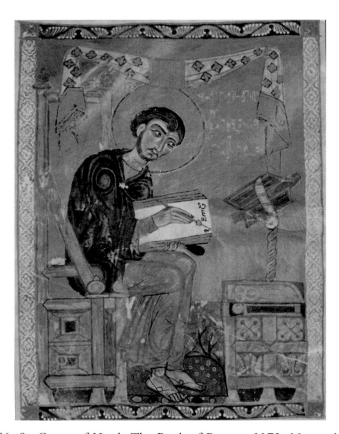
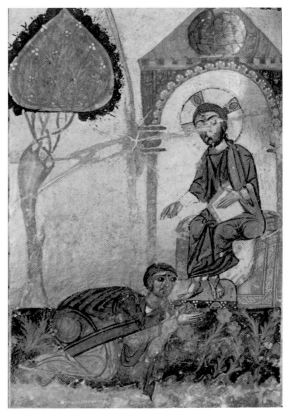

96. *St. Gregory of Narek,* The Book of Prayers, 1173. Matenadaran Manuscript Library, Erevan.
97. *St. Gregory of Narek before Christ,* The Book of Prayers, 1173. Matenadaran Manuscript Library, Erevan.

chitectural elements. The space dominated by the gold background heightens the Byzantine character of these stylized portraits. Only the fantastic red tree which grows behind the prostrate poet seems to come from Arab painting.

Great Cilician painting matures during the thirteenth century. Miniaturists have mastered their art and practice it with consummate subtlety. Kirakos seems to be the first in this line of painters. A gospel book[36] illuminated in 1248 fully reveals this school's plastic vigor. The master fashions his images and ornaments with assiduous finesse and care. Eusebius' letter, the ten canons, the dedication in verse, and the marginal decorations are masterpieces of ornamental painting. The four Evangelists' portraits embody in a striking way the glorious Byzantine tradition. Sumptuous, learned, and refined, Kirakos' style marks the birth of the Cilician school. The most illustrious of this movement remains the towering Toros Roslin. The life of this monk, whose name suggests a foreign origin, is unknown to us. A scribe and painter, he works in Hromkla and directs the patriarchal scriptorium during the third quarter of the thirteenth century. His production comprises seven manuscripts executed between 1256 and 1268. Three other manuscripts are attributed to him. The painter closely shares in Byzantine art which, from the Comneni to the Palaeologi, renews itself and becomes more human-oriented while remaining profoundly rooted in the tradition crystallized at the time of the Macedonians. The figures are set against a gold sky; the modeling and movement are freer; attitudes and gestures are animated and lively. Hieratism is quickened by a dramatic breath; the plasticity of the colors suggests a subtle and restrained interplay of light and shadow; the bodies are lithe, and the faces, solemn and serious, silently reflect the souls in their innermost depths. Toros remodels traditional compositions and recreates them in his own way. Clothed in luminous white, the Christ of the Resurrection floats against a background of pure gold; hell is transformed into a fortified city, and the number of its inhabitants is reduced to five. The Crossing of the Red Sea links, according

PL. 26,27

PL. 28,29, 30,31

PL. 25b

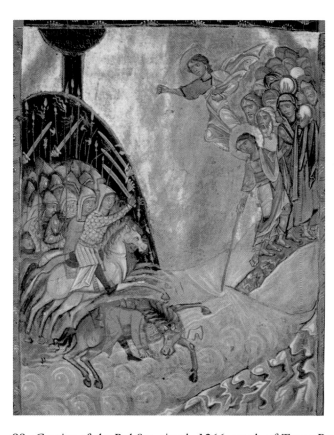
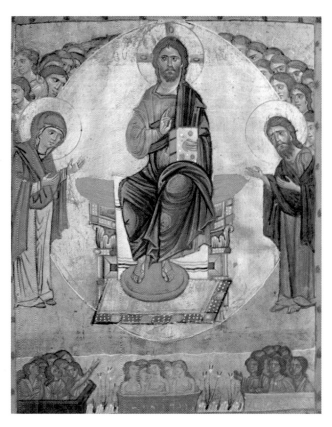

98. *Crossing of the Red Sea,* ritual, 1266, work of Toros Roslin. Armenian Patriarchate, Jerusalem.
99. *The Last Judgment,* gospel book, 1268, work of Toros Roslin. Matenadaran Manuscript Library, Erevan.

147

to the continuous style, the successive events of the miracle at the sea: the Egyptian army and the Jewish people are in opposite groups separated by the blue fringe of the sea; Moses lifts his staff to divide the waters while above him, the Angel of God flies, brandishing its sword; the dark column of cloud is set off by the gold background and covers the Egyptian troops with a black veil; attired in the purple costume of a *basileus,* Pharaoh is thrown down in the middle of the sea; standing behind Moses, Israelite women hold their tambourines aloft as a sign of victory. The scenes arranged on many levels offer stunning details. On the lowest part of the Last Judgment, the painter creates a woeful damnation scene: the unconcerned rich man implores Abraham to send Lazarus to refresh him; between the two protagonists, a Cherub lifts its sword in order to prevent the damned man from crossing the boundary between the sheep and the goats.

The miniaturists are passionately fond of ornaments. The initial pages, the tables of the canons, and the margins are covered with new kinds of flowers. Kufic arabesques are joined to French fleurs-de-lis. Blue is conjugated with gold according to a method which is similar to that of Islamic illumination. The Cross is everywhere; garlands are adorned with palms, acanthus, small flowers, and festoons. "The place of your paradise is great," a Christian psalm says, "nothing is sterile there; everything is heavy with fruit."[37] Innumerable animals populate this found-again Eden: "the four-footed beasts with all their species, and the winged creatures which live in the air,"[38] familiar and docile, fabulous and composite. Peacocks are intertwined around the life-giving Cross; doves drink from a fountain; herons surround a large vase; roosters challenge one another; a falcon pounces upon a duck; having come from faraway China, lion-dogs and serpent-dragons find their places in this ancient bestiary.

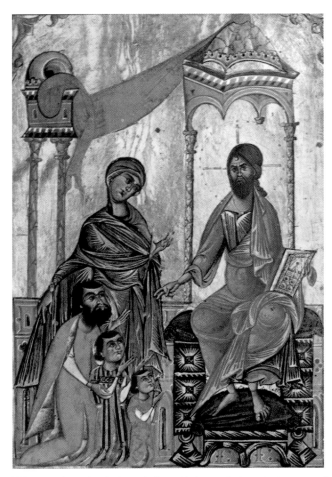
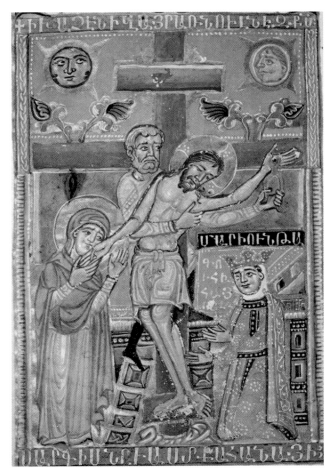

100. *Vasak and His Sons before Christ and the Virgin,* gospel book of Vasak, 13th c. Armenian Patriarchate, Jerusalem.
101. *Descent from the Cross,* gospel book of Queen Marium, 1346. Armenian Patriarchate, Jerusalem.

From the beginning, the kingdom of Cilicia maintains very close ties with the Latin world. Paradoxically, this shared history leaves but few traces on Armenian artistic creativity. Miniaturists remain insensitive to Romanesque Bibles, psalters, breviaries, Gothic chronicles. The West which influences them is that of "the Greek manner," superbly represented by the Italian masters of the thirteenth and fourteenth centuries. The specifically Latin contributions are limited to a few symbolic signs. In the gospel book of Prince Vasak,[39] following the type of the Virgin of Mercy, the Mother and Queen lifts the folds of her cloak and places it on Vasak and his two sons kneeling before the throne of Christ. In a gospel book[40] of 1287, the Mother of God exchanges her traditional maphorion for the Gothic crown and robe of Notre-Dame. In a contemporary gospel book,[41] the crucified Christ and the good thief bear Latin crowns with three points. These borrowings are assimilated and the painters' styles remain firmly planted in the Byzantine tradition.

Sargis Pidsak is an exemplary witness of the Eastern current. A prolific painter, the last representative of Cilician painting illuminates a series of forty manuscripts during the first half of the fourteenth century. His style is clearly recognizable in the gospel book of Queen Marium,[42] produced at Sīs in 1346. Graphics and colors are definitely according to Eastern taste. In Byzantine tradition, the head is generally about one ninth of the total length of the body; in Sargis' miniatures, it is somewhere between one sixth and one fifth. Faces are enlarged, shoulders narrowed, and legs shortened. The background space is a simple one-dimensional plane and prolongs the horizontal strip in front, representing the ground. As in carpets of the time, space is reduced to a unified plane treated in flat perspective. Fulvous colors dominate; red, blue, and green are spread without transition in wide flat strips. Buildings are integrated in this space. Movements are stiff and action is expressed by simple gestures. In the Descent from the Cross, the Mother holds her Son's hand against her face. Kneeling, her hands uplifted to the Cross, Queen Marium takes the place traditionally occupied by the Apostle John. The Cross symmetrically divides the pictorial space from top to bottom; four leaves grow out of its arms and become stylized into arabesques.

Modern Times

The geographic map of the East becomes more fixed in the fifteenth century. The international melee is at an end and the borders are becoming stable under the Ottomans. However, the new empire continues to expand. In the seventeenth century, it reaches the east coast of the Adriatic and thus extends beyond the regions formerly occupied by Byzantium. An Armenian community is settled in Constantinople. The Armenian patriarchate is established in 1461: responding to a call from the sultan Muḥammad the Conqueror, Hovakim, bishop of Brusa and metropolitan of the Armenian colonies of Asia Minor, receives the titles and attributions that were given to the Greek patriarch in 1453. The Islamic central power confirms the "Armenian Orthodox Patriarch of Constantinople" and ratifies his religious and civil authority over all Armenians and also over the Monophysite subjects of the empire. According to the patriarch Malachia Ormanian, "From the day the patriarchal see and a strong colony were established in the capital of Turkey, this city became the center of the Armenian nation."[43] Just as in former days, Armenia finds itself between two warring empires. The wars between Ottomans and Ṣafavids ravage it in the sixteenth century, and the major part of the country falls into Ottoman hands. Shāh 'Abbās retaliates in the beginning of the seventeenth century and conquers eastern Armenia. An Armenian community, native to Julfa for the most part, is deported and settled in the vicinity of Esfahān where "the New Julfa" is founded. Very early, it becomes prominent in the business of Persian silk and actively participates in international commerce. The Armenian horizon extends from Greater Armenia to Turkish Armenia, Persian Armenia,

maritime Crimean Armenia, to the little fragmentary Armenias settled in Thrace, Bulgaria, Transylvania, Poland, Italy, and France.

Owing to historical events, whether internal or foreign, art continues to bear new fruit. Paintings, reliefs, metalwork, ceramics, textiles: everywhere, ancient iconography represents a multiplicity of styles stamped by neighboring traditions and cultures. Western European influences are added to Mediterranean, Persian, Caucasian, and Far Eastern influences. The West seduces the East and painting on easels becomes the fashion. Interior and exterior church decoration manifests a wild eclecticism, and it is not rare to see Armenian Saints, poorly painted in the European manner, dwelling in an Islamic setting adorned with flowery lattices. Cosmopolitan and composite, Armenian art of modern times has a many-faceted repertory. Its most accomplished works are those dependent on its two great traditions, illumination and funerary relief.

Always limiting itself to the relief, sculpture remains tributary to architectural decoration and tombstones. Sculptors continue to carve figures on a surface covered with geometric and floral arabesques. The ornamental background loses nothing of its strength and grandeur; however, animal and human figures rarely reach the peaks of former times. Schematic and rough, they are sometimes reduced to a low relief more akin to engraving than to sculpture. Remaining classical, non-religious themes repeat scenes of hunting, feasting, and music-making. Religious scenes favor the prominent gospel figures and those of donors in attitudes of prayer. Zoomorphic and floral elements are mingled with chains of branches, interlacing, torsades, and stars. These are found on spacious facades as well as on the limited surfaces of the khatchkars. The last architectural examples of Armenian art are found in many countries of Greater Armenia; examples of this are the monastery of St. Stephen to the west of Julfa, the great church of Ananuri in Georgia, the cathedral of Etshmiadzin, and, in Ararat, the church of the Mother of God in Kanakei. While keeping their sacrosanct crosses, the khatchkars develop fresh variations. The lacy ornaments become more elongated and transform the stone space into a tapestry. The human figures are merely linear silhouettes engraved with parallel lines. Either kneeling or on horseback, the donors lift their faces in prayer in order to glorify the Cross.

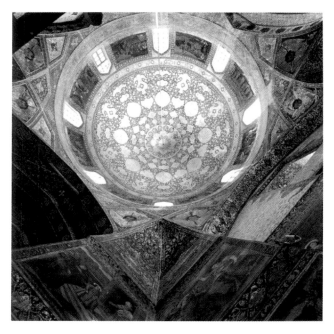 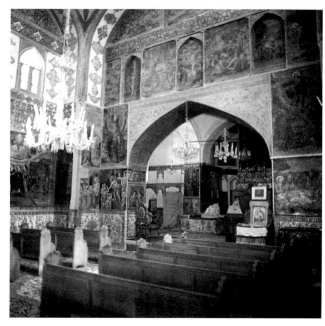

102. Cupola of the Church of Bethlehem. New Julfa (Esfahān).
103. Church of the Mother of God, 1610–1613. New Julfa (Esfahān).

150

The art of the miniature pursues its glorious course on the two paths of Byzantium and the East. Manuscripts of the more learned sort keep to traditional design. Everywhere signs of paradise reign. The skylight opens for "the holy dove, the color of gold."[44] The painter takes the "strait and narrow way" and enters through the "Sublime Gate,"[45] "following the example of the workers of the eleventh hour entering the vineyard of the garden of Eden."[46] The "class of the luminous ones" reigns over this regenerated world. Donors are found in prayer either at the level of the Deesis or before PL. 32,33 the ever-victorious Cross. Rather than narrating, the artists evoke events by reducing narrative scenes to sign-images fitting in the margins of the manuscripts. Busts are set against a plain background. The Massacre of the Innocents is illustrated by a soldier armed with a sword and holding a child by the feet. Simeon carries the Divine Child in his veiled hands. Christ cures the man born blind with a touch of his hand. Jonah emerges from the whale's mouth. Rows of crowns are set on the minuscule heads of the Martyrs of Sebaste gathered in a wide-mouth cup. A fig tree evokes the incident where Christ curses the fig tree. A rooster represents Peter's denial; a walled building, the Jerusalem Temple; a fish, the lake of Tiberias.

The miniatures in the Eastern style are a faraway echo of Timurid painting. Those showing the PL. 36,37 influence of Byzantium manifest an increasing attraction to the illusion of depth. Sometimes both tendencies mingle and work together. Two miniatures from a synaxarion[47] of 1658 admirably illustrate these unexpected and subtle interactions. In the first, the artist clothes St. Gregory the Illumi- PL. 46 nator with the mantle of the Virgin of Mercy and represents him with open arms covering King Trdat and the courtiers gathered at the Saint's feet. The theme follows a Western model, but the style retains its Eastern savor. The second miniature unites the two iconographies of the Resurrection. Thus, PL. 47 while taking up the Eastern model of the Holy Women before the empty tomb guarded by the Angel of the Lord, the painter borrows the Western representation of Christ rising and inserts it at the center of the background. The mode of execution is purely Eastern: the Angel's rock is replaced by a carpet carefully worked in a flat manner; the empty tomb is in the shape of an elegant mausoleum; four large rosettes with eight petals are set off by the Prussian blue of the background.

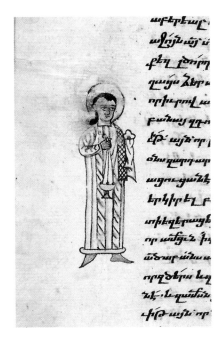

104. *Emperor Theodore,* synaxarion, 1658. Armenian Catholicosate of Cilicia, Anṭilyās, Lebanon.
105. *Massacre of the Innocents,* synaxarion, 1658. Armenian Catholicosate of Cilicia, Anṭilyās, Lebanon.
106. *St. Stephen,* synaxarion, 1658. Armenian Catholicosate of Cilicia, Anṭilyās, Lebanon.

Refined painting yields an important place to popular tradition. Rough, linear, and using primary colors, the design of the latter is dominant in late manuscripts and also in the innumerable small scrolls of the nineteenth century. Parallel to these dominant currents, Western painting leaves its stamp on the art of bookmaking. In the Middle Ages, Armenia communicates with Europe without participating in its art. The rare paintings showing Italian influence are executed in Italy, for example, the gospel book copied in Rome by the priest Timot, the lectionary transcribed in Bologna in 1324, and the gospel book copied in Perugia in 1331. In the second half of the seventeenth century, miniaturists become students of Western art by reproducing in their own way Italian and Flemish paintings popularized by engravings imported from Europe. They deliberately renounce the ancient prototypes for people, landscapes, and buildings in order to adopt, without much success, those of Dürer or de Bry.

Green Sunday

The Armenian people defines itself as "Armenian Christian worshiper of the Cross." The visions of Armenian Saints are dominated by the presence of a celestial Cross sparkling with light and standing among the columns of an immaterial Church. Liturgical prayers invoke "the intercession of the Immaculate and Virgin Mother of the only Son of God and of his holy and precious Cross." In the course of the celebration of Epiphany, the Cross is immersed in holy water in commemoration of the Baptism of Christ. Armenian art confesses its faith and makes the Cross its sign and "icon." Tree of Life, it blossoms in the center of the garden of the eighth day. Armenian tradition calls the Transfiguration the Feast "adorned with roses." The third Sunday after the Resurrection is called "Green Sunday." The commemorative inscription on one manuscript speaks of the exile "during which bread is bitter and water has the taste of blood."[48] Painting says nothing of this: devoted to the celebration of the Eternal, it multiplies the signs and images of an inner paradise. "A garden full of roses," says the painter Hagob Tjoughastsi, "blossoms like paradise in spring."[49] A garden watered by all the rivers of the world. A dwelling where the "Savior of all" reigns, "Jesus Christ, the dispenser of all riches,"[50] with his Mother, "True Queen," his Apostles, "who invited earth into heaven," and his Saints, "Angels in bodies and stars lighting the earth." Armenia disappears behind its Garden, bathed in the light of "the inextinguishable lamp of the Illuminator,"

the inexhaustible lamp, the torch of
Armenia—God's eye, always crystal-clear,
which watches over the world.[51]

Notes

1 Quoted by Karekin II, *Histoire vécue, nullement fictive* (Anṭilyās, Lebanon: Catholicossat Arménien de Cilicie, 1992) 42.

2 K. Chahinian, *Œuvres vives de la littérature arménienne* (Anṭilyās, Lebanon: Catholicossat Arménien de Cilicie, 1988) 29.

3 M. Ormanian, *L'église arménienne* (Lebanon: Anṭilyās, Catholicossat Arménien de Cilicie, 1954) 19.

4 J.-M. Thierry, *Les arts arméniens* (Paris: Mazenod, 1987) 48.

5 Hypatios of Ephesus. Quoted by ibid., 40.

6 Theodore of Siounie. Quoted by J. Mécérian, *Histoire et institutions de l'église arménienne* (Beirut: Imprimerie Catholique, 1963) 77.

7 Ormanian, *Église arménienne*, 84.

8 C. Delvoye, *L'art byzantin* (Paris: Arthaud, 1967) 112.

9 Mécérian, *Histoire et institutions*, 84.

10 E. Sivan, *L'Islam et la croisade* (Paris: Maisonneuve) 10.

11 K. Otto-Dorn, *L'art de l'Islam* (Paris: Albin-Michel, 1967) 85.

12 S. Der Nersessian, *L'art arménien* (Paris: Flammarion, 1989) 247. Sirarpie Der Nersessian, *Armenia and the Byzantine Empire: A Brief Study of Armenian Art and Civilization* (Cambridge: Harvard University Press, 1945).

13 Thierry, *Arts arméniens*, 173.

14 Der Nersessian, *Art arménien*, 93.

15 Thierry, *Arts arménien*, 179.

16 Library of the Monastery of Saint Lazarus of Venice, no. 1144.

17 Erevan, Matenadaran Manuscript Library, no. 2374.

18 Ibid., no. 6201.

19 Ibid., no. 7736.

20 A. Micha, trans. and ed., *Les enfances du Christ* (Paris: Aubier, 1993) 180.

21 Jerusalem, Armenian Patriarchate of Jerusalem, no. 2556.

22 Der Nersessian, *Art arménien*, 107.

23 A. Brissaud, *Islam et Chrétienté* (Paris: Robert Laffont, 1991) 240.

24 Alexius III Angelus. Quoted by Mécérian, *Histoire et institutions*, 109.

25 Karekin II, "L'église: L'Arménie œcuménique," C. Mutaffian, *Le royaume arménien de Cilicie* (Paris: CNRS, 1993) 151.

26 Quoted by C. Mutaffian, ibid., 84.

27 John Chrysostom, *Homily on the Providence of God.* Jean Chrysostome, *Homélie sur la providence de Dieu*, G. Peters, *Lire les Pères de l'Eglise* (Paris: Desclée de Brouwer, 1981) 609.

28 Nerses the Gracious (Snorhali), *Jesus Only Son of the Father* (734). Nercès Snorhali, *Jésus Fils unique du Père*, SC 203 (1973) 182.

29 Ibid. (872) 210.

30 P. Claudel, "Ode I: Les muses," *Cinq grandes odes* (Paris: Gallimard-Poésie, 1975) 41.

31 Matenadaran, no. 7729.

32 Ibid., no. 6288.

33 New Jufla, no. 36 (Gospel of 1236).

34 S. Der Nersessian, *Miniatures arméniennes d'Isphahan* (Bruxelles: Les éditions d'arts associés) 93.

35 Gregory of Narek, *Prayer 1.* Grégoire de Narek, *Prières* (Orphée-La Différence, 1990) 79.

36 Anṭilyās, Lebanon, collection of the Armenian Catholicosate of Cilicia.

37 A. Hamman, *Livre d'Heures des premiers chrétiens* (Paris: Desclée de Brouwer, 1982) 36.

38 Nerses the Gracious, *Jesus Only Son* (45). Nercès Snorhali, *Jésus Fils unique*, 47.

39 Armenian Patriarchate of Jerusalem, no. 2568.

40 Matenadaran, no. 197.

41 Ibid., no. 7651.

42 Armenian Patriarchate of Jerusalem, no. 1973.

43 Ormanian, *Église arménienne*, 68.

44 Nerses the Gracious, *Jesus Only Son* (49). Nercès Snorhali, *Jésus Fils unique*, p. 48.

45 Ibid. (432). Ibid., 125.

46 Ibid. (638). Ibid., 172.

47 Armenian Catholicosate of Cilicia.

48 Quoted by L. Dournovo, *Miniatures arméniennes* (Galerie d'art de R. S. S. d'Arménie, 1967) 35.

49 Ibid., 176.

50 V. Godel, *La poésie arménienne* (Paris: La Différence, 1990) 19.

51 H. Toumanian, "La lampe de l'Illuminateur," Godel, ibid., 109.

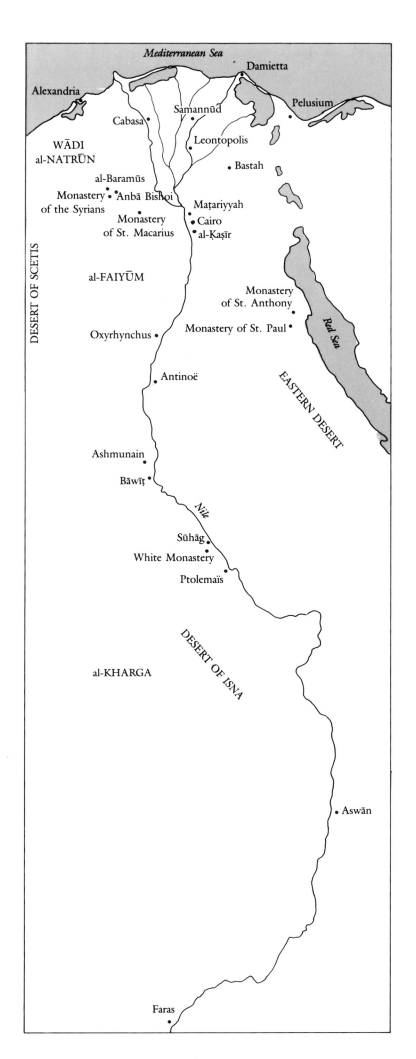

EGYPT

CHAPTER SIX

The Egyptians

Obeying Yahweh's call, Abraham leaves his country and journeys "on by stages" through the land of Canaan and reaches Egypt, where he sojourns (Gen 12). Joseph is given "authority over the land of Egypt" by Pharaoh. "For," he says, "God has made me fruitful in the land of my misfortunes" (Gen 41:52). Adopted by Pharaoh's daughter, Moses is "instructed in all the wisdom of the Egyptians" (Acts 7:22). As a child, Christ is taken into Egypt to escape Herod's persecution. The liturgy says: "He whom Angels praise came today to the provinces of Egypt in order to save us, his people. Rejoice and exult, O Egypt, with your children and all that lies within your boundaries, because he came to you, he, the friend of humanity, the One who was before all ages."[1] According to Coptic tradition, this stay lasted for three and a half years. The apocrypha retrace in detail the steps of the journey. They go from Bastah to Minyat Samannūd. At Maṭariyyah, the Holy Mother and Child rest at the foot of a tree whose balm will serve for a long time in the preparation of holy chrism. Later, the Holy Family come to Cairo. At Sotin, idols totter and fall in the temple when Emmanuel goes by: "The idols of Egypt will tremble at his presence, / and the heart of the Egyptians will melt within them" (Isa 19:1). God makes himself known to the Egyptians. Finally, they arrive at Qūṣiya. Touched by grace, a brigand named Titus spares the exiled family; tradition identifies him with the good thief on Golgotha and calls him "thief of the reign." Struck by the indescribable beauty of the Child, a man from the Ermont announces to his companions the arrival of a king's son who will overturn all images of the gods; he is murdered and wins, long before St. Stephen, the crown of the first martyr. Hosea's oracle is twice fulfilled: God calls his Son from Egypt after Herod's death; and, once risen, Christ goes back to the mountain at Qūṣiya, near his childhood home, where he gathers his Mother and Apostles in order to entrust them with his last instructions before his Ascension.

St. Mark founds the Church of Egypt. "The city of Alexandria has become the mother of all the cities of Egypt because it welcomed Mark, the Father, the Evangelist, the Apostle, who initiated its inhabitants into the faith."[2] From Rome through Venice to the Cyrenaican Pentapolis, the "Contemplator of God" returns to Alexandria where, on the day after Easter, he dies, a Martyr at the hands of the worshipers of Serapis. Cosmopolitan and multicultural, the great metropolis of the Hellenistic East becomes one of the principal centers of Christianity in its period of development. The in-depth allegorical exegesis of the Scriptures is on-going, and about 180, the Catechetical School opens its doors. Greek wisdom and Jewish miracles are both interpreted in the light of Christ. Doctrinal and mystical, the "True Knowledge" attacks the varied paganisms as well as the many gnosticisms. Alexandria gives the Church its "Greek" Fathers: Clement and Origen ponder the mysteries

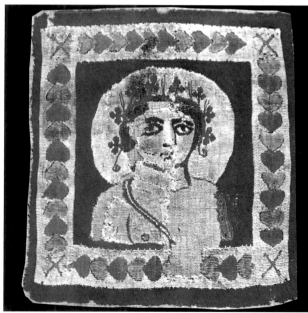
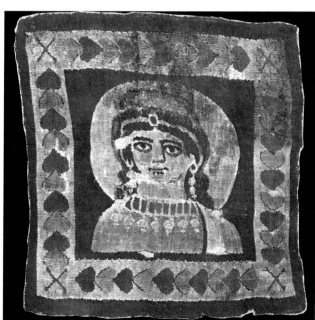

107. *The God Nile,* 2–3rd c. Pushkin Museum, Moscow.
108. *The Goddess Gē,* 2–3rd c. Pushkin Museum, Moscow.
109. *Dionysus,* 5th c. The Louvre, Paris.
110. *Ariadne,* 5th c. The Louvre, Paris.

hidden behind biblical reality; Athanasius confesses the divinity of the Son and his consubstantiality with the Father; and Cyril strenuously affirms the hypostatic union in the Incarnate Word. At the time of these doctrinal disputes, monasticism is born with "the ascent to the desert" of the great ascetics. St. Paul of Thebes withdraws to live the eremitical life; St. Anthony intuitively founds monasticism; St. Pachomius organizes cenobitical life. The Desert Fathers engage in spiritual combat in order to attain "the divine measure."[3] Questing for the Parousia, the Solitaries spend their lives in pure prayer before lying down toward the east to give their souls back to God.

The antagonism between Alexandria and Constantinople worsens in the sixth century. The council of Nicaea in 325 names Alexandria immediately after the Church of Rome. In 381, the second ecumenical council grants preeminence of honor to the bishop of Constantinople after the bishop of Rome. Constantinople is honored with the title of "new Rome and second after it." At the council of Ephesus, Alexandria triumphs: Nestorius is deposed and exiled to the far recesses of the Egyptian desert. Ecclesial rivalries and national ambitions are intermingled with Christological controversies. Doctrinal battles are accompanied by secessionist wars. The council of Chalcedon divides the Christian East. Alexandria and Antioch join forces in one common battle. While confessing "the unique nature" of the Incarnate Word, St. Severus of Antioch purifies "Alexandrian" Christology from all trace of Eutychianism. The Syrian St. Jacob Būrd'ānā consecrates twelve bishops and thousands of priests in Egypt. The arrival of the Arabs completes the break with Byzantium. Egypt finds itself integrated into the Umayyad empire of Damascus, and the conquerors give the name "Copts" to its people. The word means "Egyptian"; it is an Arabic abbreviation *(qubt)* of the Greek *Aiguptos,* and with the Islamization of the country, it becomes synonymous with "Egyptian Christian."

Early Coptic Art

Byzantine Egypt bequeaths an extremely rich artistic legacy. Greco-Roman tradition leaves a profound imprint. Pharaonic reminiscences are rare. The ankh survives: the hieroglyph meaning "life" becomes the sign of the "immortal life-giving wood." Engraved on the funerary stelae of Christians, it crowns the epitaph which implores the "life-giving" Cross to give "life and rest" to the dead. The Greek heritage remains alive. Heroes, myths, and legends continue to inspire artisans. Painters, sculptors, and weavers take up the eternal images of the Greco-Roman legacy: Dionysus, Aphrodite, Leda, Apollo, Daphnis, Orpheus, Artemis, and Pan remain familiar subjects until the seventh century. Nereids, tritons, the Graces, fauns, and chimeras populate the scenery. Parthian horsemen also appear. The common artistic culture mixes together themes, symbols, and signs of the Mediterranean milieu. Themes are still indebted to antiquity, but their treatment evolves toward a new style. Along with the academic tradition, Egypt veers toward an Eastern style dominated by schematism and hieratism. In the Hermitage Museum, the goddess Geb and god Nile figure on two tapestries of the third century: the anatomy, modeling, and treatment of the garments' folds are patterned on the canons of the Roman portrait. In the Louvre, Dionysus and Ariadne have new visages: the work—woven in the fifth century—is in the Coptic style. Forms become more geometric and colors lack any shading. Reduced to a flat disk, the head rests on narrowed shoulders. Large globular eyes accented by thick black eyebrows dominate the summarily drawn features of the face. Although it is faithful to the Greek memory, this Coptic creation shares in this transitional art which announces the all-important tradition of the Christian East. The many sculptured works show the same characteristics. The Palmyrene traits are pushed to the extreme: artists diminish the size of bodies and enlarge that of faces. The modeling is less pronounced and simplified. Sculpture abandons the round and limits itself to the relief. The dying gods of late antiquity are orientalized before they altogether yield their place to the heroes of God.

Human portraits are sacralized. Independently of Christianity, the funerary art of the Faiyūm prepares for the Christian art still to come. The gallery of these faces of the "dead" suggests two tendencies. The first one is faithful to the canons of antiquity and constitutes a precious ethnographic testimony to that era. The second manifests its originality by "idealizing" the faces of its models. With its fixed look, large eyes, thin nose, and closed lips, the spiritualized portrait prefigures the iconic face. The features "reproduce those of the dead person, but the way they are treated ushers in a transcendence open, if not favorable, to the Incarnation. This will be achieved by Byzantine art through the means of its incorruptible gold."[4] Executed by the encaustic method, the oldest icons which have survived to our times are akin in their technique to the Roman-Egyptian portraits of the Faiyūm. And far from arriving at the pure iconic model, their style reveals the same twofold tendency. Mediterranean currents are different but not separate: antique works belong to the school of Constantinople; Greco-Oriental ones to the Syro-Palestinian school. Specifically Coptic works are clearly distinct from these. The most original of these pieces is Christ and St. Menas in the Louvre. The "Loving Friend" has his arm around the Prior's shoulders and presents him to viewers. The gesture recalls that of the pharaonic god Anubis as he introduces the pharaoh to the realm beyond. Represented facing forward, the two stand against a background of hills drawn on an orange-ocher space. Christ's tunic, his halo inscribed with a cross, and his gospel book encrusted with pearls presage the model of the Pantocrator that is to become traditional. The folds, simplified to ample curves, derive from the Greek method of treating garments, but the proportions are typically Coptic: the bodies are minuscule; the faces, enormous; Christ's head is slightly larger than St. Mena's. The schematic features focus on the gaze: the artist rounds the almond-shaped eyes and circles them with lines; black eyebrows accentuate the fixity of the gaze. Hieratic and immobile, these faces radiate humble meekness and restraint.

Christian Egypt elaborates its style far from the illustrious Alexandrian school. Without pretending to emulate great, refined art, the Coptic tradition develops and prevails. Neither sophisticated

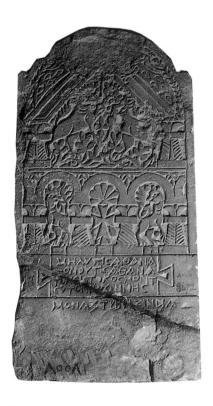 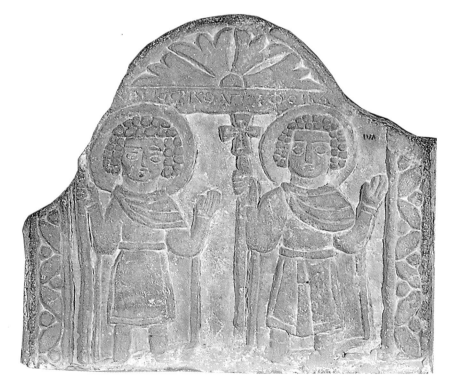

111. Stele, 4–5th c. Museum of Coptic Art, Old Cairo.
112. *Two Holy Legionaries,* 5–6th c. Museum of Coptic Art, Old Cairo.

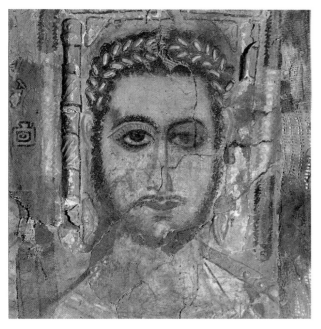

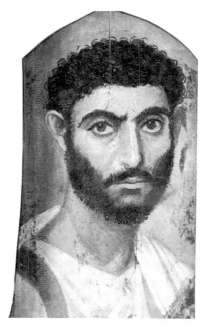

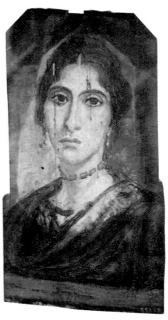

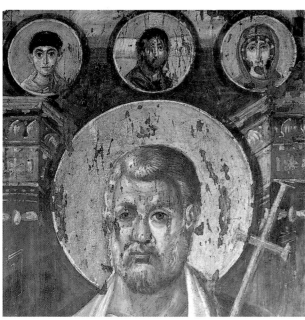

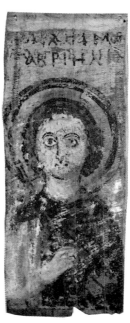

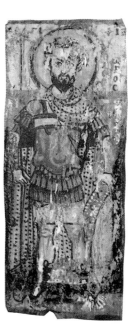

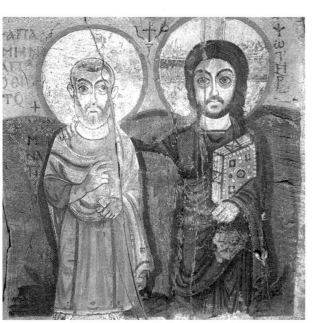

113. *Portrait of a Man*. Museum of Coptic Art, Old Cairo.

114. *Portrait of a Man*. Egyptian Museum, Cairo.

115. *Portrait of a Woman*. Egyptian Museum, Cairo.

116. *St. Peter,* 6–7th c. Monastery of St. Catherine, Sinai.

117. Biface icon: *Archangel,* 6th c. Museum of Coptic Art, Old Cairo.

118. Biface icon: *St. Theodore,* 6–7th c. Museum of Coptic Art, Old Cairo.

119. *Christ and St. Menas,* 6–7th c. The Louvre, Paris.

159

nor popular, art unmistakably attests to this strong spiritual force which nourishes and strengthens it. In the oasis of al-Kharga, the funerary chapels of al-Bagawāt preserve the earliest Coptic mural paintings. Thought to date back to the fifth century, they present a biblical cycle in a singular style. Recognizable are The Hebrews Leaving Egypt, The Fall of Adam and Eve, Daniel in the Lions' Den, The Three Youths in the Furnace, The Story of Jonah, The Sacrifice of Abraham, The Ark of Noah; and there are other unidentified scenes. The choice of subjects from the Old Testament is typically Christian. By announcing "typologically" the salvific action of the uni-trinitarian God, the events narrated there prefigure those described in the New Testament. The inscriptions are in Greek. People are represented in landscapes freely adorned with vineyards, clusters of grapes, flowers, and birds. The execution is sometimes polished, sometimes awkward and unskilled. While taking their inspiration from paleo-Christian funerary art, the artists seek to represent a two-dimensional space which they never quite succeed in stabilizing. As O. Wulff has described it, "lively in its power of evocation," the work belongs to an "art of a back-country in the wild but full of freshness."[5]

PL. 49

The mural painting of pre-Islamic Egypt is also known to us through the renowned frescoes of the monastery at Bawīṭ in upper Egypt. Compared to the works produced in Constantinople, Salonica, or Ravenna, these paintings appear at first sight to be a provincial branch of Byzantine art. The ensemble is by no means sumptuous. The technique is reduced to elementary methods. However the plastic language has a remarkably expressive strength. The design is cleverly sketched with a sure and skilled line. The colors are vivid and simple; the outlines are enhanced with small touches in half-tints. The monastery was founded by the holy monk Apa Apollo, the "friend of the Angels," who is represented several times on the walls. The artistic program is of great richness. To the abundant images of Christ, Prophets, and Saints are added vast decorative compositions which adorn the walls and ceilings. Mediterranean iconography survives in a lion hunt, a gazelle hunt, branches teeming with life, braided foliage, and garlanded curves. Variations witness to the evolution of a universal Christian art: Christ, now youthful and beardless, now mature and bearded. The main Coptic tendencies take shape. Abstraction and the trend toward geometric forms are powerfully manifested. Impassive faces are enlivened by souls grown more steadfast, attached to God forever. Beings are endowed with monastic virtues whose twelve attributes are listed on the walls of a chapel: "forbearance, peace, meekness, charity, hope, faith, continence, mercy, virginity, patience, wisdom, and chastity."[6] Movements are restricted to repetitive gestures. Overarching hieratism sometimes transforms the fixed prototypes. The vault of a chapel is adorned with a painting on two levels. On the first, Christ, flanked by two Angels, is enthroned under the sun and moon and in the center of a mandorla supported by the four symbols of the Evangelists. On the second, "True Vine Bearing the Cluster of Life," the Mother with the Child is seated in majesty in the midst of the Apostles. The superposition of the two scenes is inspired by the Ascension. The painter eliminates the action of the agitated Apostles and represents them all full-face, standing and immobile, each holding with both hands a richly bound gospel book. "As the emperor's soldiers do not dare look right or left when they stand at attention," says Abba Serapion, "so it is with human beings when they stand before God and look straight ahead in awe at all times; then they have nothing to fear from the enemy."[7]

Coptic iconography becomes purer and more codified. The work of the seventh century announces that of the medieval period. Bodies stiffen and are transformed into columns. The Egyptian iconic face attains its norm: like the Cherubim and Seraphim, it is "but one eye."[8] The ornamental figures are flattened and take one-dimensional shapes. Islamic stylization begins. Anthropomorphic and zoomorphic motifs harmoniously alternate with abstract geometric motifs. Deer and birds are joined to lattices and interlacing. A circle of fish evokes "the water of life, bright as crystal, flowing from the throne of God and of the Lamb" (Rev 22:1). The Incarnate Word takes the "pure fish" and leads them from "the hostile wave"[9] to the Father's dwelling.

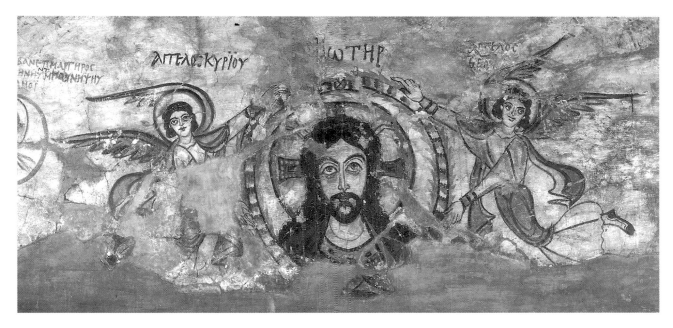

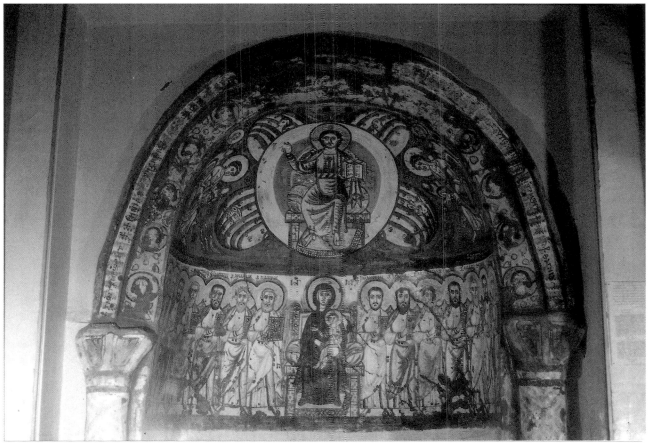

120. *Christ* in a medallion, Bawīṭ, 7th c. Museum of Coptic Art, Old Cairo.
121. *Ascension*, Bawīṭ, 7th c. Museum of Coptic Art, Old Cairo.

In 639, Egypt falls under Arab power. Islamic dynasties succeed one another. From the Umayyads to the 'Abbāsids, Egypt becomes progressively Islamized and arabized. Now integrated, now marginalized, now oppressed, the Copts undergo the ever alienating conditions of socio-political history. Their original insurrections are followed by waves of oppression. In 829, their revolt in the lower Delta is violently suppressed. Followed by a vast number of conversions to Islam, it marks the "end" of a period. The chronicler al-Maqrīzi writes: "From then on, God subjugated the Copts over the whole Egyptian territory and their power was definitively crushed; no one was able to resist the government, and the Muslims won the majority in the villages. The Copts reverted to their system of deception in their dealings with Islam and the Muslims, and thus succeeded in assuming the charge of collecting the tax."[10] The number of Egyptian Christians shrinks: the community is only one part of a country with a Muslim majority. However, the Church remains alive; and in spite of repeated edicts and revocations, the Copts continue to occupy public posts. The socio-economic difficulties of the central power often go hand in hand with numerous discriminatory measures, such as increases in taxes, extension of the poll tax to the clergy, prohibition of processions, and many vexatious prescriptions relating to the manner of dress. The government of Ibn Ṭūlūn rules Egypt independently from Baghdād. The relations of those in power with the Christians are extremely kindly. The Copts have access to administrative positions and take part in public life. The advent of the Fāṭimids in the tenth century strengthens this favorable state of affairs, and Egypt has its own Christian officials. In the thirteenth century, Bar Hebraeus writes: "At that time, Christians could be appointed viziers in the Arab kingdom of Egypt without changing their faith. Such is not the case nowadays: if they do not become Muslims, they are not entrusted with the office of vizier."[11]

According to a Coptic legend, al-Mu'izz, the first Fāṭimid caliph and founder of Cairo, asks the Copts to move mountains by their faith and thus accomplish the word of Christ. "Muslims, Jews, and Christians were standing at the foot of the mountain which is near the Basin of the Elephant. At the Christians' prayer, the mountain immediately pulled itself from the ground and began to slide before the eyes of al-Mu'izz and the whole people."[12] Marvelling at this spectacular miracle, the caliph orders the churches repaired, turns over his power to his son al-'Azīz, receives baptism, and withdraws to a monastery. Al-'Azīz has a Christian wife and his two brothers-in-law are the Melchite patriarchs of Alexandria and Antioch. The ascent of his son to the throne ushers in a painful parenthesis: a crowned madman, al-Ḥakīm bi-'Amr Allāh strikes at his whim Jews, Christians, and Muslims. "Suffering a deranged brain,"[13] this cruel despot behaves like a new Caligula, governing and legislating according to his caprices and vagaries. R. Hartmann sees in his violence against Christians the only official persecution aimed directly at Eastern Christianity. Although he maintains some Christian viziers in their positions, he undertakes the destruction of churches and razes the church of the Resurrection in Jerusalem. Toward the end of his reign, the tyrant engages in counter-politics. Thus, he legalizes apostasy and allows converts to return to their original religion. Some churches are built with his aid. Resuming contact with Christians, he frequents monks and mysteriously "disappears" on his way to the monastery of al-Kaṣīr. Wounded and exhausted, the Church catches its breath after this distressful bloodletting, and the successors of al-Ḥakīm give it their help and support.

The crusaders' wars and the inter-Muslim struggles muddy the waters. Saladin puts an end to the reign of the Fāṭimids in 1169. Ayyūbid sovereigns govern Egypt. Fearing to see the cathedral of St. Mark in Alexandria transformed into a fortress by the crusaders, he orders it demolished. At the same time, he grants the Copts a monastery, called "the Sultan's Convent," adjacent to the Holy Sepulcher. The Arab-Latin wars sometimes turn against native Christians. In 1218, ten thousand Copts fleeing from persecution take refuge in Ethiopia. In 1349, more than one hundred churches are demolished after the ephemeral victory of Louis IX in Damietta. Two years later, Egypt falls to

the power of the Mamlūks. Once more, discriminatory measures are leveled against Christians. A civil "war" breaks out in 1320. Al-Maqrīzi relates the Muslims' furor and the Christians' rebellion in great detail. The former destroy churches and the latter retaliate by burning down mosques. Muslim revenge causes the destruction of sanctuaries and the forced conversion of a great number of Copts. Only the intervention of the authorities saves the Copts from a fateful debacle.

The Great Medieval Art

The history of the arts attests to a total "communion" between Islamic and Coptic traditions. Very early, Christian artisans place their talent at the conquerors' service. A Coptic carpenter installs in the mosque of 'Amr a pulpit offered by the prince of Nubia. Another is hired to cover the Ka'bah with the wood of a wrecked Byzantine ship. Coptic artisans collaborate with Greeks from Syria in the construction of the mosque of Medina. The mosque of Ibn Ṭūlūn is entrusted to the hands of the Coptic architect Ibn Kātib al-Firghāni. Two Christian architects, Abū Manṣūr and Abū Mashkūr are engaged by Saladin to erect the new enceinte of Cairo and the citadel of al-Muqaṭṭam. Symbiosis is total. Coptic art walks in step with Islamic art in its evolution. From the 'Abbāsids to the Mamlūks, with the Ṭūlūnids, the Fāṭimids, and the Ayyūbids in between, Egypt adopts the canons of Sāmarrā', but affirms its originality through its creative genius capable of embracing the many facets of art. While preserving its vocation and Christian specificity, Coptic artistic production is part of this prodigious movement. P. du Bourguet underlines: "There is no dependence, but interdependence: the Copts, along with others, supply Islam with motifs and methods, and in their turn borrow from Islam themes which their art is robust enough to assimilate. In its origins and characteristics, Coptic art is indeed no stranger either to the renewal of naturalism in a complexity, which during the Umayyads' reign is rather monotonous, or to the vast ensembles dear to the Ṭūlūnids, or to the explosion of liveliness and complication which happens under the Fāṭimids. Every time, the new orientation enters smoothly into the fundamental movement of Coptic art."[14]

The decorations in the church of the Virgin in the monastery of the Syrians marvelously illustrate the early development of the Egyptian school. Acquired by merchants of Tagrīth for monks of the same confession as themselves, this monastery, situated in the valley of Wādi al-Naṭrūn, was inhabited by Antiochenes from the ninth to the seventeenth centuries. The decorations in the church go back to the tenth century. The sanctuary is adorned with a stucco frieze—one meter high and extending along three walls—resembling that of the mosque of Ibn Ṭūlūn, itself built on the model of the great mosque of Sāmarrā'. However, the Christian imprint is unmistakable because of the clusters of grapes, a Eucharistic symbol, and the Cross, "especially visible on the east wall, toward the Orient where Christ is to appear at his second coming."[15] Monumental folding doors, separating the sanctuary from the nave, are the pride of the church. Their superposed rectangles bear an ivory composition in which crosses of different forms are inserted into a geometric design also made of ivory. The whole thing is made of horizontal bands each of which is devoted to a single motif uniformly repeated in each rectangle. There is nothing figurative about these motifs. Only one row, the highest, represents Saints, standing. Unfortunately, pieces of ivory have fallen and the Saints are now faceless, but inscriptions with their names allow us to identify them. The choice proclaims in its own way the friendship sealed between Antioch and Alexandria: Sts. Mark and Ignatius flank Emmanuel on one of the doors, replaced by Sts. Dioscorus and Severus on the other. Made by Coptic artists, this precious ivory work of the Ṭūlūnid period inaugurates the handsome aniconic iconostases of Egyptian churches.

The ornamental component of art predominates. Grape vines replete with leaves are turned into arabesques; lobes are multiplied; the Cross acquires new forms. It flowers among braids of reeds and

palms and is inserted into networks of circles and lozenges. Christian iconography is harmoniously integrated into this space covered with signs. Saints are reduced to their prototypes: the Equestrian Saint, the Monk, the Bishop. These figures and the aniconic motifs are either interwoven or alternated symmetrically in separate frames.

It is in mural decorations that the figurative element reaches its true dimension. Always open to many currents, painting deepens its dominant intuitions and establishes the great school which becomes the norm in the diverse parts of Egypt. The church of the monastery of the Syrians preserves an ensemble made of four great Feasts: the Annunciation, Nativity, Ascension, and Dormition. Added to Syriac inscriptions are some Greek ones transcribed in Coptic characters. Executed by Syrian painters or by a Syrian-Coptic team, the work does not share in the unified style visible in neighboring monasteries. It diverges from the canons of Byzantium, without, for all that, adhering to the local fashion of the time. Revealing a Mesopotamian touch, its Greco-Oriental style is akin to the medieval creations of Cappadocia. Through the cracks, one can glimpse previous frescoes. The Ascension has fissures and reveals a masculine face: the painting, now restored, shows a magnificent Annunciation, PL. 50–51 the most accomplished of the Egyptian works showing the influence of Byzantium. Four Prophets join the Virgin and Angel of the Lord: on the right, Moses and Isaiah; on the left, Ezekiel and Daniel. Written in Coptic on their open scrolls, their prophecies announce the Divine Incarnation and the virginal Motherhood of Mary. In the open space, an idyllic city with a church prefigures the heavenly Jerusalem; a tree outlined in red evokes the burning bush. The personages move with restraint; the gestures of the hands are both graceful and majestic. The Mother and Angel bathe in an immaculate azure blue. The garb of the four Prophets is colored red. The treatment of folds is in the Greek manner, wavy and fluid. The blue is softened with white; the white, variously tinted; and the red, shaded with earth tones.

122. Stucco work, 10th c. Monastery of the Syrians, Wādi al-Naṭrūn.
123. Folding door, 10th c. Monastery of the Syrians, Wādi al-Naṭrūn.

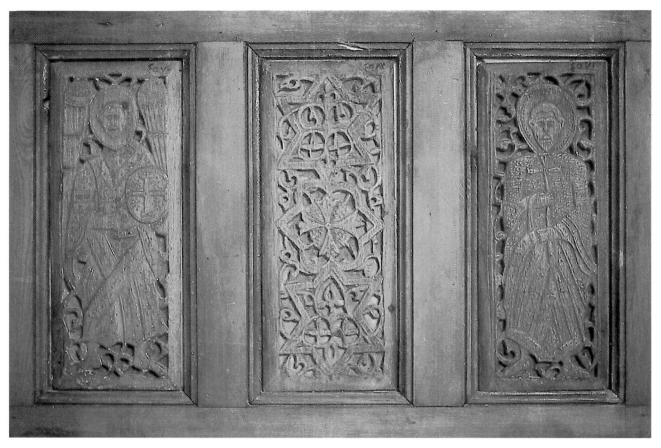

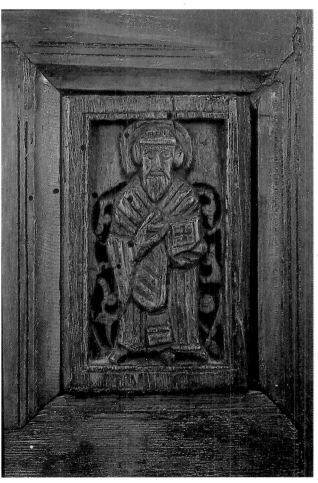

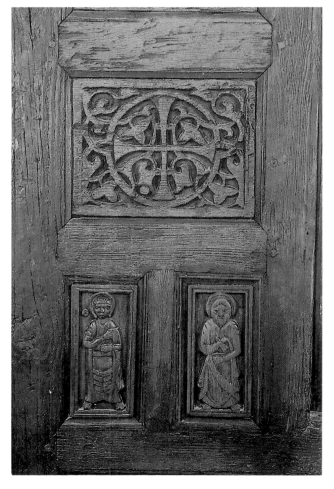

124. Carved wood, detail, 12–13th c. Museum of Coptic Art. Old Cairo.
125. Carved wood, detail, 12–13th c. Church of St. Mercurius, Old Cairo.
126. Carved wood, detail, 12–13th c. Church of St. Mercurius, Old Cairo.

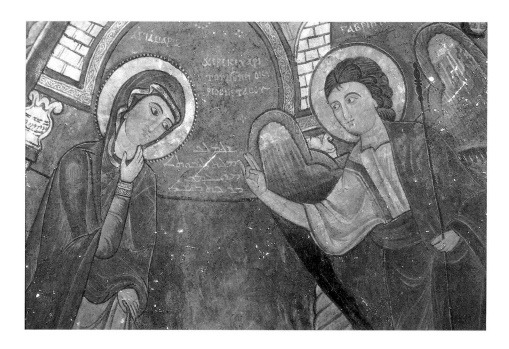

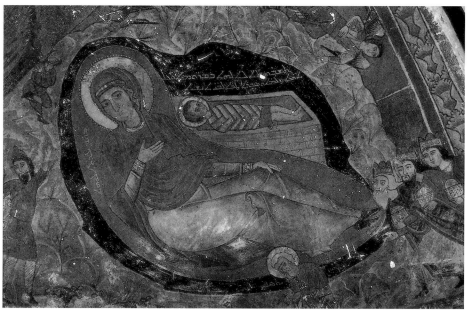

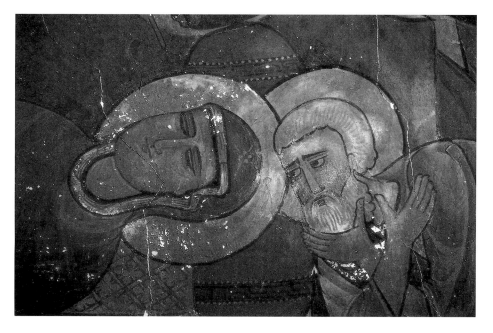

127. *Annunciation,* 11–12th c.
Monastery of the Syrians,
Wādi al-Naṭrūn.
128. *Nativity,* 11–12th c.
Monastery of the Syrians,
Wādi al-Naṭrūn.
129. *Dormition of the Virgin,*
11–12th c. Monastery of the
Syrians, Wādi al-Naṭrūn.

166

The Coptic style is revealed in the diverse frescoes that have endured. Whether in Cairo, in the Pl. 52,53 desert of Scetis, in the eastern desert, or in the desert of Isnā, the remnants of mural paintings attest to a native art, original and powerful. A spiritual beauty is glimpsed through images, forms, and colors. A work of the tenth century shows Adam and Eve standing among flowering trees. Using the continuous style, the artist links different events in a single space. In a twofold scene, the man and woman, naked and sexless, eat the forbidden fruit and cover themselves with loin cloths. Shown on a smaller scale, a horse tethered to a tree symbolizes control over passions, a reminiscence of Plato's restive horse which carries tumult and chaos. A thin line traces the contours of the figures. The bodies have reached their incorruptible form. The faces are gentle and serene, their coloring without any modeling. Nothing seems to speak of the fall. The great monastic vision is apparent: after trial, passions are eliminated, and "the soul has only pure memories."[16] Trees lose their material form; their leaves and fruit are metamorphosed into a tapestry of green hachures studded with little red circles. Paradise is interiorized: "The reign of heaven is the impassibility of the soul together with the true science of beings."[17] Action is absorbed into contemplation. Church after church, image after image, painting celebrates "the excellent state" of pure prayer.

The plastic language becomes more precise. These canons are adopted and perfected by numerous teams of painters. The taste for pure form persists and becomes dominant. Monumental figures of the Living Ones are placed side by side with wide ornamented spaces. The iconographic programs are extremely rigorous. The Savior keeps his central place, "heavenward wing of the assembly of the Saints."[18] The families of Angels, Monks, Prophets, Bishops, and Equestrian Saints are grouped around the Invincible Word. In the monastery of St. Macarius, Christ, flanked by two Angels, is enthroned on the west wall of the sanctuary of Benjamin. The Apostles and Evangelists surround him as in a Deesis. However, the standing figures—seen facing forward— are separated by columns and under their narrow arches watch like Solitaries. The Elders of the Book of Revelation are in a row on the walls of the sanctuary. Seated in identical positions on ornate chairs, they hold in one hand a rolled up scroll and, in the other, a cup with a base: celestial spirits and priests of truth, "they remain in ardent adoration night and day." The general plan continues in the sanctuary of St. Mark. Scenes from the Old and New Testaments on pointed arches correspond to one another. Movements cease; the hands are uplifted, and the faces, three-quarter, are united in a silent communion. The Angel

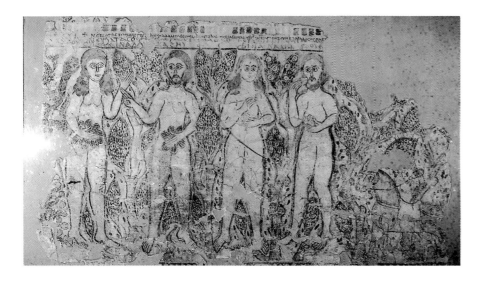

130. *Adam and Eve*, 11th c. Museum of Coptic Art, Old Cairo.

of the Annunciation blesses the Virgin. Moses and Aaron run toward each other. The Announcement to Zechariah repeats the Annunciation. The same movement unites Isaiah and Abraham: arms extended and hands open, the two prophets find themselves side by side, the former receiving the Angel of the purification of lips, the latter receiving from Melchizedek's hands the communion of bread and wine. The Desert Fathers are painted on the walls, standing, facing forward, and holding their hands in the traditional gesture of prayer. Side by side are Paul of Thebes and Anthony the Great, Pachomius and Theodore, Macarius and a monumental Seraph. Like the Angel, the Saint is nothing but eyes. Possessing "holy humility," he keeps his soul steadfast, disposed to contemplation, and continually attached to God.

PL. 56–57 The frescoes of the monastery of Baramūs are in the same vein. The parallelism of the themes and styles is evident. Once again, Melchizedek, blessing "God Most High, / maker of heaven and earth" (Gen 14:19), offers the chalice to Abraham. What is left of a tier painted with gospel scenes suggests the Annunciation and Visitation. A gallery of Ascetics unites the Desert Fathers and Mothers.

131. *Melchizedek, Abraham, Isaiah,* 13–14th c. Monastery of St. Macarius, Wādi al-Naṭrūn.
132. *Announcement to Zechariah,* 13–14th c. Monastery of St. Macarius, Wādi al-Naṭrūn.

The figure of St. Onophrius is apart from the rest. Devoid of realistic details, his body is on a larger scale than the novice monk and tree that flank him. Naked and very slender, his long white beard reaching to his knees, the inflexible "giant" lifts his arms in prayer: "His food, his drink, his clothing, everything is the Holy Spirit."[19] Planted in the desert, he grows like a palm tree to bear the fruit of the Holy Spirit. Vulnerable mortals are absent. Earthly Angels and heavenly Angels lead the "living life" in the light of the "Sun of Justice." In the monastery of St. Anthony, the Four Incorporeal Animals join the Mother and Baptist, praying with them to Christ in majesty. Here, the traditional Deesis acquires a specifically Coptic dimension. The four animal figures are no longer symbols of the Evangelists, but concrete "spirits" venerated by the Church. "Face of a lion, face of an ox, face of a human, face of an eagle, they are full of eyes in front and in back" says the liturgy. Their prayer embraces the whole of creation: the lion implores for the wild animals; the ox, for the cattle; the eagle, for the birds; the human, for humankind—mural painting adds new praying ones to the Deesis and the portraits of Saints. Martyrs for the faith, Christ's Soldiers are immobile on their horses,

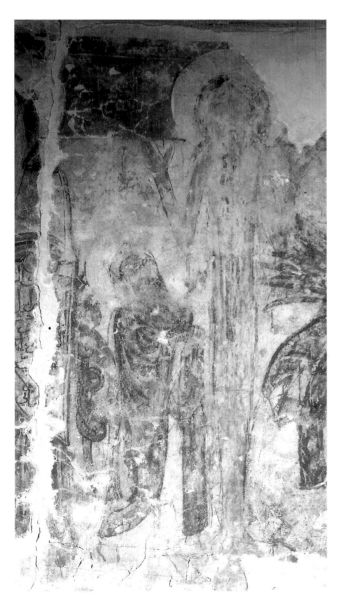 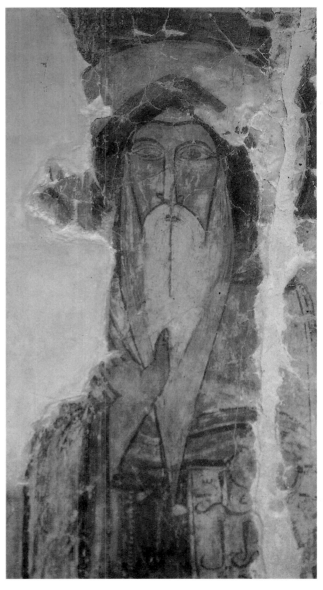

133. *St. Onophrius,* 13–14th c. Monastery al-Baramūs, Wādi al-Naṭrūn.
134. *A Saint,* 13–14th c. Monastery al-Baramūs, Wādi al-Naṭrūn.

walled within the great silence that prevails throughout the whole composition. The figures, seen full-face, share in the contemplation of the Apostles and Hermits. Armed with the breastplate of faith and charity, the soldiers of the army are converted into warriors of the Spirit. The pageant stops its movement. Sober and wide awake, the children of the Day transcend all pain. The Cross is raised, "sword of the Spirit and source of grace." Painters glorify the Cross by multiplying its representations. Always aniconic, it is decorated with interlacing motifs and arabesques. A cloth hanging from its arms symbolizes the salvific Passion of Christ. The liturgy repeats: "We glorify you because you have made from the moments of your only Son's suffering moments of consolation and prayer. . . . Through the triumphant Cross, hell has been destroyed and death vanquished. We were dead and now we have been awakened. The delights of paradise and the merits of eternal life have been granted to us."[20]

Christian iconography assumes the great art of the time and becomes part of its ethos. Arabesques are abundant. The Islamic touch is omnipresent. In the monastery of St. Macarius, painting felicitously covers typically Fāṭimid engaged arches. In the church of St. Mercurius in Old Cairo, it blends

Pl. 54,55 into the little horns of the *muḳarnas,* and one sees the Visitation, Annunciation, and two full-length Ascetics together in a niche placed under the ceiling, in the angle of two walls. In the White Monastery at Sūhāg, the Mother with the Child exchanges her Byzantine throne for a beautiful seat of in-

Pl. 59 laid woodwork representing octagonal stars. In the monastery of Baramūs, one sees an Archangel of supreme beauty which seems to have stepped from a sumptuous 'Abbāsid manuscript: its head is crowned, its hair black, its eyes slightly slanted, its features marked with an incised outline in red. In the monastery of St. Anthony, the Equestrian Saints, with the folds of their clothes treated in ovoid masses, give to the prototype of the Arab miniature a monumental mural dimension. In the

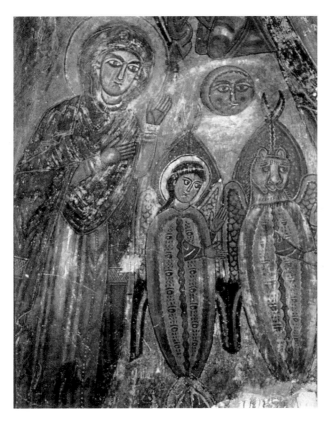
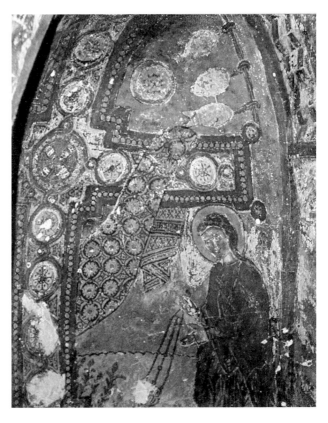

135. *The Virgin with Two of the Four Incorporeal Animals.* Monastery of St. Anthony, Red Sea.
136. *Triumphal Cross.* Monastery of St. Anthony, Red Sea.

170

monastery of St. Paul in the eastern desert, the taste for simple and pure forms reaches its zenith. The Mother with the Child, the Equestrian Saints, and the Desert Fathers join the Archangels, the Seraphim, and the twenty-four Elders of the Book of Revelation: the themes are traditional, but the plastic treatment is new. Fresco artists adopt the style of Egyptian potters. Figures are now devoid of any modeling; forms are emptied of weight; and colors are no longer shaded.

The Arab-Coptic Book

The same inspiration animates both mural painting and illumination. Calligraphy of different sorts, arabesques, and images: the art of bookmaking becomes richer with the precious contributions of the times. In the fifth century, Christian Egypt creates its language by adopting a Greek alphabet augmented by demotic characters. In the eighth century, this language is progressively arabized and from the year 1000 on produces an original Coptic-Arab literature, especially in fields of dogma, hagiography, and hymns. The manuscripts are written in Coptic at first, but in the Middle Ages also make use of Arabic. The symbiosis between arts is at its peak. Arabesques play their part, and the use of gold confers a luxurious character to Coptic illumination. Ornamental handwriting, supple and refined, celebrates the Gospel of Christ and his redeeming Cross. Zoomorphic and floral ornaments are inseparable from geometric motifs. Birds, gazelles, does, hares, fish are simply indicated by their "hieroglyphic" signs, found over and over again in the decorations on woodwork, ivory, ceramics, and cloth. Calligraphy is incorporated into the blue and gold and takes on quasi Qur'ānic forms. The bare Cross stands on a stepped pedestal, "indelible sign in the hands of the Most-High." The illuminators cover it with interlacing designs, braids, ribbons, flowery and leafy branches. Sometimes it is submerged within a gilded space made of imbricated geometric forms in which the Cross stamps the work and confirms its Christian identity. Miniatures reflect the dominant currents of the time. As in the large frescoes, portraits of Saints show them standing, immobile and unchanging, in absolute frontality. Their clothing erases every anatomical detail of the bodies. The expression is concentrated in the unassailable eyes that stare at the viewer. Painting incarnates the ascetical ideal which sees in the Anchorite—possessing inner unity—the supreme degree of holiness. Abba Moses teaches, "Those who flee the world are like sun-ripened grapes, but those who remain among human beings are like green grapes."[21] Devoted to the celebration of the divine, imagemaking untiringly repeats the iconic figures of Saints and Angels. The rare architectural representations appear in the scenes of Feasts. The iconic setting is a plain and neutral background. Painting scrupulously avoids narration and vivid detail. "In the world, there is only God and I,"[22] the Monastic Fathers repeat in their search for Holy Peace. The Saints ascend alone into the divine aura. The hymn to St. John the Dwarf sings, "Luminous star on the earth, your humility and your angelic life make all of Scetis like a mere drop of water on your finger."[23] Landscapes vanish. "Golden lamp more brilliant than the sun," deified humanity dwells in space and illuminates it with its light.

The illustration of the Gospels opens another path to painters. There are in Paris two precious gospel books which show an ensemble of 'Abbāsid paintings of exceptional richness. Luxuriant and abundant, the images retell the major events of the Life of Christ. Iconography recaptures animation; the choice of themes is enlarged; people become more numerous; buildings are erected; vegetation grows; river banks and rocks appear in the landscapes. The principles of the Arab school dominate and modulate the many elements of the compositions. With regard to both themes and style, the painters renew Christian iconography by enriching it with new images. The first[24] of the two manuscripts has an important historical value. E. Blochet calls it "an incunabulum of Mesopotamian painting from the twelfth century"; dated 1180, it is the oldest 'Abbāsid manuscript to have survived the hazards of history. It contains seventy-seven paintings and is incontestably one of the great monu-

ments of the medieval Christian art of bookmaking. Framed by lettered bands decorated with flowers, three full-page paintings represent respectively Mark, the seventy-third patriarch of Alexandria; Christ enthroned; and the four Evangelists.[25] The gospel illustrations are inserted within the text in horizontal bands according to a typically Byzantine method. They accompany the text which they immediately translate into images. The drawing lacks skill; however, the boldness and creativity of the pictorial interpretation give the painting its real value. Byzantine contributions are minimal. The painter does not hesitate to modify or even reinvent the prototypes of the Feasts. The idyllic environment of 'Abbāsid miniatures replaces the iconic milieu. The action takes place on a ground line defined by two small trees or two rocks. The background remains empty. The exterior and interior scenes are treated in the same way: the event occurs in a space open to all. The perspective escapes any temptation of naturalism. Typical figures form the setting. There are more landscapes, but they retain the usual common elements. Brook, lake, and sea are painted in an identical manner: they are restricted to the dimensions of a small pool; the water is represented in rhythmic parallel lines accented by large fish; harmonious undulations symbolize "the stilled storm." Rocky landscapes are painted in wavy curves and are ubiquitous: their size varies with the demands of the scene. Buildings faithfully follow the typical representations of the Arab school: walls of pink brick, blue cupolas, and golden entablatures. Vegetation is luxuriant: according to the 'Abbāsid manner, flowers, other plants, and small trees are everywhere, in stylized and imaginative forms ignorant of all realistic models; gigantic stems grow like small trees bearing golden flowers and fruits. All this is lavished in crucial scenes such as the Epiphany, Transfiguration, Raising of Lazarus, Burial, and Empty Tomb. Sometimes, the images contrast with the passages they illustrate. A tree with an ax at its base is next to St. John the Baptist: "Even now the ax is lying at the root of the tree; every tree therefore that does not bear good fruit

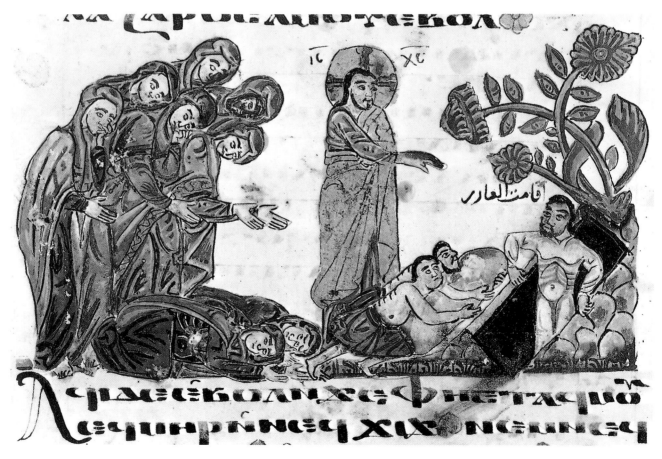

137. *Raising of Lazarus,* gospel book, 1180. National Library, Paris.

172

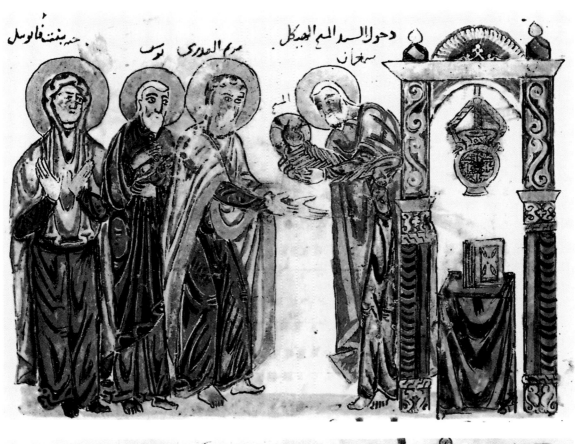

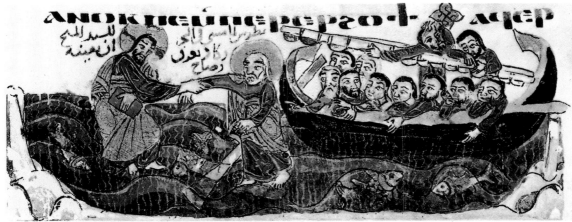

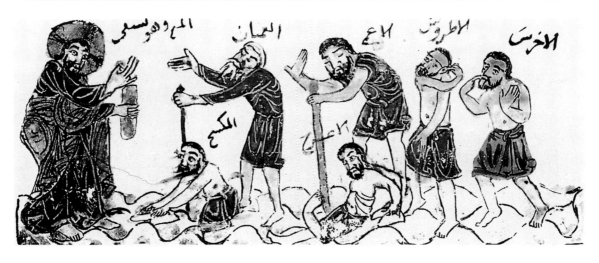

138. *Presentation,* gospel book, 1180. National Library, Paris.
139. *St. Peter Walking on the Water,* gospel book, 1180. National Library, Paris.
140. *Healing of the Sick,* gospel book, 1180. National Library, Paris.

is cut down and thrown into the fire'' (Matt 3:10). But in contrast to the text, the painter has it stylized in the shape of an almond tree and bearing golden fruits: the event is transcended, and the pictured tree announces the Tree of Life which bears fruit in the City to come. Golden palms, crystal-like water, gently curved rocks, and buildings crowned with cupolas appear in the desert of Christ's Temptation. A bird flies in the air, two fish cross the water, and a lion cub crouches on the ground. The presence of the cub recalls the actual location of the action: "He was with the wild beasts; and the angels waited on him" (Mark 1:13). Here the desert is transformed into an Eden. Holding the Gospels in one hand and blessing with the other, Christ stands erect on the summit of the rock: "Like a generous king, he distributes spiritual favors to his servants."[26]

The heroes keep their "Greek" costumes, the chiton and the himation for holy men, and the maphorion for holy women. They are represented three-quarter face. Princes have 'Abbāsid features. According to the model of the feasting king, Herod, cup in hand and attended by two assistants and two servants, is seated in the Oriental manner with one leg dangling and the other folded. The Samaritan woman and Peter's mother-in-law wear Arabian veils. Interior decoration is metamorphosed: seats of inlaid woodwork covered with embroidered cushions replace the ancient thrones. The Presentation in the Temple shows the book of the Gospels, adorned with a cross, on a Jewish altar placed under a small baldachin lighted by a large mosque lamp. Traditional gestures yield to new expressions: in the Annunciation, the Virgin is crouching; in the Nazareth Synagogue, Christ is sitting on the ground. The action is more animated and human. The painting of the Wedding at Cana devotes one of its tiers to the traditional banquet scene: nine persons are gathered around an Islamic still life of vases filled with flowers and baskets with fruit.

Christ blesses life. In an illustration of the Miraculous Cures, he faces six people representing sick humanity: the Arabic inscription names "the mute, the deaf, the blind, the lame, the paralytic." The painter "transgresses" the Coptic canon and shows the Crucifixion in its historical dimension. The Son of Man is crucified between the two thieves; the three men have their eyes closed; the Marys and the Beloved Apostle are in attendance in front of the Roman soldiers. A group of legionaries brandishing swords and bucklers is added to the scene of the Casting of Lots for the Tunic. The episodes are connected one to the other: the two Marys lament at the Descent from the Cross and swing two censers before the Angel of the Resurrection.

Whereas they had always been scrupulously ignored by Coptic art, the damned and the demon now come on the scene: in a small vignette, the hanged Judas is next to a black winged devil. This image "is lost" within the cycle of Christ, culminating in the Ascension. The artist reinvents the image of the Feast: the kneeling disciples are in four rows on a vast rocky mass; Christ is lifted into the air at the center of an Asiatic flaming mandorla, a forerunner of the iconographic formula which Islamic art will adopt in the fourteenth century to halo its heroes in religious representations.

The second manuscript—kept at the Catholic Institute in Paris—is part of the same artistic current. Dating from 1249, it brilliantly embodies the mature style of the 'Abbāsid school. The paintings inserted in the text are reduced to the headings of the Gospels. Four full-page portraits represent the Evangelists. The illustrations of the book are concentrated on ten pages, each page divided into six equal squares. A multitude of images narrating the life and work of Christ is added to the principal Feasts. The artisanship demonstrates an exceptional refinement. The painter draws, paints, and applies gold with mastery and assiduous care. Surrounded by luxurious splendor, the Evangelists, seated on their divans, model four variations on the theme of the author-caliph. Matthew is represented in half-profile, with one leg folded and the other straight, writing the first words of his Gospel in Arabic. His hands covered with a white cloth, Mark devoutly receives the codex handed him by St. Peter. Luke, with his legs dangling, meditates while contemplating the open book he holds in his right hand. John reclines on his soft couch, listening to the Word of God and covering his mouth with his hand in a sign of silence and recollection. The exuberant decoration changes from one pic-

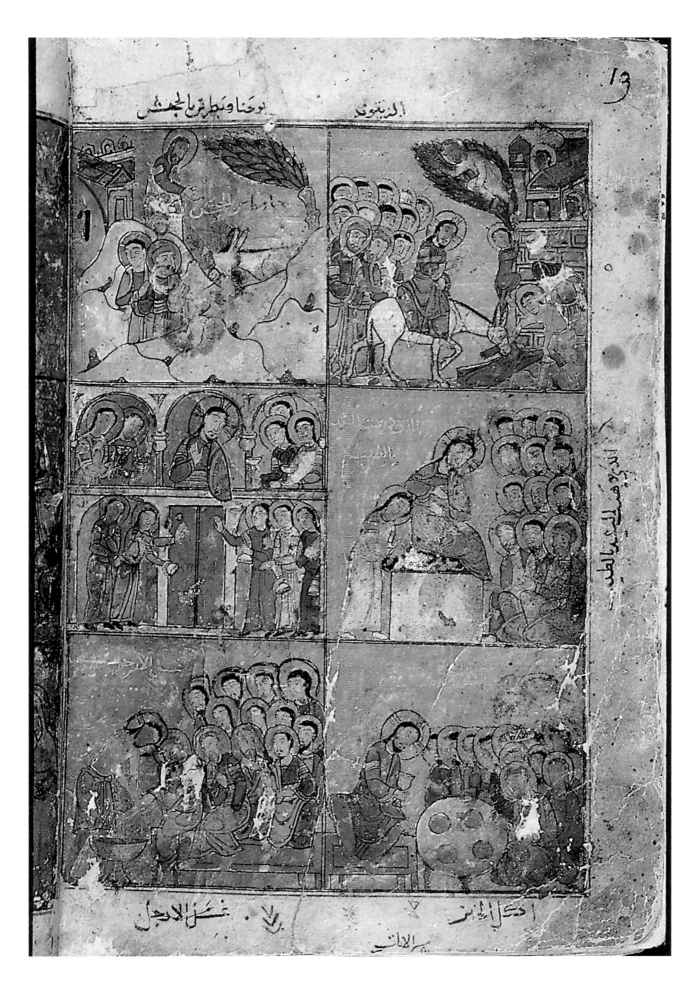

141. Gospel scenes, 1249. Sers Library/Catholic Institute, Paris.

49. *Christ,* Bawīṭ, 7th c. Museum of Coptic Art, Old Cairo.

60. *Archangel,* painting on marble column, 13–14th c. Sitt Maryam, the Hanging Church (al-Muʿallaq), Old Cairo.
61. *Mother and Child,* painting on marble column, 13th–14th c. Church of St. Mercurius, Old Cairo.

50–51. *Annunciation,* 11–12th c. Church of the Mother of God, Monastery of the Syrians, Wādi al-Naṭrūn.

62. *St. John,* 1249. Sers Library/Catholic Institute, Paris.
63. *St. Matthew,* 1249. Sers Library/Catholic Institute, Paris.

52. *A Holy Bishop,* 13–14th c. Church of St. Mercurius, Old Cairo.
53. *Christ Enthroned,* 13–14th c. Church of St. Mercurius, Old Cairo.

64. a. Headpiece, Gospel of St. Luke: *Announcement to Zechariah, Annunciation, Visitation,* 1249. Sers Library/Catholic Institute, Paris.
b. Headpiece, Gospel of St. John: *Pentecost,* 1249. Sers Library/Catholic Institute, Paris.
65. Scenes, Gospel of St. John: *Wedding at Cana; Christ and Nicodemus, and the Samaritan Woman, and the Paralytic, and the Woman Caught in Adultery, and the Man Born Blind,* 1249. Sers Library/Catholic Institute, Paris.

54. Painted niche: *Cherubim, Prophets, Visitation, and Holy Monks,* 13–14th c. Church of St. Mercurius, Old Cairo.
55. *Holy Monks,* 13–14th c. Church of St. Mercurius, Old Cairo.

56–57. *Melchizedek Giving Communion to Abraham,* 13–14th c. Monastery al-Baramūs, Wādi al-Naṭrūn.

66. Scenes, Gospel of St. Luke: *Birth of St. John the Baptist, Presentation in the Temple, Christ and the Doctors, Christ in the Synagogue at Nazareth, Christ Driven to the Edge of the Cliff, Raising of the Son of the Widow of Nain,* 1249. Sers Library/Catholic Institute, Paris.
67. The Passion, Gospel of St. Matthew: *Suicide of Judas, Pilate Washing His Hands, Christ Carrying His Cross, Crucifixion, Descent from the Cross, Burial,* 1249. Sers Library/Catholic Institute, Paris.

58. a. *A Saint,* 13–14th c. Monastery of St. Bishoi, Wādi al-Naṭrūn.
b. *An Equestrian Saint,* 13–14th c. Church of St. Mercurius, Old Cairo.
c. *A Saint,* 13–14th c. Church of St. Mercurius, Old Cairo.
d. *A Saint,* 13–14th c. Church of St. Mercurius, Old Cairo.
59. *Standing Archangel,* detail, 13–14th c. Monastery al-Baramūs, Wādi al-Naṭrūn.

68. *St. Anthony the Great,* 18th c. Museum of Coptic Art, Old Cairo.
69. *St. Paul of Thebes,* 18th c. Museum of Coptic Art, Old Cairo.

70. *St. Michael,* work of Abraham the Scribe, 18th c. Monastery of the Syrians, Wādi al-Naṭrūn.
71. *St. John the Baptist,* work of Abraham the Scribe, 18th c. Church of St. Mercurius, Old Cairo.

72. Chalice case: *Mother and Child, Last Supper, Aaron, Moses.* Monastery of the Syrians, Wādi al-Naṭrūn.

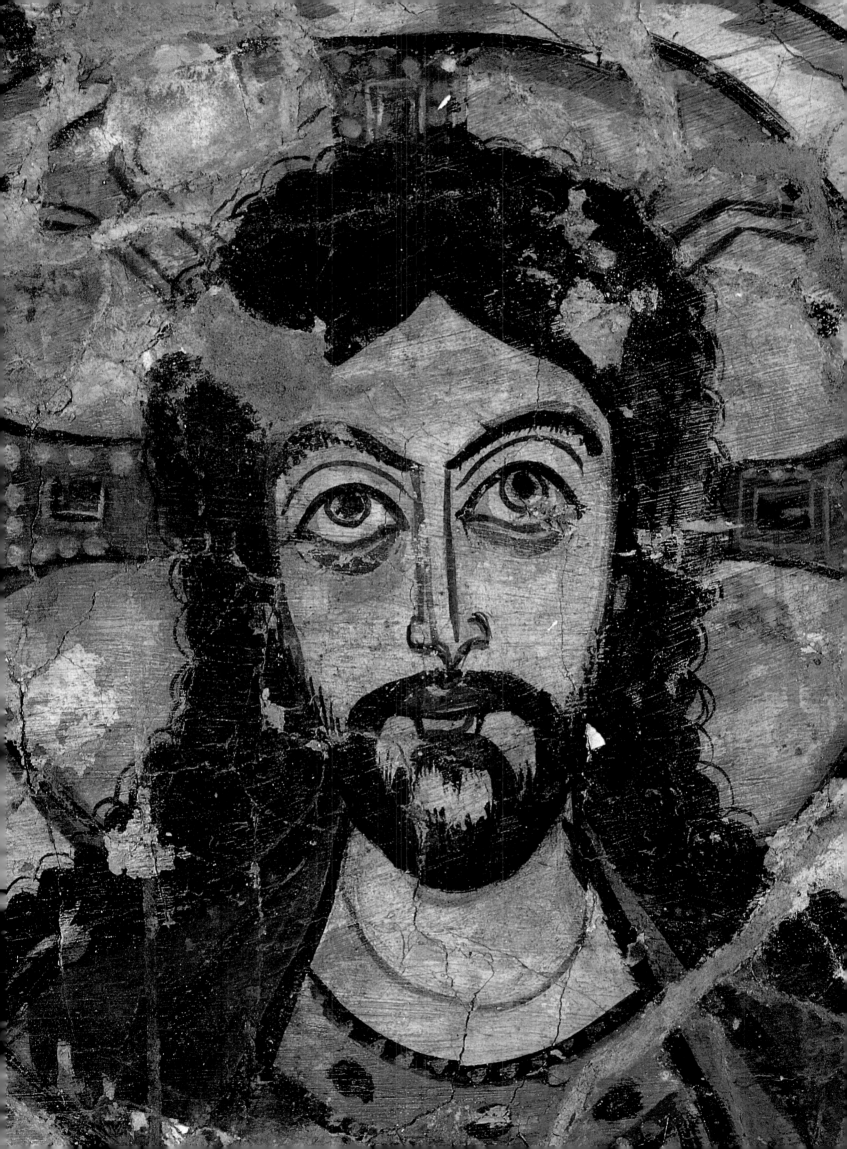

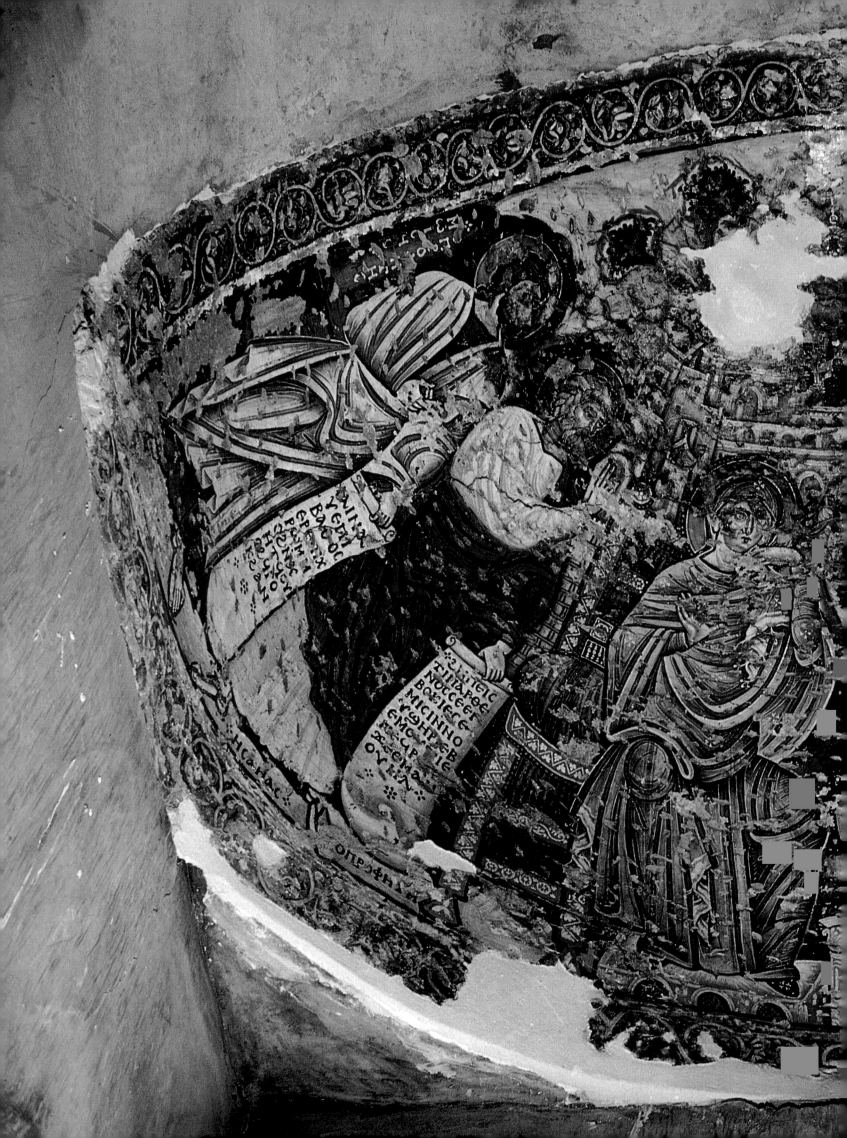

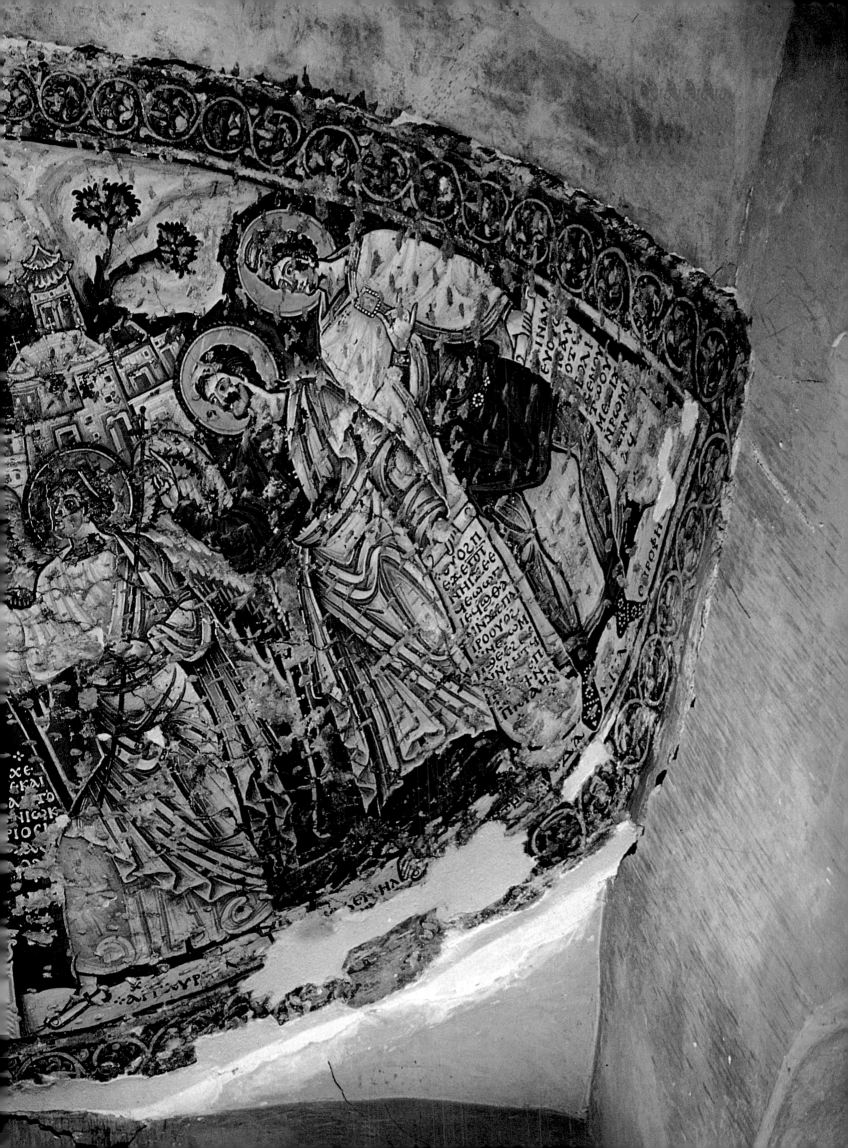

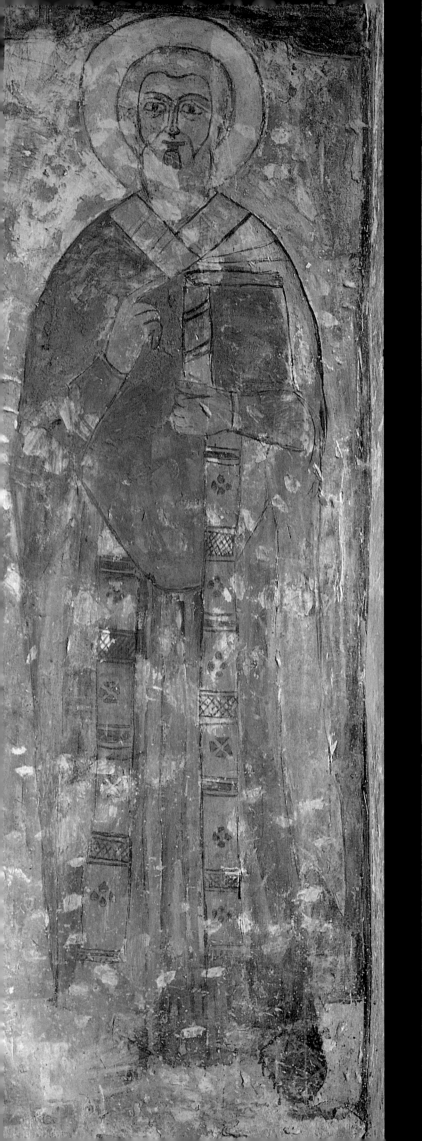

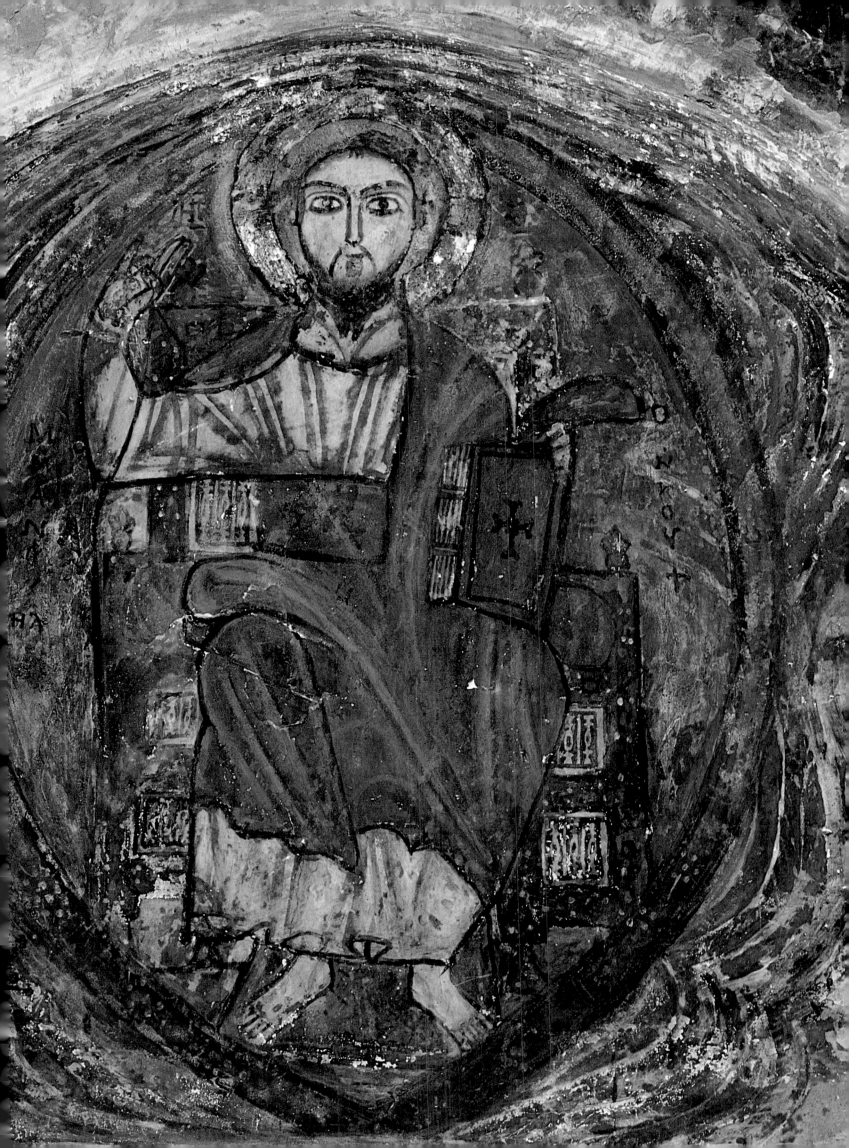

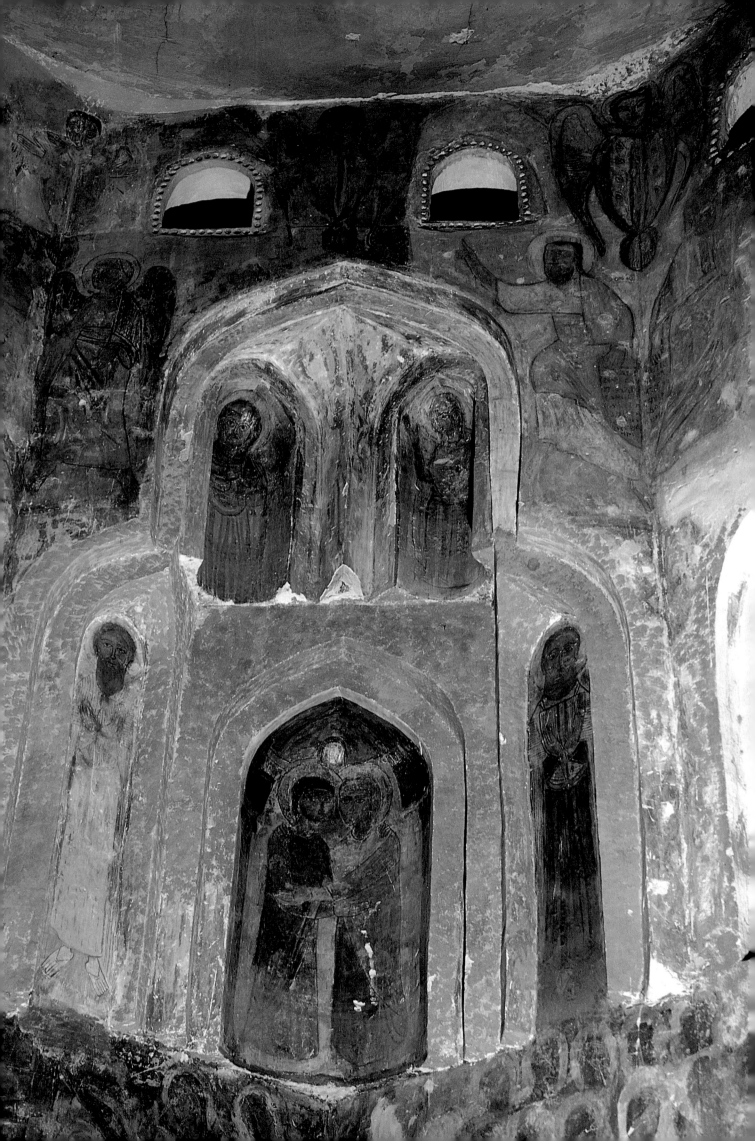

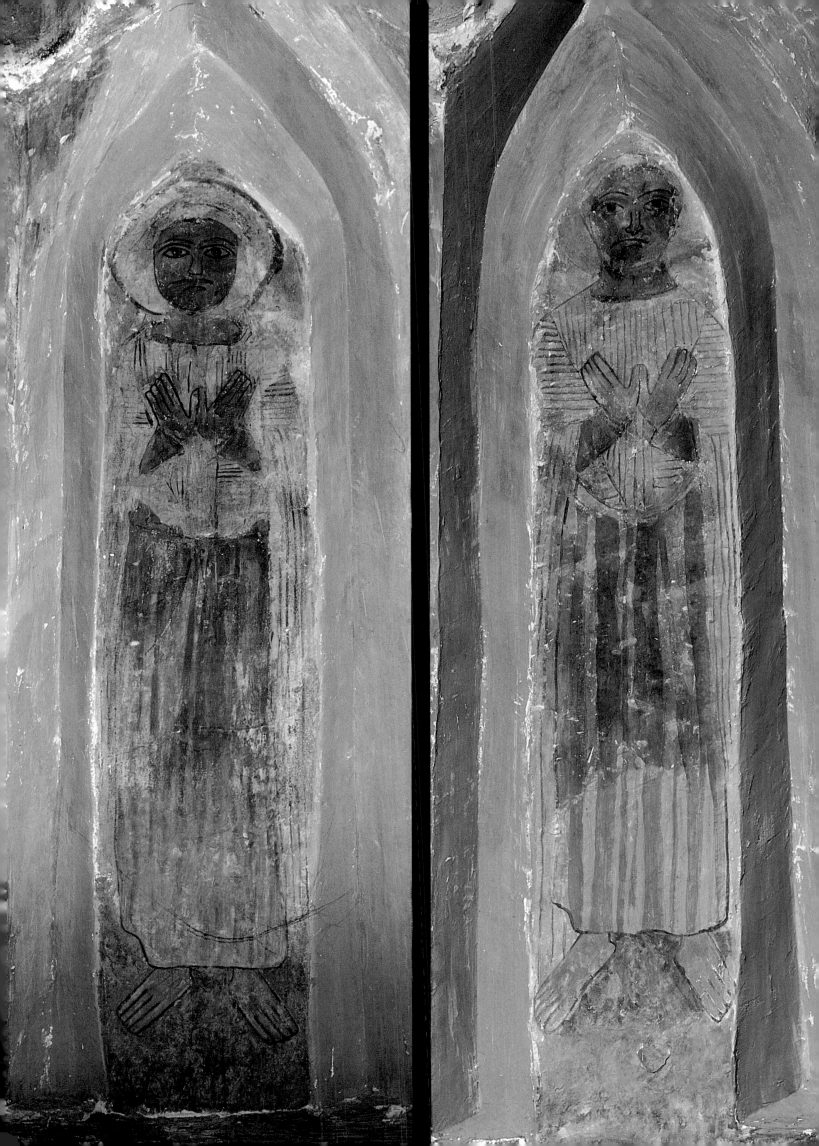

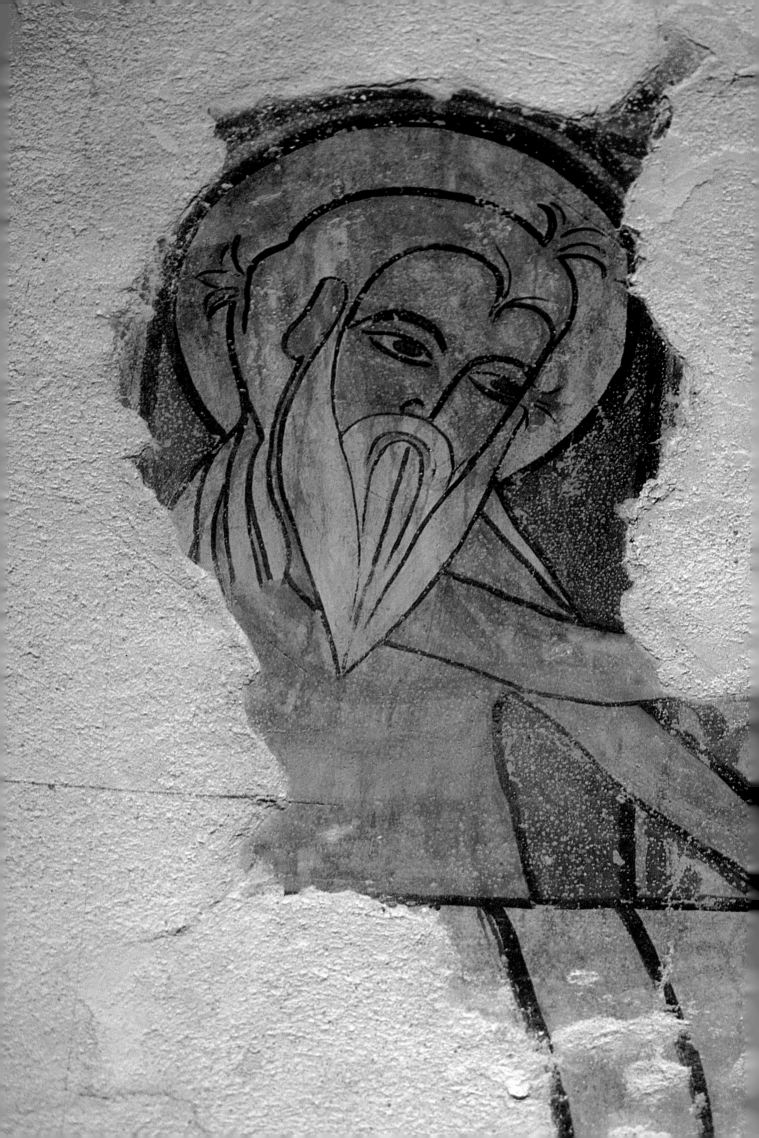

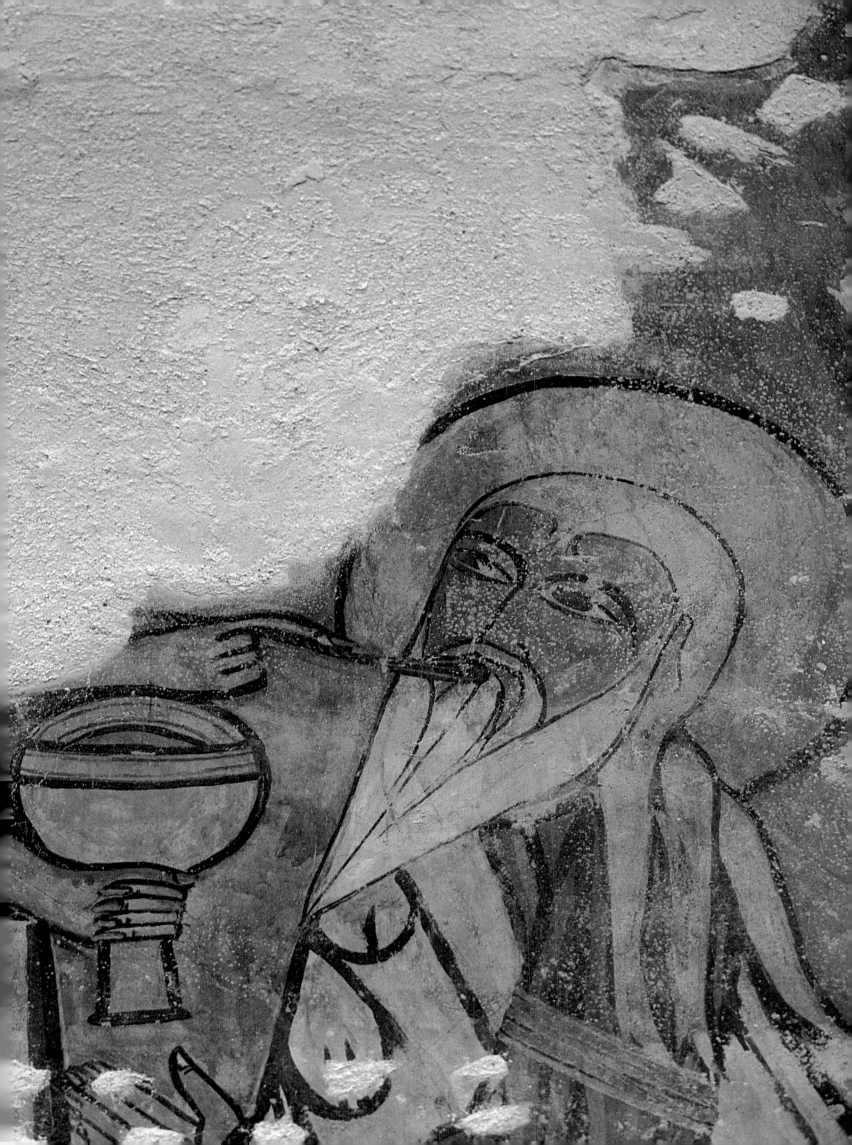

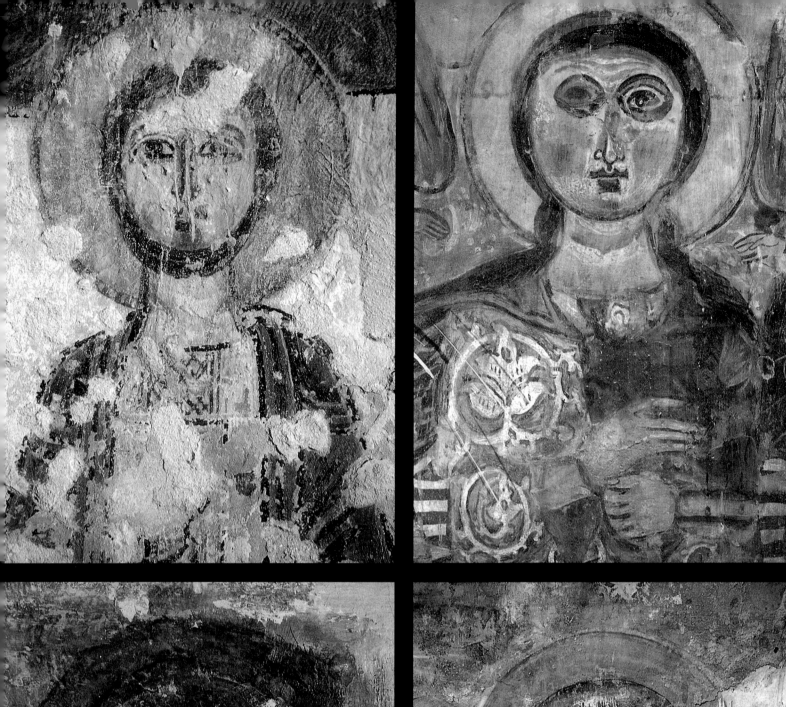
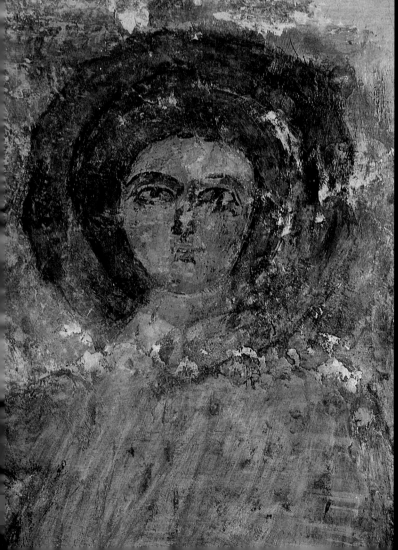
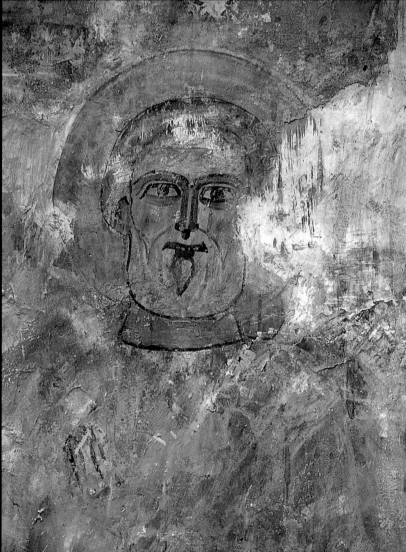

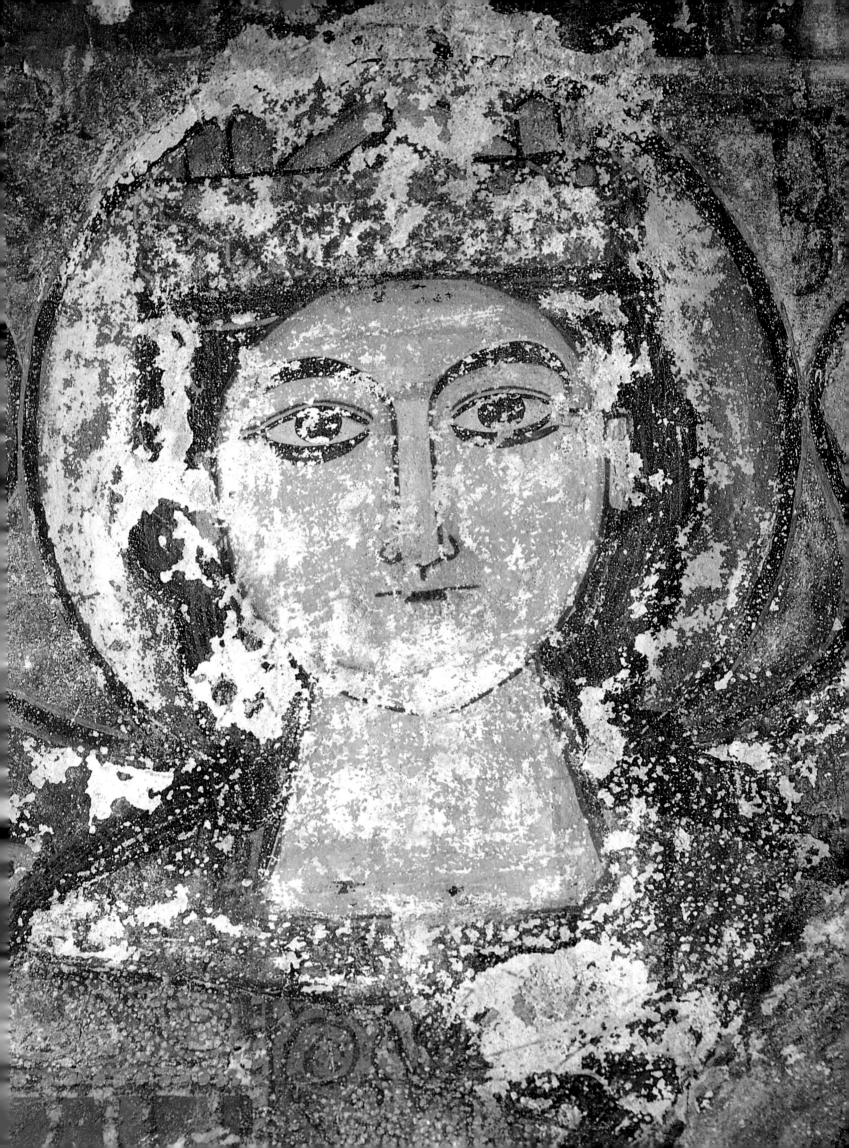

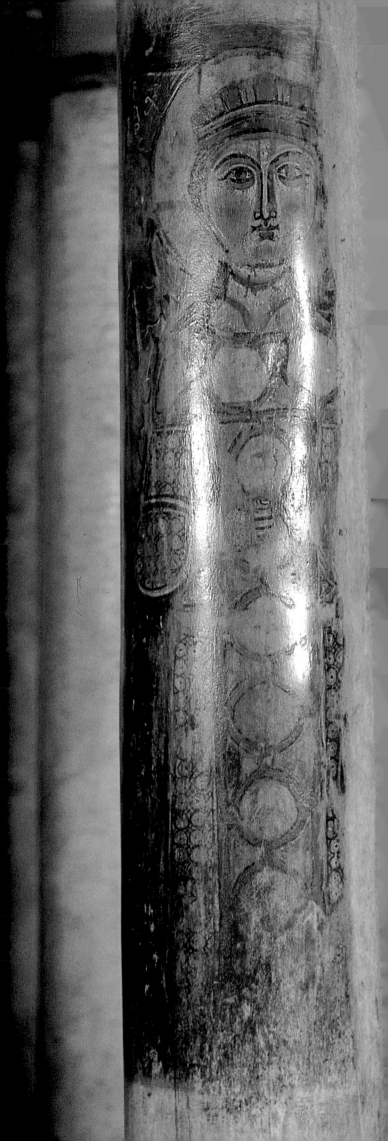

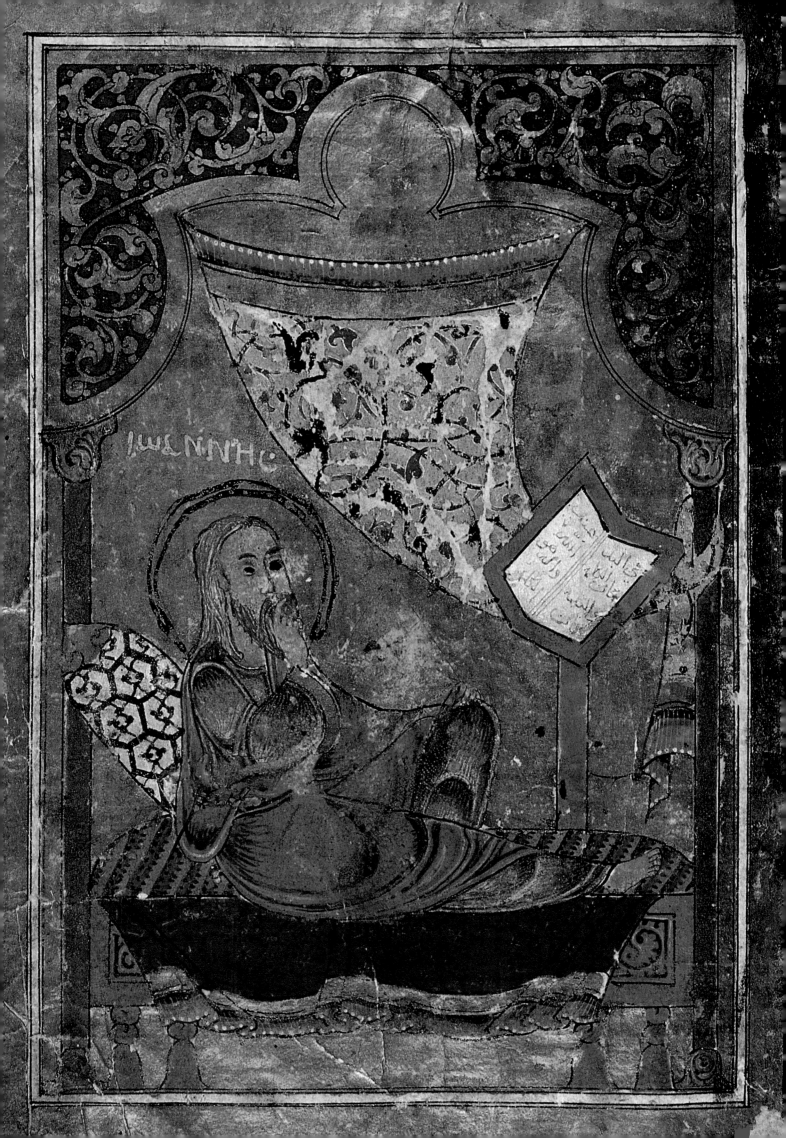

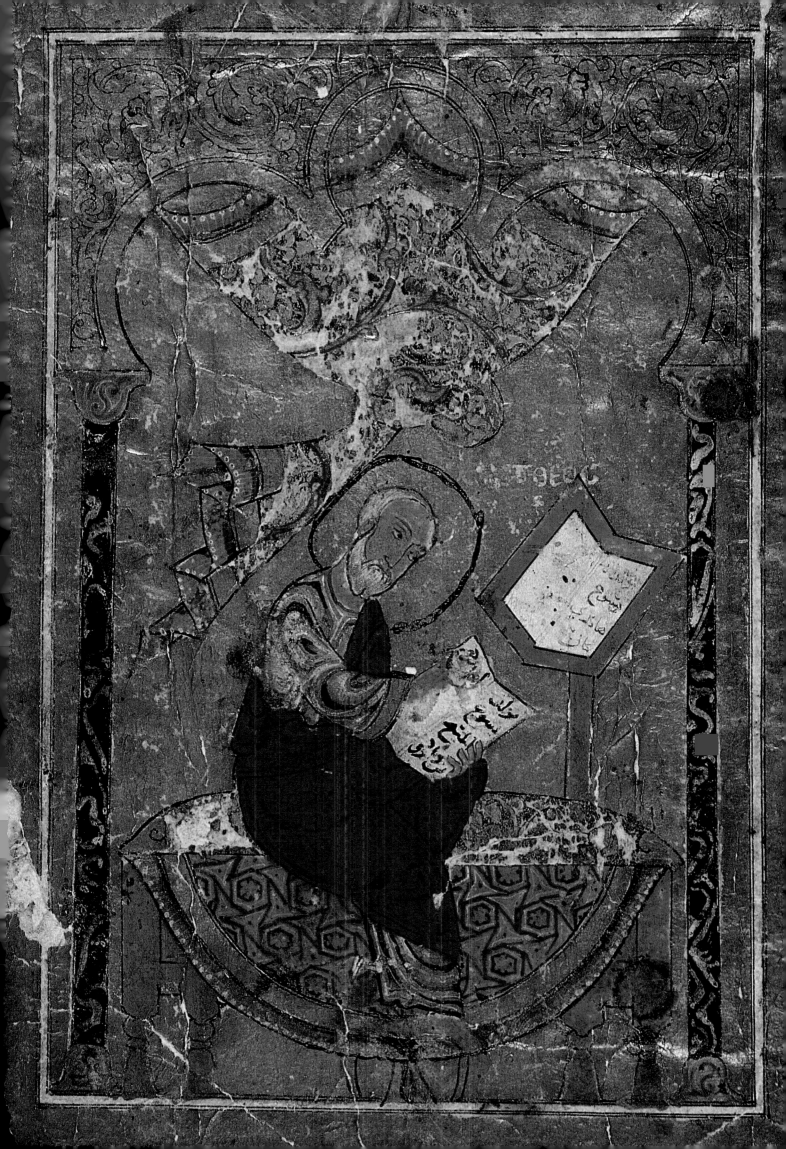

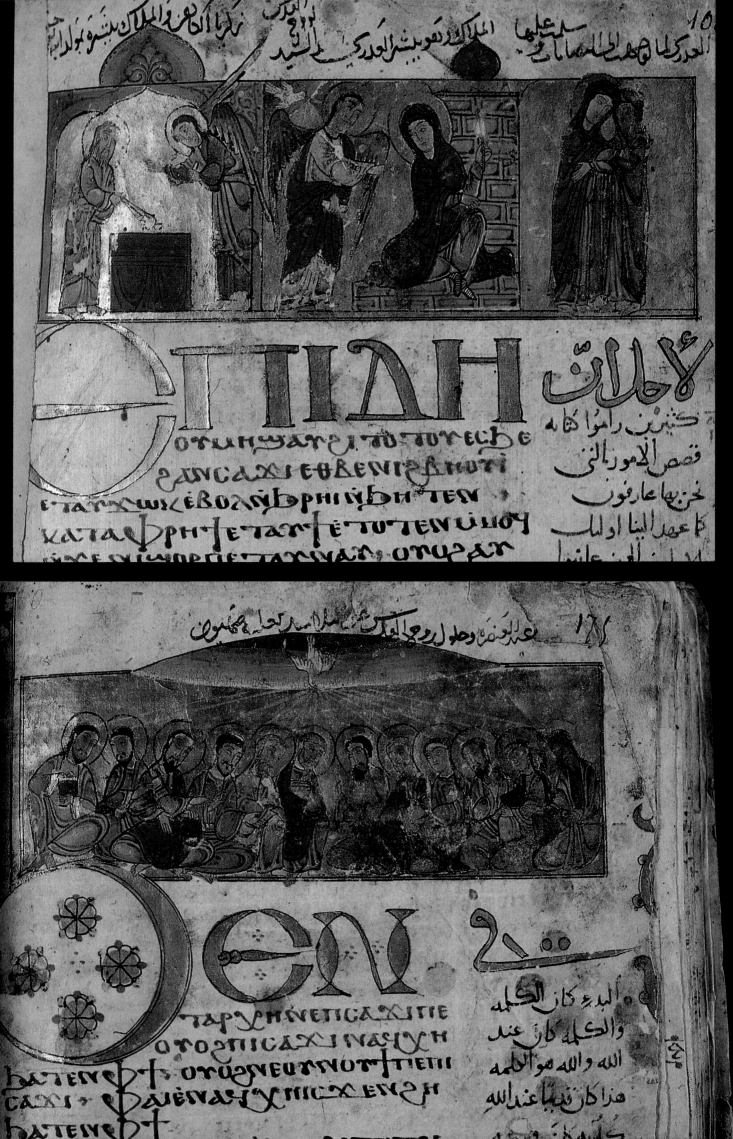

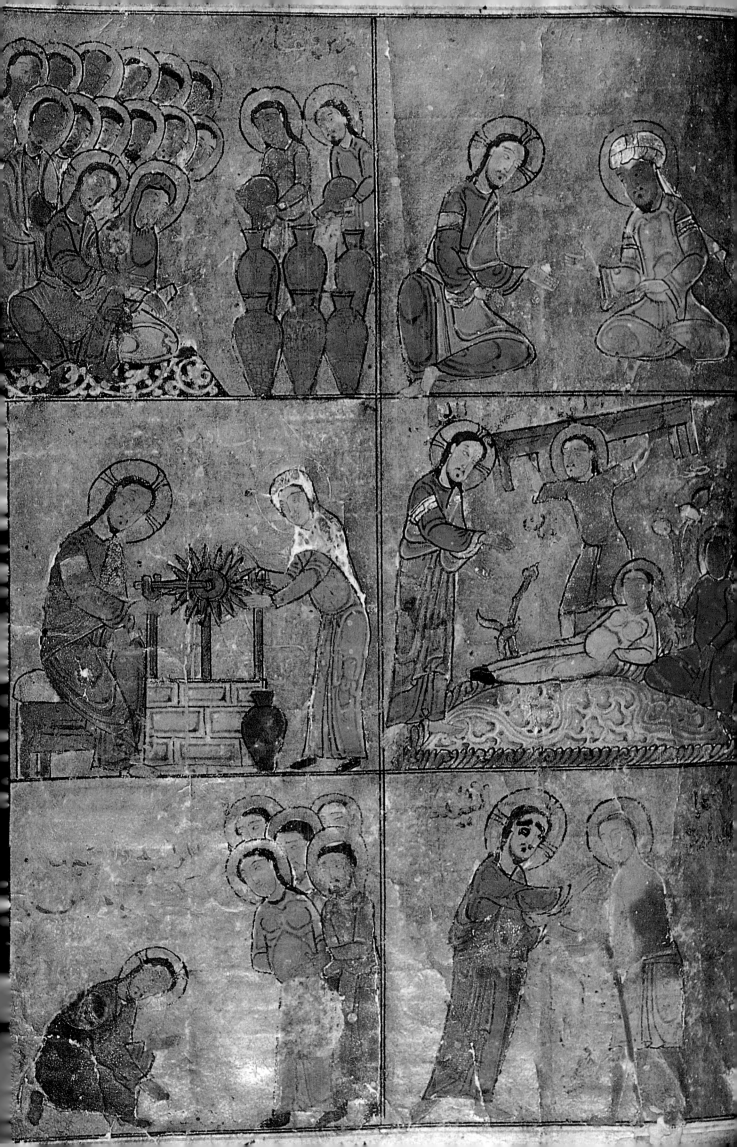

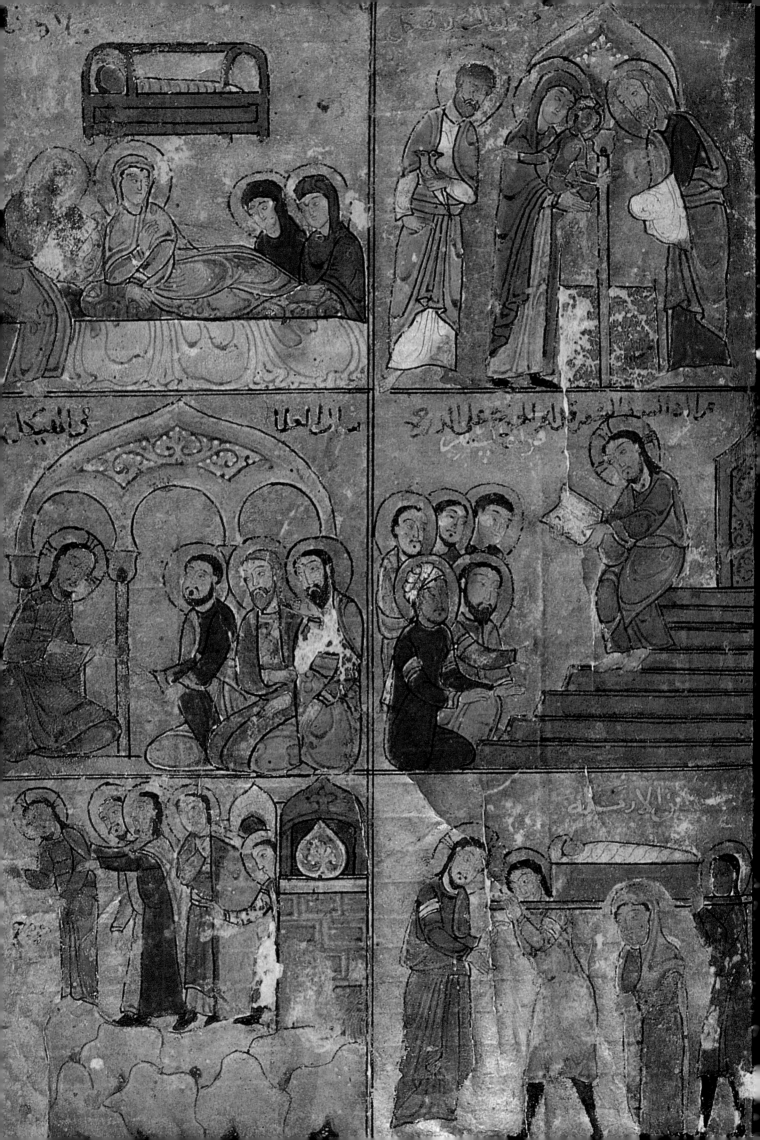

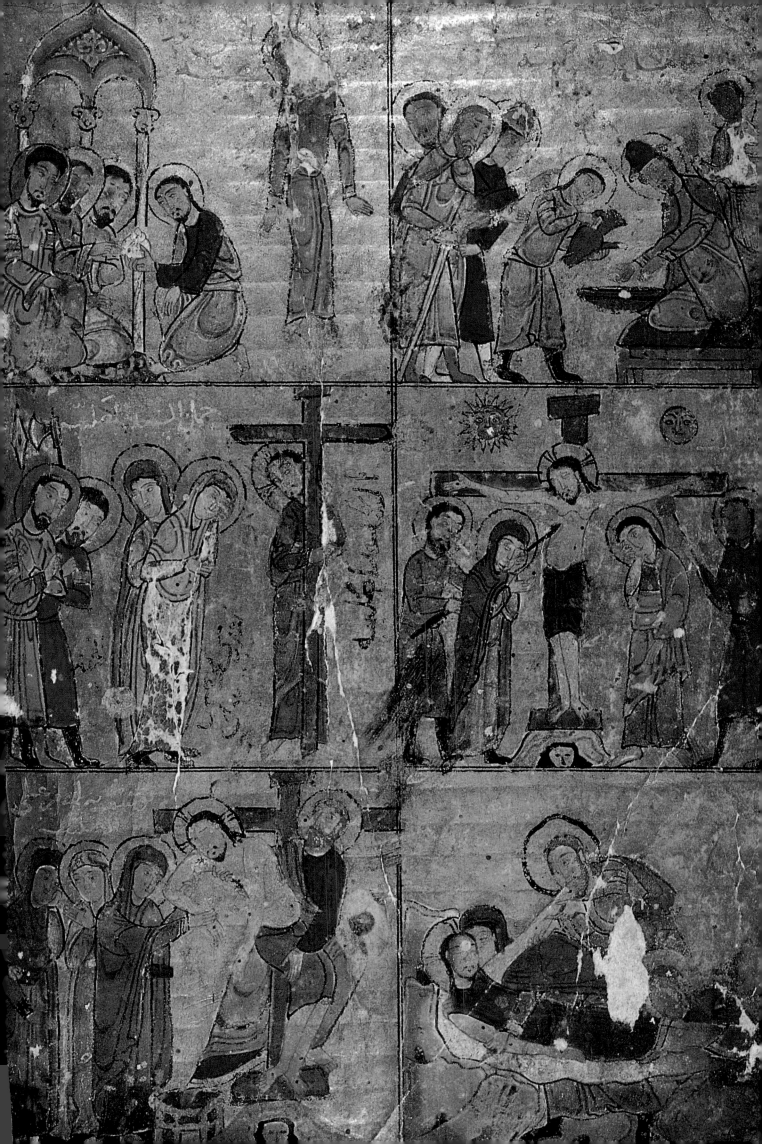

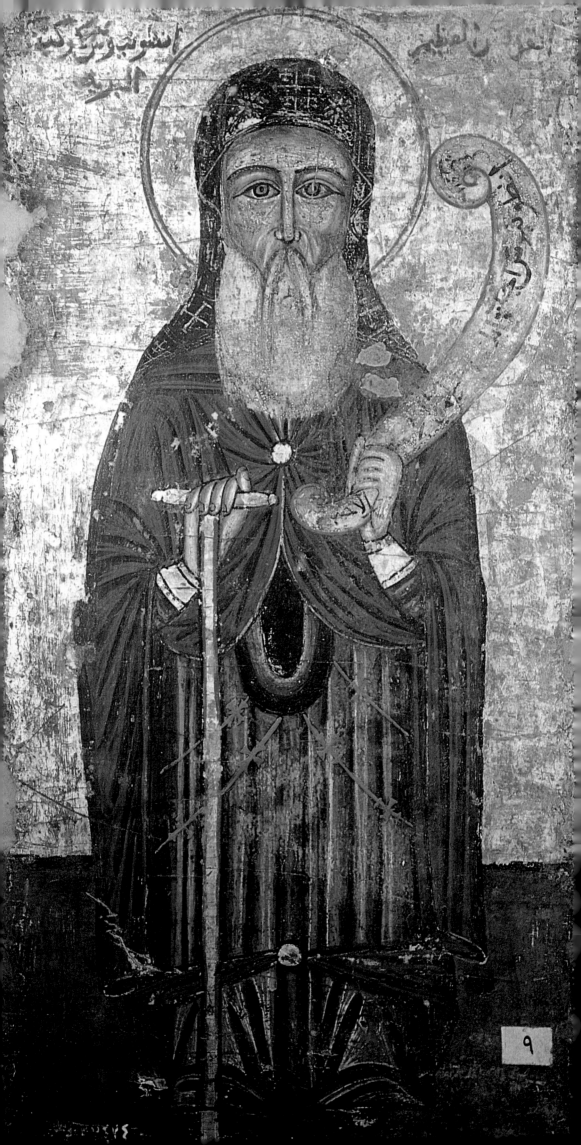

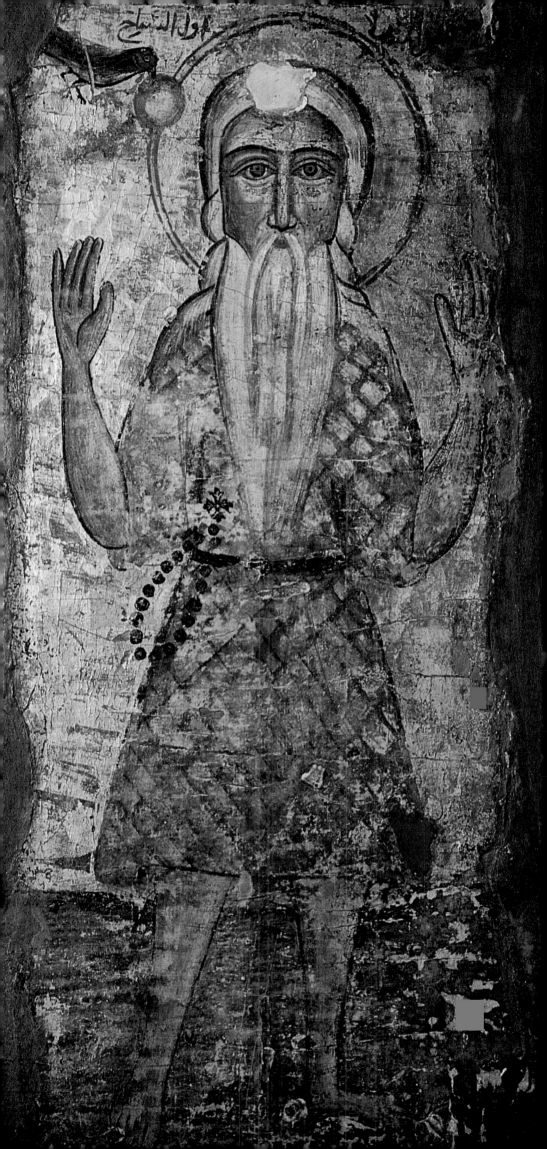

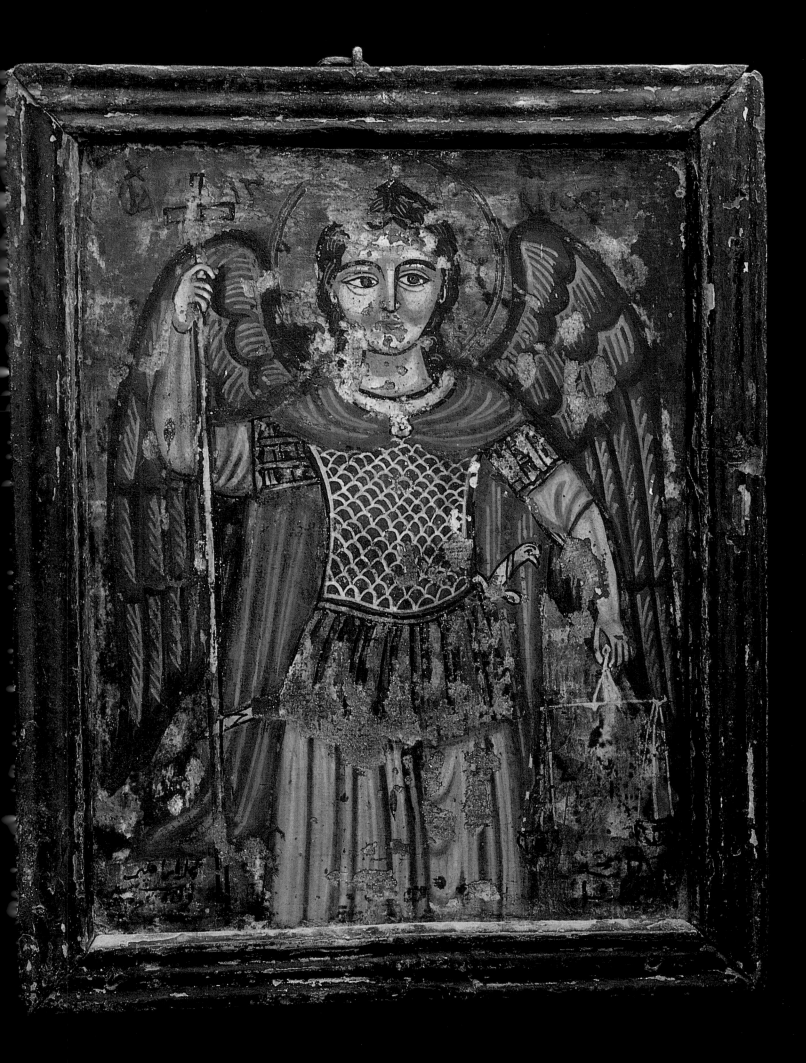

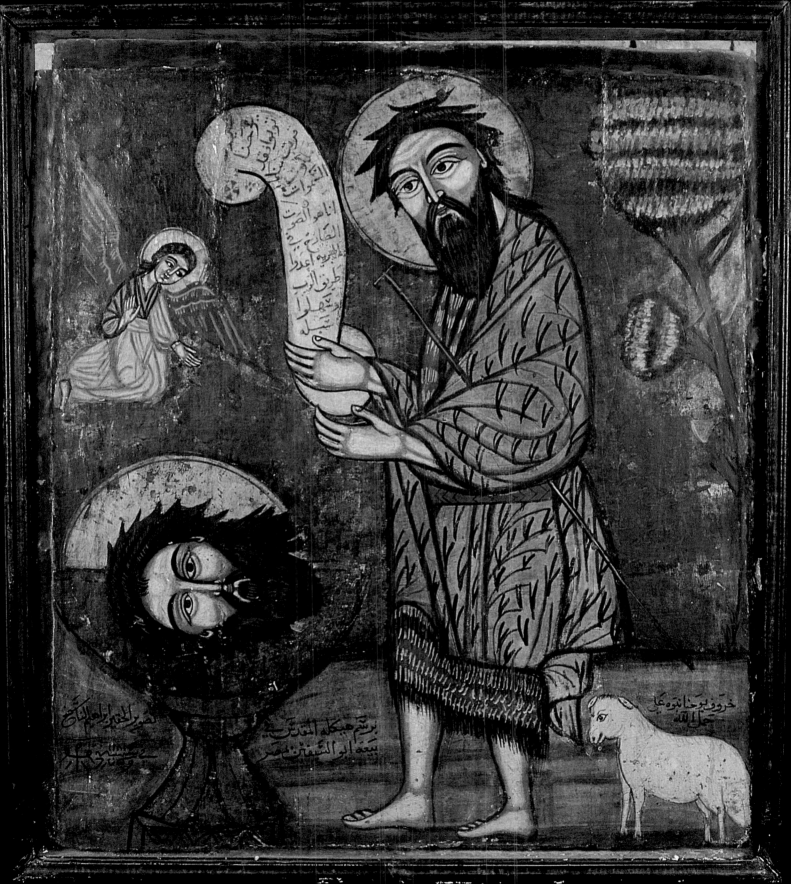

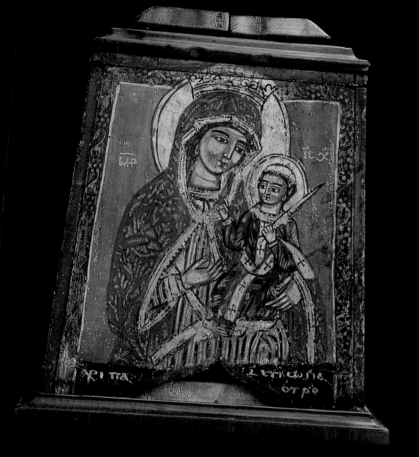

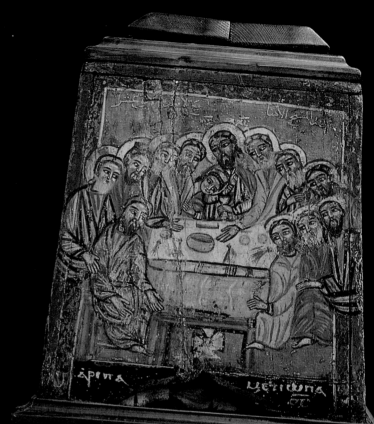

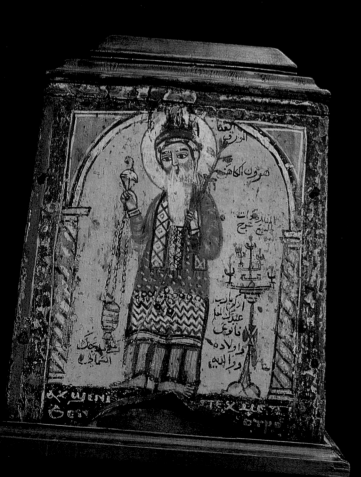

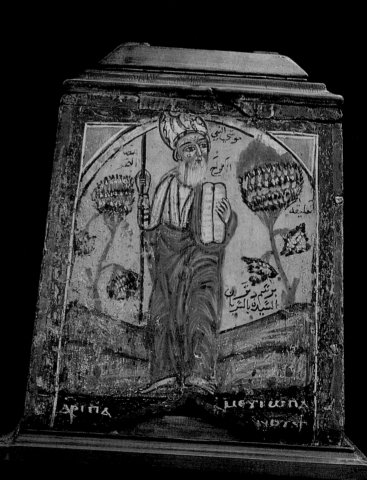

ture to the other. The Evangelists are settled under polylobed arches. Sumptuous curtains hanging from the vaults are rolled around columns surmounted by capitals. The diverse elements are meticulously decorated with traditional ornamental motifs. Flowery branches, hexagons, volutes, stylized flowers, and confronted chimeras alternate in the corners, on the divans, cushions, carpets, and hangings.

The four initial paintings are devoted to six Feasts. The Nativity and Baptism of Christ are faithful to the fixed prototypes but treat them in an Arabian way. The initial page illustrating St. Luke gathers in one band the Announcement to Zechariah, Annunciation, and Visitation: the painter reinforces PL. 64a the Eastern character of the work by having the Virgin seated in the Turkish manner and by crowning the buildings with two blue cupolas. The initial page illustrating St. John shows the ancient Feast of Pentecost in a novel way: a network of light emerges from the dove of the Holy Spirit, inundating PL. 64b the Twelve sitting on the ground side by side, each one holding in his hand the Book of the Good News. The sixty squares of the full-page paintings narrate the Life and Work of the Savior. Settings, ornaments, costumes, and gestures are purely 'Abbāsid. Brick walls, small buildings, and cupolas are everywhere. Vegetation appears only in a few scenes: four succulent stems sprout behind Abraham and Lazarus on the mount of the reign; plants grow behind the paralytic at the pool of Siloam; a leaning tree stands between the Risen One and the two disciples of Emmaus. Images succeed images. PL. 65,66 Christ, his legs dangling, is shown enthroned on a seat of inlaid woodwork; sitting in the Turkish manner in the synagogue; and preaching on the steps of a staircase. Men wear short robes; women, long slitted ones. The widow of Nain wears a veil of the time; Nicodemus, a turban; Pilate, a red helmet and high boots. The plastic interpretation of the Scriptures produces surprising images. Kneeling, Christ writes on the ground, "bowing" to the woman caught in adultery. The scene of the Washing of the Feet shows him bare-chested, head bowed in front of the heads of his disciples drawn on different levels. The Parable of the Ten Bridesmaids is placed on two superposed tiers under a triple arcade: the sensible ones surround the Savior while the foolish find themselves flat on the ground in front of the closed door, still holding their overturned lamps. Tradition and creativity are in wondrous agreement. The Passion obeys the established canons. The cycle of the miniatures ends with a hier- PL. 67 atic Ascension: forming the central axis of the composition, the standing Christ extends his arms in the shape of a cross above the bowed heads of his Faithful Ones.

Levantine Egypt

Solidly rooted and unified, Coptic art asserts itself. From monumental art to the art of bookmaking, its work innovates and multiplies its epiphanies. But after brilliantly shining during the Middle Ages, its light grows dim in the sixteenth century; it progressively loses its moorings and its unifying vision. As a swan song, artisans and artists leave an abundant production, the last manifestation of a centuries-old art which weakens upon entering modern times. Just like Islamic work, Coptic work degenerates at the time the country is sufficiently unified to establish itself as a free and sovereign state, inaugurating another history with a new spirit and a new art.

Egypt falls to the Ottoman power in 1517. The Mamlūks, still on the scene, attempt to recover their place. The country becomes part of Levantine culture. Alexandria "finds again" its former cosmopolitanism: just as in the first centuries of Christianity, an abyss seems to "separate" it from the interior of Egypt. Syrians, Greeks, and Armenians find places of honor in the great city; Catholic and Protestant missionaries attempt to gain a foothold. The Church, which had shown a great intellectual and spiritual vigor, retreats and falls into a long lethargic sleep, taking refuge in its inex-

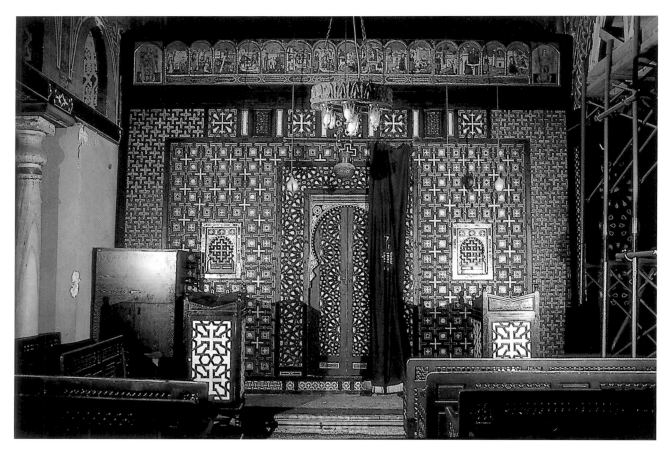

142. Iconostasis. Sitt Maryam, the Hanging Church (al-Muʿallaq), Old Cairo.
143. Window. Sitt Maryam, the Hanging Church (al-Muʿallaq), Old Cairo.
144. *St. Mark*, icon encased in wood. Sitt Maryam, the Hanging Church (al-Muʿallaq), Old Cairo.

haustible liturgy. The community experiences new waves of exactions and vexations. This does not prevent the Jesuit P. Bernat from writing in 1711, "In all the Muslim empire, Egypt is the country where the Christian religion is exercised with the greatest freedom; for this reason, many Christians from other lands take refuge there."[27] The West makes another inroad into Egypt at the time of Bonaparte's expedition in 1798. Pre-modern Egypt opens up to the European Enlightenment. Culture becomes interested in numerous new topics. Religious art undergoes a profound mutation. Ever anachronistic, the image allows the observer to discern "the signs of the times" through the alternation of signs and symbols.

Faithful to established formulas, artisans continue to make assemblages of wood inlaid with mother-of-pearl which are set up as aniconic iconostases. Mural painting recedes before painting on easily moved pieces of wood. The "new" Coptic icons now decorate church walls and crown iconostases by forming a higher row placed above the geometric designs of the aniconic screens. The art of book-making follows suit while at the same time retaining the models and ornamental formulas of its golden age. Icons become a major mode of expression. Late Coptic art shows a pronounced predilection for them, and the Church surrounds them with a veneration which is akin to that of the "Greek" tradition. (Of course, the medieval period had its icons, but those which have survived are extremely rare.) The faces are moon-shaped; hieratism and frontality are absolute; graphics are linear and the style geometric: traits common to both fresco artists and iconographers, although different techniques give different artistic expressions their specific plastic forms. The cultic role of the icon is underlined by Abū al-Barakāt ibn Kabar, the renowned encyclopedist of the fourteenth century. The veneration of images is treated in the manner of the great "Greek" iconodules of the eighth and ninth centuries. The sacred image is a likeness of and a bond with the model it represents. The veneration accorded to it is addressed to the holiness that it shows. "The holy books," the author reminds his readers, "are also venerated; we kiss them, and we place them on our heads because they hold the word of God—and that in spite of what they contain in the way of paper, ink, leather, and decoration. Similarly, we venerate icons and frescoes because of those whose figure and likeness they reproduce. We do not accept the pictures because of their colors and ornamentation when we know that they were not executed in honor of those we have mentioned. We do not authorize the veneration of such icons."[28] The image is focused upon holiness, the source and origin of the divine radiance. Inseparable from the themes, the style crystallizes this vision through many variations.

In the seventeenth century, the Coptic Church becomes open to Byzantine and post-Byzantine traditions. Greek and Syrian icons find places of honor in its sanctuaries. The quantity and quality of the works proves that artists from the Levant settle in Egypt: the encounter occurs from inside. However, as in Byzantine Egypt, the native production is distinguished by a particular style. The representations of Christ and the Virgin Enthroned often appear as bulky, popular copies of Byzantine paintings. Coptic work comes into its own only in the representation of Egyptian Saints. Intuitively, the painter renounces Greek stylization in order to return to the tradition of early Coptic art. PL. 68,69 The proportions of the human figure again represent immense faces and small bodies. 'Abbāsid trees stand in the background and a stylized bird perches on a flowery branch. The Holy Family is surrounded by tall verdant stems in the Flight into Egypt. St. Mark the Ascetic dwells in an Eden-like desert where gigantic flowers are as tall as slender trees. Frontality continues to be the rule. Icons showing several people juxtapose the standing figures. The meeting of two Saints is represented as the encounter of two solitudes. The first two monks are side by side: standing immobile, Sts. Paul of Thebes and Anthony the Great fix their gazes on the observer. No gesture suggests the "historical" meeting of the two Desert Fathers; pure prayer alone unites them. Paul lifts his arms in supplication while two little lions are recollected at his feet. Clad in his monastic tunic, Anthony carries his famous staff in one hand and in the other an open scroll inviting his "children" to follow his teachings. The encounters of Solitaries happen outside history. The Egyptian St. Onophrius and the Ethio-

pian St. Tekla Haymanot meet in the same desert, "separated" by a tree bearing dates. Lifting a Cross symbolizing the white martyrdom of asceticism, Apas Apollo and Apip stand shoulder to shoulder without looking at each other. Invariably holding beads and a cross, Sts. Macarius the Egyptian, Macarius of Alexandria, and Macarius of Tkoou are attached together like three stars reflecting a single Light.

The figure of the Equestrian Saint is omnipresent. St. George has brothers: Sts. Mercurius, Ishkirūn, Behnam, Menas, Ptolemy, Theodore the Easterner, Isidore of Antioch, and Jacob the Sawn Asunder. The scenery retains its traditional elements: trees and buildings are visible behind the Saint. The action is focused on the prototypical figure of the Equestrian Saint. "Friend of the Father, strong in Christ," he carries "the armor and arms of faith"; leaving aside terrestrial things in order to seek the celestial ones, he is powerful in combat, "full of valor on the Martyrs' field."[29] The hagiographic narrative is limited to one event of supreme importance, represented on a lesser scale by the figure of the rearing horse. St. Jacob the Sawn Asunder is enthroned on his mount. He is seen a second time in a vignette incorporated into the scenery: seated, eyes cast down, a gentle and melancholy expression on his face, docile in the hands of his torturer who cuts him into pieces. The Acts reports that this guard, a renegade Christian at the court of the king of Persia, confesses in a loud voice the faith he had previously denied, courageously embracing the torments of martyrdom. The painting shows Jacob's severed limbs hanging beside him. "O God of Christians," he implores, "receive the branches of the tree. If the vinedresser prunes the vine, it will bloom and extend its roots farther." The executioner is about to cut his second arm. The painting expresses the Martyr's silent prayer: "I no longer have any hands to raise toward you; here are my scattered members; receive my soul, O Lord."[30]

Scenes of martyrdom enter iconography. The Byzantine cycle of the Passion has its Coptic replica in the eighteenth century. The icon shows the Crucifixion, Descent from the Cross, Lamentation,

 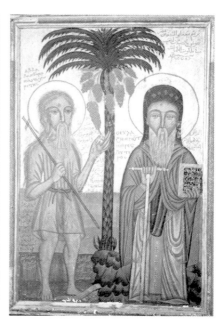

145. *Flight into Egypt,* 18th c. Monastery al-Muḥarraq, Asyūt.
146. *St. Mark the Ascetic,* 18th c. Monastery of St. Anthony, Red Sea.
147. *Sts. Onophrius and Tekla Haymanot,* 18th c. Church of St. Mercurius, Old Cairo.

and Burial. One of the iconostases of the Hanging Church is decorated with a row of seventeen scenes depicting St. George's martyrdom. Like the Man of Sorrows, the Saint undergoes in silence the long red martyrdom. The style is in accordance with Coptic tradition: the face is round, the complexion smooth, the expression meek and restrained. The body is out of proportion to the head and its form is simplified to the extreme. Pain is submerged by unshakable prayer. Through the trial of martyrdom as through the Cross of the Son, "hell has collapsed and death has been abolished."

The inscriptions on the icons are in Arabic and Coptic. The dates follow now the Coptic calendar, now the Muslim calendar. Working with Egyptian artists, certain painters from the Levant experience the influence of Egypt and adopt the local style. Ohan Karapatian, a Jerusalem Armenian settled in Cairo, paints typically Coptic icons which he signs in Arabic. His first name is arabized and the last name is replaced by the mention of his origin: Yuḥanna al-Armani, that is, John the Armenian. He cooperates with Abraham the Scribe, the illustrious Coptic iconographer of the eighteenth century. Pl. 70,71 They jointly sign a vast output spanning some forty years. The most prolific of the painters of the nineteenth century is a Greek-Palestinian called Anastasius the Rūmī. His icons embody a Coptic variation on the popular school of Jerusalem. His style inspires George of the monastery of St. Macarius, the iconographer archpriest who works for the monasteries of the desert of Scetis. The tradition falls into decadence and becomes a popular artisanal activity of surprising abundance, but devoid of skill and inspiration.

The Mixing of Ages

Hellenistic Egypt was annexed to the Roman empire in 30 B.C.E. and appropriated the intellectual heritage of Greco-Roman antiquity at the expense of the gods it had worshiped from immemorial

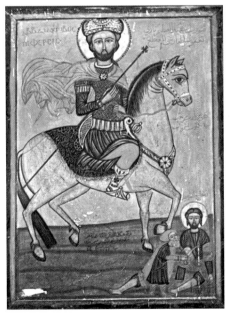 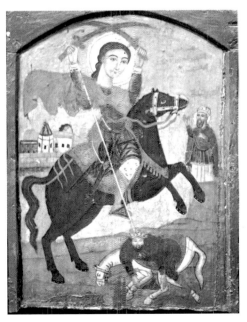 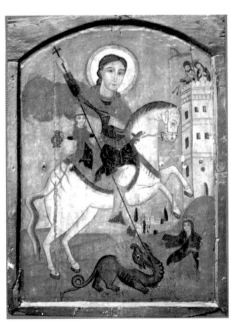

148. *St. Jacob the Sawn Asunder,* 18th c. Church of St. Mercurius, Old Cairo.
149. *St. Mercurius,* 18th c. Church of St. Theodore, Cairo.
150. *St. George,* 18th c. Church of St. Theodore, Cairo.

times. Having broken away from pharaonic history and tradition, Christian Egypt progressively separates itself from the Greco-Roman world and enters the orbit of the Muslim world where it remains for the greatest part of its history. Without being enormous, its artistic production leaves a body of pluralistic and continuous works, eloquent witnesses to a presence always alive. The decoration of the ancient churches of Old Cairo reflects the important epochs of this presence. The ages build one upon the other and the styles intermingle. A medieval painting places the figure of an Archangel on a column of ancient marble. A Byzantine icon of St. Mark is incorporated into a Fāṭimid ensemble where two reliefs representing the Annunciation and St. John the Evangelist closely follow the undulations of arabesques carved in wood. Art, both aniconic and iconic, devotes itself to the celebration of God, "adored and glorified in all times and at every moment, in heaven and on earth." The image opens onto eternity, and the prayer said over it at its consecration calls on the "Friend of humanity" to cover it with his Spirit "so that it may be helpful for salvation and perseverance."[31] The ankh is Christianized and makes its home among the decorations adopted from Islamic art. Surrounded by arabesques, it reproduces itself by multiplying its forms and its arms: "sign upon which the angels fear to gaze," "immovable stone," "source of grace," "tree of paradise whose fragrant branches give life to all."

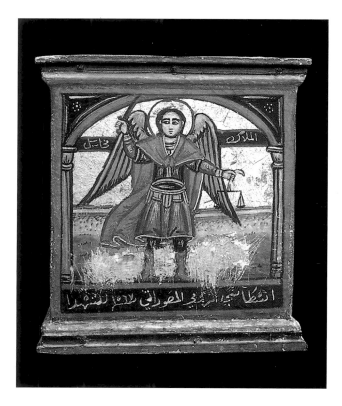 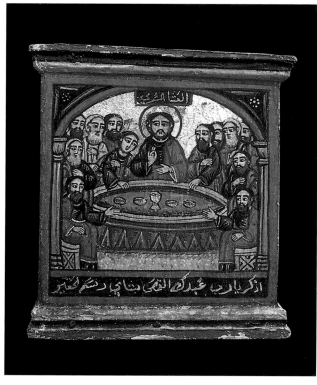

151. Chalice case: *St. Michael*, 19th c. Monastery of the Syrians, Wādi al-Naṭrūn.
152. *The Last Supper*, 19th c. Monastery of the Syrians, Wādi al-Naṭrūn

Notes

1 M. de Fenoyl, *Le sanctoral copte* (Beirut: Imprimerie Catholique, 1960) 154.

2 Cyril III ibn Laqlaq. Quoted by C. Cannuyer, *Les Coptes* (Belgium: Brepols, 1990) 119.

3 J.-C. Guy, *Paroles des anciens* (Paris: Seuil-Sagesse, 1976) 42.

4 J.-E. Berger, *L'œil et l'eternité* (Fontainemore-Flammarion, 1964) 9.

5 O. Wulff. Quoted by K. Wessel, *L'art copte* (Bruxelles: Meddens, 1970) 170.

6 Quoted by M.-H. Rutschowscaya, *La peinture copte* (Paris: Réunion des Musées Nationaux, 1992) 73.

7 Apa Serapion. Quoted by Guy, *Paroles des anciens*, 159.

8 Ibid., 45.

9 Clement of Alexandria, "Hymn to Christ the Savior," *Paidagōgos* 3:12. Quoted by A. J. Hamman, *Les Pères de l'église* (Paris: Desclée de Brouwer, 1977) 97.

10 Al-Maqrīzi, *Kitāb* 1. Quoted by S. Chauleur, *Histoire des Coptes d'Egypte* (Paris: La Colombe, 1960) 108.

11 Bar Hebraeus. Quoted by J.-M. Fiey, *Chrétiens syriaques sous les Abbasides*, CSCO (Louvain, 1980) 174–175.

12 *Chronicon Orientale*. Quoted by Cannuyer, *Les Coptes*, 122.

13 Al-Maqrīzi, *Kitāb*. Quoted by H. Lammens, *La Syrie, précis historique*, 3rd ed. (Beirut: Dar Lahd Khater, 1994) 102.

14 P. du Bourguet, *L'art copte* (Paris: Albin Michel, 1967) 167.

15 J. Leroy, *Le décor de l'église du couvent des Syriens*, Cahiers Archéologiques 23 (Paris: Klincksieck, 1974) 161.

16 Evagrius Ponticus. Evagre le Pontique, *Praxis et Gnosis* (Paris: Albin Michel-Cerf, 1992) 62.

17 Ibid., 49.

18 Clement of Alexandria, "Hymn to Christ the Savior." Quoted by Hamman, *Les Pères*, 97.

19 Dom L. Regnault, *Maîtres spirituels au désert de Gaza* (Solesmes, 1976) 18.

20 *La prière des heures* (Paris: Eglise copte de France, 1984) 62.

21 Abba Moses. Quoted by Guy, *Paroles des anciens*, 106.

22 Quoted by Guy, ibid., 42.

23 De Fenoyl, *Sanctoral copte*, 78.

24 Paris, Bibliothèque Nationale, Copte 13.

25 Washington, DC, Freer Gallery.

26 Theodore Studites. Théodore le Studite, *Petite Catéchèse* (Paris: E. Auvray, 1891) 150.

27 P. Bernat, *Choix de lettres édifiantes écrites des missions étrangères*, vol. 5, p. 226. Quoted by Chauleur, *Histoire des Coptes*, 137.

28 Abū al-Barakāt ibn Kabar, *The Lamp of Darkness*. Quoted by J. Leroy, *Les manuscrits coptes et coptes-arabes illustrés* (Paris: P. Geuthner, 1974) 38.

29 De Fenoyl, *Sanctoral copte*, 93.

30 Quoted by ibid.

31 Quoted by Chauleur, *Histoire des Coptes*, 180.

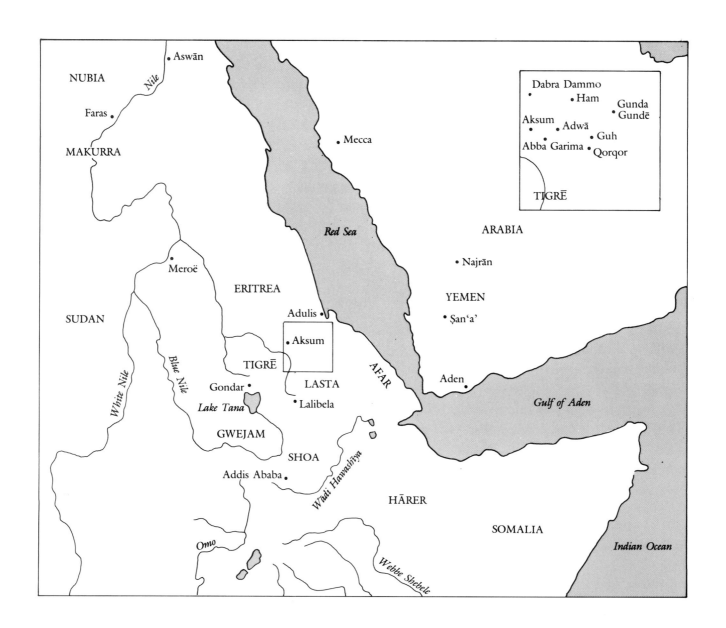

ETHIOPIA

CHAPTER SEVEN

The Ethiopians

The Abyssinians are descendants of Cush, himself a son of Ham, Noah's son and the father of all black peoples. The Bible speaks of the land of the Cushites. The Septuagint and Vulgate translate the Hebrew by *Aithiopia:* the Greek term designates "burnt-facedom." Homer writes in the *Odyssey* that humans with burnt faces are "dispersed to the ends of the earth, some toward sunset, some toward dawn."[1] Because it is beyond the world known to the Greeks, this faraway land has in the mind of people an undetermined geography. Gate to sub-Saharan Africa, ancient Ethiopia floats between East and West. It comprises Nubia and Sudan and extends beyond the Red Sea to the southern part of the Arabian Peninsula. Its Cushite people claims a glorious Semitic ancestry. In the desert, Moses marries a Cushite woman. When Aaron and Miriam speak against their brother "because of the Cushite woman whom he had married," God's anger strikes them: Miriam becomes "leprous, as white as snow," and Aaron implores divine pardon through his brother (Num 12:1, 10-12). The biblical symbolic value of colors is reversed: the snowlike whiteness becomes a sign of curse; the "black" wife is blessed and protected by God. Her alliance with Moses opens the Way of salvation to the land of Cush. "Ambassadors will come from Egypt, / Ethiopia will stretch out her hands to God" (Ps 68:31-32, JB). In the First Book of Kings, the Ethiopian queen of Sheba journeys to Jerusalem in order to meet the illustrious Solomon and "to test him with hard questions." She sees "all the wisdom" of the king and receives from him all the things fulfilling "every desire that she expressed" before going back to her kingdom (1 Kgs 10:1-13). An apocryphal narrative transforms the meeting of the two sovereigns into a sexual liaison, and the queen of Sheba gives birth to a child she names Menelik, literally, "son of a king." When he reaches adolescence, he goes to Jerusalem to meet his father. The resemblance between father and son is so complete that the people of Israel are unable to tell them apart. Solomon designates him his successor, but the young Ethiopian remains attached to his native land: he returns there in the company of levites and other Jews from the tribes of Israel, taking along the Ark of the Covenant, which he and Eleazar, son of the high priest, have stolen from the Temple of Jerusalem. Centuries later, the sacred monument finds its "definitive" resting place in the cathedral of Maryam of Ṣeyon in Aksum. The Abyssinian city becomes the new Jerusalem; Ethiopia, the new Israel; and its king, the "Lion of Juda." The Christianization of the country is the fulfillment of its Judaization. The Flight of the Holy Family leads it to an island in Lake Tana, which, according to some accounts, is to shelter the Ark for six centuries. The Mother stays there for one hundred days with her Child and on departing, leaves her necklace behind; it is jealously kept in the church of St. Qirqos (Cyriacus). The arrival of St. Matthew confers upon the land an apostolic origin. The first Ethiopian baptism takes place in Palestine: on "the road that goes down

from Jerusalem to Gaza,'' Philip converts "an Ethiopian eunuch, a court official of the Candace, queen of the Ethiopians." This conversion is triggered by a reading from Isaiah: "Starting with this scripture," Philip announces the good news to the stranger and gives him baptism. Snatched away by the Holy Spirit as they came out of the water, Philip leaves the newly baptized official to continue alone "on his way rejoicing" (Acts 8:26-40).

In the fourth century, a Syrian philosopher named Meropius sets sail for the African kingdom with his two pupils, Sts. Frumentius and Aedisius, residents of Tyre. The ship puts in at a port to replenish provisions. The philosopher and crew are massacred by the inhabitants; the two young men, taken into captivity. Impressed with the wisdom and erudition of his new slaves, King Ezana raises them to the ranks of high officials. Moved by their faith, he is converted in 329 and stamps the Aksum coinage with the sign of the Cross. Frumentius departs for Alexandria in order to establish a bond with the patriarchal see: consecrated bishop by St. Athanasius, the Syrian Illuminator places his young Church under the authority of the mother Church in Egypt. From now on, Frumentius' name is Abba Salama, that is, father of peace; Aksum calls him the "Revealer of the Light." In the fifth century, Christological quarrels divide the Christian East. Subordinate to the Church of Alexandria, Ethiopia sides with the Monophysites. In their flight from the imperial persecution of the "Diophysites," nine "Syrian" monks arrive in Ethiopia after a stay in the monastery of St. Pachomius in upper Egypt. Scattered throughout northern Ethiopia, where they found nine monasteries, they translate the New testament into Ge'ez and zealously participate in the evangelization of the country. The Syrian contribution leaves its mark on Christian Abyssinia: "The biblical text in old Ethiopian reveals a Syriac original, and not a Greek Alexandrian one; besides, the names of the new monastic foundations resemble those of Syrian monastic centers."[2]

Always multi-confessional, Aksum adopts Christianity without eliminating Judaism or pagan religions. At the peak of its glory, the kingdom extends its dominion as far as southern Arabia. In the Yemen, the Jewish monarch of Ṣan'ā' attacks Nadjrān and attempts to impose Judaism on its subjects. Men, women, and children undergo martyrdom by the thousand. With the support of the Byzantine emperor, Ethiopia intervenes and occupies the Yemen. A cathedral built in Ṣan'ā' becomes the center of pilgrimage for the Christians of Arabia, rivaling the Ka'bah in Mecca. At the time of the Arab Prophet's birth, viceroy Abraha al-Ashram leads a military expedition in order to destroy the cultic center of Arabia. Pelted with a rain of stones, his troops are knocked down, crushed like "plants cropped by cattle," the Qur'ān will say (S 105:5). In their turn, the Persians intervene on the part of Arabia and drive the Ethiopians back to their own territory. Muḥammad grows up. Islam takes its first steps, and the faithful of this early period endure the hostility of their fellow-citizens. The Prophet urges them to emigrate: "If you go to the Abyssinian country," he says, "you will find a king in whose realm no one is oppressed: it is a land of truth; you will stay there until Allāh grants you salvation."[3] "Attended by the bishops carrying the Gospels," the king of Aksum welcomes the refugees from Mecca. Their spokesman says: "We have adored Allāh, the only true Allāh, without associating him with other gods. . . . Our own people oppress us, persecute us, oblige us to renounce our religion, to cease worshipping Allāh, in order to return to the worship of idols. . . . Now, in search of a refuge, we have come into your kingdom, which we prefer to any other; we have implored your protection in the hope, O King, that in your kingdom, we shall not be oppressed." The chronicle continues: "Hearing the sūrah of Mary, the monarch bursts into tears and grants his protection. 'What I have just heard,' he says, 'and what Christ has taught flow from the same source. Go in peace! I shall not betray you.'"[4]

According to Ethiopian tradition, Islam during its conquest spares Ethiopia as a sign of gratitude. It is reported that the Prophet said, "Leave the Abyssinians in peace, as long as they do not take the offensive."[5] Arabia becomes Muslim and its Christians accept to melt into the new religion. The Red Sea is an Arab lake. Enclosed within a chain of Muslim states, the kingdom of Aksum declines

and loses its maritime and commercial power. Curiously, the Ethiopian Church remains dependent upon the Coptic Church. The patriarchate of Alexandria appoints the Ethiopian metropolitans, while at the same time submitting their consecration for the approbation of the Islamic political authorities of Egypt. Only rarely does the Christian enclave in Ethiopia contest this subordination: about 840, it refuses a metropolitan sent by Alexandria and attempts to elect another one. The mother-Church excommunicates the Ethiopian king and for one century refuses to send any metropolitan. Without the authority to legitimately consecrate a prelate, the Ethiopian Church resigns itself to submitting to the domineering control of the Alexandrian Church and accepting the bishops it sends.

In the tenth century, a queen named Judith lays the country waste and puts her husband, the king, to death. The kingdom recovers with the accession of the Zagwē dynasty. About the end of the twelfth century, the sovereign Lalibela moves the capital to the south. Built as a replica of Jerusalem, with churches dedicated to Sinai, the Jordan, and Golgotha, the city bears the name of its founder, a mighty builder venerated as a Saint. In former days, having received from the Archangel Michael's hands the divine ring and seal, Solomon subjugated demons and had them help in the construction of his Temple. Like a new Solomon, Lalibela engages Angels to erect twelve churches without any mortar or stones. "Those who do not go to the holy city Roha [Lalibela]," it is said, "resemble people who do not desire to see the face of Our Lord Jesus Christ."[6] In 1270, Yekuno Amlak overthrows the Zagwē and "restores" the power of the Solomonids: the descendants of Solomon and Menelik regain their throne. While Islam penetrates Ethiopia from the inside, 'Amda Ṣeyon confronts the neighboring Muslim emirates and insures the expansion of the Christian kingdom. Relations with the sultan of Cairo grow tense and involved. "Through ups and downs, as events dictate, the Muslims of Ethiopia experience a situation comparable in all respects to that of the Christians in Egypt: they do not have access in any circumstance to administrative or political responsibilities; they often are forbidden to build mosques; they must pay a heavy tax."[7] In 1423, the closing of Jerusalem to Christian pilgrims causes, in retaliation, a persecution against Muslims: mosques are razed to the ground; men are slaughtered; women and children sold as slaves. War is declared. King Zar'a Yakob promotes an intransigent Christian politics. Pope Eugene IV writes to him, calling him "our dearest son, Prester John, illustrious emperor of Ethiopia." At the time a Portuguese embassy settles in the country, the sultan Selim offers his help to neighboring Muslim principalities. Under the leadership of Aḥmad ibn Ibrāhīm al-Ghāzī, nicknamed Grāñ, the Left-Handed, the armies of the Somalis invade the whole territory of Ethiopia and devastate it by fire and sword. Churches and monasteries are destroyed along with their archives and libraries. The *History of the Conquest of Abyssinia* depicts in detail the extent of the ravages. The Muslim chronicler enumerates a score of sanctuaries laid waste, proudly listing the liturgical objects that were destroyed. Famine strikes both the inhabitants of the country and the conquerors. Having withdrawn to a safe place, the Ethiopian monarchy appeals to the Portuguese. Under the command of Christovao da Gama, the son of the renowned Vasco da Gama, four hundred musketeers march against Muslim troops. Christovao is captured and beheaded. His squire revenges his death by assassinating Aḥmad Grāñ, whose death puts his troops to rout. Christian Ethiopia is liberated and finds itself facing a "new" world. Latin missionaries settle in great numbers to rally the Church and the kingdom of Prester John.

The Great Medieval Art

The history of early Ethiopia depends on that of southern Arabia. The boundaries of the land of the Cushites extend far beyond those of the Aksum kingdom. It is possible that Sheba was the Yemen, that the Ethiopian baptized by Philip was a Nubian. Close to Hebrew, Arabic, and Aramaic, the language of the Cushite people is purely Semitic: akin to the languages of southern Arabia, Ge'ez has the most developed of the Semitic alphabets. Ethiopian writing adapts the Sabaean alphabet and

adds consonants to it. The language develops by adopting over two hundred signs created to express all vocalic nuances. Archeology witnesses in its own way to this early stage since inscriptions in the Sabaean language are not lacking. What the valley of the Nile contributes is minimal: ancient Ethiopia resolutely turns to Arabia in order to share in its culture, as is shown by its stelae, thrones, statues, figurines, and ceramics. Aksum coins are engraved with the disk and crescent in conjunction, images of the planetary gods of the country. In the fourth century, the pagan full moon is transformed into a half moon dominated by the Cross, sign of the emperor Ezana's conversion. The inscriptions of this period are in three languages, Ge'ez, Arabic, and Greek juxtaposed in parallel columns. Christian iconography of the first centuries leaves no trace. Architecture of the same period is powerful and original but lacks any mural decorations. Literary sources concerning these ancient paintings are of the rarest. Having returned to Mecca after "the flight to Ethiopia," as aṭ-Ṭabarī relates, the immigrant Umm Ḥabībah praises the "marvels painted on the walls" of the cathedral Maryam of Ṣeyon in Aksum and evokes them with nostalgia on his deathbed. Ancient edifices do not confirm this observation. Christian Ethiopia accuses Queen Judith, during her reign in the tenth century, and Aḥmād Grāñ, during his conquest in the sixteenth, of having destroyed the artistic heritage of the country. In the opinion of researchers, the existence of this sort of painting remains hypothetical. The walls of the churches are furrowed with engaged beams and seem ill-suited for murals. We do not possess even one painted parchment going back to the first millennium. The art of the Aksum kingdom does not include any images and the existence of an ancient Ethiopian painting seems quite improbable.

The rock-hewn churches of the north are a living museum of medieval art. Monolithic churches carved into the rock or erected within existing caves, these edifices are among the most spectacular monuments of the Christian East. They were discovered in the sixties: a priest by the name of Twelde Medhin "revealed" their secret and permitted some people to visit a score of churches with mural decorations. Even today, this priceless ensemble remains an inaccessible and faraway world, reserved for Ethiopologists and jealously guarded by archeologists. Its paintings are partially photographed, but the diffusion of these photographs is limited to rare publications. Precise dates are the object of controversy. Executed between the thirteenth and sixteenth centuries, these decorations reflect the cultural and artistic mixtures of the medieval period. In spite of the many rifts that separate Muslim Egypt from Christian Ethiopia, the daughter-Church remains subordinated to the mother-Church. While enlarging his territory through victorious campaigns against Muslim emirates, 'Amda Ṣeyon encourages the growth of a cultural renewal marked by an intense activity in translation. The most important books of the Ethiopian Church, all dating from this period, derive from Coptic works. "In most cases, Ethiopians translate these works from Arabic versions, whether original or translated from the Coptic text itself—the Coptic language having been abandoned by Egyptian Christians in favor of Arabic as early as at the end of the first millennium."[8] The Church asserts itself in a country where races, cultures, and beliefs are continually in flux. Its missionary monks carry the Good News as far as the west and east coasts of Africa, from the Atlantic Ocean to the shores of the Indian Ocean. Bonds are formed with both East and West. Abyssinian monks settle in Jerusalem where, according to a Byzantine chronicle, Saladin grants them an altar in the church of the Nativity and a chapel in the church of the Holy Sepulcher. A monastic community is established on the island of Cyprus, another at Santo Stefano dei Mori in Rome. In the northeastern part of Africa, a Christian rectangle is formed by Egypt, Nubia, and Ethiopia. And in its many facets, medieval art attests to the existence of this Christian block.

Carved Decorations

Christian iconography merges with an ornamental background where geometric patterns predominate. Still prohibited, sculpture in the round is replaced by images carved in relief on wood or stone,

decorating the coffers of ceilings, the capitals of columns, and the frames of windows. Vegetal, zoo-morphic, and anthropomorphic motifs are combined with pure geometric forms. Omnipresent cross-shaped designs give a Christian character to images from antiquity. The church of Dabra Dammō has a wooden ceiling richly carved with predominantly animal ornaments. According to the Hellenistic formula, the beasts are enclosed within juxtaposed frames of equal dimensions. Out of the thirty-nine frames, thirty-three contain animal figures. The decorations multiply animal representations de-void of any Christian symbolism. The stylization betrays the Islamic-Coptic influence. Traditional figures continue to be used and one can see two peacocks drinking from a vase, two birds drinking from a cup, two antelope back to back, two gazelle face to face, and two confronted ibex. There are representations of flesh-eating animals: a snake coiled around a gazelle, a wolf pouncing on an antelope, a leopard leaping on its prey, and a dragon devouring a fish. The repertory is enriched by the introduction of new animals, wild and domestic, such as the rhinoceros, hippopotamus, hyena, elephant, bison, monkey, donkey, mule, camel, and dog. The vaulted rotunda of the church of Maryam in Dabra Sinā shows a typically Christian relief: the Mother and Child between the two Archangels Michael and Gabriel. In Lalibela, the monolithic altar in the church of the Trinity is "guarded" by the Four Incorporeal Animals, dear to the Church of Alexandria: dressed in Ethiopian fashion, they lift their arms in prayer, interceding for the whole of creation. At Beta Maryam, "House of Mary," two figures of Equestrian Saints are placed on top of the porch of the main entrance: surrounded by animal figures, they brandish a buckler in one hand, a spear in the other, triumphantly crushing the dragon coiled around their horses' feet. In the church of Golgotha, the relief is almost in the round and takes on monumental dimensions: wearing the *timtim,* the Ethiopian turban, seven standing figures are carved lifesize. Erect in a hieratic pose in niches with a round arch, they hold a staff, sur-mounted by a Cross, and a closed scroll. Besides these, there is a sculpture carved on a tomb-niche: an Angel, in low-relief, watches over the Man of Sorrows lying in his sepulcher.

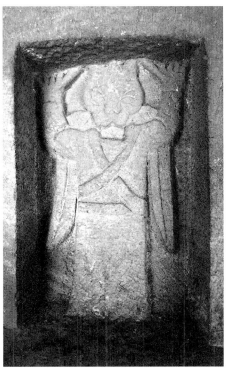

153. *Incorporeal Animal with the Face of an Eagle.* Church of the Trinity, Lalibela.
154. *Incorporeal Animal with the Face of a Lion.* Church of the Trinity, Lalibela.
155. *Incorporeal Animal with the Face of an Ox.* Church of the Trinity, Lalibela.

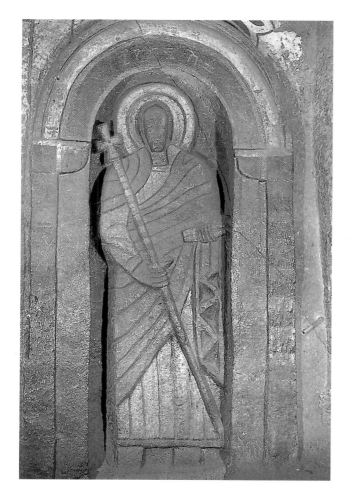

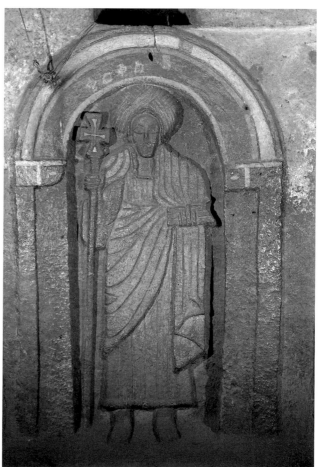

156. *A Standing Saint*. Church of
Golgotha, Lalibela.
157. *A Standing Saint*. Church of
Golgotha, Lalibela.
158. Portable altar, detail:
Crucifixion. Telasfarri Estifanos
Church, Wallo.

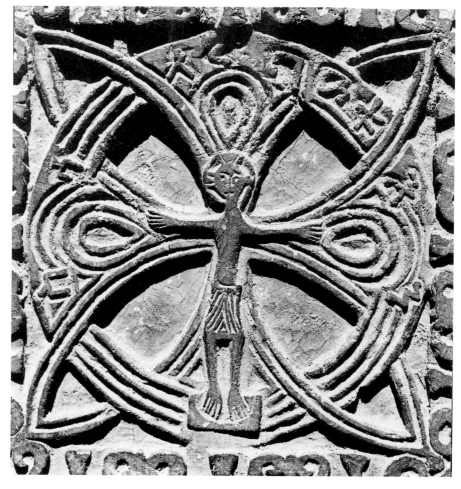

The same decorations that grace the walls are also found on cultic objects. A portable altar in Telasfarri Estifanos is an outstanding example of the richness of the ornamental designs of the period. Figurative and purely geometric elements are closely united. The Crucified Christ is shown within a quadrilobe set within an Islamic border. Dressed like a Byzantine emperor, the Archangel Gabriel stands under a rounded arch, holding the cross-headed staff and globe of the world. A similar composition shows the Archangel Michael carrying his cross-headed spear. The rounded arches and columns are carved with zigzag and interlacing ornaments; corners have palmette motifs. This sort of architectural ensemble, inspired by Coptic funerary stelae, is found again—under an aniconic form—on two faces of the altar where a quadrilobe is placed under an arch. G. Gerster observes: "The tiered base, the tiered capital, and the profile of the shaft of the column belong to the earliest Aksum antiquity. The decorative details—especially the ornamentation of the corners—remind the viewer of the Lalibela churches and their processional crosses."[9]

Mural Painting

Mural paintings continue those of medieval Egypt while bringing new variations to them; the two styles become differentiated and yet share a common store. Islamic-Coptic interlacing motifs, freed from geometric rigor, take on a resolutely Ethiopian form. Traditional animal decorations continue to be used, but they adopt new stylized shapes. The ethnic African character of these shapes sometimes brings Nubian paintings to mind. (Nubia, an Egyptian-African province separated from PL. 73 Byzantium in the eighth century, remains tied to the Coptic Church until the disappearance of its last Christian establishments in the fifteenth century.) Linear graphics are undisputedly dominant; PL. 74–75 the figures are drawn on the even surface of stucco; the outlines are defined by supple and precise lines. The way space is used ignores perspective and the play of light. Bodies are concealed under clothes that have become decorative masses. The Gospel of Thomas declares, "Whoever has come to know the world has discovered a carcass, and whoever has discovered a carcass, of that person the world is not worthy."[10] In the church of Holy Mary at Qorqor, the account of the fall is transformed into a talismanic allegory. Ostriches, doves, and gazelles evoke the paradisiac place. Eve is shown next to a serpent standing column-like; she points to the tree of knowledge with one hand and hides her nakedness with the other. A succession of images in which snakelike figures are knotted around humans seems to symbolize the perpetuity of the temptation. Bodies are extremely schematized. Faces are seen either frontally or three-quarter; but even in the latter position, the large black eyes look at the observer. From one church to the other, the stylization of faces varies and innovates, but the thoughtful gaze obstinately persists. The geometric treatment of the features sometimes verges on pure abstraction, thus conferring on faces an unexpected modernity. In the church Gannata Maryam, PL. 77 "Paradise of Mary," the faces of the elect resemble those of the futuristic Kazimir Malevich. The nose and mouth are erased; only the eyes are hollowed out in the emaciated faces of the deified Living Ones. Figures are emptied of any volume, their flatness accentuated by the arabesques of their garments. The horizon is stark; landscapes and buildings have vanished. The Saint occupies the whole space: "I am the light that is over all things. I am all: From me all has come forth, and to me all has reached."[11] Interlacing motifs, foliated designs, crosses, and intertwined curves are linked into ornamental masses and are the images of those trees of paradise which "do not change, summer or winter, and [whose] leaves do not fall."[12] Angels, Saints, and Prophets share this heavenly place; the world, humans, and things are absent from there: "This heaven will pass away, and the one above it will pass away. The dead are not alive, and the living will not die."[13] Prayer leads even sinful mortals to the threshold of the paradise of the Living Ones:

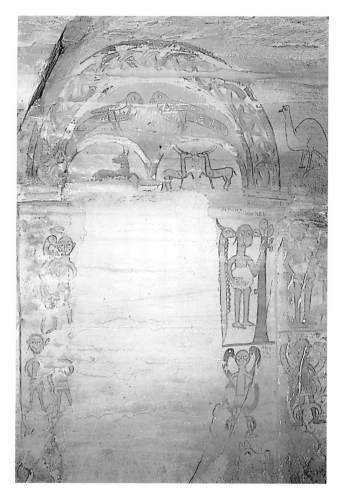

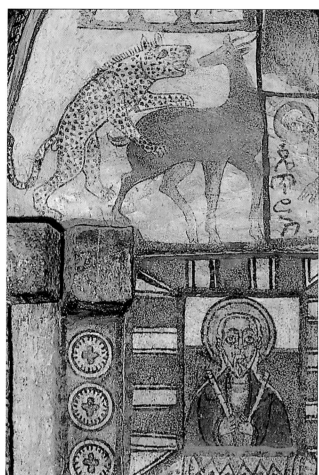

159. *The Fall.* Church of Holy Mary, Qorqor.
160. Interior decoration. House of Mary Church, Lalibela.
161. Interior decoration. Paradise of Mary Church, Wallo.

right:
162. *David.* Church of St. Daniel, Qorqor.
163. *Baptism.* Church of St. Daniel, Qorqor.
164. *St. Onophrius.* Church of Holy Mary, Qorqor.

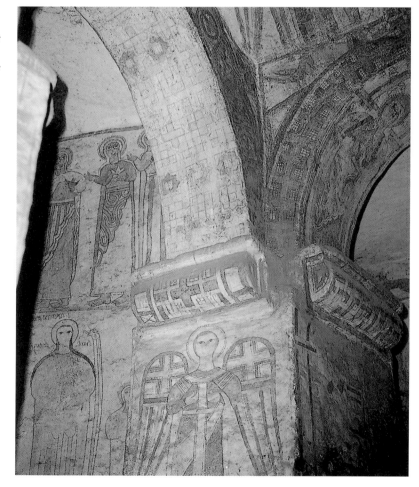

Emmanuel, the kind, I place my hope in you.
Grant me, your humble servant, to live
in your garden, with the Saints, in fellowship.

Emmanuel, the living, Ancient One,
outside of you I have no protector;
do not abandon me in this world when misfortune strikes me.

When you come for the Last Judgment
with your Father, the kind, and the Holy Spirit, the merciful,
Emmanuel, the watchful, indefatigable creator,
say to my soul, "Where I have stayed, stay,
and where I have dwelt, dwell with me."[14]

Christ occupies the summit of the Heavenly Hierarchy. Ethiopian piety sees in church architecture an "incarnate" image of salvation history. The Patriarchs, as it were, are the doors; the Prophets, the windows; and the Apostles, the pillars. The Evangelists are the corners; the holy Fathers, the lights; the Equestrian Saints, the walls. The Holy Innocents are the roof, and the Angels, the beams. Holy Mary is the sanctuary. The two covenants become one and their protagonists are united in one same eon. In Qorqor, the church of St. Daniel possesses a beautiful cupola where the Prophets and Saints form a single legion. With their wings unfolded, the four praying Archangels define a square framing the eye of the cupola, image of the celestial vault. The people walk in silent procession; the historical framework is deliberately ignored. Astride their horses, Sts. George, Mercurius, and Theodore the Easterner alternate with the Prophets and Saints represented full-length. Abraham, Isaac, and Jacob are together with Zechariah, Peter, and James. Stephen officiates with Melchizedek, Moses, and Aaron, all shown with censers in their hands. The four "priests" of the Temple, in an attitude that designates the Epiphany, are turned toward a representation of the Baptism of Christ. Gesture becomes symbol: "The handle at the top of the censer is God," declares the *Fetha Nagast*. "The chains are the Holy Trinity; the coals, Christ; the smoke, the Holy Spirit; the ashes, sinners."[15]

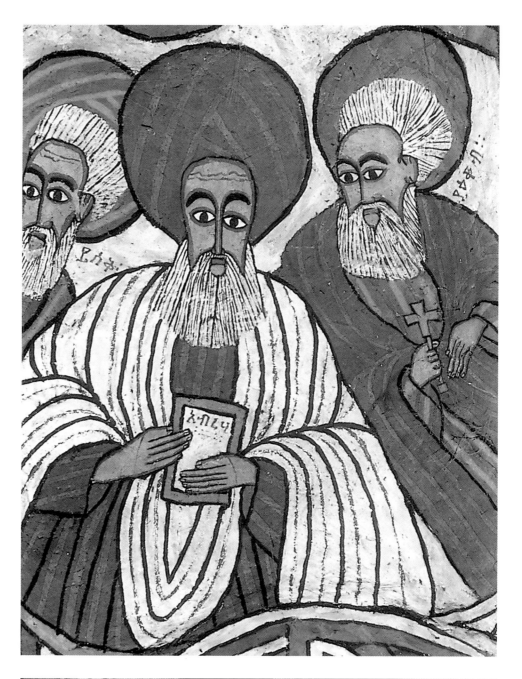

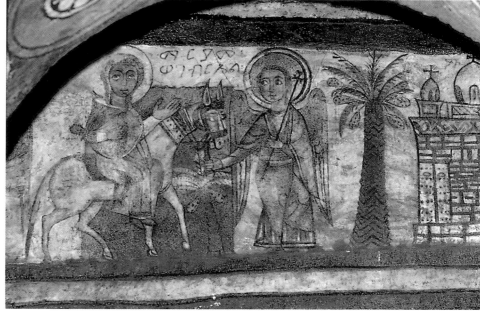

165. *The Patriarches
Abraham, Isaac, Jacob,*
fragment. Church at Guḥ.
166. *Flight into Egypt.*
House of Mary Church,
Lalibela.

right:
167. *Christ in Glory.*
Church of Dabra Salama,
East Tigre.

218

The same programs continue in use, but the plastic interpretation renews them with surprising freedom. Prophets, Apostles, and Saints are assembled in three circles in the church of Guḥ. The Pl. 78,79 Prophets of the Old Testament occupy the drum of the vault; the Apostles of the New Testament, the south cupola; and the Nine Saints who came from Syria, the north cupola. The workmanship is purely Ethiopian. The personages leave aside their ancient garb and don the local tunics and turbans. Other Saints and other Prophets take their places on the church walls. The folds of the clothing are reduced to parallel curves. Outlines are cursive and assertive; black and red define forms and contours. The chromatic repertory is slight. Hands are uplifted in order to carry the signs of the Good News; the Prophets of Yahweh become the messengers of Emmanuel; Jacob, the descendant of Abraham, holds the Cross of Christ, "Sun of the world."

Christophanies are many: *Emmanuel the Good, Arm of the Father, Emmanuel the Merciful, Emmanuel the Pearl, Emmanuel the Powerful, Emmanuel the Unique,*[16] *Savior of the World, Christ: Child and Old Man.*[17] In Dabra Salama, Emmanuel, beardless and youthful, is enthroned with his legs crossed; he is clad in the manner of Eastern princes and supported by the Four Incorporeal Animals. In Gannata Maryam, he is seated, one leg extended, the other folded, on a chair adorned with a Cross, his hands raising a closed book of the Gospels. The scenes overlap. In the church of Holy Mary at Qorqor, *Christ in Glory* is placed above the *Entrance into Jerusalem,* creating a composition which is not unlike that of the Ascension. In Beta Maryam, Christ blesses the five loaves and two fish. The presence of the sinful woman with her jar of ointment evokes the meal at Simon's house. The hieratism of the Savior as he gives his blessing transcends the historical event, transforming it into an eternal thanksgiving. The gesture of blessing is repeated at Jacob's well where the Samaritan woman comes to draw water. Priest of priests, Christ transforms the water into "a spring of water gushing up to eternal life" (John 4:14).

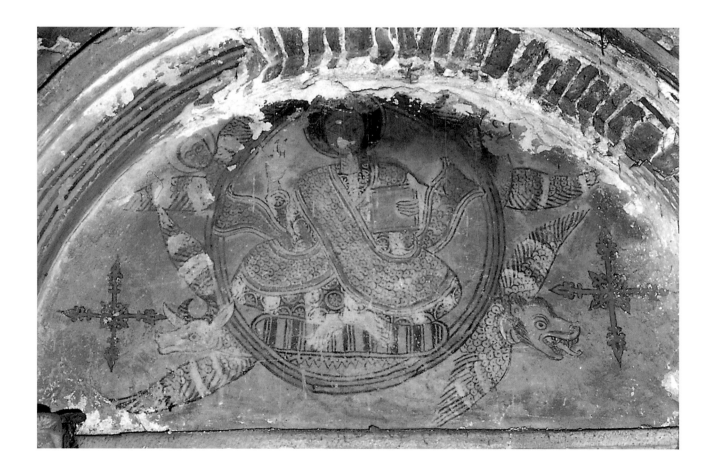

The roads of northeast Africa crisscross one another. With his hair held by a flattened crown, his paten, and his cross-headed staff, the Archangel Raphael in one of the churches at Qorqor is a replica of that in the Nubian church at Faras. The iconographic program of Gannata Maryam attests to an Egyptian participation: "A row of Saints, who are represented together with episodes from their lives, . . . are not part of the Ethiopian synaxarion but actually of the Coptic one."[18] In Egypt, at the monastery of St. Macarius, an Abyssinian by the name of Tekla has his signature on an impressive cavalcade. St. Basilides, an illustrious Martyr in Diocletian's persecution, is accompanied by a familial group of four Equestrian Saints, Macarius, Eusebius, Justus, and Apoli, and by a woman represented full-length, St. Theoclia, Justus' wife and Apoli's mother. As J. Leroy[19] remarks, the names of the mother and the son are preserved exclusively in the Ethiopian version of the Acts of Basilides, and the fact that they appear in the painting reveals the artist's nationality. To this thematic detail, one must add the specifically Ethiopian character of the pictorial style, reinforced by the presence of a typical ornament carved above St. Macarius.

The Abyssinian Book

Manuscript illuminations share in an original use of colors. The earliest witnesses of bookmaking are, it appears, two gospel books discovered by J. Leroy in the monastery of Abba Garuma in the region of Adwa. These paintings go back to the eleventh and twelfth centuries and they show that

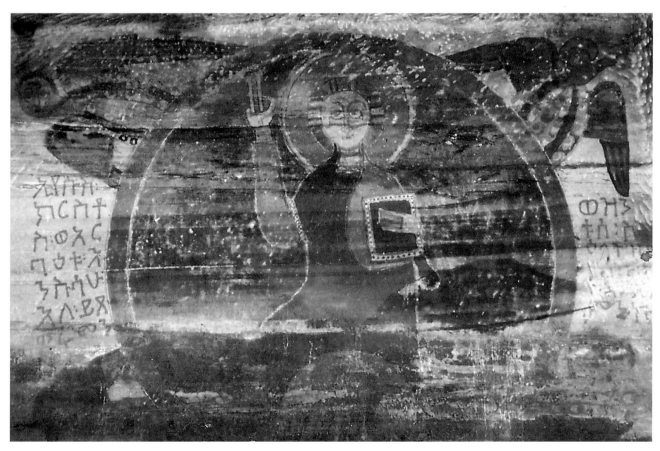

168. *Christ in Glory.* Church of Holy Mary, Qorqor.

Ethiopia adopted Byzantine models. Their execution is clearly different from that of later manuscripts. The ornamental forms, the pieces of furniture used by the Evangelists, and the treatment of the folds of garments betray a model strongly influenced by antiquity. The eyes circled in black, the long noses, and the large hands with slender fingers announce the Ethiopian style which will be full-fledged in the fourteenth and fifteenth centuries, the medieval period. Dates prior to these are the object of lively controversies. Ethiopia continues to use a formula dear to the whole of the Christian East. The two gospel books open with Eusebius' famous Canons: the tables of concordances succeed one another in the frontispiece, with an architectural ornamentation replete with birds, other animals, plants, various objects. In addition to these introductory pages, there are the portraits of the four Evangelists and the representations of the main Feasts of Christ. There is no longer anything Byzantine about the plastic style: the visual field offers no illusion of depth; the palette is restricted to simple and vivid colors, applied in a flat manner in large swaths; there is no trace of gold; the volume of forms has vanished; interior and exterior spaces are one and the same. Animate beings and inanimate objects, assuming geometric forms, are drawn on a plain background. The shape of the faces is now round, now rectangular. Whether full or three-quarter face, standing or sitting, the Saints are immured in their inflexibility, immobile and unmovable. Their ecstatic look keeps its eternal fixity. Movement does not disturb this profound rest: any action is reduced to stereotypical gestures repeated by the many individuals. As in 'Abbāsid paintings, face and hands are outlined in red, eyes and eyebrows in a pure and intense black. Hanging objects float like those seen in the miniatures of Mamlūk Egypt. Towards the end of the fifteenth century, new tendencies appear: an Asiatic look prevails

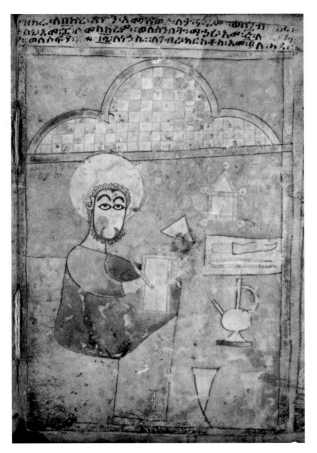
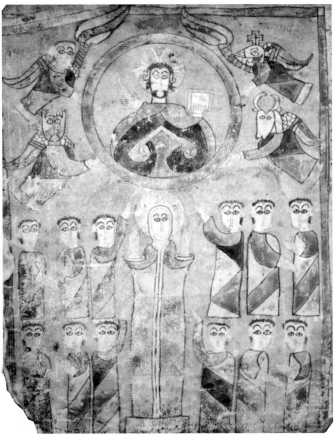

169. *St. Matthew,* gospel book, 14th c., 19th c. Sam Fogg Gallery, London.
170. *Ascension,* gospel book, 14th c., 19th. c. Sam Fogg Gallery, London.

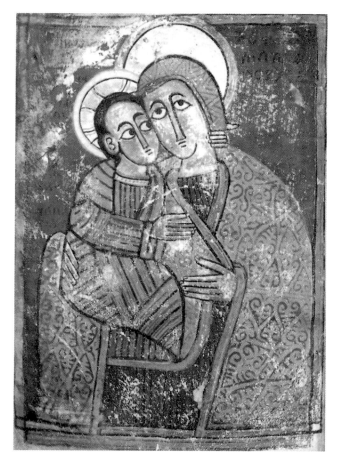

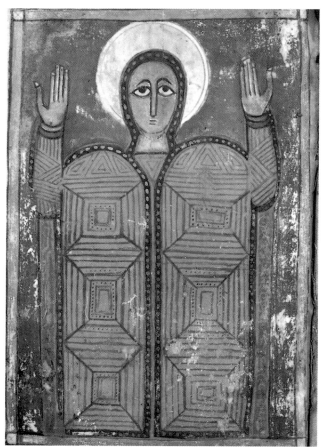

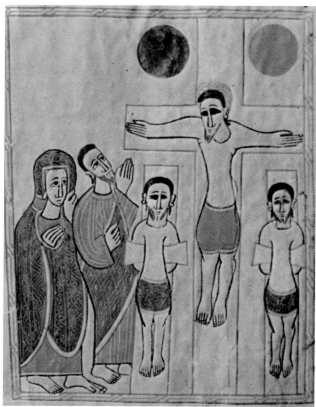

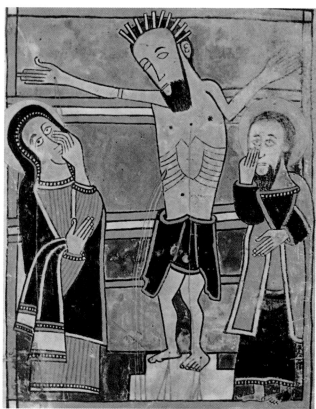

171. *Mother and Child,* 15th c. Sam Fogg Gallery, London.

172. *The Virgin, Gate of Life, in Prayer,* 15th c. Sam Fogg Gallery, London.

173. *Crucifixion,* 15th c. Church of Bethlehem, Dabra Tābor.

174. *Crucifixion,* 15th c. National Library, Paris.

in painting. The almond-shaped eyes become slanted and the arch of the eyebrows becomes more flexible. The human element asserts itself: movements grow animated; faces betray a restrained psychic force. A profusion of ornamentation and color applied in a flat manner continues to insure the otherworldly character of the images. Combined and repeated, motifs made of lines and points blend harmoniously with the many elements of the pictorial space, whether architectural details, pieces of furniture, or clothing. The figurative is immersed in an abstract world without horizon line, perspective, or weight. The reign of signs replaces the world of shadows. "Everything old has passed away; see, everything has become new" (2 Cor 5:17). "The creation—earth and heaven—whose unity was once broken, sings the new friendship: humans are in accord with the angels and celebrate their knowledge of God."[20]

The artists' inventive genius enriches traditional iconography with new models. A beautiful manuscript[21] from the middle of the fifteenth century shows two images of the Mother of God. The first one takes up the traditional prototype and gives it an Ethiopian twist. "Throne of the Sun," the Mother holds the Son on one arm and points to him with her other hand. The image is dependent upon a Byzantine model which joins together two centuries-old representations: the closeness of the Mother's face against the Child's follows the prototype of the Virgin of Tenderness, and her raised hand, that of the Mother of God as Guide. The stylization of the faces and clothing give the work its Ethiopian character. The second image shows the Virgin opening her arms wide in the sign of prayer. The stylization of the body transforms the prototype of the Orant into a specifically Ethiopian model, making the Mother of God the "Gate of Life." Rigorously constructed, Holy Mary's split robe is represented as two closed panels accented by a twofold geometric composition: "Lift up your heads, O gates! / and be lifted up, O ancient doors! / that the King of glory may come in" (Ps 24:7). Sanctuary of the Church, the Mother of God is called "door of light, ladder to life, dwelling of divinity." "You are the Holy of Holies," says the *Praise;* "you are called pleasure of the Father, dwelling of the Son, and shadow of the Holy Spirit"; "you are the empyrean of heaven, you who have been the empyrean of earth"; "through you and in you, we have drawn closer than the earth to the dwelling which is in the empyrean; through you and through your Son's name, we have drawn close."[22]

The variations in iconography reflect its multiple theological dimensions. According to the first model of the Crucifixion, the Cross of the Lord stands bare between the two crucified thieves, as the sign and trophy of him who conquered the world (John 16:33). "Praise befits your life-giving Cross," says the Prayer, "because the whole creation has been saved by your Cross."[23] A lamb placed at its summit illustrates the canticle from Revelation, "Worthy is the Lamb that was slaughtered / to receive power and wealth and wisdom and might / and honor and glory and blessing!" (5:12). A second model shows the Incarnate Word. Christ stretches his arms on the Cross. His face and body remain impassive: all suffering has been swallowed. Lord of life, the Son is "the high priest of the Father who has reconciled humanity with God."[24] A third model manifests the kenosis of the Human One. A painting at the National Library[25] in Paris has a poignant image. According to established tradition, the Mother of God and the Apostle John witness the torments of "Emmanuel Bound, Martyr of the Lord."[26] A network of ten thorns covers the head of the Crucified; the muscles of the bare chest are outlined; arms and legs sag. The disproportion of the body emphasizes the dramatic character of the scene. Rivulets of blood flow from the five wounds. Curiously, the painter adds a sixth wound in the middle of the chest. Undeniably, there is here a European influence; however, the execution faithfully observes the canons of the native style. The people are reduced to boldly drawn geometric masses; the Cross is one with the walls of Jerusalem; the blue, red, and ocher are applied in parallel bands separated by a black line, without nuance or transitional hue. The colors of the costumes blend with those of the background, thus creating a one-dimensional space. Eschewing all naturalistic perspective, the work is a plastic composition of striking expressionism.

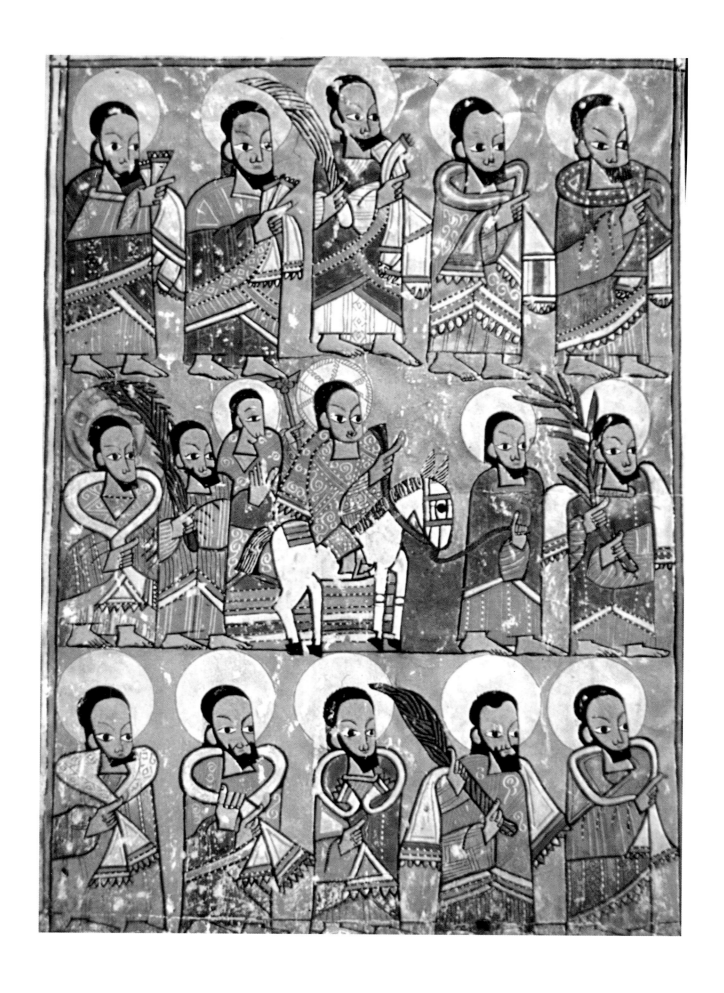

175. *Entry into Jerusalem,* gospel book of Gunda Gunde, 15th c.

Paintings on stuccoed wood embody the Ethiopian icon in their own way. The multiplicity of influences is revealed in the variety of techniques, but the indigenous style comes into its own with smaller, movable paintings. Parallel to this purely Ethiopian style is a line of works inspired by European paintings in the Byzantine manner. The initial design persists; however, the outline is more slender and refined. The salient lines are transformed into undulating curves. Gentleness and grace replace the austerity of the geometric style. Flesh tones are subtly modeled; the folds of costumes are set off by light tints. In the fifteenth century, an admirable painting by an artist named Fer Şeyon, Fruit of Zion, shows the Mother nursing the Child—an excellent representative of this stylistic trend. The spare drawing reminds the viewer of Japanese prints. The turtledove tightly held in the Child's fingers attests the Italian origin of the iconographic model. In contrast, the motifs decorating the clothing are purely Ethiopian, and the two Angels placed behind the Virgin-Mother confirm the local provenance of the work: the Guardians of the Living Sanctuary proudly brandish their swords in sign of reverence and trace with their wings, opened in a fan shape, the confines of the divine Place. Paintings continue to celebrate holiness as the source and origin of every figurative representation. A handsome diptych in Addis Ababa gathers on its two panels an assembly of fourteen Saints. The figures are in tiers on a monochromatic red background; the tiers are indistinct. Four busts of Saints occupy the center of the composition and are surrounded by a cavalcade of eight Saints. In the lower tier, a bust, and a head enclosed in a medallion, complete this daring group portrait. The choice of Saints reflects Ethiopian piety. One recognizes the Equestrian Saints dear to all the faithful of the Church of Alexandria: Theodore the Easterner, Basilides, Mercurius, Apoli, George, and Claudius. Riding his lion, St. Mamas joins the procession. Raised to the rank of Saint, King Lalibela finds his place of honor here. Dressed in the Ethiopian way, the Knights all have floating cloaks and

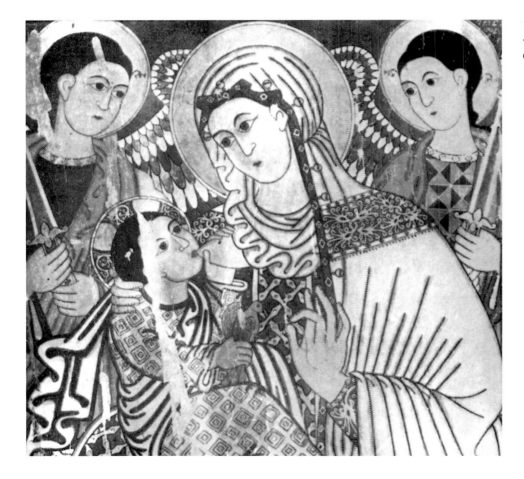

176. *The Nursing Virgin,* work of Fer Şeyon, 15th c. Church of Daga Estifanos.

225

hold the reins in one hand, the spear in the other. The medallion presents an unheard-of portrait of St. John the Baptist: represented frontally with an abundant head of hair, the face of the Forerunner resembles that of a talismanic lion. Figures of Angels, Apostles, Saints, these fixed themes, untiringly repeated, are renewed through the profusion of variants and styles.

Modern Times

Strengthened by Portuguese military success, the Roman Church penetrates into Ethiopia in the middle of the sixteenth century. Polemics break out between Abyssinian clergy and Latin missionaries. From the viewpoint of Rome, Ethiopia is more a virtual ally against Islam than an imperiled Christian country. For centuries, this faraway land appeared in the Latins' eyes as a region with indeterminate frontiers, situated at the extremities of the earth, sunburnt, inhabited by a dark people: malformed humans with black skin, black being the color of sin and vice. From paradise, the river Gihon flows to the south of Egypt where it encircles Ethiopia, accursed place undermined by the blackness of evil. The first river of paradise is compared to chastity, but *Aithiopia* to dark sinfulness. To wash oneself from Ethiopian blackness is to repent and purify oneself. According to St. Jerome, the people with burnt faces are called Ethiopians "because of their bloodthirsty, dark, and cruel customs."[27] From then on, one generic term is applied to blackness and sin. Ethiopians are identified with demons: inspired by the iconographic representation of the devil, the *Song of Roland* describes

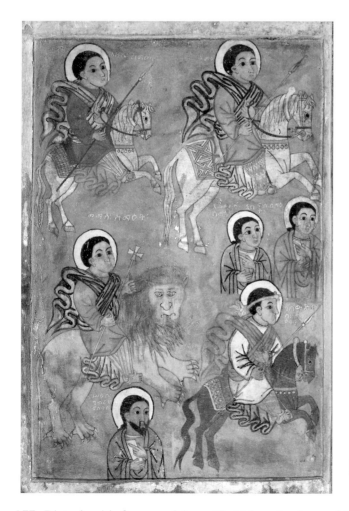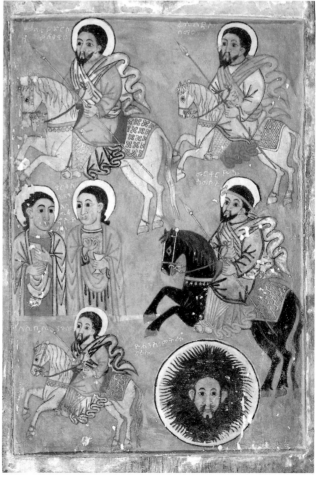

177. Diptych with fourteen Saints, 15–16th c. Institute of Ethiopian Studies, Addis Ababa.

226

the Cushite pagans as black with white teeth, enormous noses, and large ears. The kingdom of Prester John is a land of sin. Abbot Absalom of Springerbach gives a cruel description of the country: "Ethiopia is this land entirely made of sand where not the slightest trace of charity can be found; for this reason, it does not produce the fruits which result from good deeds. Its inhabitants, burnt by heat, have extremely black faces, a horrible appearance, and dissolute relationships; they are completely misshapen as a result of the blackness of sin. As a consequence, one must flee the country, not with measured steps but at a very fast run."[28]

Rather than "fleeing" Ethiopia, Latin missionaries seek to convert it. The religious approach goes hand in hand with a political strategy of taking the Muslims from behind. Contacts are numerous. A first Dominican mission disembarks in 1350. An unofficial delegation of Ethiopian monks from Jerusalem is present at the first part of the council of Florence (1438–1445). A Portuguese embassy is established in 1520. Naturally allied to the Alexandrian positions, Ethiopia "discovers" in the sixteenth century the passion of doctrinal battles. In a treatise entitled *Confession*, King Claudius declares himself opposed to union with Rome. The soldiers of St. Ignatius lead the fight in spite of all obstacles. In 1603, Pedro Paez succeeds in converting the king Za Dengel, and the "errors" of the Ethiopian Church are condemned by an imperial decree. However, the union is rejected by clergy and laity and is without effect. Abandoned by his own, the sovereign is defeated and condemned to death. In 1622, his successor Susenyos confesses the Chalcedonian faith and the supremacy of Rome, "mother of all Churches." Paez' successor, Alphonso Mendez, undertakes the systematic latinization of Ethiopia, condemning with one stroke all centuries-old usages: the Latin missal and Roman calendar replace the Divine Liturgy and sanctoral cycle; feasts and fasts follow Roman regulations; the Inquisition is set up; divorce is abolished and circumcision prohibited. The missionaries reconsecrate the churches, transform the altars, reordain the priests, and rebaptize the people. The union triggers a stormy polemics. Two works written at the time reflect the intensity of the controversy: on the one hand, the *Scourge of Lies* praises Rome; on the other, the *Treasure of the Faith* is an apology of the Ethiopian Church and refutes Latin claims. The debate degenerates into war. Ten years after his conversion, Susenyos abdicates in favor of his son Fasilides. Catholicism is extirpated. The Jesuits are banished: some are expelled from the country, others rounded up and sold as slaves to the Turks. One bishop and six priests are assassinated. Two French Franciscans are captured and hanged with the ropes of their religious habits. The kingdom repairs to its high plateaux. In the west, far from the sea, Gondar becomes its capital. Castles are built with the help of Portuguese architects and artisans. The city flourishes for over two centuries, then declines with the beginning of the Age of Mesafent, that is, "Judges": just like the Israelite kingdom of former days, Ethiopia plunges into anarchy and is divided into rival principalities. The sovereign Theodore vainly attempts to restore the empire. Weakened, the Church sees a great number of its members convert to Islam. In ruins, Gondar expires at the end of the nineteenth century. In a supreme effort, Ethiopia rises again and doubles its size. At the heart of Shoa, Addis Ababa, "the new flower," becomes the capital of the empire.

The Gondarian Age

Gondar is the center of an intense cultural efflorescence. Artistic creation manifests new tendencies. Whether mural paintings, icons, manuscripts, or crosses, the production is of astonishing abundance. Styles, programs, and techniques are extremely varied. Mutual influences increase the cultural mixture. Adopted by local painters, European models are interpreted, enlarged, and transformed to suit Ethiopian taste. The treasury of themes is enriched. The number of people represented grows; the hieratic figures of Saints take on new forms. Without renouncing the tradition of the icon-portrait,

artists devote themselves to narrative painting. Literary connotations proliferate. A new pictorial genre takes a definite shape: didactic and historical, the image welcomes long anecdotal cycles. The works of the seventeenth century remain attached to the medieval spirit. Byzantine iconography is no longer anything more than an underlying common ground. Dressed in the Ethiopian manner, Saints are placed in tiers against a plain background; action is reduced to uniform gestures; the clothes are treated in flat masses accented by parallel curved or straight lines. Geometric designs still play an important part. Forms are without volume and colors without shading. But in the eighteenth century, the style changes noticeably: Ethiopian painting falls under the influence of European painting.

This change is not a local phenomenon: in the Christian East as well as in the Islamic East, painters become students of the Western school. In the Greco-Slav world, sacred art is divided before undergoing decay. In the second half of the sixteenth century, Michael Damaskinos has a dual career, simultaneously producing Byzantine icons and Italianate paintings. In their efforts to unify the two esthetics, his disciples create a heavy, hybrid, and heterogeneous style which spreads into the Christian countries of the Ottoman empire. Simon Ouchakov, the Russian Raphael, treats Byzantine prototypes in the manner of the Renaissance masters. His style attracts many students and, in the seventeenth century, is established in all Russian lands. Far from the great centers, the age-old tradition continues, but marginally, in the studios of the Old Believers in the villages of the region of Vladimir, such as Palekh, Mstera, and Khuli. In the Mughal empire, Indian-Persian painting opens itself to the influence of Western art. Reconciling Hinduism and Islam, the Mughal emperor Akbar founds the "divine belief" and installs Jesuit missionaries at his court. The priests initiate artists into the secrets of naturalistic painting. Latin esthetics and themes triumph and spread. The sovereign decorates his imperial mausoleum with a painting representing, according to the description of the Venetian Mannucci, "the holy Crucifix, the Madonna holding the Child Jesus, and on her left, St. Ignatius, Archangels, and Cherubim."[29] The work—no longer extant—has its counterparts in the "catholic" miniatures executed by Indian and Muslim painters, such as the Crucifixion, dated 1590, Man of Sorrows, dated 1605, and Jesuit in Front of the Holy Virgin, dated 1610. Miniaturists treat traditional prototypes in the Western manner, shading colors into one another, creating contrasts of light and shadow, exploring atmospheric effects, painting three-dimensional landscapes against the horizon. The optical visions of material nature shake the *mundus imaginalis* of great Islamic art. The mixture of styles verges on a "disastrous syncretism": as A. Papadopoulo remarks, this work created by Muslims is but a "Western painting technique" allied to an Indian "representation of the world."[30] Persians and Turks follow a similar syncretic path. Even the figurative elements do not escape this metamorphosis: seduced by the world of sensible appearances, artists and artisans exchange rosettes for material roses and thus transform the iconic signs of the ornamentation into natural elements represented in their earthly shape.

In this momentous clash of cultures, Ethiopia occupies a special place. Like religious literature, painting incorporates Western contributions while transforming them according to its own canons. Flesh tones are modeled; the technique of shading off modifies the use of colors; shadows lighten the drawing of folds; the background is more airy. However, painters show little interest in a three-dimensional representation founded on the laws of Western perspective. Proportions are granted scant attention; the initial drawing remains clear and precise. Primary colors keep their place of honor: vermilion red, buttercup yellow, and pure blue are lavished in all their brilliance; full-tones dominate over half-tones, and shaded nuances are swallowed in the thickly applied vivid colors. Faces continue to be interchangeable. The Blessed and Angels are shown full or three-quarter face; the malefactors and devils, in profile. The preeminence of large, black, ecstatic eyes proclaims the contemplative character of the scenes. Transcendent vision modifies the appearance of visible forms. Expressionistic distortions reinvent the proportions of animate beings and inanimate things. Certain uses of foreshortening contradict optical perception. "The father's [reign] is spread out upon the earth, and people do not

see it,"[31] the Gospel of Thomas declares. What is visible and what is invisible are entwined. The eye of the spirit continues to search what the imperfection of the terrestrial gaze hides from humanity. A profusion of images covers the walls of churches. Frescoes give way to large paintings on canvas attached to the walls. Icons are grouped into altarpieces—diptychs, triptychs, and polyptychs. Paintings accompany the manuscript texts of gospel books, psalters, and prayer books. Media and techniques vary, but there is one single conception of beauty: painters use the same palette and share one common esthetics.

Christophanies

What comes from the West is merely a number of new themes. Artists make use of the models circulated by missionaries and create new iconographic formulas. This pictorial osmosis gives rise to unheard-of types completely unknown to the Greek-Eastern world. Painters enjoy a considerable freedom of inspiration: the imported models are reworked and reinvented. The representations resulting from these innumerable cultural mixtures are strong and bold. Christ dominates the hierarchy of Angels and Saints. Ethiopia dresses him in sumptuous apparel and glorifies him by recounting his earthly

178. Gospel scene, engraving by Roberto Tempesta, 1591.
179. Gospel scene, 17th c. British Museum, London.

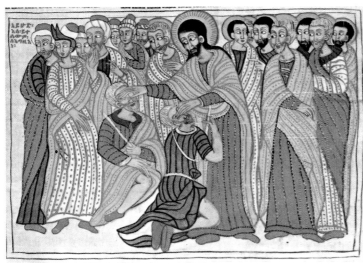

life and his heavenly reign. The Child sits on his Mother's arm. The fundamental prototypes are traditional, but the decoration and mode of execution innovate continually. In contrast to Byzantine convention, Ethiopians change the Son's attire with every painting and clothe him in new colors and ornaments. As in Italian paintings, the Child tightly holds in his hand a dove, a fruit, a flower. However, Ethiopia scrupulously avoids the model of the baby, dear to Roman piety, and faithfully retains that of the young adolescent with the forehead of an adult: "Ancient One," "Child and Old Man." His complexion is often dark. The arrangement of his hair reflects this ethnic diversity; the pepper-colored hair accentuates the Abyssinian identity of the divine Child. The Feasts of Christ are of a rare originality. The way people are placed in the scenes is obviously whimsical, and the scenes are expanded or condensed according to the present needs and dimensions of the work. Attitudes, clothing, and furniture are ethiopianized. The cycle of Christ's miracles is found also in large miniatures in the manuscripts of gospel books. In these images, the inherited prototypes are "forgotten." The drawings of a Roman gospel book written in Arabic become a basic model for the local painters. Far from being an original work, these drawings are italianized copies of the famous engravings of Albrecht Dürer made by Roberto Tempesta. Reaching Ethiopia through Egypt, they are literally ethiopianized. Local costumes replace the draped Roman garments. The profiles of Christ and his first followers become three-quarter face. No illusion of depth remains. The selected colors are gaudy and dominated by a flamboyant vermilion. The German-Italian original is recreated according to the Ethiopian spirit and vision.

Roman influence is conspicuous in the representations of the Passion. Painting departs from Coptic tradition in order to express the pain-filled journey of Christ to Calvary. Imbued with Catholic imagery, Ethiopia shows the sufferings of the Incarnate Word. A Western painting of the *Ecce Homo* becomes fixed into an iconic prototype: his eyes lowered under the crown of thorns, his hands open in sign of submission, the blood-covered Christ seals the new covenant by offering himself as holocaust. The dramatic character of the Sacrifice is still more emphasized in the Crucifixion. Rivulets of blood have now become rivers: "Under the law almost everything is purified with blood, and without the shedding of blood there is no forgiveness of sins" (Heb 9:22). With their hands raised in a sign of terror, the Mother and Beloved Apostle share in the Master's torments by shedding abundant tears. The kenotic trial ends in a glorious Descent into Hell. Ethiopia abandons the Byzantine

PL. 90a

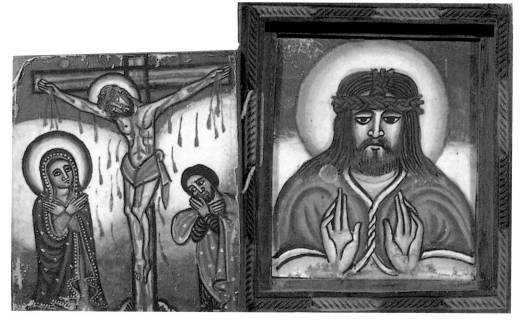

180. *The Passion,* 18th c., Tigre. Private collection, Italy.

right:
181. *Salus Populi Romani.* Santa Maria Maggiore, Rome.
182. *The Virgin,* after the type Salus Populi Romani, 18th c., Goǧǧam. Private collection, Italy.
183. *The Virgin,* after the type Salus Populi Romani, 19th c. Sam Fogg Gallery, London.

prototype in order to create a novel native model: standing, his hands stretched out, the Abyssinian Christ draws Adam and Eve, shown bare-chested in small pools of water, which is the Old Testament symbol of the abyss. Taken into heaven after his Resurrection, the Eternal Word watches over humanity. Inspired by Latin culture, the Covenant of Grace unites in heaven the Son and Mother. Christ grants his Holy Mother the right of intercession for the faithful who venerate her: every sinner, every sufferer, every penitent who implores her name when offering a prayer or accomplishing a good deed will enjoy heavenly protection and salvation.

Mariophanies

The images that have the Virgin as their subject are more numerous than all other representations. "Splendor of the Saints," "she who is purer than the pure" watches over the world and remains "merciful toward all sinners." The new paradise replaces the lost paradise. "When Adam came out of paradise, land of flowers, he caused the incense of prayer to ascend toward you, Mary, beauty of the spikenard." The *Praise of Mary* adds: "You are the blessed tree, the tree of life, and the tree of salvation. In place of the tree of life that was in paradise, you have become the tree of life on earth. Your fruit is a fruit of life and those who eat of it will have eternal life."[32] Circulated by the Jesuits, a print of a painting of the Virgin in Santa Maria Maggiore becomes the favorite model of Ethiopian painters. Called *Salus Populi Romani*, "Salvation of the Roman People," the original work is a Byzantine icon. Piety attributes it to St. Luke and affirms that it was authenticated by the model herself. The style of this work is traditional and represents one of the variants of the Mother of God as Guide. The position of the faces follows the age-old prototype, but the Mother's crossed hands inaugurate a new model: while holding the bottom of her Son's robe, Mary carries a small white cloth, an iconic rendition of the napkin, the *mappula,* which the emperor or consul threw into the arena to signal the beginning of the games. The Salvation of the Roman People becomes Holy Mary of the Ethiopians. Painters do not submit to one unified scheme, but multiply the variants while Pl. 86 preserving the respective positions of the Mother and Child. The robes are vividly adorned with leafy branches, stars, and flowers. Mary shines, "crown of the sky and the stars, land made beautiful by flowers, grapes, and palms," "fragrance of gardens at the time of jam-making," "flower of the fields,"

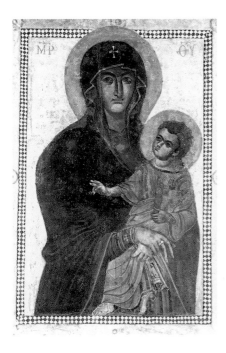

231

73. *St. John Chrysostom and a Nubian Bishop,* 10th c. Museum of Coptic Art, Old Cairo.

84–85. *Adoration of the Magi,* 19th c. Private collection, Paris.

74–75. *Entry into Jerusalem.* Church of St. Michael, Dabra Salama, East Tigre.

86. Composite tryptic: *Mother and Child,* after the type Salus Populi Romani in Santa Maria Maggiore, *Covenant of Mercy, Crucifixion, Resurrection, Saints,* 18–19th c. Private collection, Paris.
87. Composite tryptic, detail: *Resurrection,* 18–19th c. Private collection, Paris.

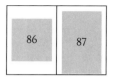

76. *Standing Saint.* Church of Sinai, Lalibela.
77. Console capital and arches. Paradise of Mary Church, Wallo.

88. *St. George,* 18–19th c. Private collection, Paris.
89. a. *St. George,* 17–18th c. Private collection, Italy.
b. *St. George,* 18th c. Private collection, Italy.
c. *St. George,* 17th c. Private collection, Italy.

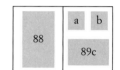

78. North cupola with eight of the Nine Syrian Saints and a cupola with nine Apostles. Church at Guḥ
79. *Moses.* Church at Guḥ.

80. a. *Annunciation,* detail. House of Mary Church, Lalibela.
b. Tryptic, detail: *Mother and Child,* after the type Salus Populi Romani in Santa Maria Maggiore. Church of the Holy Archangels Gabriel and Raphael, Lalibela.
81. Tryptic: *Mother and Child, Archangels, Equestrian Saints.* Private collection, Italy.

90. a. *Descent into Hell, Crucifixion,* 18th c. Private collection, Italy.
b. *Covenant of Mercy, Crucifixion,* 18th c. Private collection, Italy.
91. a. *St. Gabra Manfas Keddus, Two Standing Saints,* 18th c. Private collection, Italy.
b. *Two Standing Saints, The Christ Child Performing a Miracle,* 18th c. Private collection, Italy.

82. *The Nursing Mother Between Two Angels,* 18th c. Private collection, Paris.
83. *The Nursing Mother Between Two Angels,* detail: The Child, 18th c. Private collection, Paris.

92–93. *Passion and Glorification of St. George,* 18th c. Sam Fogg Gallery, London.

94. Magic scroll, detail: *Archangel,* 19th c. Sam Fogg Gallery, London.
95. Magic scroll, detail: *Face Surrounded by Eight Eyes,* 19th c. Sam Fogg Gallery.

96. a. *St. Gabra Manfas Keddus,* 19th c. Private collection, Italy.
b. *Alexander the Great,* 19th c. Private collection, Italy.
c. *St. Tekla Haymanot,* 19th c. Private collection, Italy.
d. *Moses,* 19th c. Private collection, Italy.

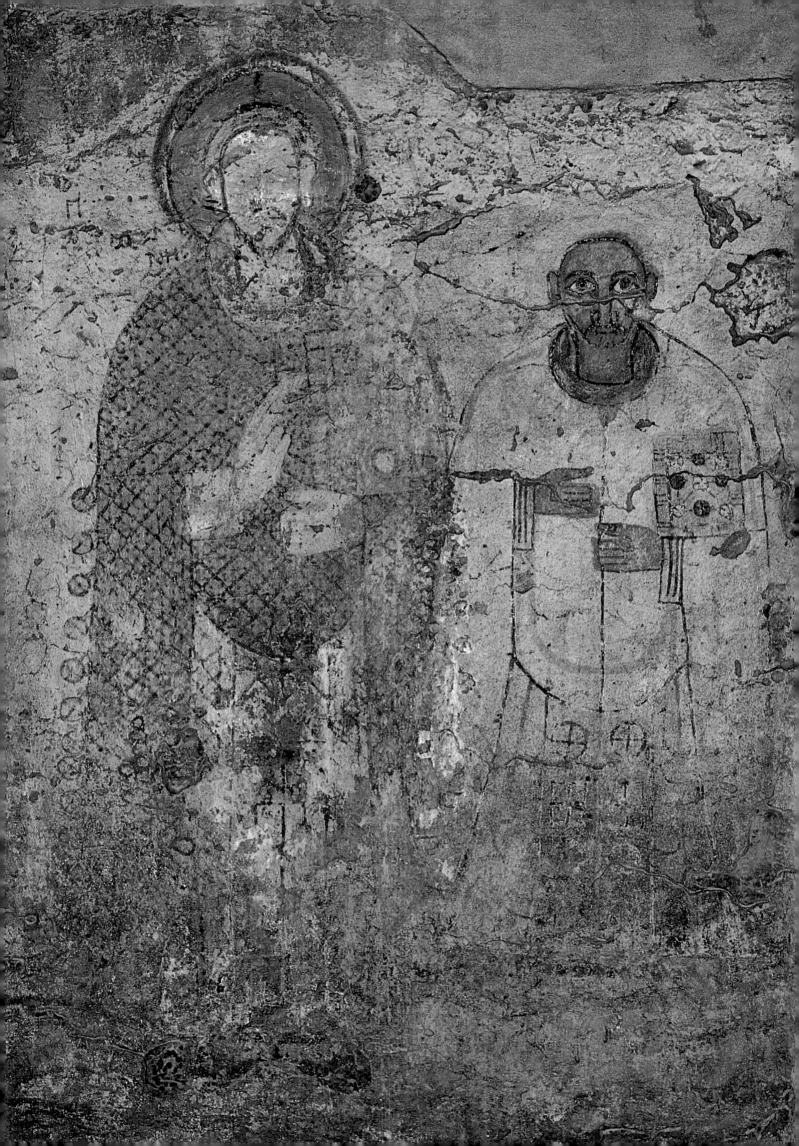

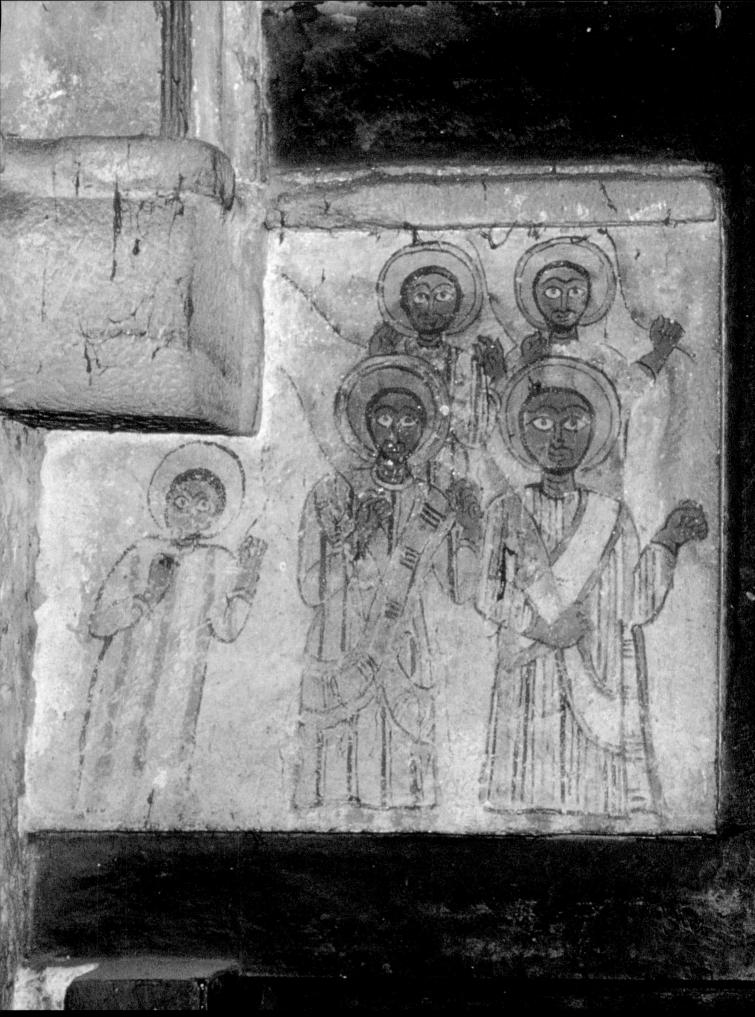

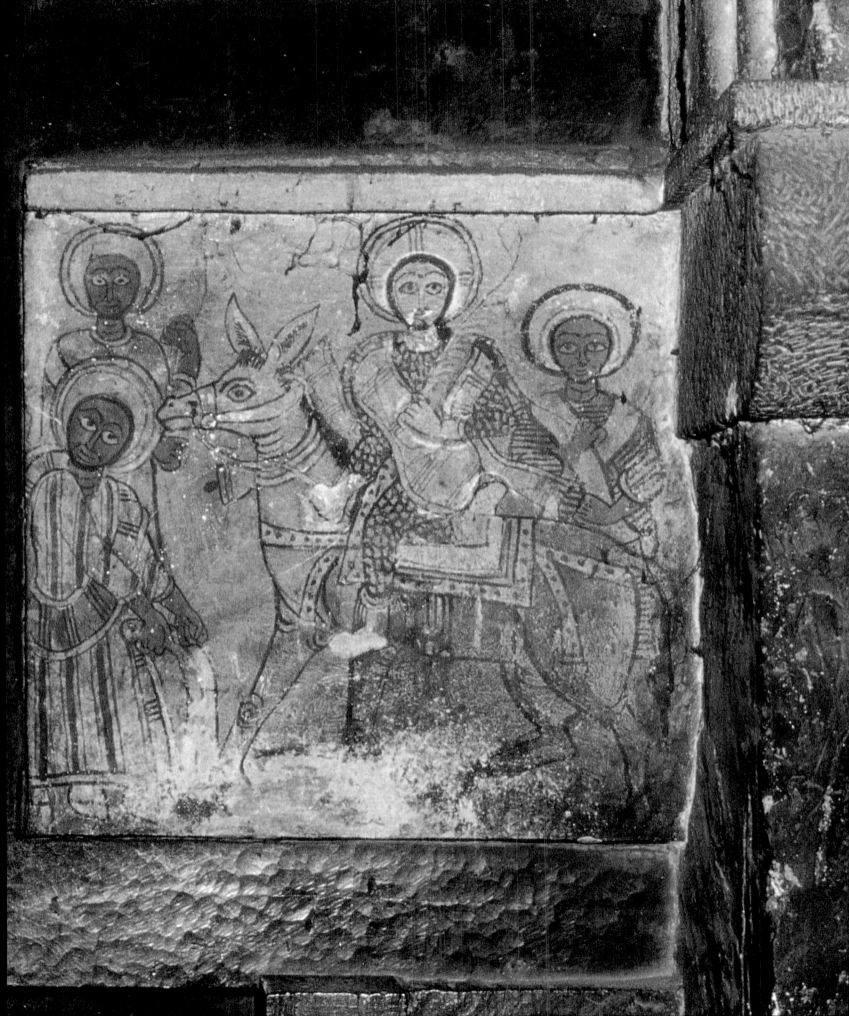

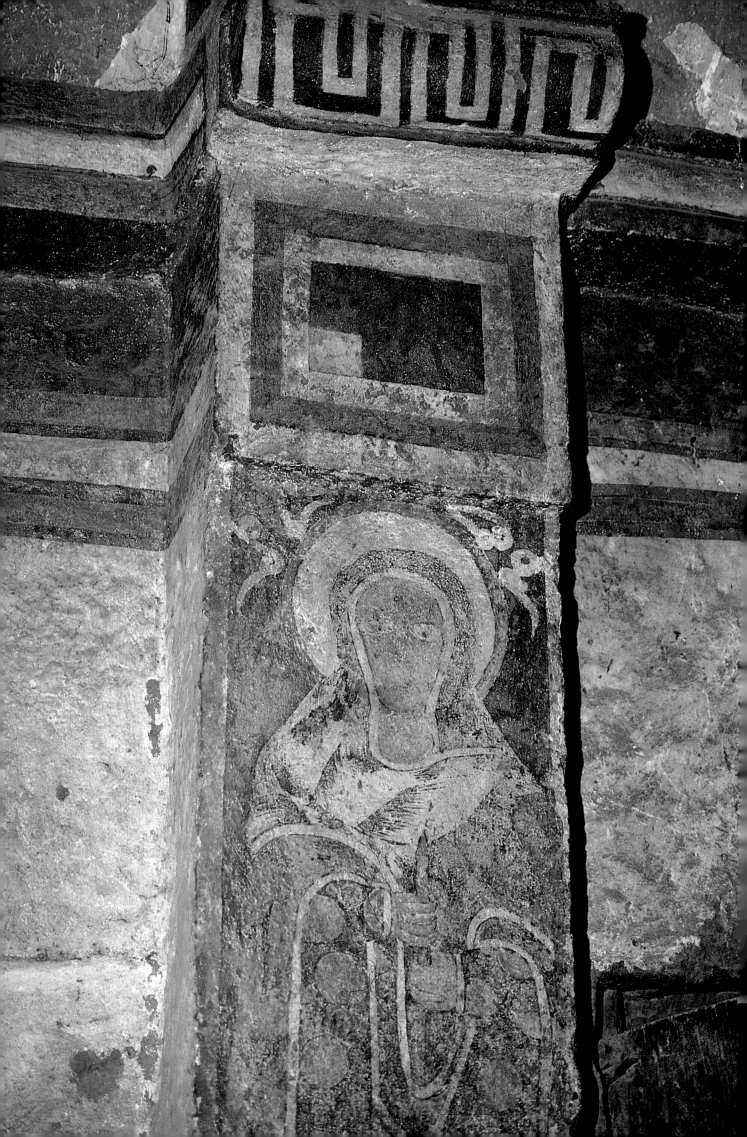

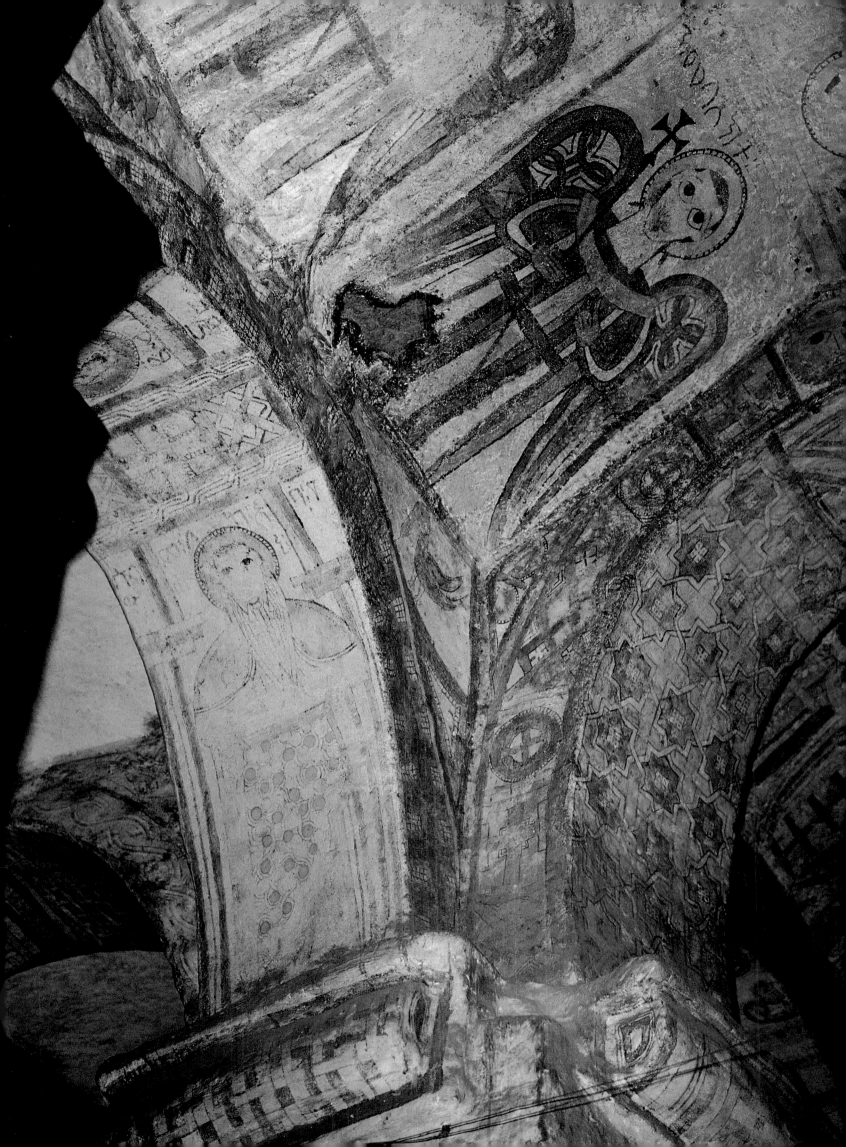

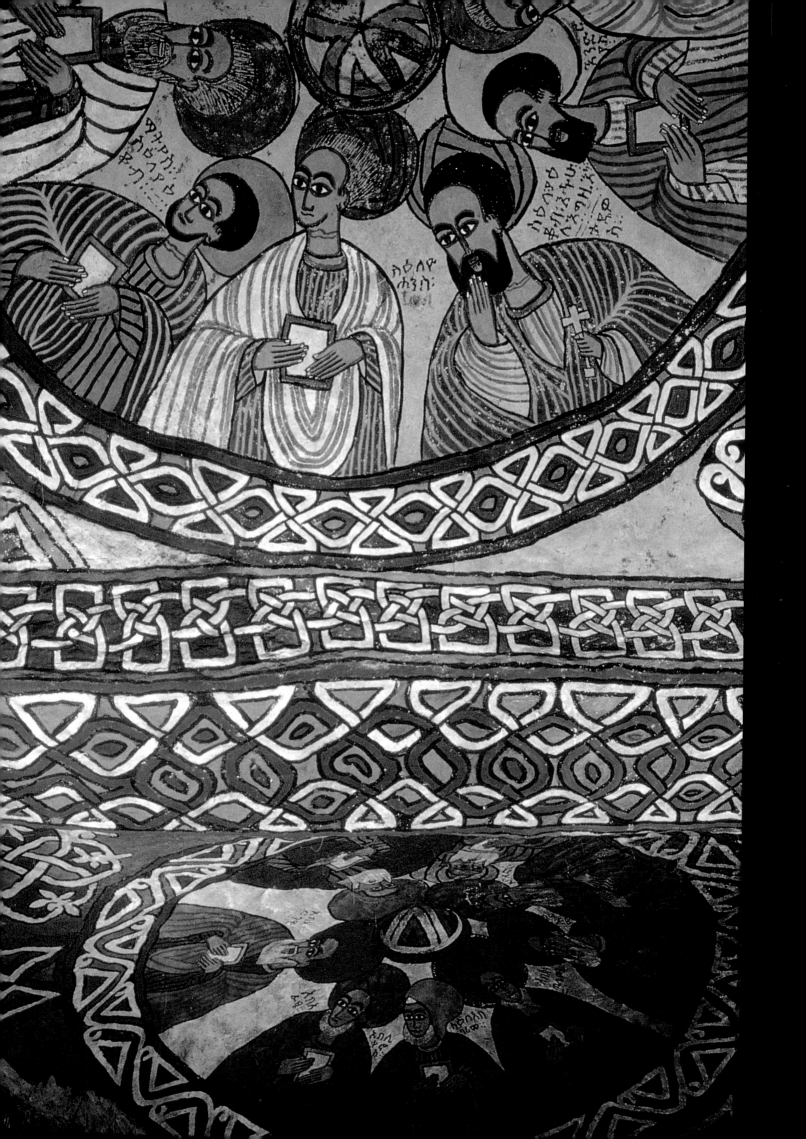

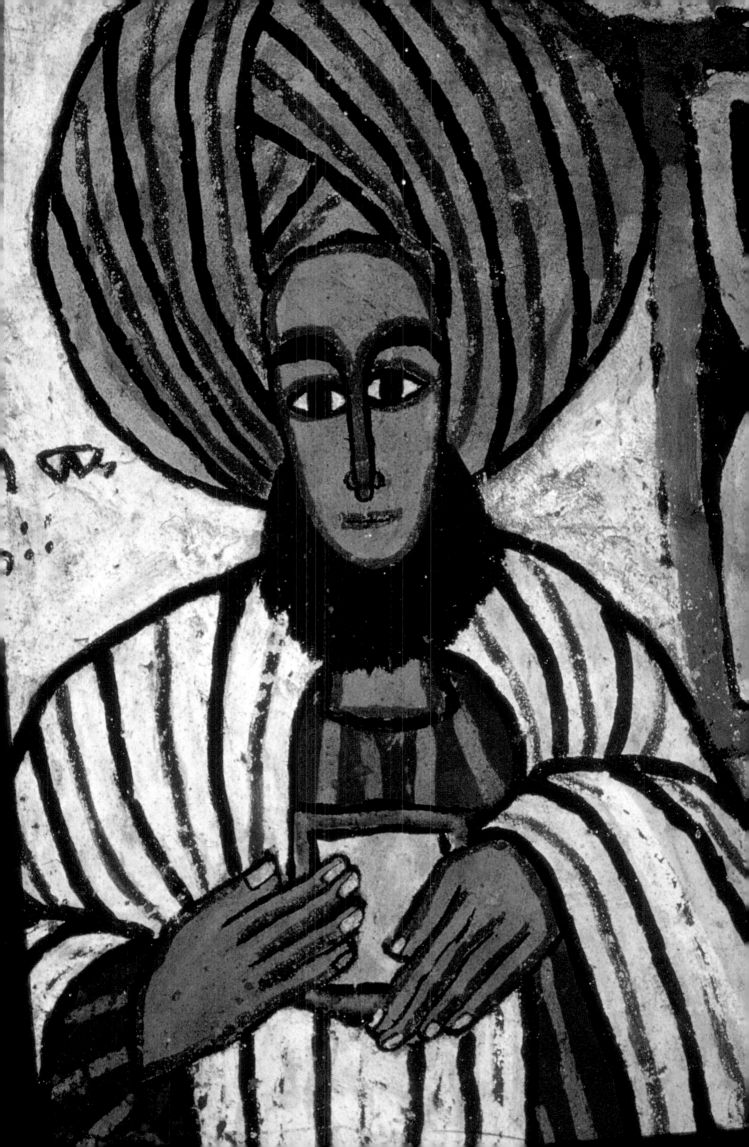

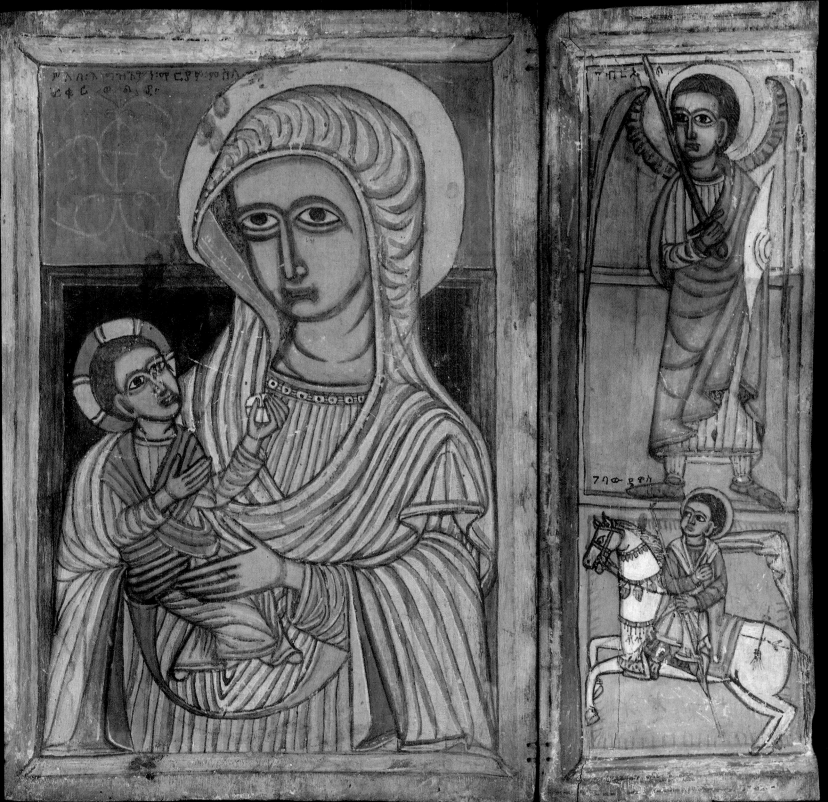

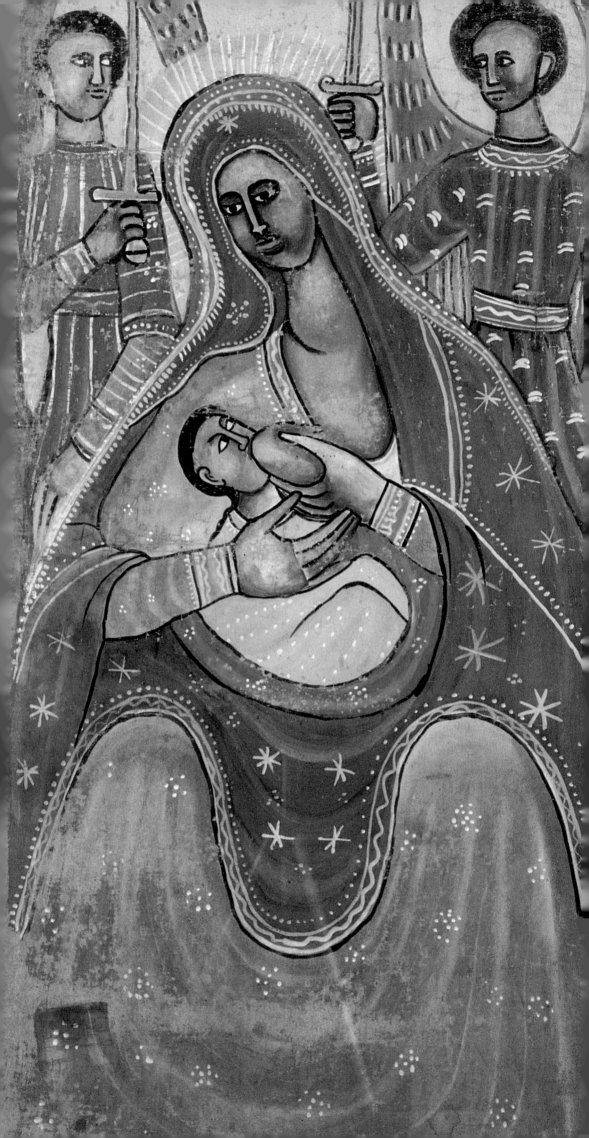

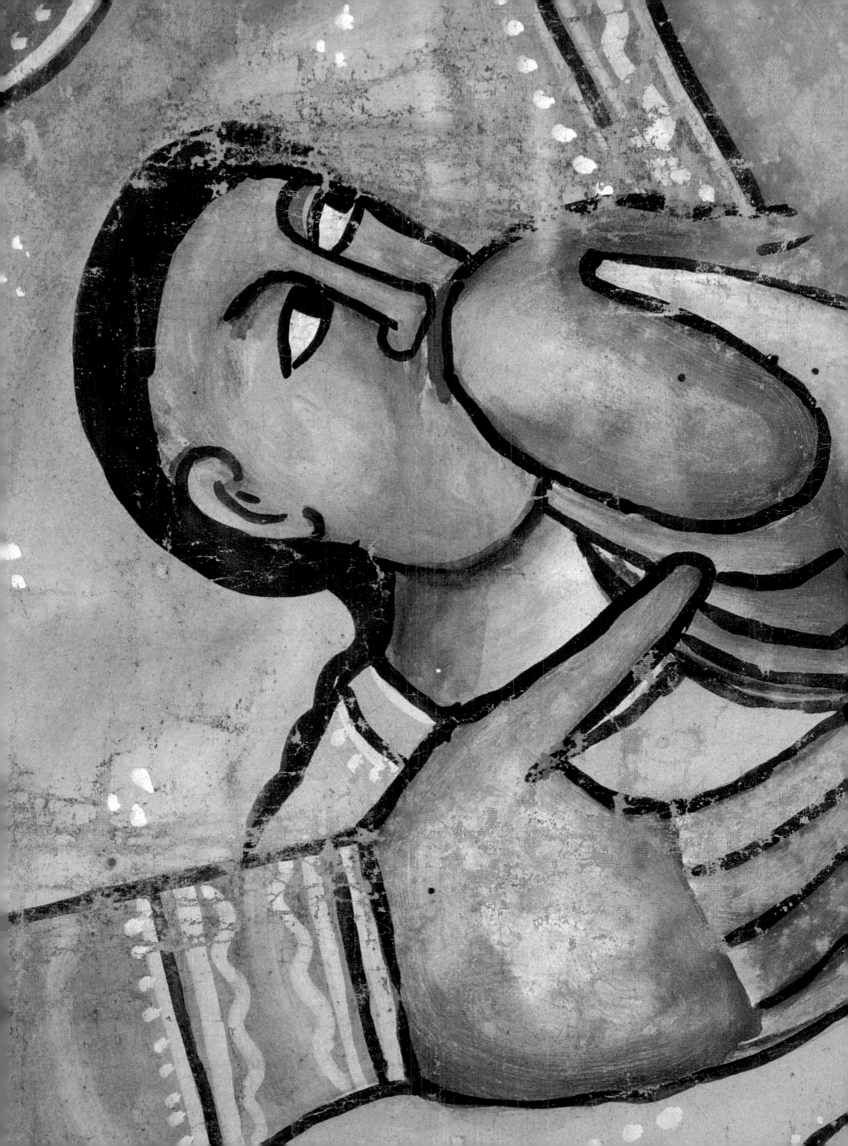

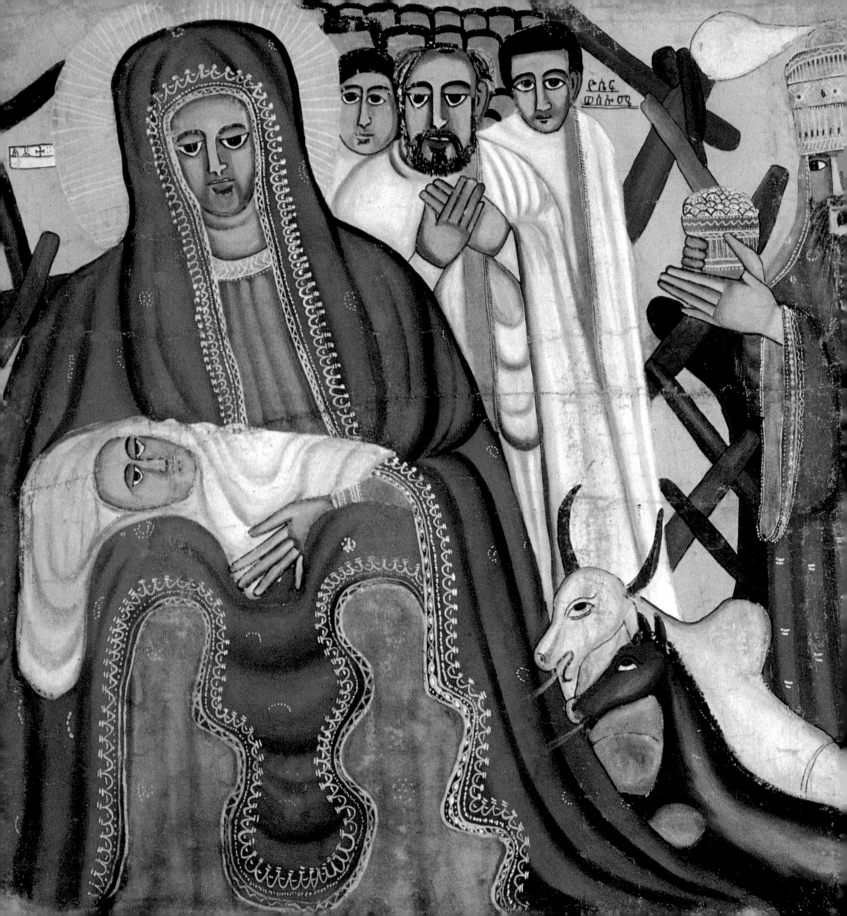

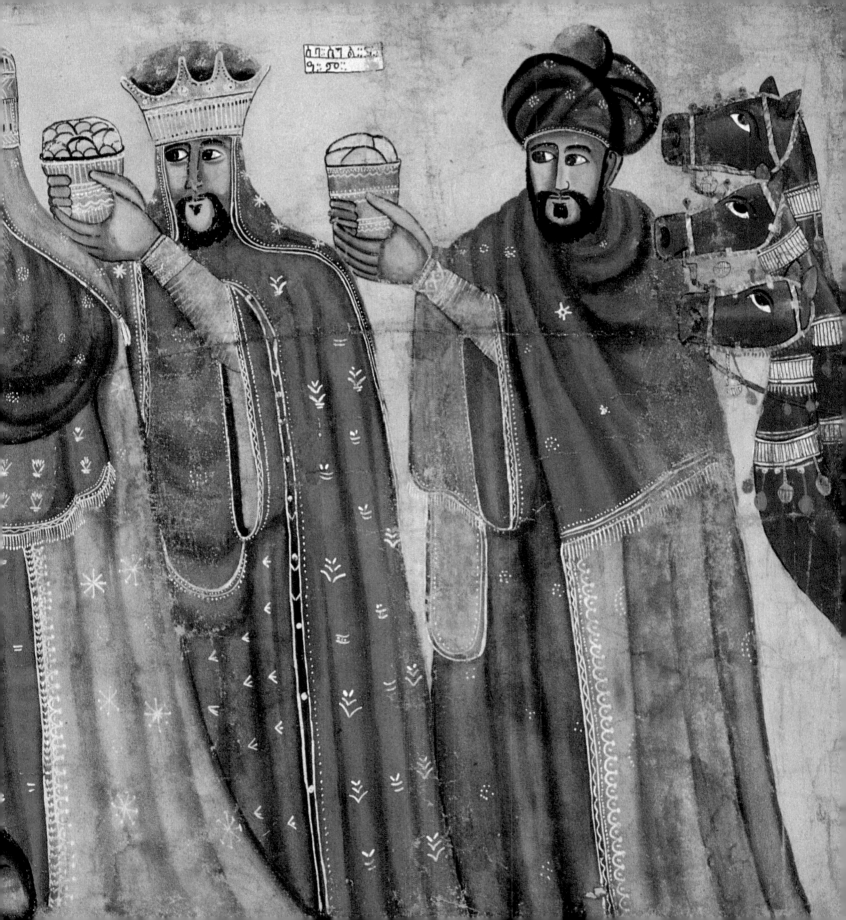

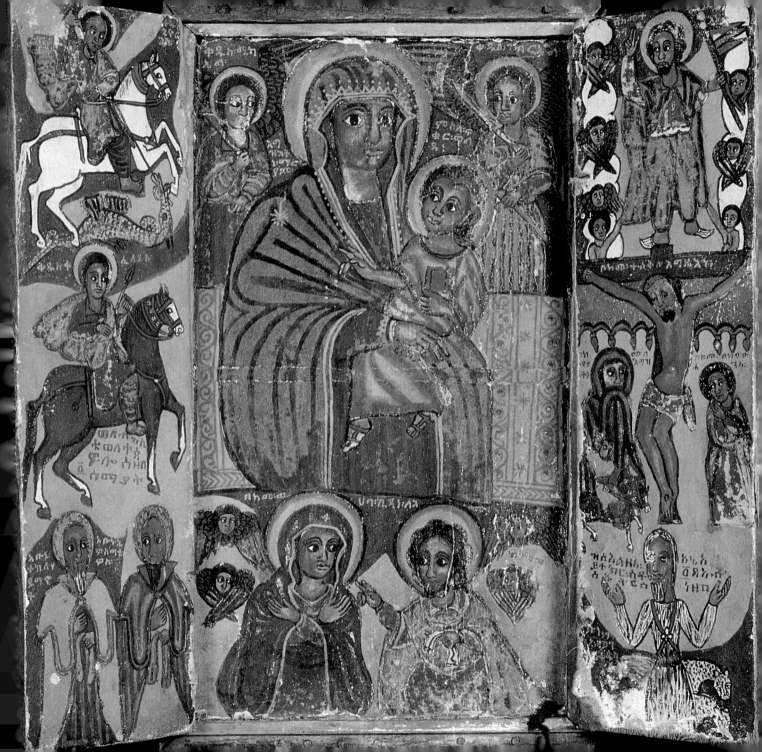

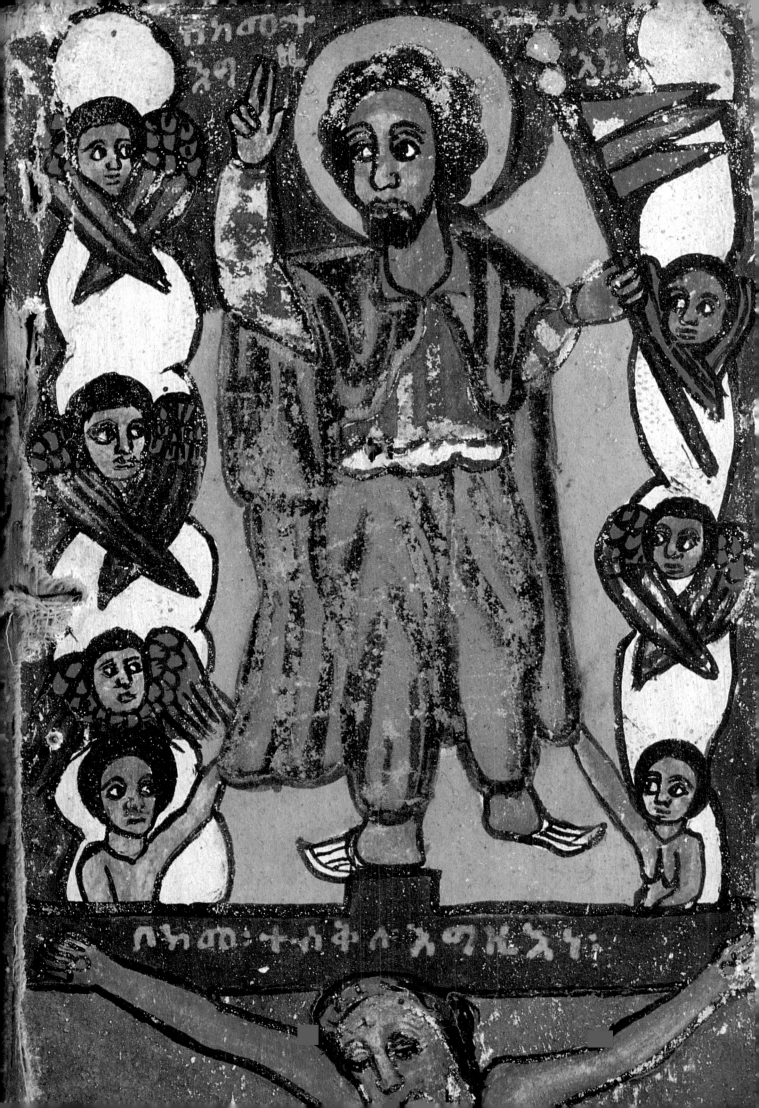

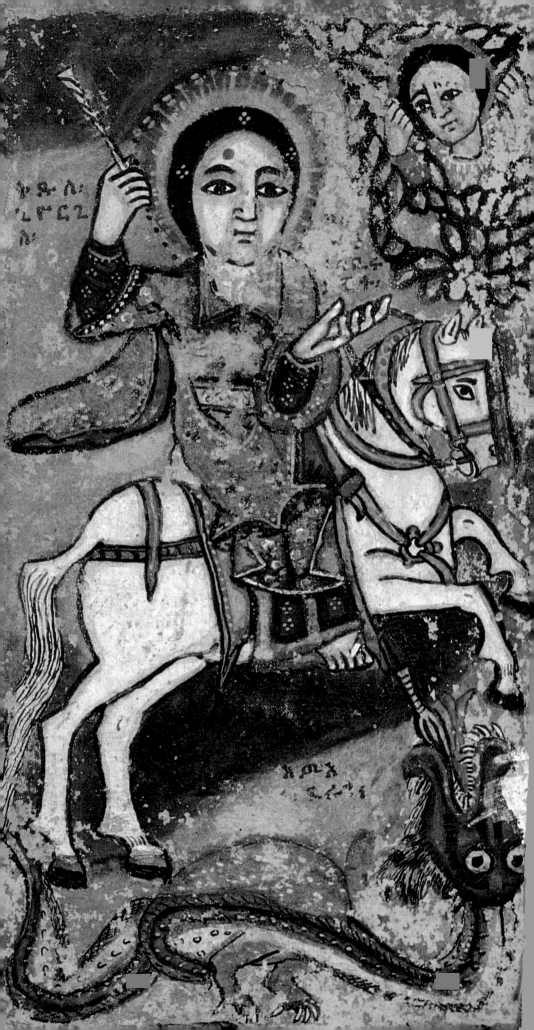

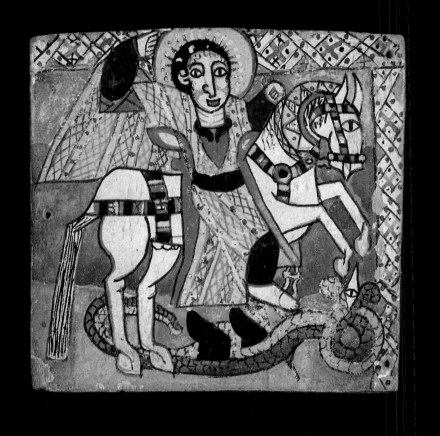
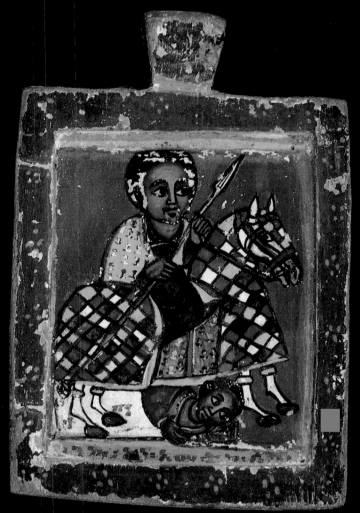
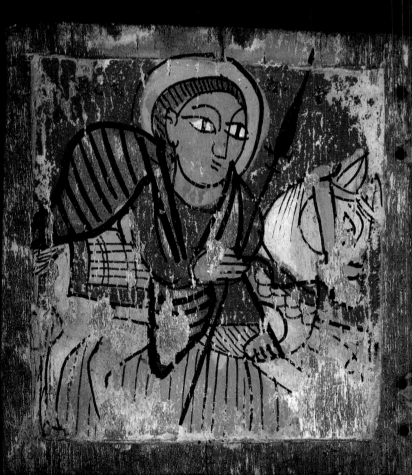
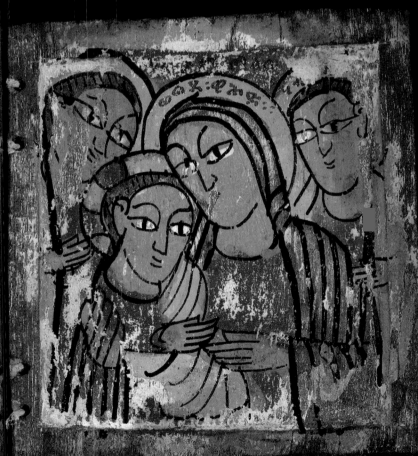

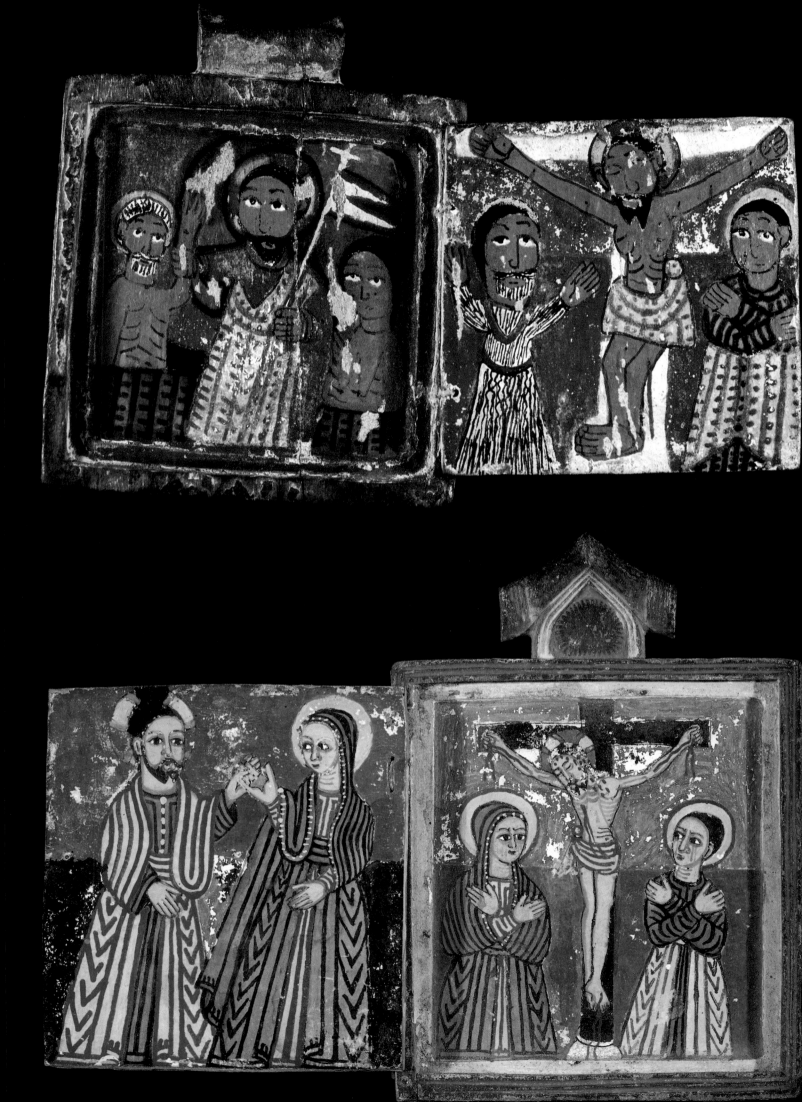

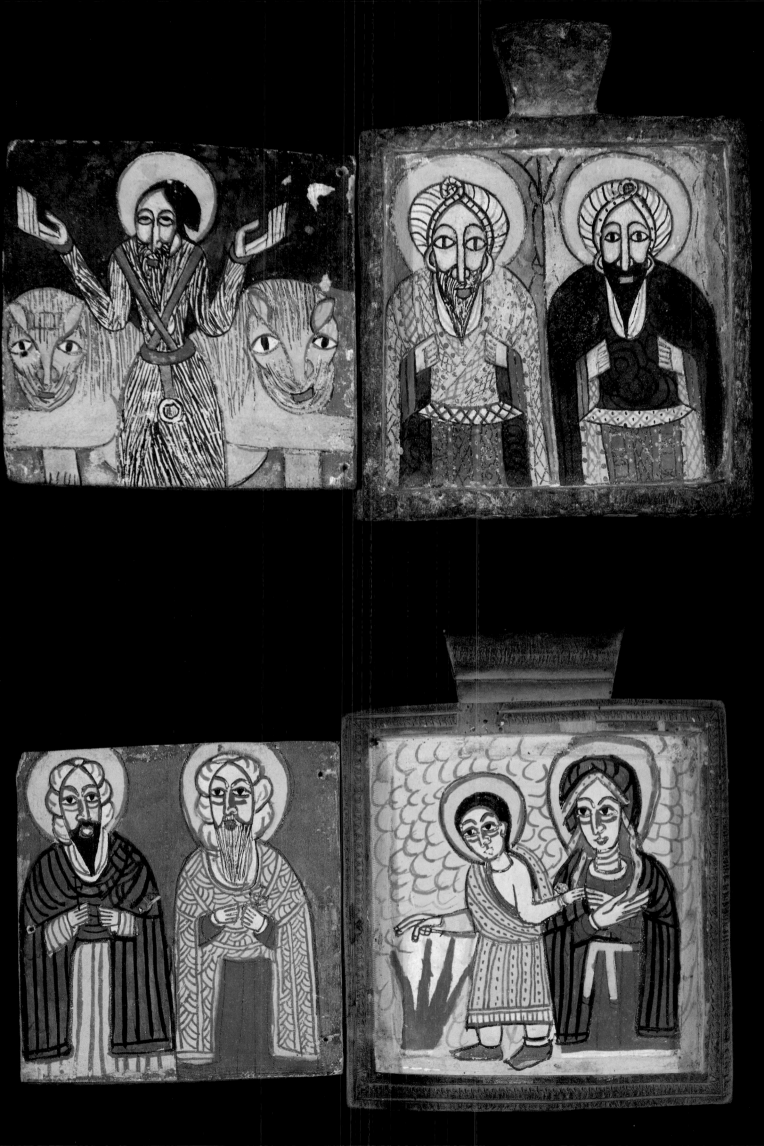

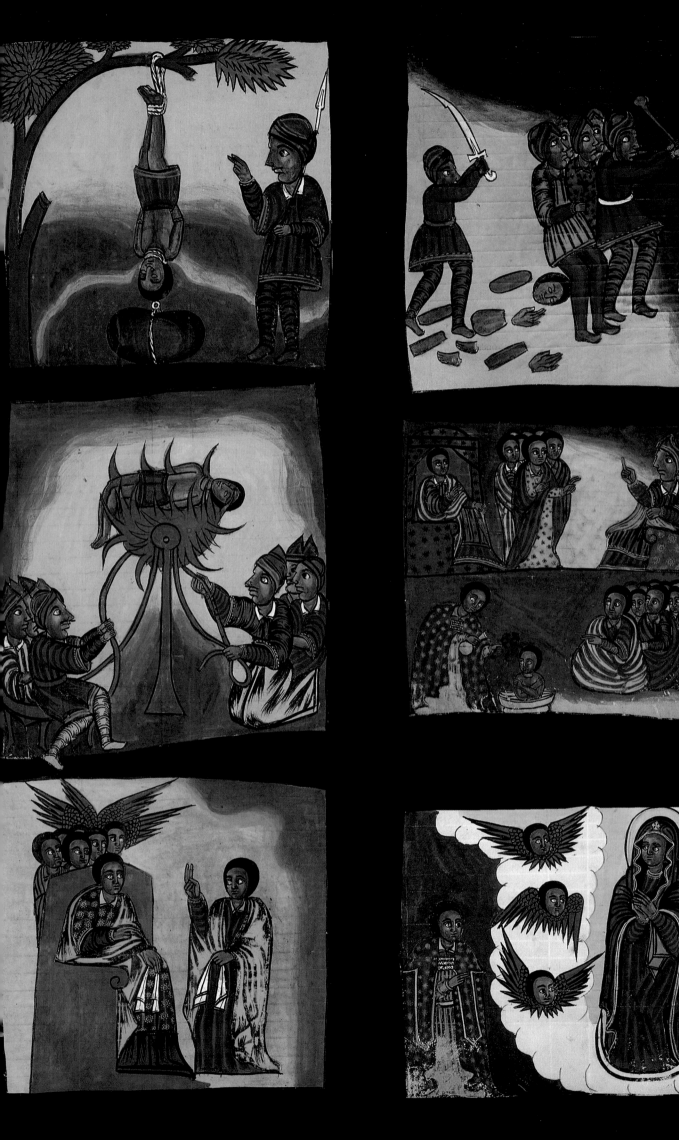

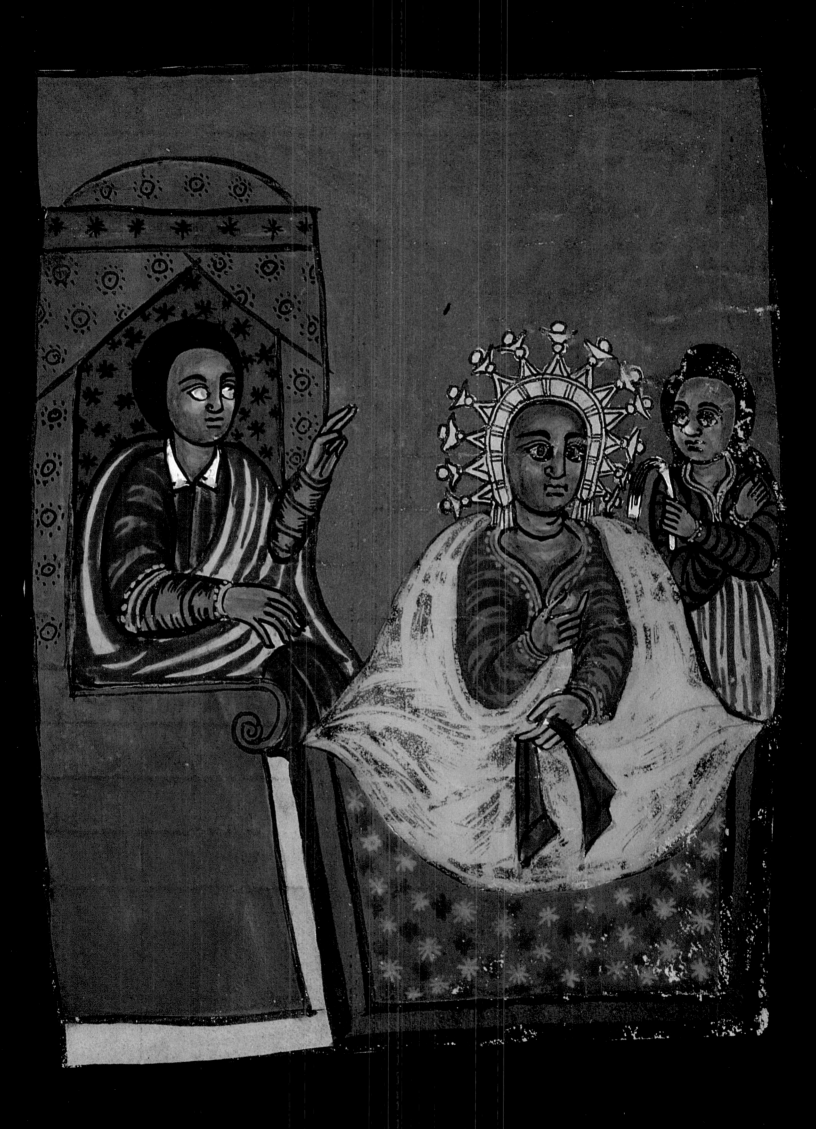

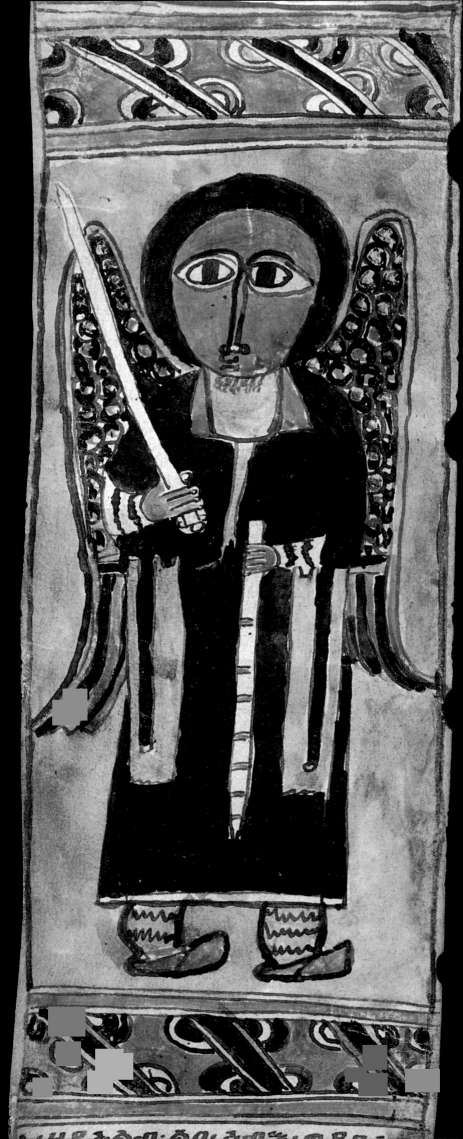

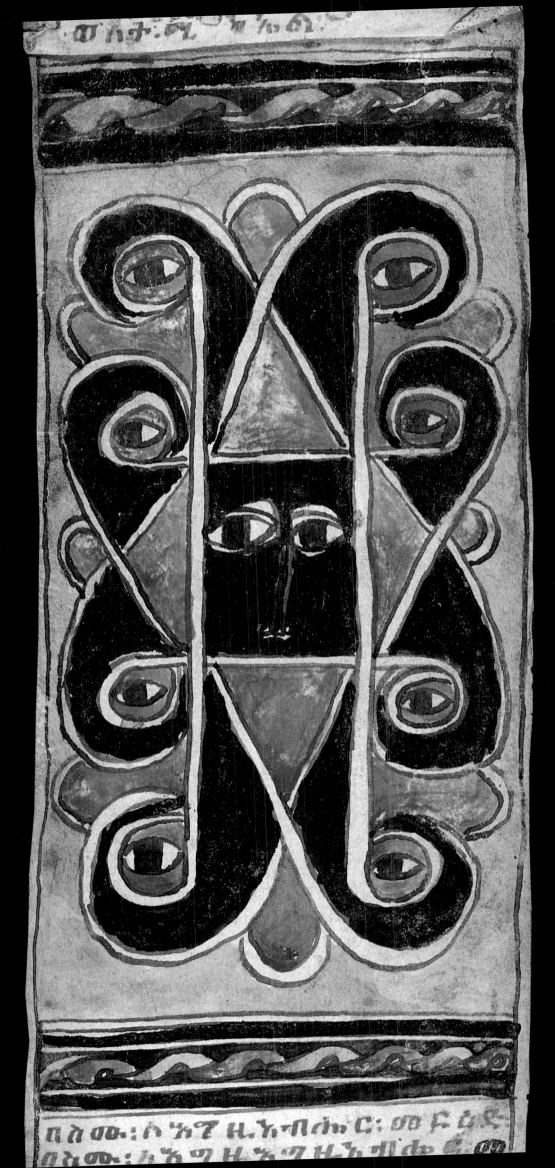

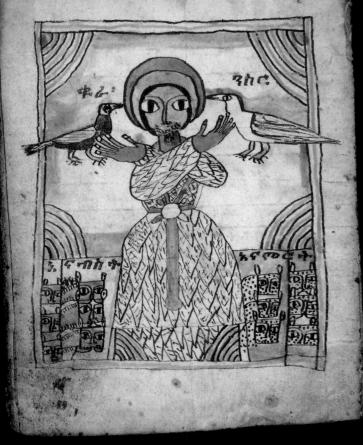

አቡነ፡ ገብረ፡ መናፈ ሉ፡ ቅዱ ሴ፡

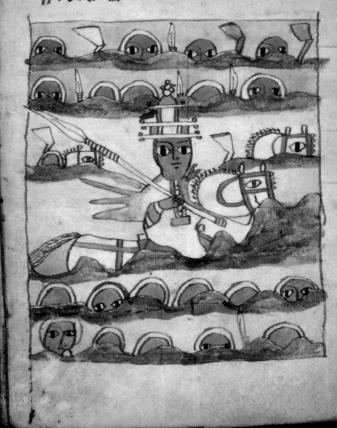

ዘከመ፡ተሰዋመ፡ፈ ሪ የን፡ ምስ
ለ፡ ሠራዊቱ፡ ውስተ፡ ባሕር፡፡

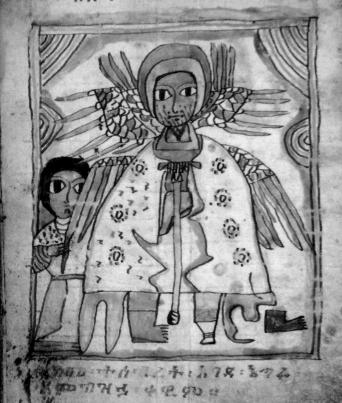

አቡነ፡ ተክለ፡ ሃይ ማኖ ቶ፡

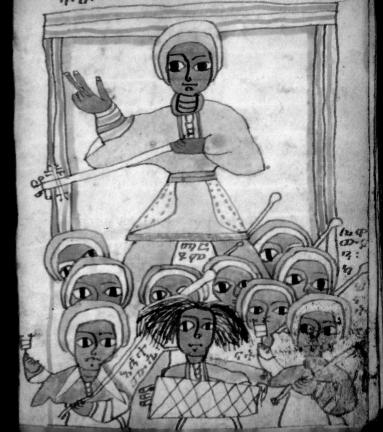

ዘከመ፡ ዘበጣ፡ ሞ ሴ፡ ለባሕረ፡ ኤ
ር ራ፡ በበ ትሩ፡፡

and "pearl of the sea."[33] The color of her skin passes from rose ocher to deeply tanned brown: "I PL. 82,83 am black and beautiful / . . . like the tents of Kedar, / like the curtains of Solomon," says the Song of Songs (1:5). In other cases, the composition is augmented by the addition of new actors. Two Angels with long swords shadow the Divine Motherhood with their wings; some Saints come to adore the Son and venerate the Mother; donors are prostrate at their feet, their bodies flat on the ground, entreating the Most-High's clemency. The taste for the picturesque is obvious in group scenes: the Mother presides over the assembly of Angels, Saints, and humans. The many variations of the Covenant of Grace consecrate her dominion over the whole of creation. "She who is purer than all the worlds" shares in the glory of the Trinity:

> Praise befits the Father, at the height of the luminaries,
> Great glory to the Son and the Holy Spirit;
> above the earth and from the lofty sky,
> Prostration and veneration unto eternity
> befit Mary, bearer of glowing divinity.[34]

The Latin compilation of Holy Mary's miracles becomes a national Abyssinian work. Having originated in France in the twelfth century, it reaches Ethiopia toward the end of the Middle Ages in an Arab translation. Continually touched up, the narrative is augmented with fresh miracles: the thirty-three "canonical" miracles proliferate and finally their number is in the neighborhood of two hundred. A long cycle of paintings illustrates these wonders wrought by the Virgin. Full of charm and life, the style indulges the taste for the picturesque with boundless freedom and fantasy. Themes increase in number. Heavenly Angels and earthly humans frame the Covenant of Grace: crowned like a negus, King David celebrates the event by playing his lyre; Angels and mortals have the same face; all place their hands on their breasts in a uniform gesture and attend the ceremony with great devotion. The Virgin's prodigies are worked for all and sundry, the repentant and sinners. An emaciated dog looking for a drink of water is chased away by the virgins of the Temple; to their great surprise,

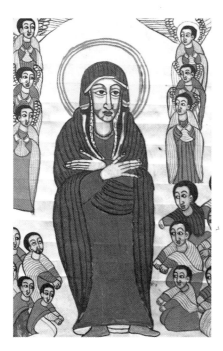 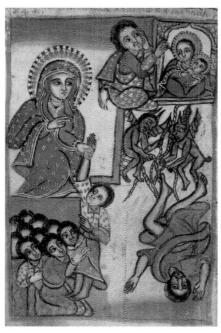 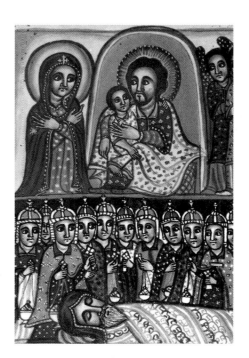

184. *Holy Mary Glorified by Angels and Humans*, 17th c. Aksum Cathedral.
185. *Holy Mary Saving Her Painter*, 18th c. Sam Fogg Gallery, London.
186. *Christ Welcoming St. Tekla Haymanot*, 18th c. Sam Fogg Gallery, London.

young Mary gives it water in one of her slippers. An abbess by the name of Sophia succumbs to carnal temptation and finds herself with child; hearing her plea, the Virgin orders the Angels to take the baby from the maternal womb and give it to a high dignitary; raised by a bishop, the illegitimate child grows up and in his turn becomes a bishop who succors souls. A thief caught red-handed is condemned to death and hanged; his most pious mother implores the Virgin, who promptly raises the man; touched by grace, the thief is converted and becomes a devout believer of the Church. Three Arabs are shipwrecked in the middle of the sea; two of them entreat the Blessed One for help, whereas the third one curses her; while the blasphemer is devoured by a crocodile, the other two escape by climbing onto a raft; once saved, the two Muslims make for a church and present their offerings as tokens of gratitude.

The Latin miracles are often reviewed and corrected. Since Ethiopia is perennially hostile to sculpture in the round, the local versions transform sculptors into painters and sculptures into paintings. The statue of the Virgin which Zechariah, a Roman, adorns with flowers every morning is changed into a painting. One day, not having found any flowers, the devout man prostrates himself before the image and vents his desolation; Holy Mary, "the true flower," lets living petals come from her mouth, which the man collects; brigands who have been watching the scene from afar are converted and don the monastic habit. The French artist who was sculpturing the likeness of the Madonna is transformed into a painter. As he is decorating the walls of a church dedicated to the Mother of God, he paints the Sovereign in glory venerated by Angels, and Lucifer chained in hell; in their jealousy, devils cast a spell on him and knock him from his scaffolding; the Virgin takes bodily form, comes out of the painting, and rescues him from a fall by grasping his wrist. From one miracle to the next, the text retains the national identities of the characters, but the painting takes another route. The Ethiopian genius systematically affects faces, decorations, and objects. The style remains unreceptive to empirical perception: places elude the laws of perspective and gravity, and dimensions vary according to the importance of the persons. Heaven communes with earth. Figures may change, images proliferate, but the Mother remains: "treasure venerated by the whole universe," "scepter of the sure truth, indescribable temple, dwelling of the One who has no roof."[35]

Equestrian Saints, Monks, and Angels

Martyrs, pictured as warriors on horseback, and Monks embody the two poles of holiness. Anecdotal hagiographic scenes are added to contemplative portraits. In both red and white martyrdom, the Saints dwell in the light of the Risen One. Ethiopia adopts the iconography of the Dormition of the Virgin to represent the blessed death of the Saints: the Son himself comes down from heaven to welcome the pure soul of the "sleeping one," symbolized by a small new-born. The prototype of the Equestrian Saint is retained but it is dressed in the national colors; thus, St. George of Cappadocia is transformed into an Abyssinian knight. Attires change according to the artists' imagination: sometimes, the hero is installed on an armored horse and resembles the Knights Templars from the West. In addition to the glorious image of the soldier crushing the dragon, excruciating scenes of protracted torments are represented, developed into a long cycle in the manuscripts of the *Book of St. George*. Before being decapitated, the Saint is flogged, cut into pieces, impaled, placed on a grill, burned, thrown into boiling water, capped with a white-hot caldron, chained, hanged, sawn in two, ground, asperged with lead, and turned on a wheel with sharp teeth. While illustrating the many steps of this agony, the painting celebrates the triumph of the hero who wins the seven crowns of martyrdom. In spite of these harrowing images, the style keeps its freshness. The torments end in celestial triumph: surrounded by Angels, the Soldier of Christ goes to meet the Sovereign Virgin. All evils have passed. The apocalyptic way leads to the Holy City of the Spirit and the Bride.

The illustrious Ethiopian Monks also have their iconographic prototypes. Tekla Haymanot is Pl. 96c represented standing on one leg, his detached foot beside him. According to hagiography, the Saint spent his last years standing and ever watchful, cramped in a little cell where it was impossible to sit or lie down. In time, "one of his thigh bones broke and fell."[36] Iconography often shows him like a heavenly Angel, wearing six wings and a tunic studded with eyes. Buried alive, the Saint rises and—in spirit—goes to the highest part of heaven in order to contemplate far from the world the Face of the living God. St. Samuel of Waldebba rides a lion like St. Mamas. The devil, who "like a roaring lion . . . prowls around, looking for someone to devour" (1 Pet 5:8), is subdued by the man of God. Concord is restored between creatures; the Saint returns to the paradisiac state of the beginning: "He approaches the murderous wild beasts. As soon as they see him, they come close to him as to their master, they wag their heads, they lick his hands and feet. This is because they have smelt emanating from him this good odor which Adam gave off before the transgression, when they drew near to him and when he gave them their names in paradise."[37] Clothed only in his hair and beard, Gabra Manfas Keddus is surrounded by several of the big cats. Guided by the Archangel Pl. 91a,96a Gabriel, as it is told, the hermit goes from the desert of Egypt to the summit of Zeqwala with a flock of sixty lions and sixty panthers. An iconographic model akin to that of the Prophet Elijah shows a raven flying above the Saint; however, whereas the Prophet's bird comes to feed him with bread from heaven, the Monk's comes to drink his tears which flow like the river of life springing forth from God's throne.

Joyous Angels are everywhere. Diminutive baroque Seraphim join the guardians of the sanctuary. Their baby features are transformed into youthful dark-hued faces. The Abyssinian use of colors transforms them into ornamental motifs grouped into decorative masses. At Dabra Berhan, myriads of winged visages cover the ceiling of the church of the Holy Trinity. The *Fetha Nagast* says: "When Solomon was crowned, many fine wool carpets were laid down. And when the Lord was born in Bethlehem, the Angels spread something like mousseline. From that time until today, Angels place themselves everywhere within the church enclosure, the church itself, and the sacristy as far as the 'door of salvation.'"[38] The depiction of Angels takes on startling forms: in baggy trousers, Archangels exhibit a new look. Gabriel offers joy and brings prompt help; Raphael comforts afflicted hearts; the greatest of them, Michael, the weigher of souls, goes down to hell to rescue the damned and lead them to paradise. A book devoted to him translates into images his long journey. He accompanies Moses and the people as they leave Egypt; he is the one who, in Isaiah's vision, ascends to heaven, raises his throne above the stars at the farthest recesses of the north, in order to make himself equal to the Most High (Isa 14:12-15). Thrust down to the depths of the pit, he plunges his right wing into it and draws it back covered with a multitude of sinful souls. Always compassionate, he plunges his left wing and saves another multitude. Finally, using both wings, he liberates an unlimited number of souls who obtain God's pardon through his intercession.

Magic Scrolls

The elliptical art of prayer scrolls represents another aspect of Ethiopian creativity. Artisanship and themes are in a completely different style. There are echoes of the great medieval tradition in this autonomous, hardly "orthodox" art in which Christian faith and magical beliefs are intimately mixed. The making of a scroll begins with the slaughtering of a sheep or goat. Stretched, shaved, and scraped, the skin of the animal is transformed into parchment. The scroll is cut according to the size of the patient in order to protect him or her from head to foot. A cleric writes the text, which contains the patient's baptismal name. Images occupy the two extremities and the middle of the parchment. Rolled and placed in a leather case, the scroll is worn by the person for whom it

PL. 94,95 is intended—a perpetual protection against evil spirits. In contrast to other paintings, the illustrations on the scrolls do not have any narration. Images of Christ and the Saints are few. The designs, in black and red ink, show Angels, snake-shaped creatures, checkers full of faces and eyes, and a profusion of geometric motifs where crosses and octagonal stars are dominant. Eyes proliferate on the edges of stars. Strange talismanic figures show a concatenation of eyes gazing at a central face. At once one and multiple, the pupil, conspicuous in the white of the eye, becomes sign, seal, and ideogram. The talismanic eye evokes either the spirits, bearers of the Divine Face, or the Cherubim, interceding with God for humankind, or the protecting Angel, repelling devils coming from the four directions. The great number of eyes reflects the great number of protagonists. Between Angels and demons stands a myriad of genies. Michael lifts his sword to expel Satan from heaven. A Gorgon comes upon the scene. Gog and Magog are large eyes set on scaly bulbous objects. The Cross is the light, the seal, the sword, and the buckler of the Gospel. Geometric networks form strange labyrinths. The number of human figures is increased by the introduction of new heroes such as Alexander the Great, who, astride a winged creature, hastens across the land of darkness in order to reach Enoch and Elijah at the highest part of heaven. The action is reduced to its essentials; the image evokes without narrating; constellations of signs and words burst out everywhere. Being the primary mediator of magical activity, the gaze is preeminent in the midst of a whirlwind of forms and signs. Notwithstanding angels and crosses, the scrolls embody a peculiar art which is clearly distinct from the great iconographic tradition. More magical than Christian, this production rejoins other forces: although very distant from the world of sub-Saharan Africa because of its arts and faith, Ethiopia finds in its scrolls the expression of its African character which allows it to take its place within its vast geographic context.

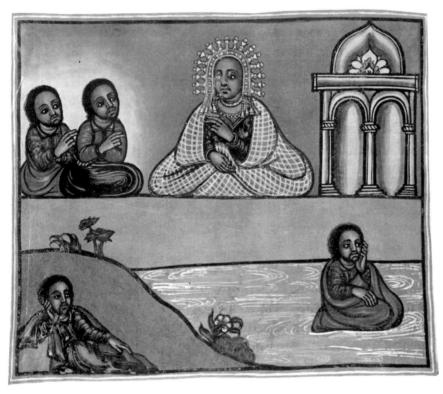

187. *Vision of John the Evangelist*, 18th c. British Museum, London.
188. *The Virgin in Glory*. Enda Medhani Church, Adwa.

Arabs gave Ethiopia the name Ḥabash, which became Abyssinia in many Western languages. The original root of the word means "mixture" and designates the many-faceted and complex character of the Cushites' land. The Ethiopian plateau, situated on the way between the Middle East and sub-Saharan Africa, is home to a common culture where populations, beliefs, and local customs mix. From sub-Saharan Africa, it opens onto Arabia and, through its faith, is linked to Egypt. Subordinated to the Alexandrian see, its Church becomes autocephalous only in the middle of the twentieth century. However, in spite of this juridical subordination, the Ethiopian Church is more a sister-Church than a daughter-Church: far from being merely an emanation of the Coptic world, it represents a unique whole that is different from Alexandria, though attached to it. The shared heritage takes root in Ethiopian soil and takes an original local form. Nourished by many cultures, its artistic tradition is differentiated from those of the rest of Africa and is integrated into the composite civilization of the Christian East. The encounter with the West opens new horizons: Delft tiles and Portuguese azulejos meld into Abyssinian decoration. Far from slavishly repeating the seductive models of European art, the indigenous genius transforms them by molding them in its own way. Besides European contributions, influences from the Far East are discernible. In the church of Adwa, the Virgin looks Asiatic. According to the description in the Book of Revelation, the Sovereign stands in heaven, "clothed with the sun, with the moon under her feet, and on her head a crown of twelve stars" (12:1). The attitude is Christian, but the halo, the attire, and the hair gathered into a chignon belong to the Buddhist world. Paintings in manuscripts show fantastic buildings inspired by Indian architecture. St. John in meditation contemplates the Woman clothed with the sun, who wears an enormous gold crown, and the messianic Jerusalem, built like a strange temple. Coming from South Asia, the emblem of dignity and the dome crown the two figures of the City to come: "The Spirit and the bride say, 'Come.' / and let everyone who hears say, 'Come.' / And let everyone who is thirsty come. / Let anyone who wishes take the water of life as a gift" (Rev 22:17).

The description of the kenotic descent does not eclipse the triumph of the Cross. Like their Coptic, Syrian, and Armenian brothers and sisters, the Ethiopians erect their trophy-crosses everywhere. The tree of life and the wood of torture are united as early as Genesis: "Before Jerusalem was built," the *Fetha Nagast* says, "a felled tree from paradise was there; if it was set up to make a pole, if it was laid down to make a threshold, it would not work. But it was carried by Christ; Christ was hung on it above Adam's head [buried under Golgotha] and thus it became the Cross."[39] Portable crosses, processional crosses, crosses used for blessings, pectoral crosses, icon-crosses—the innumerable variations are continually adorned with interlacing designs and images. The language of the forms is inspired by a scriptural source. The Cross stands under an honorific arch; the repeated interlacing motifs evoke the enveloping coils of the serpent. The Book of Numbers recounts that "Moses made a serpent of bronze, and put it upon a pole; and whenever a serpent bit someone, that person would look at the serpent of bronze and live" (21:9). Stylized forms suggest bird heads: the Cross is the altar of God where "even the sparrow finds a home" (Ps 84:4). The arms of the Cross become larger and receive the traditional effigies, such as Christ crucified or the Virgin between two Archangels. The images engraved on metallic crosses develop into painted panels on wooden crosses. The combinations, which become more and more numerous, transform the icon-crosses into church-crosses. Worked on its two faces, the vertical beam unites painted images with images carved in relief. The Mother with the Child, Angels, and Saints alternate with the cycle of the Passion. Whether sitting on the Cherubim or lifted on his Cross, Christ radiantly shines: "Savior of the world," "Splendor of the East and West and South and North," "King, in heaven and on earth, in the sea and on the solid land."[40]

Notes

1 Homer, *The Odyssey,* 1:22–26.
2 J. Meyendorff, *Unité de l'Empire et division des Chrétiens* (Paris: Cerf, 1993) 137.
3 Ibn Hishām, *Sīrat* (1); aṭ-Ṭabarī, *Ta'rīkh* (2). Quoted by E. Rabbath, *Mahomet, prophète arabe et fondateur d'état* (Beirut, 1981) 67.
4 Ibid., 70–71.
5 Quoted by J. Leroy, *L'Ethiopie: archéologie et culture* (Paris: Desclée de Brouwer, 1973) 202.
6 Quoted by G. Gerster, *L'art éthiopien* (Zodiaque, 1968) 89.
7 A. Brissaud, *Islam et Chrétienté* (Paris: Robert Laffont, 1991) 258.
8 K. Stoffregen-Pedersen, *Les Ethiopiens* (Belgium: Brepols, 1990) 54.
9 Gerster, *Art éthiopien,* 142.
10 *The Gospel of Thomas: The Hidden Sayings of Jesus,* trans. and ed. Marvin Meyer (San Francisco: Harper, 1992) no. 56, p. 45.
11 Ibid., no. 77, p. 55.
12 Ibid., no. 19, p. 31.
13 Ibid., no. 11, p. 27.
14 *The Book of Emmanuel. Le Livre d'Emmanuel,* trans. and ed. D. Lifchitz, Librairie Orientaliste (Paris: Paul Geuthner) 77–81. Originally published in *Journal Asiatique* (Paris: Imprimerie Nationale, 1948).
15 *Fetha Nagast,* which includes both civil and ecclesiastical law. *Règles de l'église,* trans. and ed. M. Griaule, Librairie Orientaliste (Paris: Paul Geuthner) 9. Originally published in *Journal Asiatique* (Paris: Imprimerie Nationale, July–September 1932).
16 *Livre d'Emmanuel.*
17 "Christ, Savior of the World." *Un poème éthiopien: Le Christ, Sauveur du monde,* trans. and ed. D. Cohen, Librairie Orientaliste (Paris: Paul Geuthner) 157. Originally published in *Journal Asiatique* (Paris: Imprimerie Nationale, 1957).
18 Gerster, *Art éthiopien,* 116.
19 J. Leroy, *La peinture des couvents du Ouadi Natroun* (Paris: IFAO, 1982) 108.
20 Gregory of Nyssa, "Thanksgiving." Quoted by A. J. Hamman, *Livre d'heures des premiers chrétiens* (Paris: Desclée de Brouwer, 1982) 95.
21 London, Sam Fogg Gallery.
22 "Mary, Gate of Light." Quoted by Stoffregen-Pedersen, *Les Ethiopiens,* 52.
23 "Christ, Savior of the World." *Un poème éthiopien,* 179.
24 The Apostles Creed. Quoted in Stoffregen-Pedersen, *Les Ethiopiens,* 52.
25 Paris, National Library.
26 *Le livre d'Emmanuel,* 79.
27 St. Jerome, *Excerpts from the Psalms.* Quoted by H. de Lubac, *Exégèse médiévale,* 1:258, quoted by F. de Medeiros, *L'Occident et l'Afrique* (Paris: Kathala, 1985) 249.
28 Absalom of Springerbach, "Sermon 12 on the Epiphany of the Lord," PL 211, col. 76–80.
29 Aldo Mannucci. Quoted by N. Ménant, *La peinture indienne,* Histoire intégrale de l'art (Lausanne, Rencontre, 1967) 78.
30 A. Papadopoulo, *L'Islam et l'art musulman* (Paris: Mazenod) 126.
31 *Gospel of Thomas,* no. 113, p. 65.
32 "Mary, Gate of Light." Quoted by Stoffregen-Pedersen, *Les Ethiopiens,* 75, 82.
33 Ibid., 75, 76.
34 *Le Livre d'Emmanuel,* 81.
35 "Prayer to the Mother of God." Quoted by Hamman, *Livre d'heures,* 181.
36 "The Acts of Tekla Haymanot." Quoted by Stoffregen-Pedersen, *Les Ethiopiens,* 92.
37 Isaac of Niveveh, "Twentieth Ascetical Discourse." Isaac le Syrien, "22e discours ascétique," *Œuvres spirituelles* (Paris: Desclée de Brouwer, 1981) 139.
38 *Fetha Nagast. Règles de l'église,* 33.
39 Ibid. Ibid., 11, 12.
40 *Un poème éthiopien,* 165, 167.

Epilogue

Passionately addicted to its Christological quarrels, the Christian East loses its unity in the fifth century. Three ecclesial families are formed. By condemning Nestorius' teaching in 431, the Council of Ephesus divides the Syriac world into two factions: Seleucia-Ctesiphon separates itself from Antioch and becomes the Church of the Persians. Twenty years later, the Council of Chalcedon divides those who accept Ephesus into Monophysites and Diophysites. Those who believe in the "one nature" are considered heretics. Under the imperial power, heresy is a crime, even a state crime. Its adherents are enemies of Church and empire: "Their contact is a stain," the Code of Justinian declares; "their trace and even their name should disappear from the face of the earth."[1] Socio-economic conflicts and national ambitions are added to dogmatic quarrels. Syria, Egypt, and Armenia reject both "Roman" power and its ecclesial authority. The arrival of Islam completes the break. Complex and composite, an "Oriental" East forms alongside the "Greek" East. Its geographic area covers Mesopotamia to the east, Egypt to the west, Anatolia to the north, and Ethiopia to the south. In spite of their many differences, Syrians, Egyptians, and Armenians are sharers in one history. Far from being marginal and secluded, these Christian communities occupy their places in Islamic societies. They participate in commercial and financial ventures, as well as in cultural and artistic activities. Although politically and geographically independent, Ethiopia belongs to this East because of its religion and culture and proves to be more Semitic-Coptic than African.

The Byzantine conquests of the tenth century do not modify in any significant way the confessional map of the Eastern Christian communities. The war between Chalcedonians and non-Chalcedonians begins anew. At the time "Arab" power declines, "Turkish" Islam replaces it and begins its ascent. Michael the Syrian reports: "The Greeks prevailed again over Syria, Palestine, Armenia, and Cappadocia; and as soon as they had the upper hand, they promptly reverted to their bad habits and began to tyrannically persecute the faithful in these countries. Whereupon God, rightly angered against them, aroused and incited the Turks to this second invasion which happened as follows: as the Arabs, that is, the Ṭaiy, were faltering and the Greeks were seizing many countries, the Ṭaiy had to call the Turks to their aid. . . . When the Turks aroused themselves and sallied forth, they covered the entire earth."[2] Muslim power is fragmented into rival dynasties; Mongols and Latins come as conquerors to "share" with them the fallen empire of the 'Abbāsids. In its turn, Byzantium declines. Turks, Serbs, and Bulgars fight over the dying "Greek" empire. At the time the crusaders are increasingly defeated, a new map takes shape. The frontier is no longer "between Christians and Muslims; it is between Westerners and Easterners, the latter—from the Byzantines to the Monophy-

sites of Egypt and Armenia—being more and more favorable to the Muslims."[3] The Ottoman empire is created in the fifteenth century. Its territory and power exceed that of the ʿAbbāsids. Grouped into self-governing communities called *rayas,* Christians form an important part of a poly-ethnic empire made up of more than twenty peoples. The Christian presence continues to comprise many religious communities. The Syriacs suffer from the effects of the Mongol tide: taking refuge in neighboring Syro-Turkish regions and in the Hakkiari mountains of Kurdistan, they fall into a total lethargy as early as the sixteenth century. Like Mesopotamia, Armenia is once again torn apart, this time between the Ottoman "Rome" and Ṣafavid Persia. Weakened in the land of its origin, Armenian vitality thrives in the principal centers of the sultanate. As always, the Copts remain firmly rooted in their motherland. The "Greek" communities are second in importance in a dyarchic empire where they form—next to the Sunni Muslims—the great majority of the population. The Capitulations concluded between Süleyman the Magnificent and Francis I of France open the doors of the Muslim empire to Latin missionaries. Efforts at reuniting Rome and other Christian Churches increase in the eighteenth century with the establishment of Catholic Churches of the Eastern rite. In its turn, Protestantism comes to "reform" Eastern Christians. At the time "the sick man of Europe" is fragmented into nations, the ancient Churches experience division and proliferation. The First World War, the social and political upheavals, the formation of states, the movements of whole populations—either because of the exodus from the country to the cities or because of emigration—appreciably modify the place and importance of ecclesial communities. Whole Christian communities leave Asia Minor. Armenians are deported and decimated. The Syriacs are exterminated in their villages. A new map is drawn: dispersed in small groups in a territory now divided into nations, the Eastern Churches become in their own way a microcosm of the Christian World.

Reduced to a minuscule flock, the Nestorian Church is the most destitute among all Christian communities. Still anathematized by both Chalcedonians and anti-Chalcedonians, the "apostolic, universal, Assyrian Church of the East" is but the shadow of its own shadow: ruined and isolated, the most eastern of the Eastern Churches is dying after a long and illustrious history. The fraction of this Church in union with Rome is called the Catholic Chaldean Church and is situated in Iraq, whose "national Church" it rightly becomes. Just like its Syriac and rival sister, the Nestorian Church, the "Jacobite" Church is down to a meager membership divided between "Orthodox Syriacs" and "Catholic Syriacs." In Armenia, Egypt, and Ethiopia, the Monophysite communities remain impenetrable to Western proselytism. The patriarchates in union with Rome and the Protestant Churches are small communities whose size is in no way comparable to that of the Churches in the past. Today, after fifteen centuries of dogmatic separation, Chalcedonians and pre-Chalcedonians are reunited to affirm their common Orthodoxy. While condemning anew "the Nestorian heresy and the crypto-Nestorianism of Theodoret of Cyrrhus," the two families recognize that "they always have loyally kept the same and authentic Christological faith, and have maintained uninterrupted the continuity of the apostolic tradition, in spite of their having occasionally used Christological terms in different ways." "Greek" Orthodox and Eastern Orthodox "accept that the retraction of the anathemas and condemnations will be based on the fact that the councils and the Fathers previously anathematized are not heretics."[4]

Images of Eternity

Throughout the centuries, the great art of Eastern Christians embodies in its own way this "Orthodoxy," disavowed for so long a time. The roots are common: easternized Hellenism announces the Byzantine synthesis. As the legacies of Palmyra and the Faiyūm show, the still-pagan provinces stylize the Greco-Roman traditions according to their own genius. Once Christianized, these intui-

tions are deepened and sacralized. Jerusalem, Alexandria, and Antioch actively participate in the elaboration of Byzantine esthetics: "The provinces march toward Rome" and offer to all of the Christian East the foundations of its artistic tradition. As far as historical events are concerned, the fifth century sees the rending and division of the Syrian-Egyptian Christian community which secedes from the Byzantine empire. This divorce becomes final with the arrival of Islam. As far as artistic and cultural values are concerned, these dates do not constitute a break. Easternized Hellenism keeps all its vitality and leaves its imprint on the "paleo-Muslim" art of the Umayyads. The crisis of iconoclasm purifies the Christian pictorial language and crystallizes it. The iconodules rank the Easterners with the "image-destroyers," but the artistic output gives the lie to this accusation. Nestorians and Monophysites continue to appreciate the art of the "Greeks." The differences have to do with the function and liturgical use of the image, not with its existence and identity. Egyptian, Syrian, and Armenian works are genuinely Byzantine creations coming from outside Byzantium. In parallel fashion, new original syntheses enrich the art of this vast East. The Muslim world experiences its golden age. Eastern Christian communities participate in Islamic culture and art. Interdependence of styles is total. Anachronistic, spiritual, and sacred, this artistic communion ignores the international melee which tears apart the caliphate in the Middle Ages. Islamic art retains its unity and vitality: there are differentiations, but they enrich this unity while diversifying it. Christian art keeps to its specificity; nonetheless, it does not separate itself from Islamic art. The symbiosis of both traditions is at its zenith. Running the gamut from monumental art to the art of bookmaking, the profusion of the output belongs to one great tradition, composite, multi-religious, and multi-national. Its canons and concepts regulate Christian iconography. The ornamentation of the mosque of Sāmārra' has its counterpart in a Syriac monastery in the desert of Scetis in Egypt, and the oldest surviving manuscript of the "school of Baghdād" is a gospel book written and illuminated in Damietta. With the passage of time, Byzantine reminiscences become fainter. An 'Abbāsid Christian art forcefully asserts itself; it escapes political boundaries and historical strictures and survives until the fifteenth century.

From its beginnings, Christian art is partial to ornamentation. Vegetal and animal forms are not merely a marginal decoration; they announce the regenerated world of the Reign to come. A mystical bond is established between Creator and creatures: "We say that all God's creatures are good," the Ethiopian Creed declares, "that nothing is to be rejected, and that the spirit, which is the life of the body, is pure and holy in all respects."[5] Purified beings manifest divine attributes. Stylized and embellished, flowers and animals are transformed into Platonic appearances, "perfect, simple, immutable, blissful." "All green is our bed" (Cant 1:16, JB): a garden of nut trees where the vine buds and the pomegranate is in bloom, a royal enclosure where gazelles, fawns, and doves frolic. Far from taking their inspiration from the landscapes of their countries, the artists create otherworldly courts populated by idyllic, "abstract" figures. Like the olive tree of the Qur'ān, this paradisiac enclosure "comes neither from the East nor from the West." Representations of the human figure are at the antipodes of the naturalistic portrait. Holiness is their sole model. The hieratic human figure is everywhere: unique human, unique face, unique gaze—absorbed in contemplation, human beings are "entirely eye." In silence they give themselves to pure prayer and become "earthly Angels." Human figures are multiplied and placed in tiers: Apostles, Monks, Bishops, and Equestrian Saints, they are an integral part of a space covered with signs. "A tree laden with fruit, full of vigorous sap, grows in them, and they are adorned with the richest fruit. . . . Salvation draws near, the Pasch of the Lord is at hand, the times are accomplished, cosmic order is in the making."[6]

The Ottoman rule opens a fresh period. Integrated into the new Muslim empire, Byzantium "recaptures" its Oriental East. The Greek empire disappears but its Church remains alive. Its artistic production influences that of Eastern Christians. The Syrian icon embodies in its own way the post-Byzantine tradition disseminated over the whole Balkan territory. Syriac Churches adopt it while keeping their doctrinal independence. Egypt takes its inspiration from it in order to create its own icon. Ornamen-

tation remains faithful to the Islamic-Christian tradition of the medieval period: woodwork and illuminations repeat the models of antiquity but introduce new variations. Having exhausted its inspiration in the eighteenth century, this style becomes lifeless and yields to the taste for Western fashion prevailing at the time. The chasm grows wider between tradition and the new style. In the seventh century, Christianity established a universal art whose forms spread—under many dynamic expressions—throughout the East and West. In Europe, the Renaissance signals the abandonment of this religious tradition. The "Greek manner" is repudiated: Saints and Angels become more human-like. The search for the "personal" element asserts itself at the very heart of religious painting. Only in its themes and use is church art different from profane art. From the fifteenth to the eighteenth centuries, a magnificent pictorial art blossoms and reaches its highest peaks. Human, very human, the Saints' eyes are lifted in entreaty for a celestial sign. A "deep and dark mirror" replaces the gold backdrop of icons. A "heartfelt sob rolling down from age to age" takes the place of the pure prayer of the eminent Saints of the past. The soul cries, weeps, and gropes—"the call of hunters lost in the deep woods."[7] Dignified and poignant, relentless and demanding, the Western "quest" ventures with genius even into the world of shadows. Yet, three centuries after the Renaissance, the arts of the Christian East remain untouched by this experience. True, literature has its secular and liberal branch represented by a vast number of "personal" writers. The fine arts have no such branch: anonymity remains their general rule. The three-dimensional treatment of space is disdained; the image is essentially religious. Obeying the same esthetics, secular themes are profoundly spiritualized. Modern times are a prolongation of the Middle Ages. In its conceptual substance as well as in its new forms, art remains faithful to its foundations. Easel painting and "personal" expression appear late, at the dawn of the nineteenth century. Then, following the Orientalists, Eastern painters borrow the artifice of trompe l'oeil to represent their countries' landscapes and inhabitants. As secular painting takes its first steps, religious art sinks into a fateful decline. Western iconographic production under its most benighted form penetrates the Eastern Churches where it becomes extraordinarily dear to popular piety. On the dogmatic plane, Orthodox today, whether "Greek" or Eastern, endorse the practice of venerating images, but the pictorial decoration of their churches remains a "stranger" to wondrous iconic beauty. Traditionalist renewals seek to rehabilitate the "national" styles that have been neglected. Iconographers attempt to pass on the ancestors' torch, but without ever being able to recover the flame that animated them. Cold and shrivelled, a certain painting "in the antique manner" rubs elbows with a populous gallery of pitiably weak and sentimental images. Inspiration runs dry and beauty deserts the Church.

The First East

In the beginning, "God planted a garden in Eden, in the east; and there he put the man whom he had formed" (Gen 2:8). A church, a Syriac text reminds us, is not a building with walls and partitions, but the figure of the redeemed world: "The sanctuary, which is at its summit toward the east, is the figure of the paradise where our father Adam dwelt."[8] New Adam, Christ is named the Orient. His Ascension took place in the east and his Second Coming will come from the east: "For as the lightning comes from the east and flashes as far as the west, so will be the coming of the Son of Man" (Matt 24:27). From the Mediterranean to the Red Sea, the arts turn toward the first East. Painted or carved in relief, images of yesterday continue to celebrate its "eternal memory." Strangely modern, they retain their ethnic character and at the same time open expansively to a pan-human perspective. There is no national exclusivism: exchanges and dialogues are unceasing. Although it preserves its initial foundations, the image becomes the place of spiritual, cultural, and artistic transubstantiations, thus becoming a reliquary of the deified creature. All worlds assemble under the Lord's search-

ing eye; the transfigured mountain covers them and inflames them with its fire. St. Anastasius Sinaita says: "This is nothing less than the house of God and the gate of heaven, this gate from which the Father gave celestial testimony and Christ shone like the sun of justice. . . . It is God's right hand that created this mountain, rough but fertile, the mountain where it pleased God to make God known and to dwell. It is in honor of this mountain that the mountains exult and the hills rejoice; it is by this mountain that the vales are covered with forests and the hollows adorned with flowers; it is this mountain which the torrents beautify, which the streams cause to resound, which the lakes venerate, which the clouds render sonorous, which the birds lead in song. This mountain is the zone of mysteries, the recess of ineffable realities, the rock of hidden secrets. and the summit of the heavens."[9]

The other East is becoming visible. Emmanuel inhabits it and illumines it with his rays. The sacred Cross stands there "so that death may nevermore have dominion."[10] All beings find their perfection there. "There, present and heaped near Christ, is the treasure of eternal good, the firstfruits of all future and eternal good, and its image is seen there as in a mirror." Open and illumined, eyes see "the divine scintillation of future regeneration, and also the realms and cities of this far land, the infinite beauty and processions, the glory and the place of rest and refreshing coolness, the joy, the understanding, the illumination, the gaiety, the future and permanent gifts, the wineless drunkenness, the immortal life, the spiritual words, the mystical feasts, the eulogies of divine perfection, and the joy of the dance in the choir of the Living, in the Reign of heaven."[11]

Notes

1 Code of Justinian, 1, 5, 12, 2. Quoted by E. Rabbath, *L'Orient chrétien à la veille de l'Islam*, Librairie Orientale (Beirut) 47.
2 Michael the Syrian, *Chronicle*, 3:154–155.
3 A. Ducellier, *Le miroir de l'Islam* (Paris: René Julliard, 1971) 287–288.
4 *Episkopsis* 446 (Chambéry, October 1990).
5 The Ethiopian Creed. Quoted by K. Stoffregen-Pedersen, *Les Ethiopiens* (Belgium: Brepols, 1990) 51.
6 "Letter to Diognetus," 12:1, 7. "Epitre à Diognète," *Les écrits des Pères apostoliques* (Paris: Cerf-Foi Vivante, 1979) 3:74–75.
7 C. Baudelaire, "Phares," *Les fleurs du mal.*
8 "De la construction de l'église syrienne occidentale d'après Yahya Ibn Jarir," *Le Muséon*, vol. 80, nos. 3–4 (Louvain, 1969) 359.
9 Anastasius Sinaita, "Homily for the Feast of the Holy Transfiguration." Quoted in *Joie de la Transfiguration*, Spiritualité orientale 39 (Abbaye de Bellefontaine, 1985) 153.
10 Acts of Pilate. Quoted in *La spiritualité des premiers siècles*, C.L.D. (1979) 76.
11 Anastasius Sinaita, "Homily for the Transfiguration." Quoted in *Joie de la Transfiguration*, 157–158.

Selected Bibliography

Byzantium and Islam

Alexander, Paul J. *Religious and Political History and Thought in the Byzantine Empire.* London: Variorum Reprints, 1978.

Atasoy, Nurhan. *The Art of Islam.* Paris: UNESCO-Flammarion, 1990.

Atiya, Aziz S. *History of Eastern Christianity,* rev. & enl. London: Methuen, 1980.

Attwater, Donald. *Christian Churches of the East,* 2 vols. Milwaukee: Bruce, 1961–1962.

Barnard, Leslie W. *The Graeco-Roman and Oriental Background of the Iconoclastic Controversy.* Leiden: Brill, 1974.

Beckworth, John. *The Art of Constantinople: An Introduction to Byzantine Art, 330–1453.* New York: Phaidon, 1961.

———. *Early Christian and Byzantine Art.* Hartmondsworth: Penguin, 1970.

Burckhardt, Titus. *The Art of Islam: Language and Meaning.* Trans. J. P. Hobson. World of Islam Festival Pub., 1976.

Cavarnos, Constantine. *Guide to Byzantine Iconography.* Boston: Holy Transfiguration Monastery, 1993.

Congar, Yves M. *Christ, Our Lady and the Church: A Study in Irenic Theology.* Trans. H. St. John. Westminster: Newman, 1957.

Corbin, Henri. *History of Islamic Philosophy.* Trans. Liadain & Philip Sherrard. London: Kegan Paul International, 1993.

Cutler, Anthony. *Transfigurations: Studies in the Dynamics of Byzantine Iconography.* University Park: Pennsylvania State Univ., 1975.

Diehl, Charles. *Byzantium: Greatness and Decline.* Trans. N. Walford. New Brunswick: Rutgers, 1957.

Encyclopaedia of Islam. Ed. H.A.R. Gibb et al., vols. 1–7. Leiden: Brill, 1960– .

al-Faruqi, Ismā'īl R. & Lois Lamyā. *Cultural Atlas of Islam.* New York: Macmillan, 1986.

Ferrier, R. W., ed. *The Arts of Persia.* New Haven, Yale, 1989.

Frend, W.H.C. *The Rise of the Monophysite Movement.* Cambridge, Eng.: Univ. Press, 1972.

Gough, Michael. *The Origins of Christian Art.* New York: Praeger, 1974.

Grabar, André. *Byzantium: From the Death of Theodosius to the Rise of Islam.* Trans. S. Gilbert & J. Emmons. London: Thames & Hudson, 1967.

———. *The Art of the Byzantine Empire,* rev. ed. Trans. B. Forster. New York: Greystone, 1967.

Grabar, Oleg. *The Formation of Islamic Art,* rev. & enl. New Haven: Yale, 1987.

———. *The Mediation of Ornament.* Princeton: Univ. Press, 1992.

Grube, Ernst J. *Islamic Painting from the 11th to the 18th Century in the Collection of Hans P. Kraus.* New York: H. P. Kraus, 1972.

———. *The World of Islam.* New York: McGraw-Hill, 1967.

Hitti, Philip K. *History of the Arabs,* 10th ed. New York: St. Martin's, 1970.

Huart, Clement I. *Les calligraphes et les miniaturistes de l'orient musulman.* Osnabruck: Otto Zeller, 1972.

Hutter, Irmgard. *Early Christian and Byzantine Art.* New York: Universe Books, 1971.

John of Damascus. *On the Divine Image.* Crestwood, N.Y.: St. Vladimir Seminary, 1980.

Kitzinger, Ernst. *Byzantine Art in the Making: Stylistic Development in Mediterranean Art, 3rd–7th Century.* Cambridge: Harvard, 1977.

Kontoglou, Photes. *Byzantine Sacred Art,* 2nd ed. Trans. & ed. Constantine Cavarnos. Belmont, Mass.: Institute for Byzantine and Modern Greek Studies, 1985.

The Koran. Trans., with notes, N. J. Dawood, 4th rev. ed. London: Penguin, 1974.

Lassus, Jean. *The Early Christian and Byzantine World.* New York: McGraw-Hill, 1967.

Mango, Cyril A. *Byzantium and Its Image: History and Culture of the Byzantine Empire and Its Heritage.* London: Variorum Reprints, 1994.

Meyendorff, Jean. *Christ in Eastern Christian Thought.* Washington, D.C.: Corpus, 1969.

———. *Imperial Unity and Christian Divisions: The Church, 450–680 A.D.* Crestwood, N.Y.: St. Vladimir's Seminary, 1989.

Oikonomides, Nicolas. *Byzantium from the Ninth Century to the Fourth Crusade.* Brookfield, Vt.: Variorum, 1992.

Oxford Dictionary of Byzantium, 3 vols. Oxford: Univ. Press, 1991–1993.

Pelikan, Yaroslav. *Imago Dei: The Byzantine Apologia for Icons.* Princeton: Univ. Press, 1990.

Rabbat, Idum. *Les chrétiens dans l'Islam des premiers temps.* Vol. 1: *L'orient chrétien dans l'Islam à la veille de l'Islam.* Vol. 2: *Mahomet prophète arabe et fondateur d'état.* Vol. 3: *La conquête arabe sous les quatre premiers califes.* Beirut: Univ. of Lebanon, 1980–1985.

Rice, David T. *Art of the Byzantine Era.* New York: Praeger, 1963.

———. *Constantinople from Byzantium to Istambul.* New York: Stein & Day, 1965.

Rodley, Lyn. *Byzantine Art and Architecture: An Introduction.* Cambridge, Eng.: Univ. Press, 1994.

Schimmel, Annemarie. *Islam: An Introduction.* Albany: State Univ. of New York, 1992.

Serjeant, R. B. *Studies in Arabian History and Civilization.* London: Variorum Reprints, 1981.

Zibawi, Mahmoud. *The Icon: Its Meaning and History.* Collegeville, Minn.: The Liturgical Press, 1993.

The Syrians

Apren, Mar. *Nestorian Missions.* Maryknoll: Orbis, 1980.

Art of Syria and the Jaz'ira, 1100–1250. Ed. Julian Raby. Oxford: Univ. Press, 1985.

Baer, E. *Ayyūbid Metal Work with Christian Images.* Leiden: Brill, 1989.

Brock, Sebastian P. *Studies in Syriac Christianity: History, Literature, and Theology.* Brookfield, Vt.: Variorum, 1992.

———. *Syriac Perspectives on Late Antiquity.* London: Variorum Reprints.

Colledge, Malcolm A. R. *The Art of Palmyra*. Boulder: Westview, 1976.

Crayg, Kenneth. *The Arab Christian: A History in the Middle East*. Louisville: Westminster-John Knox, 1991.

Drijvers, H.J.W. *East of Antioch: Studies in Early Syriac Christianity*. London: Variorum Reprints, 1984.

Ephraem of Nisibis. *Hymnes sur le paradis*. Sources chrétiennes 137. Paris: Cerf, 1960.

Fiey, Jean Maurice. *Assyrie chrétienne*, 3 vols. Beirut: Imprimerie catholique, 1965–1968.

_____. *Chrétiens syriaques sous les Abbasides*. Louvain: CSCO, 1980.

_____. *Chrétiens syriaques sous les Mongols*. Louvain: CSCO, 1975.

_____. *Communautés syriaques en Iran et Irak des origines à 1552*. London: Variorium Reprints, 1979.

_____. *Coptes et Syriaques: Contacts et échanges*. Studia Orientalia Christiana Syriaca, 15. 1972.

_____. *Jalons pour une histoire de l'Eglise en Irak*. Louvain: CSCO, 1970.

_____. *Mossoul chrétienne*. Beirut: Imprimerie catholique, 1959.

Grabar, Oleg. *The Great Mosque of Isfahan*. New York: New York Univ., 1990.

Hitti, Philip K. *History of Syria, Including Lebanon and Palestine*. New York: Macmillan, 1951.

Humphreys, R. Stephen. *From Saladin to the Mongols: The Ayyubids of Damascus, 1193–1260*. Albany: State Univ. of New York, 1977.

Isaac of Antioch. *The Ascetical Homilies*. Trans. Holy Transfiguration Monastery. Boston: Holy Transfiguration Monastery, 1984.

Isaac of Nineveh. *Mystic Treatises*. Trans. A. J. Wensinck. Wiesbaden: M. Sandig, 1969.

John of Edessa. *Lives of the Eastern Saints*, 3 vols. Trans. E. W. Brooks. Paris: Firmin-Didot, 1923–1925.

Lassner, Jacob. *Shaping of 'Abbāsid Rule*. Princeton: Univ. Press, 1980.

Light from the East: A Symposium on the Oriental Orthodox and Assyrian Churches. Ed. Henry Hill. Toronto: Anglican Book Centre, 1988.

Narsallah, Joseph. *Architectes d'art religieux de la Syrie centrale et septentrionale des villes mortes de Syrie du IVème au VIème siècles*. Paris: Société des antiquités nationales, 1967.

Nau, F. *Les Arabes chrétiens de Mésopotamie et de Syrie du VIIe au VIIIe siècle*. Paris: Imprimerie Nationale, 1933.

Perkins, Ann. *The Art of Dura-Europos*. Oxford: Clarendon, 1973.

Shaban, M. A. *'Abbāsid Revolution*. Cambridge, Eng.: Univ. Press, 1970.

Stewart, John. *Nestorian Missionary Enterprise*. New York: AMS, 1980.

al-Ṭabarī. *Reunification of the 'Abbāsid Caliphate*. Trans. C. E. Bosworth. Albany: State Univ. of New York, 1987.

Theodoret of Cyrrhus. *A History of the Monks of Syria*. Trans. R. M. Price. Kalamazoo: Cistercian Publ., 1985.

Zayd'an, Jirj'i. *Umayyads and 'Abbāsids*. Trans. D. S. Margoliouth. Westport, Conn.: Hyperion, 1980.

The Armenians

Agathangelos. *History of the Armenians*. Trans. R. W. Thomson. Albany: State Univ. of New York, 1976.

Armenian Art Treasures of Jerusalem. Ed. Bezalel Narkiss. New Rochelle: Caratzas Bros., 1979.

Burney, Charles. *The Peoples of the Hills: Ancient Ararat and Caucasus*. New York: Praeger, 1972.

Chahin, M. *The Kingdom of Armenia*. London: Crown Helm, 1987.

Der Nersessian, Sirarpie. *Aght'amar, Church of the Holy Cross*. Cambridge: Harvard, 1965.

_____. *Armenia and the Byzantine Empire*. Cambridge: Harvard, 1945.

_____. *Armenian Art*. Trans. S. Bourne & A. O'Shea. London: Thames & Hudson, 1978.

_____. *Armenian Manuscripts in the Freer Gallery of Art*. Washington, D.C., 1963.

_____. *Armenian Manuscripts in the Walters Art Gallery*. Baltimore: The Trustees, 1973.

_____. *Armenian Miniatures from Isfahan*. Anṭilyās: Catholicosate of Cilicia, 1986.

_____. *The Armenians*. New York: Praeger, 1970.

_____. *L'illustration des psautiers grecs du Moyen-age*. Paris: Klincksieck, 1966

_____. *L'illustration du roman de Barlam et Joasaph*. Paris: E. de Boccard, 1937.

_____. *An Introduction to Armenian Manuscript Illuminations*. Baltimore: Walters Art Gallery, 1974.

_____. *Miniature Painting in the Armenian Kingdom of Cilicia from the 12th to the 14th Century*. Washington, D.C.: Dumbarton Oaks Research Library & Collection, 1993.

Durnovo, Lidiia A. *Armenian Miniatures*. Trans. I. J. Underwood. New York: Abrams, 1961.

Garso'ian, Nina G. *Armenia between Byzantium and the Sasanians*. London: Variorum Reprints, 1985.

_____, et al., eds. *East of Byzantium: Syria and Armenia in the Formative Period*. Washington, D.C.: Dumbarton Oaks, 1982.

Gregory of Narek. *Le livre des prières*. Sources chrétiennes 78. Paris: Cerf, 1961.

Kostof, Spiro. *Caves of God: The Monastic Environment of Byzantine Cappadocia*. Cambridge: MIT, 1972.

Lang, D. M. *Armenia, Cradle of Civilization*, 2nd ed. London: George Allen & Unwin, 1978.

Matthew of Edessa. *Armenia and the Crusades, 10th to 12th Centuries*. Trans. A. E. Dostourian. Landham: Univ. Press of America, 1993.

Mécérian, J. *Histoire et institutions de l'église arménienne*. Beirut: Imprimerie Catholique, 1963.

Nerses the Gracious. *Jésus Fils unique du Père*. Sources chrétiennes 203. Paris: Cerf, 1973.

Samuelian, Thomas J., ed. *Classical Armenian Culture: Influences and Creativity*. Chico, Calif.: Scholars Press, 1982.

_____, ed. *Medieval Armenian Culture*. Chico, Calif.: Scholars Press, 1984.

Sarkissian, Karekin, Bp.. *The Council of Chalcedon and the Armenian Church*. London: S.P.C.K., 1965.

Thierry, Jean-Michel. *Armenian Art*. Trans. C. Dars. New York: Abrams, 1989.

Thierry, Michel. *Répertoire des monastères arméniens*. Turnhout: Brepols, 1993.

Thierry, Nicole. *Peintures d'Asie Mineure et de Transcaucasie aux Xe et XIe siècles*. London: Variorum Reprints, 1977.

Thierry, Nicole & Michel. *Nouvelles églises rupestres de Cappadoce*. Paris: Klincksieck, 1963.

The Egyptians

Abū Salih al-Armanī. *The Churches and Monasteries of Egypt and Some Neighbouring Countries*. Trans. B.T.A. Evetts. Frome: Butler & Tanner, 1969.

Atiya, Aziz S. *The Copts and Christian Civilization*. Salt Lake City: Univ. of Utah, 1979.

Aylon, David. *Studies on the Mamlūks of Egypt (1250–1517)*. London: Variorum Reprints, 1977.

Badawy, A. *Coptic Art and Archeology*. Cambridge: MIT, 1978.

Bourguet, Pierre du. *The Art of the Copts*. Trans. C. Hay-Shaw. New York: Crown, 1971.

Butler, A. J. *The Ancient Coptic Churches of Egypt*. Oxford: Univ. Press, 1970.

Coptic Art and Culture. Ed. H. Hondelink. Cairo: Shouhdy, 1990.

Coptic Encyclopedia, 8 vols. Aziz S. Atiya, editor-in-chief. New York: Macmillan, 1991.

Fenoyl, Maurice de. *Le sanctoral copte*. Beirut: Imprimerie Catholique, 1960.

Ḥabīb, Ra'ūf. *The Ancient Coptic Churches of Cairo*. Cairo: Mahabba Book Shop, 1979.

Irwin, Robert. *The Middle East in the Middle Ages: The Early Mamlūk Sultanates, 1250–1382*. London: Croom Helm, 1986.

Kamil, Jill. *Coptic Egypt: History and Guide*. Cairo: American Univ., 1987.

Kamil, Murad. *Coptic Egypt*. Cairo: Le Scribe égyptien, 1968.

Lane-Poole, Stanley. *A History of Egypt in the Middle Ages*, 4th ed. London: Cass, 1968.

Leroy, Jules. *Les manuscrits coptes et coptes-arabes illustrés*. Paris: P. Geuthner, 1974.

_____. *Les peintures des couvents du désert d'Esna*. Paris: MIAFO, 1975.

_____. *Les peintures des couvents de Ouadi Natroun*. Paris: MIAFO, 1982.

Little, Donald P. *History and Historiography of the Mamlūks*. London: Variorum Reprints, 1986.

al-Maqrīzi. *A History of the Ayyūbid Sultans of Egypt*. Trans. R.J.C. Broadhurst. Boston: Twayne, 1980.

Meinardus, Otto F. A. *Monks and Monasteries of the Egyptian Deserts*. Cairo: American Univ., 1989.

al-Mi'srī, 'Irīs Ḥabīb. *The Story of the Copts*. Middle East Council of Churches, 1978.

Palladius. *The Lausiac History*. Westminster: Newman, 1965.

O'Leary, DeLacy. *The Saints of Egypt*. Amsterdam: Philo Press, 1974.

Sawirus ibn al-Muqaffa' (Severus of Ashmunain). *History of the Patriarchs of the Coptic Church of Alexandria*. Trans. & ed. B.T.A. Evetts. Paris: Firmin-Didot, 1907.

Tawa'drūs, Ṣamū'īl. *Guide to Ancient Coptic Churches and Monasteries in Upper Egypt*. Cairo: Institute of Coptic Studies, 1990.

Thomas, Thelma K. *Textiles from Medieval Egypt, A.D. 130–1300*. Pittsburgh: Carnegie Museum of Natural History, 1990.

Watterson, Barbara. *Coptic Egypt*. Edinburgh: Scottish Academic Press, 1988.

Wessel, Klaus. *Coptic Art*. Trans. J. Carroll & S. Hatton. New York: McGraw-Hill, 1965.

Winter, Michael. *Egyptian Society under Ottoman Rule*. New York: Routledge, 1992.

The Ethiopians

Abir, Mordecai. *Ethiopia and the Red Sea: The Rise and Decline of the Solomonic Dynasty*. London: Cass, 1980.

Annequin, G. *Aux sources du Nil Bleu: Enluminures et peintures chrétiennes*. Geneva: Crémille, 1990.

Appleyard, D. *Ethiopian Manuscripts*. London: Jed, 1993.

Book of the Saints of the Ethiopian Church. Trans. E. A. Wallis Budge. New York: Olms, 1976.

Chojnacki, Stanisław. *Major Themes in Ethiopian Painting*. Wiesbaden: F. Steiner, 1983.

Gerster, Georg. *L'art éthiopien*. Zodiaque, 1968.

_____. *Churches in Rock: Early Christian Art in Ethiopia*. Trans. R. Hosking. New York: Phaidon, 1970.

Girma Kidane. *The Ethiopian Cultural Heritage*. Addis Ababa, 1976.

Heldman, Marilyn. *African Zion: The Sacred Art of Ethiopia*. New Haven: Yale, 1993.

_____. *The Marian Icons of the Painter Fre Ṣeyon*. Wiesbaden: Harrassowitz, 1994.

Isaac, Ephraim. *The Ethiopian Church*. Boston: H. N. Sawyer, 1967.

Kaplan, Steven. *The Monastic Holy Man and the Christianization of Early Solomonic Ethiopia*. Wiesbaden: F. Steiner, 1984.

Langwir, Elizabeth, et al. *Ethiopia, the Christian Art of an African Nation*. Salem, Mass.: Peabody Museum, 1978.

Leroy, Jules. *L'Ethiopie, archéologie et culture*. Paris: Desclée de Brouwer, 1973.

_____. *Ethiopian Painting, in the Late Middle Ages and during the Gondar Dynasty*. Trans. C. Pace. New York: Praeger, 1967.

Marcus, Harold G. *A History of Ethiopia*. Berkeley: Univ. of California, 1994.

Pankhurst, Estelle S. *Ethiopia: A Cultural History*. London: Lalibela House, 1955.

Rosenfeld, Chris P. & Eugene. *Historical Dictionary of Ethiopia*. Metuchen, N.J.: Scarecrow, 1981.

Sanceau, Elaine. *The Land of Prester John: A Chronicle of Portuguese Exploration*. New York: Knopf, 1944.

Stoffregen-Pedersen, K. *Les Ethiopiens*. Turnhout: Brepols, 1988.

Ullendorff, Edward. *The Ethiopians: An Introduction to Country and People*. London: Oxford Univ., 1965.

York University Art Gallery. *The Rayfield Collection of Ethiopian Art*. Toronto: The Gallery, 1978.

Glossary

Acathistus Hymn A Greek liturgical hymn in honor of the Mother of God said standing, hence its title Acathistus ("not sitting").

Acephali Literally, "without a head"; specifically, the Monophysites of Egypt who refused to accept the Chalcedonian patriarch imposed on them by the emperor of Byzantium.

Anchorite One who retreats alone to a desert place to pray and battle the devil under a rule such as that of St. Anthony.

Aphthartodocetism A division of Monophysitism which teaches that from the moment of its incarnation, the body of Christ was immortal, incorruptible, and impassible.

Apophatic Refers to a spirituality which emphasizes the inadequacy of human language to express anything about God.

Basileus King.

Canons of Eusebius Tables devised by Eusebius of Caesarea to enable a reader to go from one passage in a Gospel to those parallel in the others.

Chalcedonian One who accepts the Christological definitions of the council of Chalcedon, specifically that the humanity of Christ is inseparable from his divine Person and that the divine and human natures are separate.

Collobium A long tunic.

Deesis Literally, "supplication"; specifically, a representation of the Holy Mother of God and St. John the Baptist standing on either side of Christ and imploring mercy for the world.

Eulogia Consecrated gifts associated with pilgrimage and made holy by contact with a holy place or object, such as the Holy Sepulchre or the place of a martyrdom.

Gnosis Immediate knowledge of spiritual truth, without the mediation of churches or other institutions.

Ḥadīth Literally, "report," "account"; the body of traditions relating to Muḥammad and his companions.

Hermit One who, like the anchorite, lives alone in a desert place, but not under a rule.

Hetoimasia Literally, "preparation"; specifically, the empty throne set up for the Son at the final judgment.

Hodegitria "She Who Shows the Way"; a representation of the Mother of God holding the Child in her left arm and pointing to him with her right hand.

Hypostasis Literally, "substance"; at Nicaea, the essence or substance of the triune Godhead; later, one of the persons of the Trinity or the one person of Christ as distinguished from the two natures, a change in meaning which caused confusion and division among the Churches.

Hypostatic Union The union of the divine and human natures of Christ in one hypostasis, or substance.

Iconoclast One who believes religious images are idols and those who venerate them are idolaters.

Iconodule One who venerates religious images, but does not worship them.

Iconolater One who worships religious images.

Jacobites The Syrian Monophysites who rejected the council of Chalcedon's teaching on the Person of Christ and became the national Church of Syria.

Kenosis Literally, "emptying"; specifically, the impoverishment of the Second Person of the Blessed Trinity when it willingly assumed human nature.

Liturgical program Individual portraits, scenes, and cycles arranged according to a fixed formula.

Mandorla An almond-shaped aureole.

Maphorion A garment covering the head and shoulders and traditionally worn by the Mother of God and holy women in artistic representations.

Melchites Eastern Christians who accept the definitions of Chalcedon.

Monoenergetism The teaching that Christ possessed one source of activity or "energy"; see also, "monothelitism."

Monophysitism A doctrine which holds that Christ's nature is wholly divine even though he has assumed an earthly body.

Monothelitism The teaching that Christ has only one will; see also "monoenergetism."

Neo Martyr A Saint martyred after the end of the Roman persecutions.

Nestorians Those who believe there are two separate Persons in Christ, one divine, the other human.

Orant A representation of the Mother of God or a Saint with arms extended and hands raised to shoulder level or higher in a gesture of prayer.

Ousia Literally, "essence," "substance"; see "Hypostasis."

Pantocrator Christ represented as Ruler of Everything.

Phantasiast One who professes Aphthartodocetism.

Physis Literally, "nature"; in theology, a term used by those who profess one or two natures in Christ.

Senmurv Dragon-like beast in Persian art, of Sāsānian origin.

Sūrah Literally, "row"; a division or chapter of the Qur'ān.

Synaxarion In the Eastern Churches, a book containing short narratives of the lives of saints and ex-positions of feasts, which are read at the early morning office.

Theopaschite One who believes that God suffered in the passion.

Theosophy A belief in intuitive knowledge of the Divine which is superior to that of historical religions or of philosophy or empirical science.

Ṭirāz A border adorned with elaborately woven, embroidered, or stitched inscriptions.

Credits

Numbers refer to captions, not to page numbers

Color Plates

All photographs reproduced here are the work of Isber Melhem, with the exception of those mentioned below.

Vatican Library: 6a, 6b, 7.
Georg Gerster, Zurich: 74–75, 78, 79, 80a.
Sami Karkabi: 76, 80b.
Adriano Alpago Novello: 25a, 25b, 77.
Mauro Magliani: 81, 89a, 89b, 89c, 90a, 90b, 91a, 91b, 96a, 96b, 96c, 96d.

Black and White Photos

Adriano Alpago Novello: 64, 65, 66, 67, 68, 70, 71, 72, 73, 74, 75, 76, 80, 83, 94, 95, 102, 103, 161.
Georg Gerster, Zurich: 153, 154, 155, 158, 159, 160, 162, 163, 164, 165, 166, 167, 168.
Sami Karkabi: 156, 157, 177.
Jules Leroy: 175, 176, 184.
Philippe Maillard: 11, 12, 13.
Arpag Mekhitarian: 90, 91.
Isber Melhem: 9, 16, 17, 18, 19, 20, 40, 41, 42, 45, 46, 47, 49, 50, 51, 56, 57, 58, 104, 105, 106, 111, 112, 113, 120, 121, 122, 123, 124, 125, 126, 127, 128, 129, 130, 131, 132, 133, 134, 141, 142, 143, 144, 147, 148, 151, 152.
Nabil Selim Atalla: 114, 115, 117, 118, 135, 136, 145, 146, 149, 150.

Ambrosian Library, Milan: 14.
Medici-Laurentian Library, Florence: 27, 28, 53, 54.
Vatican Library: 37, 38, 39.
National Library, Paris: 15, 29, 30, 137, 138, 139, 140.
British Museum, London: 52, 187.
Office of Tourist and Archeological Publications, Baghdād: 43, 44.
Editions Citadelles/Dominique Genet, Paris: 8, 116.
Gabinetto Fotografico Nazionale, Rome: 1, 3, 4.
Sam Fogg Gallery, London: 169, 170, 171, 172, 183, 185, 186.
Museum of Damascus: 22.
Sursock Museum, Beirut: 55.
Museum of Islamic Art, Berlin: 33.

Photos 77, 78, 79, 98, 101 from *Treasures of the Armenian Patriarchate of Jerusalem,* Jerusalem, 1969.
Photos 59, 60, 81, 82, 87, 89 from *Decorative Art of Medieval Armenia,* Leningrad (St. Petersburg), 1971.
Photos 84, 85 from *Armenian Khatchkars,* Erebouni, 1973.
Photos 86, 88 from *Kunst des Mittelalters in Armenien,* Union Verlag, Berlin, 1981.
Photo 2 from *La pienture byzantine,* Skira, Geneva.
Photos 5, 31, 32, 34, 35, 36 from *La peinture arabe,* Skira, Geneva, 1962.
Photos 21, 23, 24, 25, 26 from *Syria,* 1931, 1957, 1961.
Photos 173, 174, 178, 179, 187, 188 from *Ethiopian Painting,* Merlin Press, London, 1967.
Photos 6, 61, 62, 63, 92, 93, 96, 97, 99 from *Miniatures arméniennes,* Matenadaran Manuscript Library, Erevan.
Photos 107, 108, 109, 110 from *L'art copte,* Albin-Michel, Paris, 1968.

Private Collections

Cyril Caraoglan: 82, 83, 84, 85, 86, 87, 88 *(color).*
Andrea Mitrano, Italy: 81, 89a, 89b, 89c, 90a, 90b, 91a, 91b, 96a, 96b, 96c, 96d *(color);* 180, 182 *(black and white).*

Maps

Cesare Sacconaghi, Gallarate, according to the following sources.

AA. VV., *Découverte de l'Ethiopie chrétienne,* Les dossiers de l'archéologie 8, 1975.
William C. Brice, ed., *An Historical Atlas of Islam,* Leiden: E. J. Brill, 1981.
Gérard Dedeyan, dir., *Histoire des Arméniens,* Toulouse, Privat, 1982.
H. Jedin, K. S. Latourette, and J. Martin, *Atlas zur Kirchengeschichte,* Freiburg: Herder, 1970.
Franklin H. Littell, *The Macmillan Atlas of the History of Christianity,* New York: Macmillan, 1976.
G. Mokhtar, *L'Africa antica,* vol. 2 of *Storia generale dell'Africa Unesco,* Milano: Jaca Book, 1986.